PC Magazine® Guide to
Digital Photography

PC Magazine® Guide to Digital Photography

Daniel Grotta and Sally Wiener Grotta

Wiley Publishing, Inc.

PC Magazine® Guide to Digital Photography

Published by
Wiley Publishing, Inc.
10475 Crosspoint Boulevard
Indianapolis, IN 46256
www.wiley.com

Published by Wiley Publishing, Inc., Indianapolis, Indiana

Published simultaneously in Canada

ISBN: 0-7645-7372-1

Manufactured in the United States of America

10 9 8 7 6 5 4 3 2 1

XX/XX/XX/XX/XX

For general information on our other products and services or to obtain technical support, please contact our Customer Care Department within the U.S. at (800) 762-2974, outside the U.S. at (317) 572-3993 or fax (317) 572-4002.

Wiley also publishes its books in a variety of electronic formats. Some content that appears in print may not be available in electronic books.

Library of Congress Cataloging-in-Publication Data

Grotta, Daniel, 1994-
 PC magazine guide to digital photography / Daniel Grotta and Sally Wiener Grotta.
 p. cm.
 Includes index.
 ISBN 0-7645-7372-1 (pbk.)
1. Photography–Digital techniques–Handbooks, manuals, etc. 2. Digital cameras–Handbooks, manuals, etc. I. Title: Guide
to digital photography. II. Grotta, Sally Wiener, 1949- III. PC magazine (New York, N.Y.) IV. Title.
 TR267.G76 2004
 775–dc22 2004015688

Credits

EXECUTIVE EDITOR
Chris Webb

SENIOR DEVELOPMENT EDITOR
Kevin Kent

PRODUCTION EDITOR
Felicia Robinson

COPY EDITOR
Foxxe Editorial Services

EDITORIAL MANAGER
Mary Beth Wakefield

VICE PRESIDENT & EXECUTIVE GROUP PUBLISHER
Richard Swadley

VICE PRESIDENT AND PUBLISHER
Joseph B. Wikert

LAYOUT, PROOFREADING, AND INDEXING
TechBooks

About the Authors

Daniel Grotta and Sally Wiener Grotta are top name journalists and consultants in the field of digital photography. In fact, they've been covering digital cameras and the industry since the early 1990s. As Amy Wohl, the renown computer analyst, has said, "If you don't know the Grottas, you don't know imaging." Among the earliest photographers to use digital equipment, they broke the story of digital photography for some of the top national magazines (including *PC Magazine*'s first roundup) and have continued to write about it for many newspapers, magazines, and online publications. Together, they have written more than 1,000 high-tech articles, reviews, columns, and features, plus five (now six) books. In addition, they have lectured and taught digital photography and imaging at many schools, conferences and other venues, including the *PC Magazine* Digital U traveling workshops, which will be premiering autumn 2004.

The Grottas' company, DigitalBenchmarks, is an internationally respected independent digital camera and imaging test lab. Using new industry-standard tests that Daniel helped develop, DigitalBenchmarks Lab puts digital cameras and related hardware and software through extensive low-level and experiential tests.

While the Grottas have tested and reviewed most of the digital cameras that have been introduced for more than a decade, technology is only part of the story. The Grottas are professional photographers whose pictures have appeared in many publications throughout the world. They understand what it takes to get a great picture in all kinds of situations, from Antarctica to the Amazon rain forest, from war zones to the most difficult shot . . . the group family picture. Regardless of how many cameras they have handled, they have never lost sight of the whole reason they started with all this . . . their fascination with how much more of the world they can see, enjoy, and capture through a camera lens.

An Internet search on their names will bring up literally many hundreds of hits—mostly links to their reviews, articles, and speaking engagements. Or you can check out their Web sites: www.DigitalBenchmarks.com, www.TheWellConnectedWoman.com, and www.Grotta.net.

For two women of vision . . . our sisters,
Amy Wiener Sosnov and Lee Yeager

Acknowledgments

In summer 1991, we spent a weekend with Fred Shippey and Katrin Eismann at the soon to be opened Kodak Center for Creative Imaging (CCCI) at Camden, Maine, discovering the amazing potential of the $25,000 prototype Kodak DCS-100 digital camera and a new image-editing program called Photoshop. Since that time, we have been indebted to numerous industry experts, associates, and friends—starting, of course, with Fred and Katrin. Other mentors and associates who have always been generous with their knowledge, information, and friendship include Dr. Al Edgar, Dr. Bob Gann, Professor Ed Granger, John Larish, Dr. Joe Runde, and Dr. Julie Skipper.

We have been very fortunate to have worked over the years with some of the best editors and lab technicians in the business. Our thanks to our editors and associates at *PC Magazine*, past and present, including Sarah Anderson, Glen Bousseau Becker, Jamie Bsales, Sean Carroll, Stephanie Chang, Jenn DeFeo, Laura Delaney, Dan Evans, Rich Fisco, Craig Ellison, Roy Goodwin, Ben Gottesman, Matthew Graven, Lori Grunin, Bill Howard, Vicki Jacobson, Jeremy Kaplan, Konstantinos Karagiannis, Carol Levin, Don Labriola, Bill Machrone, Carol Mangis, Peter McKie, Glenn Menin, Michael Miller, John Morris, Brian Nadel, Ann Ovodow, Melissa Perenson, Robyn Peterson, Alfred Poor, Laarni Ragazza, Robin Raskin, Charlie Rodriguez, Paul Ross, Nick Stam, Sharon Terdeman, Don Wilmot, and Lance Ulanoff. A special thank you to M. David Stone and Jan Ozer, *PC Magazine* contributing editors, for their suggestions and input into the printer and video chapters. Our thanks to Mark Pope of Ziff Davis for first fielding our idea for this book. And to the team at John Wiley & Sons, including Chris Webb, our acquisitions editor, for his perseverance, respect, and patience; Kevin Kent, our development editor, for his guidance, open communications, and clear-headed editing; and Felicia Robinson for shepherding all our art through production.

We've enjoyed our numerous conversations with fellow photographers, many of whom shared their expert knowledge, tips, and techniques and allowed us to reproduce their beautiful photographs and digital art. Our thanks to Ben Gottesman, Greg Gorman (and his associate Trish Sword), John Isaac, Lewis Kemper, Michael Lewis, Peter Read Miller, Steve Rosenbaum, and Marilyn Sholin.

Naturally, this book couldn't have been written without supportive interaction and communication with numerous companies and people in the digital camera and imaging industry. Cameras and other equipment were loaned to us by Canon, Concord, Casio, Eastman Kodak, Epson, FujiFilm, Hewlett-Packard, Konica Minolta, Kyocera, Lexar Media, Lexmark, Monaco Systems, Motorola, Nikon, Olympus, SanDisk, Sigma, SmartDisk, Sony, and Sony Ericsson. Software was provided by ACD Systems, Adobe Systems, Corel Corporation, Extensis, Jasc, Macromedia, Microsoft, Mountaincow, PhotoParade, Picasa, Roxio, and others. Quite a few individuals have been instrumental in helping us with information, illustrations, software, and the loan of digital cameras and other devices, including Kim Agricola, Nicole Andergard, Iqbal Arshad, Cyndi Babasa, Pam Barnett, Joslyn Beloff, Ritch Blasi, Elissa Brown, Michael Bourne, Teresa Bridwell, Paul Buckner, Christie Burgner, Nancy Carr, Rick Champagne, Dario Chiarini, Sally Smith Clemens, Kevin Connor, Jenny Cooley, Alex Curyea, Leah Barret Demers, Brett Denley, David Dickstein, Patricia Doherty, Anna Doi, Caitlin Donahue, Karen Drost, Gabrielle Elmer, Steve Everett, Kim Evans, Bonnie Fladung, Rosemary Flynn, Bill Giordano, Keith Gordon, Jessica Gould, Leigh Grimm, Jennifer Gurien, Jo Ann Guear, Jim Gustke, Dan Harlacher, Kylie Ware Heintz, Adam Hersh, Scott Houchin, Jennifer Hudson, Ross Jacobs, John Jatinen, Ann Johnson, Elisha Joseph, Roxanne Jurtschenko, Jay Kelbley, Kelly Kessler, Monisha Khanna, John

Knauer, Thomas Knoll, Andy LaGuardia, Mats Lindeberg, Ryan Lucklin, Chris MacAskill, Jeffrey Mandell, Michelle Martin, Stephna May, Anne McIntosh, Nate Murphy, Grant Myre, Cheryl Balbach Nelson, Scott Nelson, Brenda Ning, Joe Paglia, Jim Peyton, Jon Piazza, Allison Pankrantz, Darrin Peeple, Jim Peyton, Nicole Ramirez, Joan Rankin, Mary Resnick, Jeff Ravencraft, Crystal Revak, Dora Ricci, Jacob Rice, Michelle Richardson, Steve Rosenbaum, Mike Rubin, Jon Sienkiewicz, Chris Sluka, Kristine Snyder, Anders Steele, Michael Stevenson, Deborah Szajngarten, Min Tak, Chris Taylor, Karen Thomas, Liz Tobey, Patricia Trapaga, Rosemary Valenta, Lyda Velez, Mike Virgintino, Saurabh Wahi, Lisa Walker, Mark Weir, Gwyn Weisberg, Aaron Wessels, Chuck Westfall, Laura Whitby, Merritt Woodward, Claudine Wolas-Shiva, Mike Wong, David Yang, Eric Zakarov, and many others. Software instrumental in our testing and in preparing our manuscript includes ACD Systems ACDSee, Adobe Photoshop Creative Suite, DO Labs DOX digital camera testing software, TechSmith SnagIt screen capture utility, Microsoft Office, and Monaco Optix color calibration. So many people were so very helpful that it has been difficult to keep track. Our apologies if we inadvertently left anybody out. Our heartfelt thanks to all.

Our thanks, also, to our assistant Jacob Rae, for all his support and long hours of testing digital cameras. Everyone should have a drummer doing timing tests for the sake of consistent and reliable results.

And to the two people who are always the first to read our copy and give us valued feedback, our deep gratitude and love to Edith and Noel Wiener.

Contents at a Glance

Contents

Part III **Photography with a Purpose**

Introduction

Photography is not technology.

Yes, your camera (whether film or digital) is indeed a technical marvel. But it is no more than a tool that you use to capture what you see in your mind's eye. Even if you are taking pictures of products or executives for the company newsletter and are not at all interested in creating great art, photography is a very human experience whose purpose is communication.

Please keep that in mind as you read this book. Don't let your camera's buttons and menus, pixels and ports get in the way of your own personal vision of what it is that has driven you to learn more about photography.

In the *PC Magazine Guide to Digital Photography*, we aim to help you develop the knowledge and skills that will eventually make the technology transparent to you, so that when you pick up your digital camera, all you'll have to concentrate on is getting the picture. We will explain the technology, of course. But more than that, we'll help you understand how to function with technology and assist you in making intelligent choices regarding camera settings and photo composition by explaining why they work. And going even further, we'll give you informed advice on the best ways to get great photographs that serve your needs and satisfy your artistic sensibilities.

Take Your Time . . . Enjoy

Our advice is to avoid the temptation to learn everything about your digital camera and photography all at once. Instead, go into one chapter at a time, preferably with your digital camera in hand. Explore how a single setting or process will affect your pictures. Once you understand what the setting or process is, try it in different ways, doing various projects, using many or all the options it offers.

For example, if you decide that you want to learn about exposures, go to Chapter 6 and read about *f*-stops and shutter speeds. Then, play around with your camera, until you understand the basics of how to change your exposure settings. Take your camera out on a walk in the neighborhood, and try out different combinations of *f*-stops and shutter speeds. Go back inside, download your image files into your computer (reading Chapter 17 to help you, if necessary) and study how your different exposure settings affected your final picture. Then return to Chapter 6 and find out more about other exposure settings. With that additional knowledge, go out again and shoot some more pictures, and look at them in the computer, side by side with the earlier images you shot.

Explore other aspects of digital photography in the same way, by reading, shooting, then reviewing and reshooting. Only by actually doing digital photography or working with your pictures in your computer will you really learn. And besides, that's where the fun is.

Finding Your Way Around

We've divided this book into four parts.

- Go to **Part I: "Understanding your Digital Camera"** to find out how digital cameras work (including understanding what megapixels really are). It also gives advice on

choosing the right model for your next (or first) digital camera, a primer on the basics of how to use your digital camera, and a discussion of what accessories you may need or want (and how to distinguish between the two).

■ Turn to **Part II: "Photography: The Play of Light and Color on the Human Imagination"** if you want to go beyond shooting everything in the point-and-shoot default mode. Here you'll learn what the various controls are on your camera, as well as how to use them and why. We also explain what effect different camera settings will have on your photographs, as well as share tips and shortcuts for getting the most out of your camera so you can get the pictures you want.

■ In **Part III: "Photography with a Purpose,"** we offer tips and guidelines on improving your photography, including advice from expert pros on shooting sports, portraits, vacations, products, and other types of pictures. In addition, you'll find guidance on creating great photographs for specific purposes, such as for newsletters, online auctions, business brochures, family albums, or email—and using them in various types of projects. You'll learn also how to choose, buy, and use a camera phone.

■ In **Part IV: "I Have My Pictures, Now What?"** you'll find guidance and tips on working with your pictures in your computer, including help in getting image files from your camera into your computer. You'll learn about editing, sharing, printing, and organizing your pictures, in ways that will ensure the best picture quality, convenience, and efficiency. In addition, you'll find out what the real differences are among the many kinds of software you could use, what they can do for you, and how to choose the right one(s) for your needs and skill level.

We hope you'll enjoy learning and mastering digital photography with us. It really is a grand adventure that goes far beyond mere technology.

Happy shooting!
Daniel and Sally
July 2004

Part I

Understanding Your Camera

Chapter 1

The Differences between Digital and Film Photography

A t first glance, digital cameras pass the "duck" test with flying colors. That is, if it looks, waddles, and quacks like a duck, it must be a duck.

To the casual observer, there's little or no difference between a digital camera and a film camera. Both have a lens, shutter, diaphragm, and viewfinder. Both take pictures when you aim them at the subject and pressing a shutter button. And to the untrained eye, both produce almost-identical-looking photographs that can be pasted in albums, mounted on refrigerator doors, used in business communications or hung in art galleries.

However, as much as digital cameras and film cameras are alike, they are also as radically different as a jet plane is from a helicopter, or a dog is from a tiger.

Some differences are obvious. Film is a chemical-based process, while digital is an all-electronic medium. Digital can provide instant feedback on your just-shot images, while you have to wait to see your film photos. Other dissimilarities become apparent only after you start using a digital camera.

The many significant and subtle differences between the two technologies can and will affect the way you take pictures. In this chapter, we'll examine how both film and digital work their magic in recording photographic images and how using digital cameras impact upon the choices you must make.

Why Film?

Film has lasted over a century and a half as the world's most popular medium for capturing and preserving visual memories for lots of compelling reasons:

- **It's cheap**—A film cassette or roll costs only a few bucks.

- **It's ubiquitous**—You usually can buy film at any convenience store, drugstore, or even newsstand anywhere in the world. And you can get it processed within an hour at almost any mall or drugstore.

- **It's portable**—Film is small, light, and travels well in a pocket or purse.

- **It stores well**—Negatives and transparencies fit very nicely in folders, sleeves, loose-leaf binders, shoeboxes, drawers, and so on.

- **It's instantly viewable**—All you have to do is hold a developed negative or transparency up to a light, and you can see the image. You don't need special equipment to view what you have.

- **It's easy**—Single-use cameras (SUC) (also called film-in-a-box) are instantly ready to shoot and require no learning or shooting skills. Just advance the film and press the shutter. No wonder 60 billion SUCs were sold last year.

- **It lasts**—If stored properly, that black-and-white negative shot by your great-great-grandfather will probably yield a print almost as good as when it was originally taken.

- **It's versatile**—There's an *emulsion* for just about any need or preference—color, black and white, fine grain, high speed, infrared, and so on.

- **It's good**—35mm fine-grain film can be blown up to poster size and maintain great color, razor sharpness, beautiful tonality, and image fidelity.

Film photography is a mature technology that has been giving us satisfaction and pleasure for generations. Is there anything more wondrous and representative of our culture than a shoebox of old fading and foxed photos of family memories? And the quality of film photos can't be beat. But film does have its disadvantages:

- Though it has fairly wide temperature latitude, film degrades quickly in extreme heat (as in a car's glove compartment in summer) and loses sensitivity in extreme cold.

- Undeveloped film must be kept in lightproof boxes or containers before and after shooting—one brief accidental exposure to the sun, and it's toast.

- Unexposed film has a practical life expectancy of 2–4 years, depending upon the emulsion and how well or badly it had been stored. Outdated or short-dated film gradually loses both sensitivity and color fidelity.

- It must be processed with environmentally hostile chemicals in a darkroom or by a photo lab, a precise, time-consuming, and costly procedure. If the temperature is too warm or too cold, the chemicals are not mixed in the correct manner, or the film is immersed for too short or too long a time, the film can be irreparably damaged, and the photos on it can be permanently lost.

- Developed color film degrades and deteriorates over time, to the point where it may be almost unusable after only a few years.

- If not handled and stored properly, film is prone to scratches, gouges, and dust, all of which adversely affect image quality.

Is Film Dead?

It was the end of the world as they knew it. This new-fangled invention, called photography, would put landscape and portrait painters out of business. Oils were obsolete and pastels passé, because

almost any yahoo with the right equipment and some basic skills could produce photographs that were more realistic-looking than the best painters could put on canvas.

Of course, they were wrong: the invention of photography in the 1830s did not make fine art painting obsolete. To the contrary: it produced a veritable renaissance and resurgence of painters and paintings. Now that they were no longer expected to paint primarily in a realistic style, artists were free to experiment with a wide variety of creative expressions, which led to innovative and free-spirited art movements such as Impressionism and Cubism.

Similarly, motion pictures didn't kill live theater, and television hasn't made the movies go away. More to the point, the advent of color film didn't knock black-and-white film from the shelves. Although the general public embraced color photography wholeheartedly, photojournalists, architectural photographers, and fine artists continue to use black-and-white film for its ability to express certain moods or impressions much better than color.

It is likely that film will probably survive against the digital tsunami for decades to come, albeit in a different and diminished capacity. Fine art photographers will sing praises to film's presumed greater tonality, grain, and other technical and aesthetic virtues and values. And until cheap disposable digital cameras become readily available (yes, they've been around since last year in some parts of the world), there's nothing in the digital world that comes close in quality and convenience to the ubiquitous single-use, film-in-a-box cameras you can buy at any minimart or corner newsstand.

Why Digital?

Digital photography is a new and growing technology that most observers predict will replace film in short order. Here are some of digital's numerous advantages:

- **It's economical**—You'll never again spend another nickel on film or processing (known in the industry as "consumables"), since your digital camera's built-in electronic memory or external memory cards can be used and reused thousands of times.

- **It's immediate**—With a digital camera, you can take a shot and instantly review it in the camera's LCD viewfinder. If your subject blinked or is out of focus, if you don't like the composition, or if the picture is too dark or light, you can then simply erase the picture at the push of a button and shoot over.

- **It's versatile**—Many digital cameras do more than take a still photograph. Your digital camera may allow you to record video or audio, create panoramas, stamp time/date and GPS coordinates on your pictures, and check world time. And if you have a camera cell phone, you can even call your friends between snapshots and quickly send the pictures to them.

- **It's contemporary**—In this day and age, the vast majority of our communications are digital. This covers everything from email to Web pages, business presentations to recordkeeping. Even material that ends up printed starts out digitally in our computers, where it is created, assembled, edited, and saved. If you want pictures to be part of your communications ("*a picture is worth a thousand words*"), then you'll need digital photos.

- **It records its own history**—A digital file of a photo can contain much more than a picture. Attached to that file can be all kinds of valuable information (called *metadata*) about where, how, and when a photo was taken. That data can be appended or edited, used to help identify and organize files, and in some situations, even be offered as legal evidence. (For more information on metadata, see Chapters 5 and 21.)

- **It's permanent**—Stored correctly on a high-quality CD or DVD, a digital photograph will never fade, fox, or lose data, and can last over a century.

- **It gives pro-like control**—Digital photography offers the average user the kind of control over the creation, editing, and use of his photos that used to be the domain of only expert photographers.

- **It's fun**—Beyond the immediate feedback and ability to display them right away on any computer screen or television, you can play with digital photos, change them artistically or humorously, remove your wrinkles, or add a mustache, try a new hair color, or paste yourself onto a Hawaiian beach. Using photo-editing software in your computer, you are limited only by your imagination. (See Chapter 18.)

As you read this book, you'll discover and master many other advantages of digital photography. But you'll also need to be aware that that digital does have its disadvantages, too:

- Digital cameras can be pricy, certainly more expensive than comparable film cameras.

- Digital cameras can be complicated. Except for the least expensive point-and-shoot models, most digital cameras offer a bewildering array of choices and options that can intimidate many users.

- Many digital cameras aren't as fast or sure shooting as film cameras. With many models, it takes a few seconds for the camera to power up before you can take the first shot. You may also encounter a frustrating, unavoidable delay between the time when you press the shutter and when you actually take the picture, so you may lose the shot if the subject moves in the interim. And because it's necessary to process and save the just-captured image, it can take anywhere from a second to a half-minute before your camera is ready to shoot again. (See Chapter 3 for tips on dealing with and reducing shooting delays.)

- Press the wrong button, and you could accidentally delete one, or even all, of your pictures.

- Connecting your digital camera to your computer can be a difficult, intimidating job. (See Chapter 17 for advice on how to get images into your computer.)

- Digital cameras may eat up batteries at an alarming rate. (See Chapter 4 for tips on buying batteries and Chapter 11 for advice on how to save on batteries.)

- The days of stumbling across a stored shoebox of memories and just sitting on the floor looking at photos of your family and friends will eventually fade away. Unless you make prints of your digital photos, you will need some sort of digital device to view them. That's why an archiving plan is important. And, of course, why those photos that are most precious to you should be printed. (Please see Chapter 20 on printing and Chapter 21 to learn about archiving.)

Still, the advantages of digital photography far outweigh the disadvantages. Besides, the genie is out of the bottle. Digital photography is here to stay. Film will soon be as foreign to the average person as old-fashioned rotary dial phones, and as obsolete as buggy whips and coal scuttles.

The Beauty of Working with Digital

When we first started doing digital photography, over 10 years ago, our fellow professional photographers tended to divide into three camps:

- Many established professional photographers poo-pooed digital as being inferior and inappropriate for the kind of high-quality work their clients expected from them.

- Others were openly or secretly fearful about what the new digital era would mean to them and their careers, often acting like ostriches with their heads in the sand. Would everything they knew and depended upon be outmoded and useless?

- The forward-thinking, adventurous pros embraced digital photography and ran with it.

Today, all the professional photographers we know do at least some of their work digitally, and many have completely retired their film cameras and closed their darkrooms. When they discuss with us what digital has meant to them, they don't talk so much about the technology as about what it has meant for their art and creativity, as well as their productivity and ability to more quickly and economically deliver what clients need and want.

Greg Gorman, the Los Angeles–based photographer well known and respected for his celebrity portraits (www.GormanPhotography.com), told us that he really enjoys working digitally. "It certainly surpasses film. The way digital sees light in low luminance is great. I always prefer the way natural light works, and with digital I get more of the nuances of the lighting. Of course, it's great knowing right away that you have the image you're looking for . . . the immediate gratification. But then, once I know I have the picture, I can push myself even further, get a little bit more out of it all."

All Cameras Are Alike . . .

The word *photography* literally means "writing with light." Photography as an art and a science has existed and evolved for about 170 years, give or take. It had a hundred births, in the cramped closets and kitchens of inventors and innovators who labored in absolute darkness, coating paper, metal, and glass surfaces with photosensitive silver salts, exposing them inside light-proof wooden boxes affixed with lenses appropriated and adapted from telescopes and eyeglasses, and then immersing them into witches' brews of caustic chemicals to develop and fix those images permanently. Although the process has been vastly improved and greatly refined through the years, film-based photography is still essentially the same as it was back in the 1830s.

At its most basic, photography requires a device that creates a photograph (see Figure 1-1). We call that device a camera, which is a box that captures the light reflected from a scene, person, or object and converts it into a tangible representation of that light, that is, a picture.

Shutter button View finder

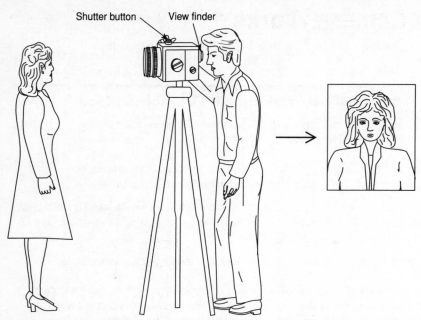

Figure 1-1: All cameras do essentially the same thing. Point the lens at a scene. Look at the scene through the camera's viewfinder. When you are satisfied with the composition you see in the viewfinder, press the shutter button. And you will end up with a photograph of that scene that looks very much like it did in the viewfinder.

To do this, most cameras typically have the following components:

- A lens for directing and focusing the light into the camera
- A *diaphragm* for regulating the amount of light allowed to pass into the camera, as well as controlling the *depth of field*
- A *shutter* for controlling the duration of the light passing through the camera
- A button or shutter release that tells the camera when to take the picture
- A photosensitive element (film or an electronic *image sensor*) to record the photo
- All contained in a light-proof box

In addition, most modern cameras also have:

- A window (or viewfinder) of some sort for the photographer to preview what the camera lens sees
- A photoelectric light *meter* for calculating exposure settings
- A built-in *electronic flash* or interface for connecting an external *strobelight*
- An electronic sensor to regulate flash intensity and duration for proper exposure

How a Film Camera Works

All of us have been using film cameras our entire lives, but most of the time it's been like driving our cars, with no thought as to what is really happening under the hood. To understand digital photography, it's important to consider its antecedents in film photography. Then, it will be easier to recognize the differences and similarities between the two technologies, which will lead to more easily and fully mastering the new world of digital photography.

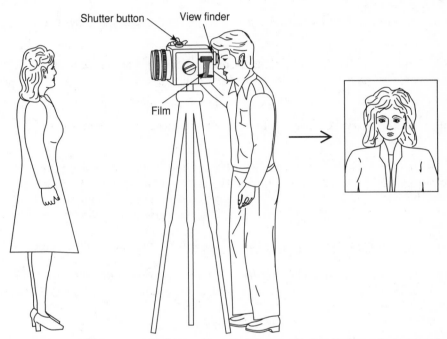

Figure 1-2: The most obvious difference with film cameras is that they record photographs onto film.

Film

Of course, the most vital part of any film camera is film. Without it, the camera is simply an expensive, useless mechanical toy.

Film is any medium or material (usually a flexible plastic Mylar base) coated with photosensitive silver halide crystals. Inside the camera, light passes through the lens and is focused onto the film. When the shutter opens, the film is briefly exposed to light, which causes an immediate chemical reaction: the sensitized silver halide crystals (*grain*) turn dark, creating a latent image. And where no light strikes, the crystals remain unchanged.

When developed and fixed (in total darkness) through a series of chemical baths, the latent image becomes visible, all reactions cease, the image becomes stable, and the unused (unexposed) silver halide crystals precipitate and are washed away.

What makes film particularly interesting for those of us who want to understand digital photography is that the attributes of both technologies are described in similar or even identical terms:

- *Sensitivity* to light (which, in film, is rated in *ISO* numbers)
- *Grain*, or the size and appearance of the small particles (crystals) that make up the picture
- *Resolution*, or the degree of sharpness and detail
- *Dynamic range*, the measure of how much detail the film can capture in the full tonal range, from deep shadows to bright highlights.

Sensitivity, grain, resolution, and dynamic range are closely related because they directly affect each other.

- A particularly sensitive, or high-speed film (that is, one that can be shot in lower-light situations), is somewhat grainer than a lower-sensitivity film.
- The bigger the grain crystals, the lower the image resolution and dynamic range.
- The finer the grain, the lower the sensitivity to light, but the wider the dynamic range and more detailed the resolution.

High-speed film (400 ISO and above) is useful for capturing available-light and low-light subjects, sports action, photojournalism, industrial and scientific processes, fidgety kids, and squirming pets.

Conversely, a low-sensitivity film (such as 64 ISO) is what you want when shooting brightly lit beach or snow scenes, portraits, and subjects where you want to capture great detail with fine subtlety and smooth gradations.

For most shooters, in typical situations, medium-grain, medium-sensitivity film (100–200 ISO) is the best choice.

Some digital cameras have controls that allow you to adjust their sensitivity to light, which are described in terms of their ISO equivalencies. (See Chapter 6 on understanding and using ISO equivalencies.)

No Free Lunch

Wouldn't it be wonderful if you could shoot with a fine-grain, high-speed film that produces top resolution and incredible dynamic range, and with spot-on accurate colors so vibrant that they would knock your socks off? Sorry, it just won't happen.

Like most things in life, film is a careful compromise, offering certain advantages balanced against corresponding deficiencies. The laws of physics and chemistry can be stretched only so far, so if you want ultrafine grain, you must give up on also having high-speed sensitivity. Or, you can shoot a film that captures accurate color, or one that produces saturated, brightened color, but not both.

As you'll learn later in the book, shooting digital always involves similar compromises and choices. You can select greater sensitivity—but you'll also get increased electronic *noise*, the digital equivalent of grain. Or, if you set your camera to *burst mode*, for faster shooting, you'll usually have to forego using the electronic flash.

Making the best choice for each picture and situation is what photography, be in film or digital, is all about.

No Film Is Color Film

You may be surprised to learn that technically, there is no such critter as color film. What we call color film typically consists of three layers of very thin black-and-white film sandwiched in between layers of red, green, and blue plastic filters. (See Figure 1-3 in this chapter and also Color Figure 1 in the color insert toward the back of the book.)

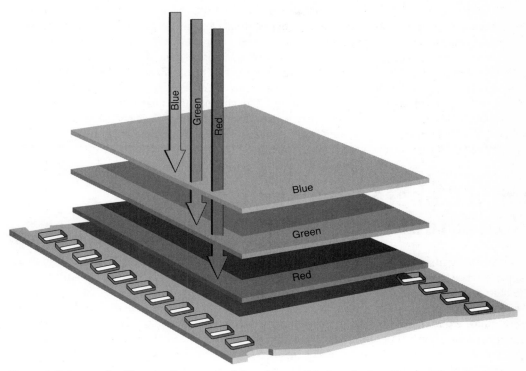

Figure 1-3: Basic color film actually consists of three layers of black-and-white film sandwiched in between red, green, and blue filters, all attached to a thicker piece of plastic. When developed, the black-and-white silver halide in each layer is replaced by corresponding red, green, and blue dyes. When composited (sandwiched) and viewed together, they appear as full color. Please also see Color Figure 1 in the color insert toward the back of the book. (Illustration based on another supplied by Foveon. © 1998–2004 Foveon Inc.)

Why red, green, and blue? Because they are the primary colors that make up *RGB*, the *color model* that governs the science behind film (and image sensors, too). Mix red, green, and blue in varying amounts, and you'll get all the different colors that a camera can capture. According to the RGB model, the absence of color (light) is black, while combining 100 percent red, green, and blue will give you white. All other colors are created by varying the percentages of the primary colors. (See Chapters 8 and 20 to learn more about color models.)

Getting back to how we get color film . . . each filter layer allows only its corresponding color through to the black-and-white film layer beneath. Then, when the film is developed, the filter layers are replaced with dye, so the black-and-white image captured beneath each filter is transformed into a red, green, or blue version of the scene photographed. When viewed together, the composite red,

green, and blue layers appear to our eyes as continuous, natural color. Keep this in mind when you read about how image sensors capture color. It's really quite similar. (See Color Figure 5 in the color insert toward the back of the book.)

The World's First Practical Color Film Was Invented in a Kitchen Sink

Although various kinds of color photography have been around since the late nineteenth century, they were, without exception, difficult, cumbersome processes that often involved exposing three separate plates of the subject and compositing them to create the full-color photo. While Kodak was pumping millions into the search to come up with the first practical amateur color film, an unlikely pair of professional musicians and avid amateur photographers named Leopold Mannes and Leopold Godowsky concocted a color film in 1935, literally, in a kitchen sink in their New York City apartment. Kodak hired the pair and bought the process, calling it Kodachrome. After nearly 70 years, Kodachrome is still considered to be the color film gold standard among serious photographers (although its composition is much different from the original 1935 version).

Digital Cameras Are Similar to Film . . . but Different

Like a film camera, the digital camera consists of a light-proof box with a lens, diaphragm, and shutter. The key difference is that in a digital camera the light is focused not onto film, but onto a photosensitive silicon chip or semiconductor, called an *image sensor* (see Figure 1-4).

Having an image sensor instead of film entirely changes things on the camera's back end. With film, once you capture the image, the only job left for the camera is to advance the film roll or cassette to the next unexposed frame. But with digital, pressing the shutter is only the beginning of a complex process that requires numerous other components and engineering considerations.

Most digital cameras incorporate the following components (see also Figure 1-5):

- *Image sensor*, to actually capture the photo

- *ADC* (analog-to-digital converter) to create the digital data of the photo

- Lots of digital circuitry, including one or more DSPs (digital signal processors) and one or more ASICs (application-specific integrated circuits), to process the data and create the image file

- *LCD viewfinder*, for composing pictures, reviewing photos already shot, and accessing some commands and controls

- Memory card slot and/or built-in memory, to save the digital image

- *USB* port for connecting to a computer

- Video out port for connecting to a TV or projector, where you can view your photos

- AC adapter port, to try to save on the cost of batteries

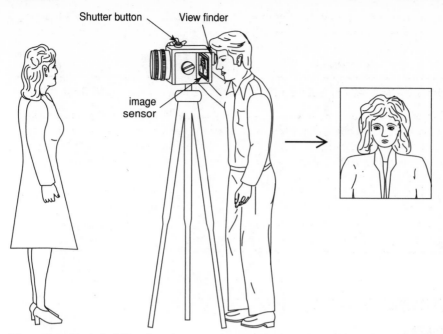

Figure 1-4: Instead of film, digital cameras capture photographs using silicon chips called image sensors.

Image Sensors

An image sensor is the photosensitive element in a digital camera that actually captures the photo. Essentially, it is what replaces film, though it doesn't do everything that film can do. Several functions (such as creating a photo and saving it) are handed off, instead, to other parts of the camera. (See Figure 1-5.)

Technically speaking, image sensors are photosensitive semiconductor chips that create an electrical charge when and where they are struck by light (photons). The more light, the greater the electrical charge generated. Digital camera image sensors have many thousands or millions of sampling points, each of which separately reacts to light. Each sampling point is called a *photosite* or *photoreceptor site*, a tiny etched area that collects light, like a bucket collects rainwater.

Photoreceptor sites are better known by their popular name: *pixels.*

WHAT IS A PIXEL?

Pixel is short for picture element. Think of a pixel as an atom: it's the smallest indivisible unit of a picture, the fundamental building block of an image.

Pixels are everywhere in computer graphics; it's what we call the dots on your screen, and when we measure the size of a digital image or photo, it's often in terms of how many pixels per inch (*ppi*) it has. But at the beginning of the imaging chain, a pixel is nothing more than a tiny etched point on an image sensor that is sensitive to light. And yet, this tiny photoreceptor site, when activated by photons, sets in motion a remarkably complex process whose end result is a digital photo.

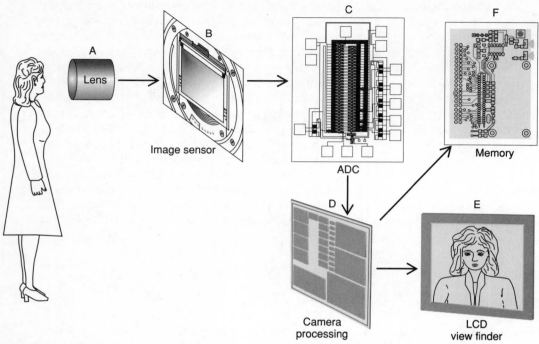

Figure 1-5: A digital camera is a complex system that when reduced to its most basic includes (A) a lens, (B) an image sensor; (C) an analog-to-digital converter (ADC); (D) extensive circuitry for image and color processing, which includes ASIC(s) and DSP(s); (E) an LCD viewfinder; and (F) internal memory and/or a slot for a removable memory card. Actually, the processing inside of a digital camera is not so linear as this illustration indicates; it includes lots of feedback, information, and controls moving back and forth and among components. In addition, your camera will certainly have many more components.

Tip: If You Want to Learn More Technical Details

For those who really want to dig into the technology behind pixels, image sensors, and digital photography, please go to www.ExtremeTech.com and read Sally's articles on the "Anatomy of a Digital Camera."

Megapixels: A Measure of Volume, Not Quality

The second most frequent question we hear when people ask us about digital cameras is "How many megapixels is that camera?" People ask the question even though they usually have no idea what a megapixel is, or even that it isn't a description of a camera, but of the amount of data an image sensor can capture. We don't blame them. It's the camera manufacturers' fault—or, at least, their advertising and marketing departments' fault. It's easier to sell by the numbers rather than explain the really important differences among cameras.

Size is everything in our society. Having the biggest and the most seems to mean more than just about anything else. Last year, 5 megapixel (MP) cameras were the hottest, best thing around. This year, it's 8MP cameras. And yet, we have seen 3MP cameras that produced better photographs than some 5MP cameras. And 8MP is simply overkill for almost every amateur photographer we know.

The fact is a camera's megapixel rating is only a measure of how many pixels (photosensitive sites) an image sensor has. More pixels means more image data, which translates directly into larger pictures. If you have larger pictures, you can get bigger prints. (See this sidebar's table for how megapixels relate to print size.) If you try to create a print that's too large for the amount of data in your photo file, the image may look soft, unfocused, and blocky and may exhibit *jaggies* (staircase-like edges where diagonals and curves should be smooth). Larger photo files can also be zoomed into to view small details without losing image integrity. But larger is not necessarily better.

An image sensor is simply one component of an entire system that produces a digital photograph. That system includes the lens, the processing of the data, the color and imaging science applied, how the photo is saved, and many other factors—starting with the photographer's eye for beauty and composition. So resist buying into the megapixel hype when you're choosing a digital camera.

Resolution	Print Size
1.3 megapixels	3.5"×5"–4"×6"
2 megapixels	4"×6"–5"×7"
3 megapixels	5"×7"–8"×10"
4 megapixels	8"×10"–8.5"×11"
5 megapixels	8.5"×11"–9"×12"
6 megapixels	11"×14"–14"×17"
8 megapixels	14"×17"–16"×20"

To read our response to the number one question, "What is the best digital camera?," turn to Chapter 2.

DOES THE SIZE OF YOUR PIXEL MATTER?

Pixels can be large or small, shallow or deep. While the number of pixels isn't a measure of image quality, their size can be. (See the sidebar "Megapixels: A Measure of Volume, Not Quality.")

Large and deep are better, because they can collect more light. And more collected light can (but does not always) translate into sharper detail, better color, greater dynamic range, and increased sensitivity. (Keep in mind that all pixels on any kind of image sensor are infinitesimally tiny and not visible to the naked eye. In fact, literally millions of pixels can fit on an image sensor the size of your pinky's fingernail.)

So why would anyone want smaller and shallower pixels?

It's all a matter of economics and practicalities. Large and deep pixels mean that the image sensor itself must be physically larger, and larger image sensors are more difficult and almost always significantly more expensive to manufacture. What's more, larger image sensors require bigger (heavier) lenses, larger camera bodies, and a host of faster, more robust components, all of which adds to the cost of a camera.

Image sensor size, and therefore pixel size, is one of the important factors that separate consumer and professional digital cameras.

Reality Check: Just How Large Are Image Sensors?

The size film that you would use has always related to what you want to do with your photographs.

- Most people use 35mm film, which measures 24 × 36mm, and is called 35mm because that's the length of the diagonal across the frame. 35mm film is what we use to shoot anything from snapshots to 16"×20" posters.

- Many professionals who want or need greater detail, control, and larger prints will use 120 roll film (which is 2¼"×2¼" square).

- For billboards, pros might use cut film for studio view cameras (which is usually 4"×5" or 8"×10" per sheet).

Like film, image sensors come in various sizes. If all other things are equal, larger image sensors will tend to produce clearer, brighter, better pictures. And yet, most image sensors are proportionately much smaller than film. That's because manufacturing large image sensors is a very expensive and difficult process; the more surface area a chip has, the more likely it is to have blemishes or other imperfections. So the rejection rate of large sensors is much higher than small ones.

Larger chips also are an order of magnitude more expensive to support, since they require larger lenses (lots more glass), bigger camera bodies, more robust components, and increased power to operate. (In fact, some professional studio cameras with large image sensors draw so much electricity that they must be AC powered and electrically cooled.)

The following table contains a brief sampling of digital cameras, the sizes of their image sensors, and the corresponding sensor resolutions:

Camera	Resolution	Image Sensor Size
Casio GV-10	1.3MP	4.54 × 3.2mm
Sony DSC-U50	2.1MP	5.27 × 3.96mm
HP Photosmart 945	5.24MP	7.18 × 5.32mm
Leica Digilux 2	5.24MP	8.8 × 6.6mm
Olympus E-1	5.6MP	18 × 13.5mm
Canon EOS-1D Mark II	8.5MP	28.7 × 19.1mm
Kodak DCS SLR/c	13.9MP	36 × 24mm

In case you can't easily visualize millimeters, 4.54 × 3.42mm is about the size of a Tic-Tac mint, 5.27 × 3.96mm is roughly the equivalent size of a small pea, and 7.18 × 5.32mm is approximately the size of a postage stamp.

The largest CCD currently used in a professional digital camera is, not coincidentally, 24 × 36mm. This one-to-one equivalent to a 35mm frame of film makes it easy to use conventional 35mm *SLR* camera lenses. (See Chapter 4 regarding lenses.) Professional studio digital cameras may have image sensors as large as 2"×2", which is many times bigger than consumer digital camera image sensors.

HOW DO IMAGE SENSORS CREATE COLOR?

Like film, image sensors are inherently black and white (grayscale) devices. They acquire the ability to capture color through elaborate engineering wizardry that is based on a concept similar to that of color filters used for film (See Figure 1-3, and see also Color Figures 1 and 5 in the color insert in the back of the book.).

One big difference with image sensors is that the color filters used are microscopic, to match the size of each individual pixel. But the one constant is that, like film, image sensors use RGB—red, green and blue primary colors—to create all the other colors that the camera can capture.

The most widely used method for creating color out of black-and-white image sensors is called the *Bayer pattern*. (See Figure 1-6, in this chapter, and Color Figure 2 in the color insert at the back

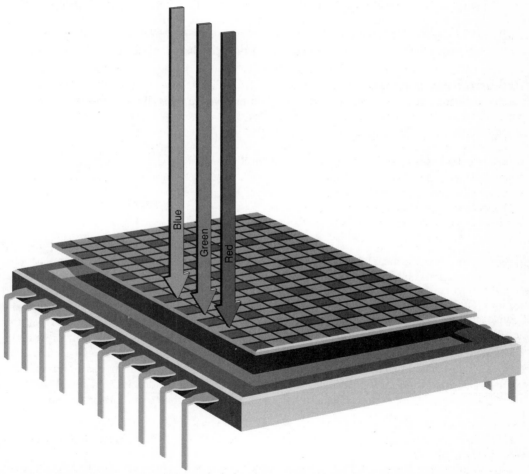

Figure 1-6: A Bayer pattern color filter array. Note the checkerboard pattern of alternating red/green/blue/green filters. The number of green pixels is doubled, because, due to a combination of psychology and physiology, the color green makes the image appear sharper to the human eye. (Based on an illustration by Foveon. © 1998–2004 Foveon Inc.)

of the book.) Named after Dr. Bryce Bayer, whose research team at Bell Labs developed it in the late 1960s, the Bayer pattern incorporates an array of primary-colored filters bonded over pixel wells. This elaborate checkerboard pattern alternates squares of red, green, blue, and green filters. (The green is doubled because the human eye sees green as an important defining element for sharpness.) The color of the filter covering the pixel allows only photons of that color to pass through. In other words, when light reaches the red square over a pixel well, only that light that is red will get through to the pixel. The other primary colors will be blocked.

When processed, the individual red, green, and blue pixels are combined, producing a composite that appears to be full, continuous color.

Some digital cameras use a similar checkerboard pattern, but with slight variations in the colors of the filter array. For instance, Sony has a color filter array that they call RGBE, in which the second green pixel in the Bayer pattern is replaced with blue-green, which they call emerald. Sony claims that when combined, the results are closer to how we humans perceive color.

The only image sensor used in commercially available consumer or prosumer digital cameras that doesn't use the Bayer pattern (or a variation on a Bayer-type checkerboard) is Foveon's X3 chip.

TYPES OF IMAGE SENSORS

While many different types of image sensors exist, four are used in most digital cameras:

- *CCD* (charge-coupled device)
- *CMOS* (Complementary Metal-Oxide Semiconductor)
- Fujifilm's *SuperCCD*
- Foveon's *X3*

CCD

CCDs are far and away the most popular and ubiquitous image sensors used in digital cameras, as well as camcorders, digital camcorders, and commercial television broadcast cameras. CCDs are generally considered to be better and more accurate at recording images than comparable CMOS chips.

While Kodak, Mitsushita, Sharp, and others manufacture CCDs, Sony currently supplies approximately 80 percent of the CCDs used in all digital cameras. Interestingly, even among cameras that use the same model CCD, we have seen wide variations in color and image quality, which only proves our earlier statement that the image sensor is not the only determining factor in how good a camera is.

CCDs are an established technology that may not sound as exciting and innovative as newer sensors. But in the numerous roundups we have done for *PC Magazine*, testing a wide variety of digital cameras, Editors' Choice for the best digital camera in the group has always gone to a CCD-based camera . . . so far.

CMOS

CMOS is ubiquitous among all kinds of computer equipment: your desktop computer probably has a battery-powered CMOS chip that retains the time, date, and other default settings when your system is switched off. When used as a photosensitive image sensor, CMOS chips have several advantages as compared to CCDs:

■ CMOS sensors are much more versatile than CCDs. That's because while all a CCD can do is capture light and turn it into electrons that are then processed elsewhere in the camera, a CMOS sensor can carry out a variety of extra functions, such as image processing, right on the chip.

■ CMOS sensors require significantly less power than a CCD, which helps stretch digital camera battery life.

■ CMOS is less expensive to manufacture. A CMOS fabrication factory costs about $150 million to bring on line, while a comparable CCD fabricating facility goes for well over a billion dollars. A typical 3 megapixel CCD may cost a camera manufacturer $30 in quantities of 10,000; a comparable CMOS chip may cost only $18.

Now for the downside (maybe): CMOS has a checkered reputation for image quality. There's no question that early CMOS-equipped digital cameras were terrible; images often were dark, muddy, and speckled with artifacts, and straight lines had a tendency to waver. But they got much better, to the point that both Canon and Kodak use CMOS in their newest ultraexpensive, high-quality, high-megapixel (11MP and 14MP, respectively) professional *D-SLR* (*Digital Single Lens Reflex*) models.

Almost every digital camera under 3 megapixels or costing less than $79 is outfitted with a CMOS rather than a CCD image sensor.

SuperCCD

Fujifilm used some nifty engineering legerdemain in designing a honeycomb-looking image sensor that they call a SuperCCD. (See Figures 1-7 and 1-8.) When all the other components of the camera

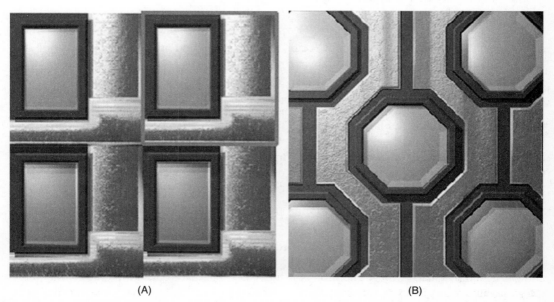

(A) (B)

Figure 1-7: Unlike the rectangle pixels of a traditional CCD (A), Fujifilm's SuperCCD has a honeycomb of octagonal pixels (B). (Copyright by Fujifilm)

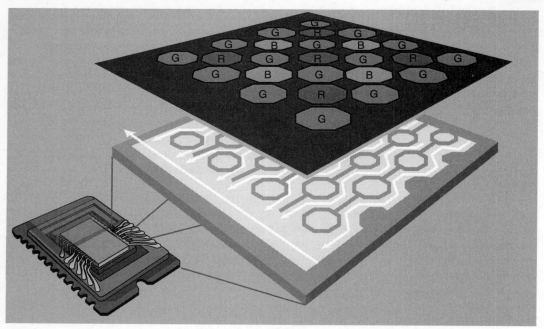

Figure 1-8: Fujifilm's SuperCCD image sensor uses an interlocking honeycombed design that forces each octagonal pixel to abut each other. See also Color Figure 3 in the color insert toward the back of the book. (Illustration based on another provided by Fujifilm.)

are tuned well, the SuperCCD can improve color, dynamic range, and image quality. In addition, the camera's smarts have the ability to hardware *interpolate* resolution to approximately double its actual physical resolution.

Fujifilm, the only manufacturer and user of SuperCCDs, currently produces several fourth generation versions of its chip. Two of its SuperCCDs, available in several camera models, have the ability to capture *two* pixels at each photoreceptor site. The HR version uses the extra pixel to double resolution, while SR's extra pixel helps extend dynamic range, for greater tonality. So far, Fujifilm hasn't combined both extended functions for a super-duper CCD with 4 pixels for each photoreceptor site that features both doubled resolution *and* greater dynamic range, but we wouldn't be surprised to see an announcement for such a hybrid within a couple of years.

X3

Back in the 1970s, Kodak reportedly experimented with engineering a CCD image sensor that would eschew the Bayer pattern checkerboard mosaic for creating color and instead would be able to capture red, green, and blue data at every photoreceptor site. We're told that Kodak abandoned work on the design because it proved to be either impractical or too difficult to commercially manufacture. Still, the idea of being able to capture all color information at each photoreceptor site was alluring, sort of a Holy Grail of image sensors.

The quest was taken up by Foveon, a small company originally known for its professional high-end studio digital cameras. In 2002, it announced the X3, the world's first commercial image sensor capable of capturing all three primary colors at every pixel. The X3 is an impressive piece of engineering. By bonding a tri-pack filter overlay to the image sensor, light representing all the primary colors is allowed to pass through into the photoreceptor site. Then, because of the differences in the wavelengths (think of how a prism splits sunlight into colors), red, green, and blue electrons are collected and register electrical charges at different depths within the photoreceptor site. (See Figure 1-9.) So, instead of the Bayer pattern's checkerboard mosaic that requires triple the number of pixels to produce composite color, the X3 needs only one photoreceptor site to create full color. Also, Bayer pattern image sensors require that the data go through a process called interpolation, to create color and build the image. The X3 has all colors and therefore does not need to be interpolated, and at least theoretically, it creates

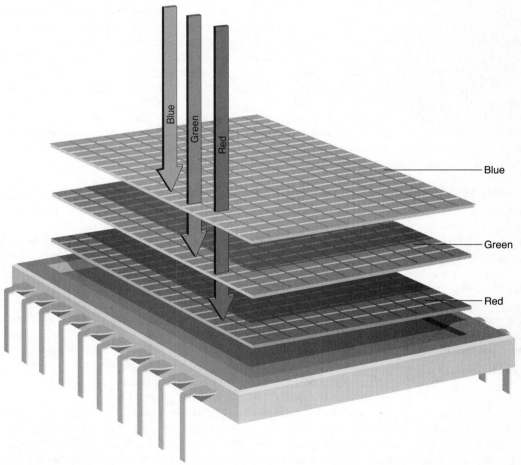

Figure 1-9: Foveon's X3 image sensor captures red, green, and blue light at each pixel by collecting the various wavelengths of light at different depths. See also Color Figure 4 in the color insert toward the back of the book. (Based on an illustration supplied by Foveon. © 1998–2004 Foveon Inc.)

better, more accurate color, as well as eliminates or minimizes common image sensor problems, such as *color aliasing*.

Other Image Sensors

While almost all digital cameras currently use CCDs, CMOS, SuperCCDs, or X3 image sensors, others certainly exist and are being used to capture digital images. Actually, we can't know exactly how many types of image sensors there are, because some are classified and used by the military. Two other sensors are worth noting—Nikon's LBCAST and Matsushita's v(nu)MAICOVICON. (And no, that last one is not a typo, though it should be.)

Famed camera manufacturer Nikon spent 10 years developing its LBCAST chip, which it says combines the high quality of CCDs with the versatility of CMOS. Nikon—which currently buys most of its CCDs from Sony—says that its proprietary LBCAST offers "high-speed, power-efficient, low-noise" capabilities better than any CCD on the market. That's why its first iteration is in Nikon's flagship digital camera, the $3,200 D2H D-SLR. The D2H is a 4 megapixel model (it's designed for sports, photojournalism, and other applications where speed is paramount and image size secondary), but Nikon will probably have higher-megapixel LBCAST image sensors in future products.

Japanese multinational Matsushita (Panasonic) recently announced production of their tongue-twister of a chip, the v(nu)MAICOVICON (try saying that rapidly six times). Developed primarily for camera cell phones, PDAs, and other small devices, the v(nu)MAICOVICON claims to combine the superior image quality of a CCD with the low power consumption and reduced cost of CMOS. The first v(nu)MAICOVICON chips are 1/4-inch square and have a resolution of either 1.3 megapixels or 2 megapixels. Future generations may offer higher resolution, and could eventually find their way into truly tiny cameras (like a cufflink-sized digital camera).

DO I REALLY CARE WHAT KIND OF IMAGE SENSOR MY CAMERA HAS?

Like most open-ended technology questions, the answer is an unequivocal yes . . . or a qualified no. It all depends upon your shooting style and preferences, and how big a budget you have.

The most important thing you should realize is that an image sensor is only one of a number of important components that affect overall image quality. The best image sensor in the world, when coupled with a mediocre lens, will produce a mediocre picture. The same goes for the other critical components that make up a digital camera.

A good case in point is the roundup of five 8 megapixel *prosumer* digital cameras we did for *PC Magazine* ("Five Super Eights," May 18, 2004). What these cameras had in common was that they all were using Sony's ICX456 CCD. On the other hand, all had different lenses, image and color processing, and other design and engineering dissimilarities. Not surprisingly, image quality and performance varied, not due to the type or brand image sensor used, but due to all the other components combined The point is that choosing a digital camera according to what kind of image sensor is inside is much less important than considering the camera in its entirety.

Then there is the reality that you really can't always know exactly what brand of image sensor you'll be getting. Digital camera manufacturers that buy components from other companies are notoriously close-lipped when you ask them what kind of image sensor their products have inside, mumbling some nonsense about how revealing the details would somehow void contractual agreements they have with the image sensor provider. Nor can you pick and choose what kind of image sensor you desire in the digital camera you hope to buy. Unlike an automobile, for which you can select the type engine, hubcaps, paint color, and accessories, image sensors are *not* interchangeable. You simply won't have a choice of what chip will be inside the model you want.

More Really, Really Technical Stuff about Image Sensors That You Don't Need to Know

There are hundreds of white papers and dozens of books written about image sensors, filled with lots of boring and virtually incomprehensible scientific formulae and engineering jargon. Equipment junkies trade information and opinions online about problems, advantages, and design deficiencies of specific types of image sensors on professional photography forums and Web sites. From these sources, you may read or hear about such technical issues as blooming and anti-blooming, smear, MTF, pixel amplification, quantum efficiency, dark current, signal readout, microlenses, lux, interline transfer verses full frame transfer, and so on. While all these and other aspects are important to pros who need to know how an image sensor works and what are its strengths and weaknesses, it's unnecessary, extreme technical overkill for most digital camera users.

ADC and Your Digital Camera's Bit Depth

It may come as a surprise to learn that all image sensors are *analog*, not digital, devices. In fact, the entire universe, except the world that exists inside a computer, is analog. Including film. Digital's sole inhabitants are zeroes and ones, period.

So how do you get digital data from an analog capture device?

That's what the ADC (analog-to-digital converter) does inside your digital camera (and in fact, the reason why it's even called a digital camera). All digital cameras have an ADC chip inside that converts the picture captured by the image sensor into digital data. Not all ADCs are created equal, however. How well and how quickly it does its job depends upon the manufacturer, chip design, and most importantly, the number of data bits it can process.

The ADC works by taking the analog data stream from your camera's image sensor, registering the charge, or number of electrons related to each photoreceptor site, and then deciding whether a piece of data should remain a zero or be a one.

These digital pixels consist of data bits that establish exactly what color that pixel will be. The more bits, the more possibilities for more precisely defining the color's hue, saturation, and brightness. Most inexpensive digital cameras process 8-bit pixels. Better digital cameras may have 10 bits or 12 bits per pixel. That's good, because more information usually translates into better color, more subtle transitions or gradations, and increased clarity of detail in the highlights and shadows. Professional digital cameras and studio digital cameras may even associate 14 or 16 bits of data with each pixel.

Since it's the job of the ADC to convert the analog pixel that the image sensor captures into a digital pixel that your computer can recognize and use, how many bits the ADC can handle (or its *bit depth*) is an important factor in rating the power and quality of your camera.

As with image sensors, you can't specify what kind of ADC your digital camera should have. But you can choose to buy a camera that has, for example, a 12-bit ADC over a 10-bit ADC by carefully looking over the specs on the manufacturer's Web site. If it's not listed, your digital camera probably has an 8-bit or 10-bit ADC, as do many inexpensive consumer models. Better, but pricier models will list the camera's bit depth.

But remember, an ADC's bit depth is only one of many components that contribute to a digital camera's image quality. So, avoid obsessing on buying only a model that has the highest data bit depth, since the lens, programming, and image sensor are equally important.

Not All Electronic Cameras Are Digital Cameras

Back in the early 1990s, when we first started working with and writing about filmless photography, we scrupulously avoided calling every electronic camera a digital camera. Why? Because most of the electronic cameras back then weren't, strictly speaking, digital devices.

Remember, all cameras are analog devices. A camera is only considered to be digital if it has a built-in ADC chip that gives it the ability to instantly convert captured analog information into digital data.

Almost all early electronic cameras used CCD image sensors, but the analog models lacked a built-in ADC chip. So, instead of instantly converting the just-shot image to digital data, it stored the analog information on tiny silver-dollar-sized floppy diskettes in hard plastic shells. (It's very similar to how nondigital camcorders record video, except the camcorders save to analog tape instead of floppies.) Once saved, the floppy was removed from the camera and inserted in a very expensive shoebox-sized disk drive attached to a PC or Mac via a SCSI (Small Computer System Interface) cable. When activated, the drive would read the tiny floppy, process that data through its built-in ADC chip, and transfer the digital file to the computer—a cumbersome, time-consuming procedure.

Not surprisingly, external ADCs quickly went the way of the dodo when affordable digital cameras began reaching the marketplace. But the concept of post-shooting processing lives on, not in hardware, but as the RAW file format so popular with professional photographers. (See more about RAW in Chapter 5.)

Tip: 8-bit Color Is the Same as 24-bit Color

Sometimes, it feels as though computer jargon is purposely complicated just to make things more difficult. When talking about color inside a camera or scanner, bits are described according to how many there are per primary color. Since all cameras and scanners use the RGB color model, that means there are three primary colors—red, green and blue. When those bits are brought into the computer, they are described according to how many there are for all colors. Therefore, 8-bit color in your digital camera becomes 24-bit color in your computer.

What Happens to All Those Data Bits?

If 12, 14, and even 16 bits per primary color sounds like an awful lot of data to you, you're right. It is. (See Table 1-1.)

If left intact, all those data bits would inflate image file size and considerably slow down in-camera processing. And it wouldn't really be of much benefit when you view the pictures. The human eye is capable of discerning approximately 12 million different colors, which is why 8-bit color is considered photo-realistic. What's more, only a handful of image-editing programs, like Photoshop, have the ability to work with image files larger than 8 bits. Even if you are able to work in 12-bit or 16-bit color, you can't really output it in that form because there isn't a desktop printer made that can use anything other than 8-bit color.

Table 1-1 How Much Data Is in Those Bits?

Bits	Formula for # of Colors in RGB	Total Possible Colors
8 bits	256 × 256 × 256	16.7 million
10 bits	1024 × 1024 × 1024	1.07 billion
12 bits	4096 × 4096 × 4096	6.87 billion
14 bits	16380 × 16380 × 16380	4.39 trillion
16 bits	65536 × 65536 × 65536	281.47 trillion

So what happens to those extra bits? They get thrown away, in a process called *sampling*. You are probably thinking: why the heck should a digital camera collect all those data bits if they're only going to be discarded? That's where the camera's smarts come into play. The camera's image processing includes examining all the captured bits, and by using mathematical formulae developed by the manufacturer's engineers, deciding which set of data bits will produce the best image. Some cameras have built-in stored profiles to which they compare the just-shot image, looking for similar pictures and then selecting the best bit set. Professionals and experienced hobbyists who don't want a camera making that decision for them will shoot in RAW file format, which keeps all the bits intact until the photographer can view them in special software in the computer and choose how they should be processed. (See Chapter 5 to learn more about RAW.)

A Computer in Your Camera

When you get down to it, the biggest difference between film and digital cameras relates to the fact that an image sensor is not an exact replacement for film. Shoot a roll of film and your pictures are saved onto the roll. Expose an image sensor to several different scenes, and all you have are a bunch of electrons, converted by the ADC into digital data. The job of turning that data into an actual photograph is handed off to a very small, but very complex computer within the camera. (See Figure 1-10.)

The camera's circuitry and chips, including ASICs and DSPs, process the data to produce form, color, contrast, and luminance and then organize and format it so it can be saved in a recognizable file format. (See Chapter 5 about the file formats, including the RAW format, which postpones much of this processing until the picture is *uploaded* to your computer.) All this is done according to manufacturer-specific proprietary imaging and color science, which is what really sets each camera apart from its competitors. And that is why you can't really tell how good a digital camera is going to be just by reading the specs about its image sensor, ADC, or other components.

Note: Lewis Kemper, Fine Art Nature Photographer

"I like to shoot digital because of the control I have in post-processing. But now you are the processing lab. A lab could take a 36-exposure roll and process all the pictures at once. Now, you have to process them one at a time yourself . . . if you want the most control." (www.LewisKemper.com)

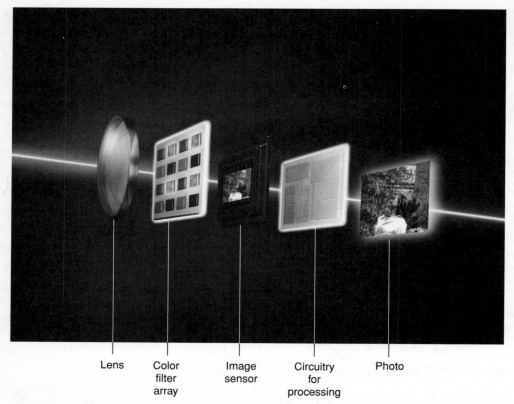

Lens Color filter array Image sensor Circuitry for processing Photo

Figure 1-10: A digital camera is a system consisting essentially of a lens, image sensor (with color filter array), and extensive circuitry for processing—all designed to produce a photograph that is indistinguishable from film to all extents and purposes. (Copyright by Sony Corporation.)

Summary

This chapter covered many issues concerning the differences between film and digital photography. Some of the key points included the following:

- Film and digital cameras are quite similar in that you can point them at any subject and take a photograph by pressing a shutter button.

- Film and digital cameras are, however, quite different inside because of all the processing that is required to support the digital technology.

- Much of what we understand regarding film can be used to help us understand digital photography.

■ Photography often involves making compromise choices between opposite possibilities, such as choosing between film type (or an image sensor setting) that would have greater sensitivity to light or one offering finer resolution and detail.

■ Having an image sensor instead of film entirely changes things at the camera's back end. Pressing the shutter is only the beginning of a complex process that requires numerous other components and engineering considerations.

■ Using a digital camera opens up lots of creative possibilities, but it also means that your job isn't over after you press the shutter button.

Chapter 2

Choosing the Best Digital Camera for You

After reviewing your grocery shopping list and making sure you haven't forgotten anything, you climb up into the cab of your huge 16-wheeler Mack truck, double-clutch into neutral, pull out the choke, and turn the ignition key. Once the powerful diesel engine catches, you ease the gearshift into first, slowly depress the accelerator, exit your driveway, and barrel down the road toward the supermarket, two blocks away.

Not the smartest choice of vehicles for doing everyday errands.

By the same token, you wouldn't want to use a sports car to help move your daughter into her first apartment or take the family sedan into the backwoods for a little offroad trout fishing. It's a matter of selecting the right vehicle for the job at hand.

Choosing the perfect digital camera is like making any other selection, be it a car, shoes, or even a mate. You must decide what it is that you want and balance it against what you really need, feel comfortable with, and can afford. It's all a matter of personal preferences combined with practicalities, ergonomics, and economics.

In this chapter, we'll take you through a questionnaire to help you determine what kind of digital camera is right for you, explain the various kinds of digital cameras and the differences among them, help you understand how to make intelligent choices when choosing among the many options, and offer advice about how and where to buy your camera.

Tip: You May Not Need the Newest Camera

If you have a digital camera and you're happy with the pictures, pause before retiring it for a newer one. A couple of years ago, digital cameras finally reached a certain level of sophistication, with most having achieved good image quality, decent handling and ergonomics, and a whole slew of features. Since then, improvements have been evolutionary rather than revolutionary. Buy a new camera only if you're ready for something more advanced, really need the extra resolution for larger files, aren't satisfied with the quality of your older one, are dissatisfied with its slow shooting speed, or just have to have a certain feature or ergonomics to better fit your lifestyle and photographic needs. By the way, given how good digital cameras have become, your camera could serve you well for at least the next 10 years.

Assessing Your Photographic Personality

The single most common question we hear about digital cameras is, "Which one is the best?" On the surface, it's a fair question. After all, at the time of this writing, literally hundreds of different digital camera models are vying for your dollars. It's a given that certain cameras are better designed, better made, or better equipped than the competition. Therefore, the logic goes, one brand or model should stand out as the very best.

Sorry, it doesn't work that way.

The fact is a camera that might be fabulous for one person may be a disaster for another. For example, one of our favorite film cameras is our Hasselblad 500C, a beautifully crafted, built-like-a-tank medium-format classic camera that most professional studio photographers once used because of its ability to create truly superb photographs. However, it would have be a downright terrible choice for taking everyday candids or snapshots because it is hideously expensive, large and heavy, touchy and temperamental, requires considerable photographic skills to operate properly, is very slow shooting, and can take only 12-exposure rolls of film.

Many pros use different cameras for different jobs—a 35mm single-lens reflex (SLR) for travel and sports, a medium-format camera for portraits and fashion, and a large $4'' \times 5''$ or $8'' \times 10''$ view camera for glossy magazine ads and covers. The object lesson from this is that what is perfect for one photographer may be terrible for another, or what's the best camera for a particular subject or style isn't necessarily just as good for other kinds of photography.

So the question isn't what is the best camera, but what is the best digital camera for you? To help you determine your photographic personality, we've compiled a short questionnaire. Circle the number of the answer that best applies to you currently or to what you are hoping for once you have your digital camera:

- What best describes your relationship and attitude to technology?

 1. I hate technology. I'm a Luddite and would avoid modern appliances and conveniences if I could, but I can't, so I live with it.

 2. I function okay with technology, but I can take it or leave it. If I have to, I can sometimes figure most things out, but I'd rather not.

 3. Technology can be fun and interesting. I get a kick out discovering something new on my computer that makes things better, more attractive, or snazzier. But I don't do it that often.

 4. I love it! I enjoy having all that power, convenience, and fun at my fingertips.

 5. I'm a geek and proud of it. I either make a living with it and/or spend lots of money on the newest, hottest, and sometimes most complex techno-toys.

- What best describes your knowledge of photography?

 1. Fuji is a mountain in Japan. In other words, I really don't know much about photography, and I don't care. All I want are nice snapshots without having to know anything else.

 2. I like taking pictures, and it would be fun to learn more if I had the time.

 3. I love photography. I understand what *f*-stops and shutter speeds are, or wish I did.

4. Photography is in my blood, and I'd love to learn more about it. If I had the time and if I could afford it, I think it might even be fun to do it professionally.

5. I do this for a living, or it is my number one passion. It's important to me to have the very best, most advanced photo equipment.

■ How do (or did) you get your prints from your film and what do you do with them?

1. I drop them off at the minilab or drug store. Then I put them under a magnet on the fridge, send them to grandma, and file them away in shoeboxes. Sometimes, I'll frame the very best and carry one or two in my wallet.

2. I reorder prints that I like, get enlargements, sometimes put them on the wall, and occasionally give them to friends. I like going through my pictures and showing my albums.

3. I once had my own darkroom or wished I did and would enjoy fiddling with my prints to make them better.

4. I make prints for my company's newsletter or reports. I sometimes shoot events for friends and family. Or a few pictures of mine have appeared in the local paper.

5. While I sometimes use a professional service to print my photos, it's usually a custom lab. I am comfortable in a darkroom and need or want great prints for professional or personal purposes.

■ What best describes the subjects you photograph?

1. Kids, animals, vacations, and family gatherings. Or, for business, quick-and-dirty scene recording.

2. All the above plus flowers, skies, and other pretty subjects, or photos for internal newsletters and other such documents that won't be seen by people outside company.

3. All the above plus conceptual pictures or photos that represent ideas.

4. All the above, plus I use the photos to document business events, products, portraits, and take pictures that have lasting meaning for others and not just me and my family.

5. I take professional pictures on assignment, or I produce professional-quality pictures for exhibition and private display.

■ How much do you spend a year on your photography?

1. I don't know, but it can't be more than about $100–$150.

2. Probably about $150–$400.

3. Depends on the year, but certainly under $1,000.

4. I'm not sure, but my spouse (or boss) says it's entirely too much.

5. Whatever it takes to get the pictures I need and/or want.

■ If you are still shooting film (or when you used to shoot film), how many rolls do you have on hand?

1. I think I have one or two rolls somewhere in the house.

2. Probably about a half dozen, though I might have used them up the last time I was shooting.

3. I generally keep about a dozen rolls in my camera bag at all times.

4. I buy film by the brick (20-roll packages) and replenish it before I run out.

5. My refrigerator is stocked with film.

■ How do you set up your picture?

1. I put the camera to my eye and press the shutter.

2. I will look at a person or scene, and if it is nice, I put the camera up to my eye and press the shutter.

3. I wait until a person or scene appeals to me, check the composition in the viewfinder, and then I press the shutter.

4. I choose what I think is the right lens and look at the scene or person from various angles until I find the right perspective, even when it means climbing on a rock. Then I frame and shoot.

5. I create the shot rather than find it, controlling as many elements as possible.

■ Describe what you want to be as a photographer:

1. I'm not a photographer. I just want to take pictures sometimes.

2. I want to learn how to take good pictures of my friends, family, business associates, and/or vacation.

3. I want to become a better photographer.

4. Of course, I'm always interested in producing better images, but I'm quite proud of my photography.

5. It's in my blood. I can't help myself. Whatever I see, no matter the time or place, I think, "I could create a great shot here."

Now go back over the questions and add up the numbers (1, 2, 3, 4, or 5) you have circled. Your result should be between 8 and 40.

What Your Answers Say about the Best Digital Camera for You

The previous questionnaire gives us a beginning point to help zero in on possible digital cameras to fit your needs, budget and personality. If you scored from:

- **8–14**—You are definitely a point-and-shoot user. Point-and-shoot digital cameras are designed to let you capture good pictures without requiring you to learn any controls or fuss with any features.

- **15–23**—You're probably a candidate for an intermediate consumer camera. It may in fact be the same point-and-shoot camera that novices and technophobes use, but once taken off automatic, it will offer you some control over your photography, though with a limited feature set.

- **24–29**—You may wish to consider a more advanced consumer digital camera, one that allows more extensive control over exposure, color, and tonality and comes bundled with more sophisticated image-editing software.

- **30–36**—You will want a prosumer or semiprofessional digital camera. Prosumers offer more/faster/better—more features, more precise control, faster performance, faster throughput, better pictures. Semiprofessional models go one step further by offering interchangeable lenses, true through-the-lens single lens reflex viewing, and system accessories and peripherals.

- **37–40**—You're a professional photographer (or very avid hobbyist) who needs the best, most advanced pro equipment to do your job properly.

Maybe You Really Need a Scanner

If you are comfortable shooting film and don't want to switch entirely to digital, or you have stacks of negatives, transparencies, or black-and-white prints, you may be better off buying a scanner than a digital camera. A scanner is a quick and easy way to digitalize and download a photograph into the computer.

Desktop flatbed scanners are relatively inexpensive ($99–$399), easy to install, and do a reasonably good job in scanning prints, text, drawings, prints, and other paper-based originals. Flatbeds with an added transparency adapter (most flatbeds now come with TAs) are adequate for imputing occasional 35mm negatives and transparencies, as well as larger format film, such as 120 or 4"×5". But when you have hundreds or even thousands of slides and negatives, or when image quality is paramount, that's when you should move up to a shoebox-sized device called a film scanner. Film scanners, while more expensive ($400–$1,400), feature higher *resolution* and *dynamic range* than flatbeds and are optimized to produce higher-quality images.

The one difference between a scanner and a digital camera is that any photo you scan will be what is called *second generation*. On the other hand, any photo image you capture with a digital camera will always be first generation. With each generation, image data can degrade. Therefore, first generation images are always preferred by pros over any other.

Recognizing the Different Types of Cameras

Now that we've narrowed down the type of camera you might wish to consider, let's look at what each class and category cameras has to offer, and what the tradeoffs are.

Table 2-1 provides an overview of typical cameras. Of course, exceptions are the rule. Following the table are more in-depth explanations and discussions of each category.

Table 2-1 Types of Cameras

Type	Questionnaire Score	Attributes	Price Range
Point-and-shoot	8–14	Simple, easy to use, inexpensive, few features.	$100–$300
Intermediate consumer	15–23	Not complicated, but some user control over exposure and focus. White balance presets. Program modes.	$250–$400
Advanced amateur	24–29	Greater control over exposure, metering, focus, white balance, and so on.	$375–$700
Prosumer	30–36*	Large, ergonomically superior, with almost every feature and function.	$800–$1,000
Semiprofessional	30–36*	Powerful system cameras with interchangeable lenses, fast performance, extensive controls and features.	$950–$2,200
Professional	37–40	System cameras with interchangeable lenses that are heavy, more durable, more complex, with great control over every shooting aspect. Very high resolution or strikingly faster performance.	$3,200–5,000

* While a prosumer and semipro shooter might have the same questionnaire score, other issues come into play in choosing between these two categories. Essentially, prosumer cameras are less expensive, while semipro models are systems with interchangeable lenses and other accessories.

Point-and-Shoot

These tend to be simple, inexpensive, easy-to-use models with few features and limited controls. (See Figures 2-1a and 2-1b.) Most have a small electronic display, called an *LCD viewfinder*, on the back of the camera, so you can frame your shots before taking them, as well as to review and replay what you have captured. Most point-and-shoots can take video clips, some with sound. A number of basic models have built-in memory, for saving your images, but most save to removable memory cards that you can swap, like rolls of film. Many models come equipped with a 2X or 3X *optical zoom* lens, while others have a less versatile fixed focus, fixed focal length lens (which means it can't zoom). Most also have a built-in *electronic flash*. And most also come equipped with a handful of functions: *exposure compensation*, *burst mode, white balance presets*, and several resolution and compression options.

Operating a point-and-shoot camera is a no-brainer: just turn it on, line up the shot in the viewfinder, and press the shutter. You'll have to know a few basics, such as how to charge or change batteries, insert and remove the memory card (see Chapter 3), and attach the camera to your computer, television set, or printer (see Chapter 17). You'll also want to become familiar with the very simple controls for the LCD viewfinder, if for no other reason than to review the pictures you've taken. (See Figure 2-1b.) But other than that, you can safely ignore all the rest of the modes, settings, parameters, and other techie stuff related to taking snapshots.

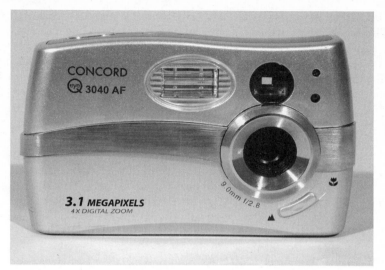

Figure 2-1a: A point-and-shoot camera, the Concord EyeQ 3040 is designed so that all you have to do is turn it on, compose your picture, and click the shutter button. (Photo courtesy of Concord Camera.)

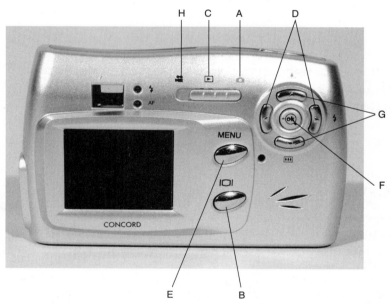

Figure 2-1b: Even at this simple level, you'll need to deal a little with technology. For example, to take pictures you'll have to flick the switch (A) to the camera icon. To review the pictures you've taken on the LCD viewfinder, turn on the LCD by pressing a button (B), switch to the playback icon (C), and then use the forward and back jog buttons (D) to page through your pictures. Incidentally, the only other controls are the Menu button (E) used to view and select among the few options; the OK button (F), which you use in conjunction with the menu; and the up and down jog buttons (G) for navigating through the menu. You'll notice there's also a movie icon (H), because the 3040 does capture small AVI video clips. (Photo courtesy of Concord Camera.)

Of course, there's a price to be paid for all that simplicity and convenience: you're at the mercy of the camera's computer. Most shooting decisions will be made by an impersonal, unfeeling machine, and that may (or may not) translate into a less-than-perfect picture. Point-and-shoot cameras generally take longer to turn on (called bootup, just as with your computer), and take longer between shots (called the recycle, or *click-to-click* time). What's more, there's an inevitable time delay between when you press the shutter button and when the picture is actually taken. This lag is usually a couple of tenths of a second, but it can sometimes be as long as a second-and-a-half. (See Chapter 3 on how to deal with shutter lag.)

Point-and-shoot cameras cut across all age, economic, and social demographics. They're great for seniors, kids, teens, and others who simply want to take pictures and don't care one iota about the details. While these cameras tend to be less expensive than more sophisticated digital cameras, they're purchased primarily for simplicity rather than price. And they are just as likely to be used by college graduates and white-collar executives as by high school graduates and blue-collar workers. The only skewed demographic is that women buy and use point-and-shoot cameras in disproportionate numbers. Perhaps it has something to do with testosterone; maybe men need to feel in control of the technology, rather than let the technology control them.

Entry level point-and-shoot cameras sell for about $100–$300, and typically offer 1–5 megapixel resolution. Some current examples of point-and-shoot cameras include the Canon PowerShot SD10, Fujifilm FinePix A330, Hewlett-Packard Photosmart 635, Kodak CX7220, Nikon Coolpix 2200, and Sony DSC-U40.

Tip: Use Any Camera in Point-and-Shoot Mode

Every camera (except studio backs) has an auto setting that allows you to just point at your subject and shoot. So, if you are a family in which some want a no-brainer camera, and others want something with more features, you can buy and use the same camera. However, if no one in your family wants or needs the extra control, why spend the money for it?

Intermediate Consumer

Intermediate consumer cameras (see Figure 2-2) are not complicated devices, but they do usually provide a variety of useful functions, which will give you greater control over your photography than point-and-shoot devices. (In many instances, these are the same cameras that the point-and-shoot crowd uses, though not necessarily in the *default* or auto mode.) These features include at least three different *resolution* and *compression* options, auto *ISO equivalency* and several manual settings, auto *white balance* and various presets, *exposure compensation*, and several different *metering modes*. (See Chapters 6 and 8 for more information these exposure and color controls.) They may provide additional features and modes, such as the ability to record sound movies, boost or subdue color saturation or sharpness, take panoramas, and with the flick of a dial, automatically invoke various *program modes* for optimum settings for photographing sports, sunlit beach and snow scenes, low light and night candids, fireworks and museum interiors, landscapes and portraits, or other specific subjects or situations (see Chapter 6). A few models also allow for automatic image transfer to your computer and the Web.

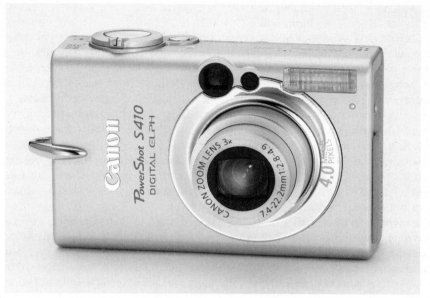

Figure 2-2: One of the popular Digital ELPH series, the Canon PowerShot S410 is an intermediate consumer digital camera that offers some control over your photography (though not as much as an advanced amateur digital camera would) in a small, stylish package. (Canon and Powershot are registered trademarks of Canon Inc. in the United States and may be registed in other countries. All rights reserved. Used by Permission.)

Intermediate consumer cameras are suitable for a wide range of users who are willing to expend some, but not a lot of effort to get a good photo and who aren't really interested in going too deeply into the technology of the camera.

Intermediate digital cameras usually cost about $250–$400, and typically offer 3–5 megapixel resolution. Almost all come equipped with a zoom lens and flash, plus the ability to save to removable memory cards (although the cards themselves may be optional, since some models have built-in memory as well). A few current examples of intermediate cameras include the Canon PowerShot S410, Casio QV-R41, Fujifilm FinePix A340, Konica Minolta DiMAGE G400, Nikon Coolpix 4200, Olympus Stylus 410 Digital, Panasonic DMC-LC70, Pentax Optio S40, and Samsung Digimax V4, plus many of the cameras also listed in the point-and-shoot category.

Tip: Optical Zoom Is the Only Zoom That Matters

Many cameras have both optical and digital zoom capability. *Optical zoom* is a physical capability related to actual picture information the lens can deliver. *Digital zoom* is a software trick that expands the size of your image through *interpolation*. However, digital zoom not only doesn't usually improve image quality; it can actually degrade your photos. Ignore digital zoom and use only optical.

Advanced Amateur

The advanced amateur category is that large area reserved for people who know a little about photography and who want to take great-looking pictures, even if it means some extra work. The advanced amateur knows (or wants to know) about *f-stops* and *shutter speeds*, back lighting and *fill flash*, *ISO* tradeoffs and manually setting *white balance* (see Chapters 6, 8, and 9 for more on these topics). This user wants a digital camera that provides lots of controls, some expandability, better performance, a superior lens, higher resolution, and a host of functions and features. He is an enthusiastic shooter, for whom fiddling with controls, trying various settings, and shooting from different angles is as much a part of the experience as is producing excellent images. At the same time, he also wants a versatile camera that works equally well in the point-and-shoot mode, for those occasions when he doesn't want the bother and fuss of making adjustments, or simply wants to grab an immediate shot that would otherwise be lost if he had to set the camera manually. And despite his relative sophistication, he does want simplicity and convenience.

The advanced amateur photographer wants functions like *aperture and shutter priority*; manual control over exposure, white balance, focus, and ISO equivalency; adjustments to flash intensity, color saturation, and sharpness; *a histogram* (to display whether or not the data he is about to capture will be exposed properly); the ability to set up custom defaults, create individual folders, and so on. He doesn't want to be held back by slow bootup and recycling times and wants a software bundle that includes a more sophisticated image-editing program. On the other hand, he's not so experienced and knowledgeable about photography that he wants a surfeit of pro-like features and functions that may complicate and confuse, or a menu structure that requires reading through a dense instruction manual just to figure out how to operate the camera.

Many advanced amateur cameras suffer from what we call "feature glut," which occurs when a camera manufacturer loads a model up with almost every possible function and command, regardless of how useful or well implemented. The more features and settings, the more difficult it will be to master the camera.

Advanced amateur cameras (see Figure 2-3) cost about $400–$700 and usually have resolutions of 4–6 megapixels. Some current examples of advanced amateur digital cameras include the Canon PowerShot A75, Casio Exilim EX-P600, Fuijifilm FinePix S7000 Z, HP Photosmart 945, Kodak EasyShare DX 6490, Konica Minolta DiMAGE Z2, Kyocera M400R, Nikon Coolpix 5400, Olympus C-5060 Zoom, Panasonic DMC-LC1, and Sony Cyber-shot DSC-V1.

Prosumer

The prosumer shooter is an in-between photographer—a serious amateur who wants the best possible images, but is not ready to make the monetary investment in a Digital Single Lens Reflex (*D-SLR*) body, lenses, and accessories. Conversely, the type person who would buy a prosumer may be a wannabe who enjoys the aura and association that a complicated-looking, professional-appearing camera exudes. Or he could simply be a person who wants to grow into a better class of camera.

Prosumer cameras are relatively large, well-constructed, ergonomically superior, fully loaded devices that come equipped with almost every feature and function needed to produce excellent image quality and superior performance. They incorporate eye-level through-the-lens viewing (usually an *electronic viewfinder*), physically larger image sensors (for a number of technical reasons, larger is usually better), and can save images to CompactFlash cards in either RAW or TIFF file format, or both (see Chapters 1 and 5). Most also function well when shooting in the fully automatic mode, which in fact

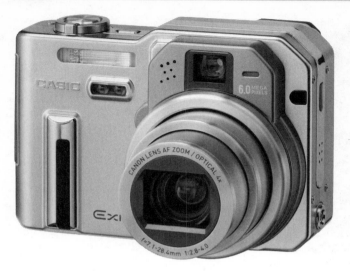

Figure 2-3: The Casio Exilim EX-P600 is a feature-rich advanced amateur camera that gives users lots of control, but still offers considerable guidance with a large number program modes, including Best Shot, which automatically select the correct settings for special situations and types of photos. (Picture courtesy of Casio.)

makes them glorified point-and-shoot models. But they are designed to be tweaked and manipulated to maximize image quality.

In addition to all the functions found on most advanced amateur digital cameras, prosumer models also offer a number of pro-like features, such as *bracketing* (some have white balance as well as exposure bracketing), *time lapse* capability, lots of external analog controls, manual focus, and the ability to synchronize with an *external flash* or studio *strobelights*. Another advantage is that most prosumer models accommodate a variety of performance-enhancing accessories, such as heavy-duty batteries, vertical shutter releases, higher-quality auxiliary wide angle and telephoto lenses, remote controls, and so on. (See Chapters 3, 6, 7, 8, and 9 for more information on some of these features.)

Prosumer cameras are generally more complex and difficult than advanced amateur cameras and have a steeper learning curve before you reach a level of comfort.

Prosumer cameras cost $800–$1,100, and usually provide resolutions of 4–8 megapixels. Some current examples of advanced amateur digital cameras include the Canon PowerShot Pro 1, Konica Minolta DiMAGE A2, Leica Digilux 2, Nikon Coolpix 8700, Olympus Camedia C-8080, and Sony Cyber-shot DSC-F828 (see Figure 2-4).

Semiprofessional

Semi-professional digital cameras are what you might term pro-lite cameras. These D-SLRs offer just about everything that professional D-SLRs have—through-the-lens optical viewing, interchangeable lenses, great image quality, film-like handling and performance, precise control, plus the ability to accommodate system accessories.

The user of a semi-professional camera is really serious about her photography and may even make a living with it. She requires top-quality images and every advantage that technology can offer. But she

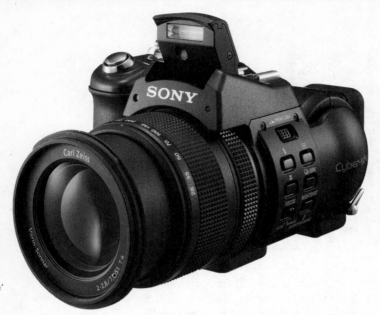

Figure 2-4: Like other prosumer cameras, the Sony Cyber-shot DSC-F828 is a complex camera requiring some sophistication to use its many features and functions. However, it is a well-constructed, loaded-for-bear camera that offers just about all the controls you could need for getting great photos. (Photo courtesy of Sony Corporation.)

can't (or won't) spend the money for a full professional D-SLR. Semi-pro cameras are fast performers and can fire 2 or 3 frames per second (fps) for a limited number of shots before the camera has to temporarily stop shooting so all the images can be written to memory. Semi-pro models also tend to be lighter than their pro counterparts, which may be perceived as an advantage by some buyers who plan to do a lot of hand-held shots.

Semi-professional cameras, however, have one important, unassailable advantage over their pro counterparts: price. A body and basic zoom lens costs between $950 and $2,200, and currently they tend to have 5–6 megapixel resolution. Some examples of semi-pro models include the Canon EOS-300D Digital Rebel, Nikon D70, Olympus E-1 (see Figure 2-5), Pentax *ist D, and Sigma SD10.

Professional

Pro models are designed and built for artists, very serious (deep pockets) hobbyists and those who make their living from photography. They are considerably heavier and more durable, more complex and harder to operate, as well as significantly more expensive than semi-pro cameras. But they generally are more versatile and offer greater user control over every shooting aspect. Depending upon the model, they also may offer considerably higher resolution or strikingly faster performance (but not both—at least, not in the same camera). And unlike semi-pro models, most of which come with a built-in flash, no pro model is flash-equipped. Rather, they're designed to work with auxiliary flashes or studio strobe-lights. Or with faster lenses and greater ISO equivalencies, they may take better available light shots.

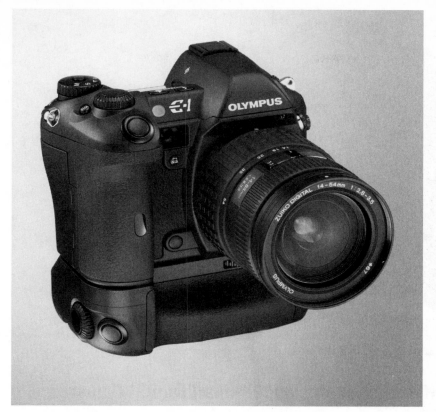

Figure 2-5: Semi-pro cameras are powerhouse systems with interchangeable lenses and other optional accessories. This Olympus E-1 is shown with an auxiliary battery pack attached to the bottom, to extend how long you can shoot before having to change batteries. (Photo courtesy of Olympus America.)

Generally, pro D-SLRs have physically larger image sensors than semi-pros, and larger usually translates into higher sensitivity, greater dynamic range, and superior image quality (see Chapter 1). Some pro models can fire better than 8 fps and have bigger buffers and faster processing power so they can capture more frames before having to pause to write the images to memory.

Unlike semi-pro models, which are generally sold as a kit with a matched lens, most pro cameras are sold as bodies only. The buyer, who almost always is an experienced and knowledgeable photographer, usually selects the brand according to whatever legacy lenses and accessory lenses he happens to own and use. For example, if he has a considerable investment in Canon bodies and lenses, he would most likely buy a pro camera that uses a Canon camera as its front end. This allows him to protect his investment in lenses, flashes, filters, and other Canon-specific accessories. Equally important, since he is most familiar with Canon gear, he'll feel right at home making the transition to digital with a Canon body very similar to his Canon film camera bodies.

Pro camera bodies cost between $3,200 and $5,000, lens not included, and typically offer resolutions of 4–14 megapixels. Current pro models include the Canon EOS-1D Mark II, Kodak DSC SLR/c (Canon-based), Kodak DSC SLR/n (Nikon-based), Nikon D2H (see Figure 2-6), and Nikon D2X.

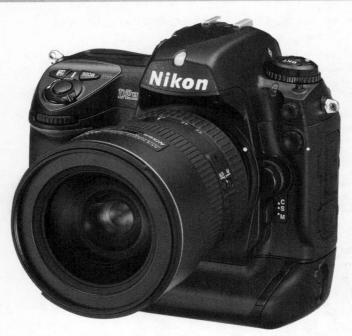

Figure 2-6: This Nikon D2H is a professional's tool, which means that it's heavy and heavy duty, with features that provide control over every shooting situation and aspect. (Photo courtesy of Nikon USA.)

Supercheap, Hybrid, Novelty, and Oddball Digital Cameras

While the vast majority of digital cameras fall into the above categories, there are other types and kinds that may interest you. Some are very cheap, as low as 20 bucks, the digital equivalent of film's disposable single-use cameras. Others are combinations, such as an instant film camera that also takes digital shots, an MP3 player that doubles as a camera, or a pair of binoculars with a built-in digital camera. Then there are the novelty items with a variety of sizes, shapes, and configurations, ones that look like pens, transistor radios, or tie tacs. Last, but certainly not least, many PDAs (personal digital assistants) and cell phones (camphones) come equipped with or accommodate a built-in or add-on digital camera. (We'll cover camphones in Chapter 16).

What these products have in common, regardless of price, is that image quality is secondary to form, fun, or convenience. Most are point-and-shoot devices that have tiny image sensors and limited memory capacity, often have no LCD viewfinder or built-in flash, take low resolution images, offer very few features, and come equipped with only the most basic software bundle. The images they produce are generally suited for snapshot prints or the Web, and nothing more. But hey! They do take pictures, they're fun to operate, and most are small and light enough to carry anywhere.

Studio Digital Cameras and Backs

Used only by professional photographers, studio digital cameras and backs are devices designed to yield the absolutely best possible image quality. Many are digital backs that attach to a conventional

professional studio camera as the front end, either a medium-format camera like a Hasselblad or Fujifilm, or a 4″×5″ view camera like a Sinar or Rollei.

A high-quality studio digital camera or back can deliver higher resolution than film, with a more extended dynamic range to boot. For example, Kodachrome, the film of choice of most pros still shooting film, has the ability to capture approximately 2.5 stops (the latitude between the brightest highlight and darkest shadow detail). Many studio digital cameras and backs can capture up to 11 stops. And while a 4 megapixel consumer digital cameras can produce a 12 megapixel image file—large enough for an 8.5″×11″ photo-quality print—some studio scanbacks generate files as large as 250MB, or larger, which is enough data to generate billboard-sized prints.

Besides being expensive ($10,000 to $40,000), studio cameras and backs require considerable photographic expertise to operate properly. They also need lots of expensive supporting equipment: top-quality lenses, a sturdy tripod or camera stand, special HMI (high intensity daylight) lights or studio strobelights, a light meter and colorimeter, backdrops, reflectors, light stands, and so on. Also required is a high-powered computer equipped with lots of memory, a calibrated color monitor, a fast graphics card, and a desktop printer capable of producing professional-quality proofs and prints. All together, the cost of a well-equipped professional digital studio can easily top $100,000.

A Perfect Fit

In addition to the types of digital cameras we described earlier, you'll have a choice regarding the size, shape, and configuration of your camera—in other words, the ergonomics. Ergonomics are important to determining if a camera will fit you and your lifestyle. Most digital cameras can be roughly divided into the following ergonomic categories (see Figure 2-7):

- **Subcompacts, also sometimes called shirtpocket shooters**—The tiniest of digital cameras (other than novelties that aren't primarily cameras), subcompacts can travel with you any time, any place, which means that you'll always have a camera for that shot you would have missed otherwise. Literally small enough to slip into a shirt pocket (though a few will stretch the fabric), most of these stylish Sharper Image–looking devices have all-metal bodies, zoom lenses, rechargeable batteries, and built-in electronic flashes. Many have both an optical viewfinder and an LCD viewfinder, though some have only the latter. The tradeoff for small size is usually performance and image quality: most are not as fast shooting or do not produce as high photo-quality images as larger cameras. Also, the small controls and tiny viewfinders (a few models have lovely oversized viewfinders, however) may be difficult to use for arthritic seniors or young children. And pricewise, they usually carry a premium over comparable compacts or full-sized cameras. But they do win the cool factor contest hands down.

- **Compacts**—Usually more conventional looking than subcompacts, compacts may not be fashion statements, but they are conveniently small and slip easily into a jacket pocket, purse, or briefcase (though not a shirt pocket). Depending upon the make or model, a compact may be a point-and-shoot camera or a miniature powerhouse with extensive controls and a long list of features. Most come equipped with a zoom lens, LCD viewfinder, and built-in flash; the bodies may be plastic or metal, and the batteries rechargeable or nonrechargeable.

■ **Full-sized traditional cameras**—These usually have the look and feel of a typical film camera. They're easier to handle than the compact and subcompact, with larger controls and easier-to-push buttons. The batteries last longer, and because the components aren't jammed up against each other, image quality is usually slightly better than comparable compacts and subcompacts. So, too, is performance. Traditional cameras range from inexpensive plastic point-and-shoot devices to feature-packed, all-metal prosumer models.

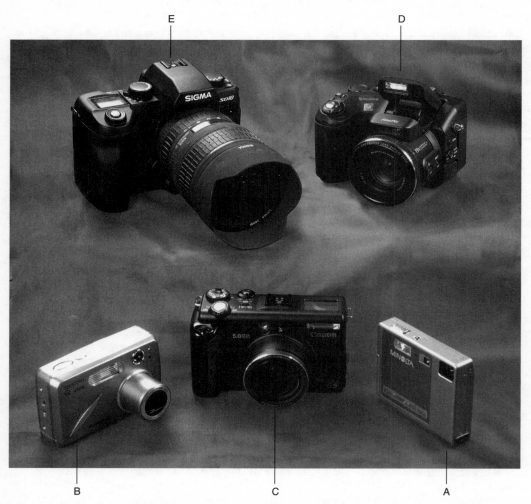

Figure 2-7: When you look at various cameras side by side, the differences in their ergonomics (look, feel, and handling) become obvious. (A) The Minolta DiMAGE XL is a subcompact that's thin enough to fit in a shirt pocket. (B) The Concord 4360z is a compact and looks a bit more like a conventional camera. (C) The Canon PowerShot G5 is a full-sized traditional camera with the familiar heft of the typical consumer film camera. (D) The Fujifilm FinePix S7000 may look like a miniature SLR, but its lens is noninterchangeable. (E) The Sigma SD10 is a true digital SLR with interchangeable lenses. (Photo taken with a Nikon D70.)

- **D-SLR types**—These advanced amateur and prosumer models are shaped like a slightly smaller version of a single lens reflex camera (though with fixed rather than interchangeable lenses). When you wrap your fingers around the battery compartment handgrip, they impart a feeling of solidity, a sense of having a real camera in your hands, especially when you use the eye-level through-the-lens viewfinder. They feature a zoom lens, a pop-up flash, and a lot of buttons and other analog controls.

- **True D-SLRs**—If you're an inveterate gadgeteer and enjoy the prospect of having, carrying, and using a variety of lenses and other stuff, then you're a candidate for a D-SLR. It will require carrying a separate camera bag wherever you go, which is the exact opposite of the subcompacts. But like the subcompacts, D-SLRs are head-turning status symbols. They're bigger, heavier, more expensive, and more difficult to use than all other kinds of digital cameras.

Don't confuse the ergonomics of a camera with its capabilities (which are described earlier in this chapter when we covered the types of cameras). Some compact models offer more controls, better image quality and faster performance than some full-sized traditional cameras. And just because a camera looks like an SLR doesn't mean that it has pro-like power and quality.

Trying Cameras on to See What Fits

You wouldn't buy shoes without trying them on, not unless they are the same make, last, and size as ones you've worn comfortably in the past. Before you buy a new digital camera, go to an electronics store and play with a few different models. How else can you find out which ones fit you and your lifestyle?

The types of things you want to check include determining if:

- The buttons, dials, and levers are well marked, strategically placed, and large enough to comfortably push or activate.

- All the controls feel responsive to your hands.

- The LCD viewfinder is clear, bright, colorful, sharp, and accurate.

- If you wear glasses, that the optical or electronic eye-level viewfinder has a focusable diopter (a small dial or lever that eyeglass wearers can adjust to particular vision needs so you can use the viewfinder without your glasses).

- The text in the LCD viewfinder is legible, and its menus make sense to you.

- The camera fits the size of your hand comfortably and securely .

- It's too heavy or too light, too small or big to hold steadily .

- You can easily access and operate the memory card door, the battery compartment, all the ports, and if your camera has it, the pop-up flash.

- The camera fits in the bag, case, purse, or pocket that you plan to normally carry it in.

In other words, handle the camera, experimenting with taking and reviewing pictures, changing menu parameters, opening and closing doors and ports. The idea is to get a sense of how comfortable and at home you feel with it.

How Many Megapixels Do I Need?

As we discussed in Chapter 1, the number of megapixels that a digital camera has is not an indication of how good its image quality will be. Megapixels refer only to the amount of data a camera captures and are directly related to the size print you can make without the image appearing soft, lacking in detail, or pixelated. Ideally, you should choose the size resolution your camera should have based solely upon output.

For the vast majority of digital camera users, 3 or 4 megapixels is the ideal practical resolution. That's the point when the cameras are relatively inexpensive, the file size will produce great-looking full-page enlargements from most color inkjet printers, but not so large that processing speed and storage considerations get bogged down. That being said, digital cameras with higher megapixel counts, although more expensive, also tend to be better built and provide more features and often faster performance. Of course, if you like making big enlargements or posters, that's when you'll want all the resolution you can afford. Another advantage to high-resolution cameras is that you can crop your photos and still end up with enough data to make a decent print. At the other end, if everything you shoot is destined only for the Web, then 2 or 3 megapixels is all you really need.

Table 2-2 is a brief chart that lists various digital camera resolutions and how they relate to print size:

Table 2-2 How Megapixels Relate to Print Size

Resolution	*Print Size*
1.3 megapixels	3.5″×5″–4″×6″
2 megapixels	4″×6″–5″×7″
3 megapixels	5″×7″–8″×10″
4 megapixels	8″×10″–8.5″×11″
5 megapixels	8.5″×11″–9″×12″
6 megapixels	11″×14″–14″×17″
8 megapixels	14″×17″–16″×20″

"Killer App" Features

Certain defining features on a digital camera might fit a particular need or interest you have, and you may decide to buy that camera for just that one application. In computerese, this is known as the "killer app." Here are some possible killer app features and why you might wish to buy your next digital camera based upon their availability and implementation:

- **Shutter speed**—Some models allow you to set the shutter speed (either via manual or shutter priority) to 1/1000, 1/2000, 1/4000, or even 1/8000 of a second. You may need superfast shutter speeds if you frequently shoot sports, kids, animals, and other action subjects. Conversely, if you like taking long time exposures at night, you'll want a camera

that offers both a low noise setting and slow shutter speeds of 1 second to 30 seconds, plus bulb (that's when the camera continues recording the light for as long as you have the shutter depressed). (See Chapter 6.)

■ **Time lapse photography**—If you are involved in any form of surveillance, be it photographing animals in the wild or criminal suspects entering a building, you may want a camera that automatically shoots a frame at specified intervals, whether it's once a minute or an hour between shots.

■ **Shoot-in-the-dark**—A number of Sony models have a night mode that allows you to see, focus, and shoot in near or even total darkness. Since this doesn't involve flash, your subject will probably never know that a photograph has been taken.

■ **A fast lens or an extended zoom range**—If you shoot lots of available-light candids, you probably want a camera with a fast speed, such as *f*2. (See Chapter 6.) Or if you shoot nature, sports, or other far-away subjects that you need to pull in closer, you'll look for a camera that offers an 8X, 10X, or 12X zoom lens. All the better if it comes equipped with some sort of built-in optical image stabilization, to minimize shake and blur at extreme telephoto.

■ **Archival recording**—Sony Mavica cameras record directly to CDs, so once an image is saved, it's a permanent record that can't be accidentally erased or changed. That's important in law enforcement and various government agencies where data integrity is vital.

■ **Ruggedized or weatherized**—If you often shoot in inclement weather or a hostile environment—such as a factory floor, construction site, or Brazilian rainforest—you'll want a camera built like a tank to withstand rough handling, with seals and "O" rings to keep out water and moisture.

■ **Underwater**—A handful of digital cameras are designed to shoot both above and underwater, albeit at 10′ or less. If you are an avid diver, you'll probably want a digital camera for which there is a readily available underwater housing. Some are good for only one atmosphere (33′) or less, while other housings can go as far down as 160′ or so and have a provision for attaching an underwater strobelight.

■ **Full frame, 30 fps video recording capability**—Most digital cameras can shoot short movies, but you may need a dual-purpose model that takes full frame (at least 640 × 480 pixels) video at the fast, nonflicker rate of 30 frames per second. That's good enough to display videos on the new high-definition TV sets (HDTV). (See Chapter 10.)

■ **Program mode**—While many digital cameras have various *program modes* that cover many common shooting situations, there might be one program mode that fits your most important photography to a "T." Perhaps you take a lot of pictures inside a museum, or love fireworks displays, or are an avid skier on bright, sunny days. A program mode automatically adjusts the camera to the optimum settings for the kinds of shots you want to take.

■ **Text mode**—If you're a businessperson or a scholar and need a camera that can be used as an inexpensive portable copier, you'll want a model that has a text mode designed to capture the printed word at its sharpest, blackest best. (See Chapter 14.)

■ **Slideshow capability**—Most camera playbacks have some sort of slideshow capability, but some provide a variety of built-in options, such as dissolves and fades, individually timed

transitions, and special effects. This makes such devices ideal for uploading and showing a business-related slideshow on any handy TV, often eschewing the need to carry an expensive video projector. (See Chapter 14.)

Keep in mind that a killer app feature may be the most important, but not the only factor involved in selecting a digital camera. It's just that when all other things are roughly equal (price, performance, image quality, ergonomics, functions, and features), the camera with your favorite killer app may tip the scales towards that particular model.

Features Glut and Marketing Hype

Engineers and scientists who design digital cameras often have no imagination. Their philosophy seems to be that if something is possible, why not include it? This everything-including-the-kitchen-sink approach makes little or no distinction between whether or not any particular feature is necessary or even desirable, or even if it is implemented well or poorly. Marketing execs loves this more-is-better approach, because the more features a digital camera offers, the better its competitive position.

While it may seem sensible to want a versatile camera capable of doing more things (especially if it costs the same as, or only a little more than, models with less features), the reality is that the more features it offers, the more complicated it is to operate. That means more menu options that you must navigate through, which can be confusing and time-consuming. Also, you may not thoroughly understand what each function or mode is or does, thereby increasing the probability of making the wrong choice of settings. And chances are that you probably won't use most of those extra features anyway. Digital cameras, like software, follow the 95/5/95 rule: 95 percent of digital camera owners use only 5 percent of their camera's available features and functions 95 percent of the time.

Choose your digital camera according to the functions you want and need, not simply what's available.

Where and How to Buy Your Digital Camera

Time was when you wanted to buy a new camera, you made a visit to your local camera store. Nowadays, full-service camera shops are all but extinct, having been done in by superstores, warehouse clubs, electronic boutiques, and of course, the Internet. With so many different sources available, where should you shop for your next camera?

Let's review some of the places you can buy digital cameras and accessories, along with the pros and cons of each:

- ■ **Local camera stores**—Although few and far between, many cities and towns still support a handful of stores that specialize in digital cameras and photographic supplies. Most, however, have expanded into other areas in an attempt to remain afloat, such as selling camcorders and other consumer electronics. The advantages of a full-service camera store are that you can have a hands-on session with the products you are thinking of buying, someone in the establishment usually has a working knowledge of photography and digital cameras and can competently answer your questions, and you can walk out of the store with

the model you buy. What's more, when you return with more questions, the staff will be more likely to recognize you as a customer and try to help you. On the negative side, prices are likely higher than elsewhere, and selection is more limited.

■ **Full-service camera stores**—Large nationally oriented camera stores, like B&H Photo, Samy's, and Olden's, sell thousands of digital camera via toll-free operators, mail order, the Internet, or their retail outlets. Assuming that you're buying from one of the biggies and not a fly-by-night outfit, these large camera stores can offer bigger selections, better prices, fast service, and occasionally, even advice on what to buy. But they also tend to be rushed and impersonal, the salespeople may be curt and even rude, and you may have to jump through hoops if you must return defective or wrongly shipped items.

■ **Superstores**—Places like Sam's Club, Circuit City, Best Buy, Costco, and even Staples and OfficeMax do a big business in digital cameras. They usually have a good selection and supply of different makes and models, may offer discounts and rebates, and as long as you're in the store, there are lots of other items that you may want to stock up on. Don't expect any advice or assistance, since these are basically pick-it-yourself outfits.

■ **The Internet**—By using search engines like `priceline.com` or `streetprices.com`, you'll find scores of sellers of the digital camera you want, listed according to price. It's a quick way to buy and may give you the best price available. You're on your own regarding selection, however, since you'll get no advice on what to buy. Likely as not, you won't ever get to speak to a real, live person. And you must be careful that what you order is what you expect, because rectifying mistakes can be costly, frustrating, and time-consuming. Buying on the Internet is best left to users who are very familiar with both computers and cameras.

■ **eBay and other online auctions**—eBay presently is the world's largest camera dealer. In fact, more digital cameras (and film cameras as well) trade hands on eBay than almost every other source combined. Buying used equipment on eBay is strictly a matter between you and the seller, but keep in mind that most of the new digital cameras are sold from garage and basement operations and the starting price is usually just a notch above the industry wholesale price. So you're likely to get a camera at a good price, but if you have any problems or need to return the camera, you'll have to deal directly with the manufacturer and not the person or firm you bought it from. Again, buy on eBay only if you have a very good idea of what camera you want and are familiar with eBay's rules and limitations.

■ **Camera and computer shows**—Do a Google search on camera and computer shows, and you're likely to find one near your home sometime soon. These shows have dozens or scores of full-time and part-time dealers selling everything from PCs to printers to digital cameras and supplies. It's a fun way to compare wares and prices, to haggle and bargain, and possibly to come away with the camera you want at a price you can afford But as with Internet sales, that dealer probably isn't local, won't have any time to talk to you, and won't be any help if you need to return the camera—you'll have to deal directly with the manufacturer.

■ **Private sellers**—The problem with buying privately through a newspaper ad, garage sale, or personal friend is that the seller usually has only one camera to sell, and it may not be what's right for you, regardless of how great a price it may be going for. Usually, the terms are simple: cash and carry and as is. So if it's not what you wanted or expected or it doesn't work properly, you're stuck with it. That is, until you manage to privately sell it to some other sucker.

Beware of SPIFS

Our friend Howard had his heart set on buying the digital camera we recommended based on his personal interests, needs, and budget—the Kodak EasyShare DX6490. But when he visited one camera and two electronics superstores in an attempt to buy it, the salesclerks all disparaged that model in particular and Kodak in general and tried to steer him to another make and model that they personally recommended and endorsed. Howard was upset because the salespeople sounded very persuasive. He asked us: what's wrong with Kodak that three separate salespeople tried to get him to buy something else?

The answer is nothing is wrong with Kodak.

What Howard encountered was something few outside the photographic industry know about: it's called SPIFS. SPIFS is an acronym for special incentives for sales, a bonus or override that a retailer, wholesaler, or manufacturer rewards a salesperson with for selling a particular product. This is above and apart from salary and ordinary commission, and, depending upon the make or model, SPIFS range from $25 to $200 and go directly into the sales clerk's pocket. They're offered to help move slow-selling models or models about to be discontinued. Most manufacturers offer SPIFS at one time or another, but usually not on best-selling or hot models. We don't know what SPIFS were being given to sales personnel at the three stores Howard visited, but you can be sure that they weren't for the very popular Kodak EasyShare DX6490.

Tip: Pay the Use Tax and Sleep at Night

One seemingly unassailable advantage of buying on the Internet is that, if the vendor isn't located or doesn't have a presence in your state, you won't have to pay sales tax. That's true, and it's a major reason why local merchants are taking such a beating from Internet firms that can offer lower prices because sales tax doesn't figure into the equation. While you may not be liable for sales tax, every state has something called a use tax, designed to extract the same amount from you for out-of-state purchases. Until the economy went south, most states didn't bother pursuing use tax offenders (unless you bought an out-of-state car, and could register it only if you paid the use tax). But now that states are hard pressed to develop additional sources of revenue, they're going after online purchasers for that use tax. You may get away without paying the use tax for your digital camera, but if the state catches you (they now have software for ferreting out such sales), you may have to pay a stiff fine as well. It's better to just pay the use tax, and in the process, you'll help out your state's economy and sleep better at night.

Paying for Your Digital Camera

The best way to pay for a digital camera—or any other item, for that matter—is with a credit card. The transaction is completed immediately, you don't have to pay anything for at least 25 days, and if anything goes wrong, you have some recourse. Credit card companies often intercede on your behalf when you have a problem with the vendor, either withholding or retrieving payment until the issue is settled.

The worst way to pay is with cash. Once it's been handed over, you may have difficulty proving that you paid what you said for the item, and the seller has no incentive to make any allowances or adjustments in case of any problems. The same applies to a check, though it's a little easier tracing where the money went. And if you're fast enough, you can stop payment if the transaction goes sour. If you don't want or can't use a credit card and you're dealing with someone over the phone or the Internet, you can use a service like PayPal, or if a fair amount of money is involved, an escrow service to hold your payment until you receive the item you ordered.

One last piece of advice: always get a receipt. Make certain that it has the seller's name, address, telephone number, and details about the item purchased. File it away with your receipts and important papers, just in case you need to prove your purchase to the IRS.

Check That Warranty

Almost all new digital cameras come with some sort of warranty. Most give a one-year, parts and labor guarantee, though some manufacturers' warranties expire in as short a time as 90 days and others last as long as 3 years.

One-year parts and labor generally means that your camera will be repaired or replaced within a year of purchase, with the following caveats: the malfunction is mechanical and not the result of physical damage or willful abuse; the owner will be responsible for the cost of shipping the camera to the repair place, while the manufacturer will pay to return it; the manufacturer will not be responsible for any lost or damaged photographs that the malfunctioning camera may have caused.

A few warranties on more expensive equipment may include an overnight replacement unit, in which the manufacturer will express a replacement camera to you while yours is being repaired.

Depending upon the make and model, you may be able to extend the warranty an additional year or two for an added fee. Or you may be able to buy an extended 3–5 year third-party warranty where you bought the camera. Incidentally, most warranties don't cover willful damage, loss, or theft, though your homeowner's or business insurance may. Check your policy.

Reality Check: If It's Too Good to Be True, It Probably Isn't True

The price is fabulous, maybe $100–$200 less than any place else you found on the Internet. The company looks legitimate and reliable, and besides, you're going to pay by credit card, just to make sure. But that bargain model might be what is called a gray market camera, which could turn out not to be any bargain.

Gray market cameras are units sold in other countries at lower prices and imported into this country privately rather than through the authorized distributor. As such, they aren't warranted by the American distributor, certain components such as the AC adapter or battery charger may not work in the United States, and the instruction manual and other materials may not be printed in English. Another common discounter ploy is to strip the camera to its bare essentials. So while you might be quoted a great price, when it arrives, you'll discover that everything you thought was supposed to ship with it—batteries, charger, memory card, software, cables, wrist strap—is optional and extra.

Then there are the shady and fly-by-night outfitters. Some vendors may sell you a camera at a fantastic price, but only if you agree to buy unnecessary, overpriced accessories, such as auxiliary lenses or a gadget bag. Others may add an undisclosed extra fee onto your credit card, charge an arm

Reality Check: If It's Too Good to Be True, It Probably Isn't True (Continued)

and a leg for shipping and handling, tack on an expensive but unnecessary vendor's warranty (which duplicates the manufacturer's warranty), or all three. Then there are the out-and-out crooks who take your money and disappear, or fail to ship your camera to you, or send you a different (usually less expensive) model than you ordered. *Caveat emptor*.

Summary

These are the key points covered in this chapter:

- There are hundreds of different makes and models of digital cameras, so narrowing the choice of which one is best for your needs, wants, personality, photographic sophistication, and budget can be a daunting task. Complete our questionnaire to help you figure out what type camera will fit you.

- Resolution is only one factor, and not the most important one, in determining what digital camera is best for you.

- Select a camera that has the features you want, not one that simply has the greatest number of features.

- Ergonomics, size, and style are all important factors in choosing the best camera for you.

- You have lots of choices of where and how to buy a digital camera, and each one has advantages and drawbacks.

Chapter 3

Getting to Know Your Digital Camera

Digital cameras are like homes. From studio apartments to mansions, all share certain features, such as a bathroom, kitchen, a place to sleep, and an area to socialize. But when you walk in the front door, you may not know whether to turn right or left to get to the kitchen, if the door on the wall leads to the garage or the hall closet, or if the nearest bathroom is just up the stairs or down by the recreation room.

Every digital camera has an on/off switch, a shutter button, and a lens. Most have memory cards, *LCD viewfinders, control panels,* and various switches and dials. But each model varies as to the number of features, where you will find them, and how they are used.

In this chapter, we'll give you a hands-on introduction that will put you on the road to using your camera right away, as well as give you a head start on learning your way around its more advanced controls, commands, and buttons. You'll find more in-depth explanations of the various controls and tools throughout this book.

Taking Your First Shot

Even with simple point-and-shoot cameras, it can sometimes be confusing how to get started. But the steps to getting your first photograph with your new digital camera are quite logical and straightforward.

1. Prep your camera.
2. Turn on your camera.
3. Do a quick setup.
4. Take a picture.
5. Review your pictures.

Prepping Your Camera

Even if you never crack the instruction manual (which, admittedly, is usually rather dense, difficult reading), at least check out the startup guide (which may be a separate sheet or the first few pages of

the manual). It provides a graphical display of where the doors, switches, and buttons are that you'll need to know to take your first pictures. It also covers important stuff, like the type memory cards (if any) the camera uses to save your pictures, the kind of batteries you'll need, and how they should be inserted or charged.

BATTERIES

All digital cameras require a battery or batteries to operate. If your camera doesn't have rechargeable batteries, simply insert the set that came in the box. If your camera doesn't turn on once you have inserted fresh batteries, check the polarity of the batteries (the +/− top or bottom) to make certain that they're installed properly.

Many models come with rechargeable batteries that must be fully charged before you use your camera for the first time. Depending upon your make and model, you may simply plug the camera into a wall outlet, drop it into a camera dock or cradle, or place the batteries in some sort of external charger. By the way, most rechargeable batteries come partially charged, so you can turn the camera on for a brief period. But to operate the camera properly, it will need a full charge, which can take anywhere from an hour to 8 hours, depending upon the type charger that came with your camera.

Tip: Get Rechargeable Batteries—Fast!

Okay, your camera didn't ship with rechargeable batteries, which probably means that it's powered by 2 or 4 AA-type batteries. The set of lithium batteries the manufacturer bundled with the camera will work well, but they'll last only a few hours and are expensive to replace. For the price of a few sets of lithium AAs (never, ever buy alkaline batteries for your digital camera, because they'll last only 15–20 minutes before pooping out), buy a set of rechargeable nickel-metal hydride (NiMH) AAs and matching charger. NiMH batteries can be recharged hundreds of times, so you'll be paying pennies and not dollars for power every time you use your digital camera.

MEMORY

Next, check your camera's memory. Most models save their pictures to small postage stamp or dinner mint–sized memory cards that you insert into a slot in the camera. They're the digital equivalent of a roll of film, though you don't have to worry about accidentally exposing them to light or having to pay to have them processed. If a memory card came with your camera, remove it from its protective plastic box, find the slot on the side or bottom of your camera, and insert it (see Figure 3-1).

If no memory card came with your digital camera, you can probably take pictures right away without it. A number of models will accommodate memory cards, but to cut costs (and the purchase price), the manufacturer may not include a card. Instead, such cameras will have enough built-in, nonremovable memory that you can use and reuse to capture a dozen to about 100 snaps. That will keep you going until you can pop down to the store and purchase a couple memory cards that will fit your camera.

Tip: Don't Touch Your Memory Card When Your Camera Is Turned On

Never open the memory card door when your camera is turned on, if you want to protect your pictures and the card itself. Be sure that the camera is off whenever you insert or remove your memory card.

Figure 3-1: Insert the memory card into its slot, which is found under a flap or door in the side or bottom. Doesn't fit, you say? Then turn the card upside down and carefully but firmly push it in without forcing it. Once installed, close the door or flap. (Photo of a Canon PowerShot G5 taken with a Sony Cyber-shot F828.)

Turning on Your Camera

Personally, we find this step often the most difficult to describe because the on/off switch or button will be differently configured and in a different place on each model. It will be easier for you than it is for us, because we have to deal with so many cameras, while all you have to do is learn one. Check the startup guide and look for a button, switch, or lever that says Power or On. It may have an icon that looks like a circle with a half line sticking out of its top or may simply be a camera icon on a dial. Press the switch or button firmly, holding it down for at least 2 seconds. Or, turn the dial to the camera icon. Those models that have a clamshell design (a panel that closes over the lens) usually turn on when you slide the panel open to expose the lens (see Figure 3-2).

Turning the camera on can take a half-second to about 6 seconds, depending upon the make and model. That's how long it takes for the zoom lens to motorize out into position, to get the electronics fired up, to turn on the LCD viewfinder, and to go through system diagnostics. However, you're not quite ready to take your first photograph.

Sleep and Shutoff Modes

To conserve power, most cameras have what are called a sleep mode and a shutoff mode.

- The *sleep mode* automatically sets the camera in a power-saving state if you don't touch any of the controls or buttons on your camera for 1 minute, 2 minutes, or 5 minutes. (You may be able to select the number of minutes in your camera's setup menu. Two minutes is a good number to start with.) Sleep mode turns almost everything off—the image sensor, LCD viewfinder, flash—but simply pressing the shutter button will wake the camera up in a second or two, ready to shoot.

Sleep and Shutoff Modes*(Continued)*

- *Shutoff mode* usually takes over after 5 or 10 minutes of inactivity, turning the camera completely off. When you want to take pictures, you'll have to turn it on again.

While we don't recommend it for most users, many cameras allow you to turn off both the sleep and shutoff modes, so you're always instantly ready to shoot—that is, if you have any battery power left after keeping the camera on continuously when it should have gone to sleep or been turned off.

Figure 3-2: This Canon PowerShot A310 has a so-called clamshell design, that is, a sliding cover over the lens. Sliding the cover to reveal the lens turns on the camera. In this picture, the cover is open and the camera is on, though the lens hasn't yet fully opened. (Canon and Powershot are registered trademarks of Canon Inc. in the United States and may be registed in other countries. All rights reserved. Used by Permission.)

Quick Setup

Many digital cameras automatically turn on the LCD viewfinder and display an initial startup menu the first time you power up. What it wants you to do before anything else is to set the time and date. That's usually accomplished by pressing a set of up/down, left/right arrow buttons found somewhere on the back of your digital camera. Collectively, those four-way buttons are called the *jog switch* or rocker button. An OK, Select, or Enter button may be in the middle; if not, then it's below, to the side, or somewhere nearby (see Figure 3-3). When the menu asking you to set the date comes up, press the left/right buttons to move between the fields (hour/minute or day/month/year) and the up/down buttons to set the actual time or date. Remember to press the OK or Enter button when you're finished. That information will be automatically associated with every picture you take, which is important for image identification, as well as a personal reminder of exactly when you took the snapshot.

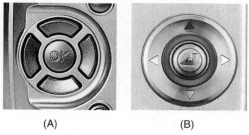

(A) (B)

Figure 3-3: The appearance of the jog buttons or switch will vary depending on your camera. Here are two examples (A) from a Kodak EasyShare CX7220 and (B) from a Kyocera Finecam S5R. Others may function and look like tiny gaming joysticks. Whatever they look like, the jog buttons are used to navigate among menu options as well as to page through your photos when you review them in playback. Elsewhere on the camera is an OK/Select/Enter button (sometimes in the middle of the jog buttons, as it is on both these cameras) that you'll use to execute and set the options you choose.

Depending upon the make and model, you may also be asked to select a few other parameters or settings. You can safely ignore most of them for the time being and use the camera with its original factory or default settings. The one exception is Format. You may be asked if you wish to format your camera's memory card. Even if it is a brand-new, never-used card, say Yes or OK and format the card. That preps the card for receiving and storing your images.

Tip: Formatting Destroys All Data

Formatting a memory card erases all data that is on it. If it isn't a new card, be sure that you have saved your pictures and other data to your computer before formatting the card for your new camera.

Taking a Shot

Now it's time to put your camera in the shooting mode. Your camera may have a button or a switch that has an icon (pictorial representation) of a camera on it (see Figure 3-4). Or it may have a circular dial (called a Select Dial or Mode Dial) that has a number of different icons or descriptions. Look for the camera icon, or the word *AUTO*, and move the dial to it. Note: if you have a model designed for serious amateurs or prosumers, your camera may also have an A or Av on the dial. That refers to a setting called *Aperture Priority*, not Automatic, so don't set the camera there quite yet.

The next step is to point your camera at your subject. Most digital cameras have two viewfinders, a tiny optical window or electronic viewfinder that you put up to your eye, and a small LCD viewfinder on the back (it looks like a miniature TV screen) that you look through at arm's length. Which viewfinder you choose to use is a matter of personal preference.

EYE-LEVEL VIEWFINDER

The eye-level viewfinder is quick, handy and bright, and is usually (but not always) uncluttered by icons and numbers (see Figure 3-4). Better cameras even have a diopter lever or knob, which you can

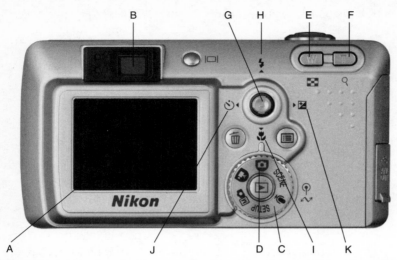

Figure 3-4: What the controls on your camera will look like will depend on its brand and model. Pictured here is the back of a Nikon CoolPix 3700. (A) The LCD viewfinder and (B) the eye-level viewfinder are easily recognizable. (C) The mode dial is on the back, though many cameras have it on the top. (D) Notice the camera icon for setting the camera to take your picture. The zoom lens is controlled by the buttons for (E) wide angle and (F) telephoto. (G) The tiny joystick-like jog button is used for navigating through menus, paging through playback photos, and setting (H) flash, (I) macro, (J) self-timer, and (K) exposure compensation. (Photo courtesy of Nikon Inc.)

focus to adjust for your eyesight. It's for eyeglasses users who don't want to look through the window with their glasses on.

Eye-level viewfinders are great, but in truth, you're probably seeing only about 75–80 percent of the total picture you'll be taking. This inaccuracy may be deliberate on the part of the manufacturer, because inexperienced snapshooters tend to chop off heads, arms and legs in their pictures. Since you're capturing about a quarter more around the edges than you see, you'll be less likely to leave someone or something important out of the picture.

LCD VIEWFINDER

The LCD viewfinder (see Figure 3-4) really looks cool, since it shows you exactly what's coming directly through the lens of the camera, giving you a fairly accurate preview of the shot you're going to get. (If you don't see your LCD viewfinder at first glance, it may be articulated, or rotatable, and currently turned around toward the camera.) Sometimes also called a viewer or a monitor (since that is what it looks like), it's tiny and often unreadable in bright sunlight, you can't see much detail, it may be cluttered with numbers and icons, you have to hold the camera away from your body, and—most importantly—keeping the LCD viewfinder on will quickly drain your batteries. As a rule, don't use the LCD viewfinder as your primary means of framing your subject if you have an alternative viewfinder available.

YOUR ZOOM LENS

Most digital cameras have a zoom lens that allows you to take in a wider view or get closer to the subject. Except for a few prosumer and semipro models that have manual zoom lenses you operate

by twisting the lens barrel, most have motorized zooms that you control by pressing a lever, rocker switch, or buttons (see Figure 3-4).

Understanding Your Zoom Lens

Zoom lenses are wonderful for bringing what's distant closer or including more of the subject in your picture. However, you should be aware of two issues when using one:

- Zooming will change image perspective. In other words, wide angle tends to push foreground and background areas and subjects further apart, and telephoto compresses them closer together. Perspective can add to or subtract from the quality, interest, and appeal of your photographs. When you want to get closer to the subject or include more in the picture, you should consider moving a few steps nearer to or further away rather than relying solely on the zoom lens.

- Your digital camera might boast a 9X or 24X zoom lens. But if you look at the fine print, you'll see that it's broken into two components: *optical* zoom and *digital* zoom. The only number that should concern you is the optical zoom (typically 3X or 4X, though some are as large as 12X), which relates to the physical construction of the lens. Digital zoom makes a small image appear larger using electronic tricks, but it actually reduces overall image quality. For optimum image quality, turn off your camera's digital zoom option.

Pressing the Shutter Button

Almost all cameras, digital and otherwise, have a shutter button on top right side of the unit. Press it down, and you'll take a picture.

AVOIDING SHUTTER DELAY

One of more common complaints we hear about digital cameras is that there's often a delay between pressing the shutter button and getting the picture. To avoid that shutter delay, use a two-step method for firing off your camera. Here's how:

- Press the shutter button very lightly while you're framing your picture, holding the button halfway down until you're ready to take your shot.
- To take your photo, squeeze a little harder, and the shutter is fully depressed.

Pressing the shutter halfway preps the camera by locking in the focus and exposure settings (and, if necessary, prepares the flash to fire). Fully depressing the shutter takes the picture.

Even under the best shooting circumstances (that is, always pressing the shutter halfway before fully depressing it), most digital cameras have a slight shutter lag. But when shot properly, it's measured in milliseconds rather than seconds. Eventually, it will become second nature to press the shutter slightly just before you expect the subject to be picture perfect.

FLASH

Did the electronic flash go off when you took your shot? That depends on how much light was falling on your subject. In the default point-and-shoot mode, most digital cameras activate the autoflash setting. It will fire only if the camera's light sensor detects that there isn't enough light to properly expose the picture. So, for now, don't be concerned if it does or does not fire.

THE NEXT SHOT . . .

After you take a photo, your digital camera won't be instantly ready to shoot again. There's probably a flashing red light on the camera indicating that something is going on.

The image you just captured must go through a complex series of computations—the camera must turn the picture into digital data, processing the *pixels* (picture elements) so the form and color are correct, and then saving the data to an image file. Hundreds of millions of calculations occur between shots, which is why it will take a half-second to 5–6 seconds before your camera is ready to shoot again. Generally, medium and large cameras and relatively expensive digital cameras have the shortest recycling time (also called click-to-click time), and smaller or less expensive digital cameras usually take longer. The recycle time may be a few seconds longer if the flash fired or battery power is low. When that little flashing red light stops, your camera is ready to shoot again.

Reviewing Your Pictures

Looking at and sharing your just-shot pictures is one of the joys of owning a digital camera. True, the LCD viewfinder is tiny and you won't be able to see much detail, but by golly, you are assured that you got your picture and can instantly show it off.

Depending upon how your camera is set up, the last picture you shot may automatically appear on the LCD viewfinder for a few seconds (giving you the option to delete or save it), or you may have to manually switch from camera to *playback* mode. Usually, the playback symbol on your camera is an arrow icon inside a small box (see Figure 3-5). Press or turn to it, and the camera will display your photos. To page through them, press the left or right arrow of the jog button.

Figure 3-5: Typically, the playback icon looks like the forward button of a VCR.

PLAYBACK OPTIONS

Depending upon your make and model, you may (or may not) have viewing options when you look at your photos on the LCD.

- While the default setting for playback fills the entire LCD with a single photo, many cameras also allow you to view *thumbnails* (tinier versions of your pictures), four or nine at a time. You really can't see much of each, but you can see more images at a single glance.

- Many cameras have a feature called *pan and zoom* that allows you to magnify and move about a recorded image by pressing the left/right and up/down arrows of the jog button.

This way, you can see more details. However, the magnified image will be too large to display at one time in the small LCD viewfinder, which is why you'll need to pan or move about to see the areas that spill over the edges.

■ You may be able to copy, crop, delete, protect (mark them to make it more difficult to accidentally delete them), orient (have all the pictures standing up rather than laying on their side if you shot them sideways), and display information about your pictures (called *metadata*).

■ Many cameras have a feature called *slideshow*, which automatically cycles through your pictures, displaying them for a few seconds before moving onto the next and the next and the next.

Tip: Hook Your Digital Camera up to Your Television Set

Looking at your just-shot pictures on a tiny LCD viewfinder is great fun, but for a real blast, attach the video cable that came with your camera to your television set. Then plug it into your camera's Video port (often identified as AV Out), activate the playback mode, and enjoy watching your pictures from your favorite couch or easy chair.

TO DELETE OR NOT TO DELETE . . .

A digital camera usually can delete individual frames, mark several or numerous photos for batch deletion, or do a global (complete) deletion of everything on the memory card. But do you really want to? Remember: once it's gone, it's gone for good. Here are our thoughts on when to delete and when not to:

■ Don't bother deleting at all if you have plenty of space left on your memory card. You can always do it later, in the computer, where you'll have a larger screen that will allow you to make a more informed decision about the quality of the image.

■ Or, delete the really obviously bad pictures to preserve your reputation as a photographer (especially if you plan to show the pictures from your camera) and to make room for more images on your memory card.

Tip: How Many Pictures Can I Take?

Every time you take a shot, the frame countdown on the LCD viewfinder (and/or control panel) will be reduced by one. However, that's only an approximation of the number of pictures you'll be able to take before your memory card fills up. For several technical reasons, the file size of each image may be different. And once you start playing with the resolution and image quality settings, those numbers will change radically. Still, it is a good approximation of how much longer you can continue to shoot. By the way, when you switch from camera to video mode (most digital cameras allow you to capture movie clips), the countdown counter will display approximately how many seconds of shooting time you have left.

A Profusion of Controls

Frankly, most digital cameras are way too complicated. And the more features and functions you have, the more options and choices you must make. Learn to navigate among your camera's options, and you'll quickly gain better control over it.

You'll change your camera's settings using three different kinds of controls:

- Menus on the LCD viewfinder (which may also be displayed in the eye-level viewfinder)
- The control panel
- Analog buttons, levers, switches, and dials

Menus on LCD Viewfinder

The vast majority of your camera's settings will be controlled through options menus on the LCD viewfinder. Since it's the same screen you can use to frame and preview, as well as playback your images, you'll need to press a button to turn on the menus or display the settings. Often the settings are superimposed over the subject; other cameras have them over a solid background.

To find and select the settings on the LCD, you'll usually have to navigate through nested menus (menus that bring up other menus). Most often, this is done by using the jog buttons described earlier (refer back to Figure 3-3). Other LCD menus have buttons surrounding the viewfinder whose functions are based on what word the LCD displays closest to the particular button. Actually, there are so many variations on how menus are navigated that we highly recommend that you read your camera's manual to give you a sense of how it works. Then, just go ahead and choose different options to see what they do. If you have the wrong setting, the worst that will happen is your picture won't turn out as you expected, and you'll need to reshoot. You won't break your camera by choosing the wrong setting. But beware you don't accidentally delete images or reformat your memory card.

Control Panel

Usually found only on higher-end cameras or, conversely, very inexpensive models that don't have an LCD viewfinder, the control panel (see Figure 3-6) is a small grey screen on the top of your camera (or sometimes on the back above the LCD), which continuously displays lots of information, such as exposure settings, the battery status, the flash mode, the number of frames left, and so on. Most of the same info is also displayed on the LCD (when it's turned on and in the proper mode), but it's always visible on the control panel. Sometimes, there's a nearby button, for briefly illuminating the control panel.

Analog Controls

An analog control is anything that you can physically touch. Scattered all around your camera will be anywhere from a few to a multitude of buttons, levers, switches, and dials. These are the controls that you use to change your camera's settings and to interact with the control panel and the LCD menus.

Figure 3-6: Usually found on the top of the camera, near the shutter button (as it is here on the Nikon D70), the control panel provides vital information about current settings. Some of these can be changed directly on the control panel using various analog dials and buttons. The button to the right turns on a tiny light to illuminate the control panel. Unlike the LCD, the control panel is always on. (Photo courtesy of Nikon Inc.)

They work in various ways:

- Pressing a button once may activate a different setting than pressing it twice or three times—usually setting another option for the same feature, such as going from no flash to fill flash to forced flash, and so on.

- Many analog controls work together. For example, when you press and hold a button and then turn a dial, it might cycle through the options of a particular setting.

- When you switch camera modes, such as from shooting to playback mode, the functions of your analog controls may change. Therefore, a button that controls the flash when the camera is in shooting mode may be the delete button in playback.

- Similarly, when used in conjunction with a dial, a button may control one function, but when pressed simultaneously with another button, it may do something entirely different.

When you use these analog controls, the settings that are activated are displayed in the LCD viewfinder and/or the control panel.

SPECIFIC ANALOG CONTROLS

Over 200 different camera models are out there, and no industry standards exist for analog controls. So, their size, shape, position, names, and labels may vary widely among manufacturers, or even among different models from the same manufacturer. The functions they achieve, however, tend to be common within categories of cameras. (For example, professional cameras have different and more features and functions than point-and-shoot devices.)

Learning to use your own camera's controls isn't hard, but it is something that requires a little bit of effort. We highly recommend that you don't put it off—the sooner you become familiar with all the controls in your camera, the more quickly you'll be comfortable with it, capturing exactly the pictures you imagined.

To give you an idea of where to start, the next few pages show and explain some of the many kinds of buttons, switches, dials, and levers found on just two cameras (see Figures 3-7a, 3-7b, 3-8a, and 3-8b). You might also want to look back at Figures 3-3 and 3-4, which cover different kinds of jog buttons, a type of zoom button, and a bit about the mode dial. None of these pictures is meant to be definitive. Rather, use them as a guide to understanding analog controls and what they can do, as well as what they may (or may not) look like on your camera.

It is better, in most cases, to use the eye-level viewfinder for your composing.

The lightning bolt is a universal symbol for flash. Press it repeatedly until it cycles through to the flash setting you want.

This button activates two different functions—self-timer or burst mode—depending on how many times you press it.

The flower is an almost universal icon for macro (close-up) focus, but this button actually cycles through all available focus options, including auto, manual, and infinity.

This is a very common icon for turning the camera to record mode in which you take your pictures.

A rocker switch for controlling the zoom. HP chose to indicate wide angle (on the left) as a group of trees, and telephoto (on the right) as a single tree.

Use the four-way jog buttons to navigate among the menus and then push the OK button to set your choices. The same buttons flip through your stored photos when in playback mode. While the LCD viewfinder can be used also for framing and previewing your pictures, it will consume lots of battery power.

Behind the door is the slot where the memory card goes.

The print button and the email button are particular to only some consumer cameras that allow you to mark photos in the camera for printing and emailing. Then, when you connect the camera to your computer (or a direct connect printer), it can automatically execute the print or email command stored with the photo.

To see the photos you've already taken, put your camera into playback by pressing this button, which displays the near universal arrow icon for playback.

Menus displayed on the LCD viewfinder.

Figure 3-7a: The back of the HP Photosmart 945. (Photo taken with an Olympus E-1.)

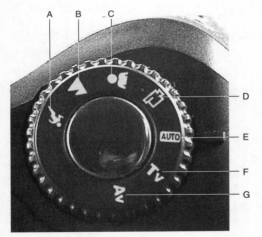

Figure 3-7b: The mode dial on the HP Photosmart 945. (Photo taken with an Olympus E-1.) Consumer cameras often have program modes for setting the best parameters for specific subjects or special shooting conditions. On the HP, the program modes are (A) sports, (B) landscape, and (C) portrait. (D) Most digital cameras can also capture limited video. (E) Auto is the default mode, in which the camera chooses all photographic settings based upon its analyses of what the scene and subject require. (F) Shutter priority and (G) aperture priority modes are advanced exposure controls though the icons are not those most photographers usually associate with those powerful options.

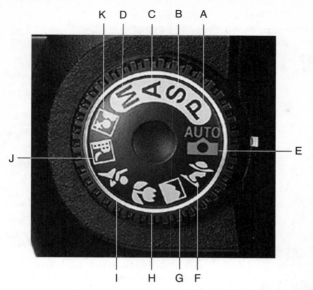

Figure 3-8a: As a semi-pro camera, the Nikon D70 has a mode dial that has elements of the consumer-type dial of the HP Photosmart 945 as well as elements of more professional cameras. The professional exposure settings are (A) program mode, (B) shutter priority, (C) aperture priority, and (D) manual exposure. But, it also has an (E) Auto mode, as well as program modes: (F) portrait, (G) landscape, (H) macro, (I) sports, (J) night landscape, and (K) night portrait. (Photo courtesy of Nikon Inc.)

Tip: Don't Let the Technology Distract or Overwhelm You

Digital cameras are simply tools, nothing more. Learn one function at a time by experimenting with it, finding out how its options affect your photography. That way, not even the most advanced cameras will be overwhelming, and you'll have much more fun using them.

Sensors, Status Lights, and Ports

Your digital camera is an electronic marvel that interacts with you and the world. That's why it has ports, or outlets that connect with other devices such as a computer or printer, and sensors that measure the quality and quantity of light illuminating your subject or scene. Understanding and recognizing these will help you better handle your camera.

Sensor Windows

To take perfectly exposed, sharply focused, well-lit pictures, most digital cameras have built-in internal and external sensors that feed vital visual data into the camera's intelligence. You don't really need

Use the shooting mode button in conjunction with the select dial to choose among single shot, continuous shooting, self-timer, and other shooting modes. Or, when held down at the same time as the control panel light button on the top of the camera (see Figure 3-6), it will reformat your memory card. These kinds of dual-purpose buttons are commonly used to save on camera real estate.

Bracketing will set the camera to take a quick series of 3–5 shots, in which the exposure or white balance of each frame is slightly different from the others. it's a pro's trick for making sure she gets the shot.

The eye-level viewfinder.

The familiar playback icon. Press this button to display the photos you've already shot.

The Menu button.

Another dual button. When in playback, it controls the size of the image you'll review—full screen or thumbnails. When used with the select dial, it sets the ISO equivalency (that is, sensitivity to light).

The white balance button assures that you get the colors right in your picture, by adjusting to the kind of light (sunlight, fluorescent, incandescent, and so on). When used in other ways, this button can also protect a photo from accidental erasure or access the camera's help menu.

A diopter, which you can focus to adjust for your eyesight. It's great for eyeglasses users who don't want to look through the eye-level viewfinder with their glasses on.

Use the four-way jog button to navigate through the menus (as well as page through saved photos when in playback).

The auto-exposure and autofocus lock of advanced cameras functions similarly to pressing the shutter button down halfway in consumer cameras. Both freeze your exposure and focus while you compose the picture.

This select dial (and a matching one in the front of the camera) is used in conjunction with other analog controls. Turn the dial while holding down a button to cycle through the various options associated with that button.

The door to the memory card compartment.

The menus in the LCD viewfinder.

Traditionally, the focus point is in the center of the viewfinder. However, with some cameras, you can choose other focus points. Using this slider with the select dial can manually set the focus point.

The trashcan icon initiates a delete, which can erase individual pictures or an entire series.

This is the Enter key for selecting options in the menus, but it's also the button for changing image quality and for zooming in for a closer look at your stored photos.

Figure 3-8b: Like other semipro cameras, the Nikon D70 has many more (and more advanced) controls than the HP Photosmart 945, though a handful are similar. (Photo courtesy of Nikon Inc.)

to know or do anything about the internal sensors, they'll function whether you're aware of them or not. However, the external kind are usually tiny round windows found somewhere near the lens (see Figure 3-9). These measure the amount and quality of light being reflected from the subject (and select an appropriate exposure setting) or the amount of light being pumped onto the subject by the camera's flash (so it knows precisely when to turn the strobelight off).

Tip: Don't Blind Your Camera

Be sure to never inadvertently put your finger or anything else in front of an external sensor window, because that, in effect, will blind your camera.

Status Lights

Most digital cameras have a variety of status lights, usually located around the eye-level viewfinder, near the memory card compartment door, and in the front of the camera near the lens. You'll want to learn to read them because what they are telling you can be important information, such as:

- When the camera is ready to shoot

- When the flash is charging

- When the camera is recycling and saving an image to memory

- If your memory card is full or your battery is running low

- If there's some sort of internal error (which is often cured by turning the camera off and back on)

Depending upon the camera's make and model, those lights could be green, red, or orange, and each color can have a different meaning. Some cameras have sound effects accompanying the lights, so you can hear as well as see what the current status of your camera is. (Usually, you can turn the sound off, or customize the sound effects.)

Another important status light is the tally lamp, a tiny red light that flashes when you've activated the self-timer (see Figure 3-9). It may also beep. Both the light and the beeping accelerate the closer you get to the camera taking the picture. (Unfortunately, you can't turn the tally lamp off on most cameras.)

One other light on better cameras is an AF Assist. It's usually about $\frac{1}{4}''$ or $\frac{1}{3}''$ in diameter, often located between the lens and the handgrip in front of the shutter. Autofocus works best in bright light, but is almost hopeless in low light. So, when the light sensor detects a low-light situation, it automatically activates the AF Assist lamp, providing just enough illumination on the subject (actually a small red, white, or orange light) to allow the autofocus to work properly. This feature can be turned off when you don't want to be obtrusive. In that case, you'll need to use manual focus, if your camera has it.

Ports

Three important ports on most digital cameras are the Universal Serial Bus (USB) port, the Video Out port, and an AC adapter connector. They're usually found together on the side or the back of the camera, covered by protective plastic or rubber flaps (see Figure 3-10).

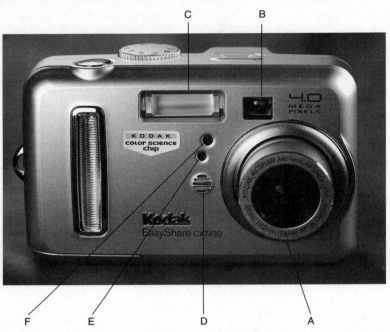

Figure 3-9: The front of this Kodak EasyShare CX7430 looks like a traditional camera, with a (A) lens, (B) eye-level viewfinder, and (C) flash. But look more closely and you'll see (D) a small grill that is the microphone and two miniscule windows that are (E) the external sensor and (F) the tally lamp. Often the sensors and tally lamp are even tinier and easy to overlook. (Photo taken with an Olympus E-1.)

- The USB port connects your camera to a computer or a direct connect printer (that is, a printer that can output your photos from your camera or memory card without having to hook up to a computer).

- The Video Out port connects the camera to a television set, where you can display the photos you shot.

- The AC adapter connector may charge the batteries, provide direct power to the camera (attaching it to the computer consumes lots of power), or both. While almost all digital cameras ship with USB and Video Out cables, the AC adapter is usually optional and extra.

Most cameras have two additional input and output devices—a microphone (see Figure 3-9) and a speaker. Added more as an afterthought than as a strategic design, they are single holes or grills located anywhere on the camera. They're very limited in volume and recording range, and the quality is only fair at best, but they do give your camera the ability to record and playback sound.

Depending upon the make and model, some cameras may have additional ports:

- A small number of more advanced models have an outlet in back or a dark red window in front for a cable or wireless remote control that allows you to shoot and operate the camera at a distance.

■ Advanced amateur, prosumer, and pro models usually have a *hot shoe* on top of the camera for attaching an optical external electronic flash. A few also have what is called a PC connector, for attaching a flash cord that plugs into studio strobelights.

■ Several semipro and all professional D-SLRs have a FireWire port (also called IEEE 1394), which transfers data to the computer faster than the USB 2.0 port (see Figure 3-10). However, not all computers have FireWire ports.

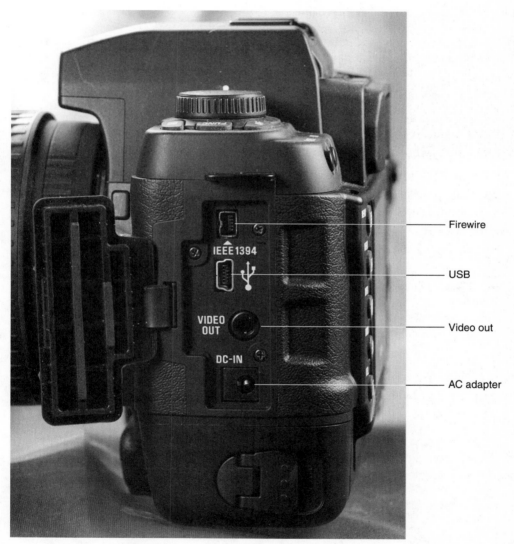

Figure 3-10: Your camera's ports for Video Out, USB, FireWire (or IEEE 1394), and the AC adapter are usually under a plastic door or rubber flap on the side of the camera body. (Photo of a Sigma SD-10 taken with an Olympus E-1.)

- Some of the better point-and-shoot models have an additional interface on the bottom of the camera for plugging the unit into a camera dock or cradle, a device that automatically interfaces the camera with the computer and at the same time recharges the batteries.

Summary

These are the key points covered in this chapter:

- Physically, digital cameras can be quite different from each other. Where the controls are, even what they are called, will vary among manufacturers and models.

- Before taking your first shot, charge and insert the batteries, install the memory card, and set the time and date.

- Because of the technology, you should be aware of and anticipate the inevitable, unavoidable shutter and recycling delays.

- When you take your first pictures, leave the camera in the default mode and let it do all the work.

- Reviewing your photos is fun and allows you to eliminate bad shots as well as determine what pictures you should reshoot.

- You'll change your camera's settings using three different kinds of controls: menus on the LCD viewfinder, the control panel, and analog buttons, levers, switches, and dials.

- Don't let the technology intimidate you. Learn each of the controls, ports, and other physical attributes one by one by experimenting with them and seeing how they affect your photos.

Chapter 4

Necessities and Niceties

Like most other devices and appliances, digital cameras can be accessorized and added to, above and beyond the basic configuration. Some of the add-ons are essential to taking pictures, such as batteries and memory cards. Others are optional and extra, nice to have and use, but not vital. These include, but certainly are not limited to, extra memory cards and spare batteries, printers and consumables, camera bags and cases, external strobes, filters, auxiliary or interchangeable lenses, portable viewers and storage devices, wireless or corded remote controls, light-reducing hoods, tripods, and extended warranties.

In this chapter, we'll cover some of the more useful and interesting peripherals and accessories for your digital camera. We'll walk you through how to assess if you really need them, where to buy them and how much they should cost, and where appropriate, how to use them efficiently and effectively. And we'll touch briefly on opportunities for learning more about digital photography and imaging.

Tip: Go Slowly with Accessorizing Your Digital Camera

Try not to go whole hog on outfitting and equipping your digital camera from the get-go. And do resist the temptation to believe that sincere-sounding salesperson who firmly insists that you absolutely, positively need this or that gadget or gizmo. Get what's necessary first. Then, add the niceties one by one, as you encounter an actual need or desire for them.

Necessities

What follows is a short shopping list of accessories and peripherals that you'll need or definitely want.

A Computer

A computer is no longer absolutely necessary for digital photography, because it's now possible to output images on printers that connect directly to digital cameras or take memory cards. Or, you can use professional services and kiosks to output your photos. (See Chapter 20 on printing.) However, practically speaking, a computer is still the best way to store, edit, and output your digital images. It's almost axiomatic to state that the faster, more powerful your computer is, the better and easier it will

be to take care of your photographic needs. That's because digital photos require lots of computing "juice" to process, save, and output them.

The components in the following list are what you want for an ideal system, but you can probably function on an older, less powerful system with an earlier operating system:

- A modern 32-bit or 64-bit processor, such as the Pentium 4 (PC) or PowerPC (Mac)

- At least 512MB of RAM (1GB is even better)

- Windows XP/XP Pro (PC) or OS X (Mac)

- 32-bit color graphics board with at least 32MB RAM (64MB or 128MB is better)

- A 17″ CRT or LCD color monitor with a resolution of 1280 × 1024 pixels (18″–24″ and 1600 × 1200 resolution are better)

- At least an 80GB hard drive (a 160GB or 200GB drive is even better)

- USB 2.0 ports (USB 1.1 although much slower, will probably suffice)

You Can Retrofit USB in Your Older System

If your older computer isn't USB enabled, you can buy a USB board that will plug into any PCI expansion slot. They sell for about $20–$35, depending upon the model and how many ports they have, though you can probably snag one on eBay for half that amount. FireWire expansion boards are also available on eBay, costing about $6–$18, but make sure that you have an empty expansion slot in your computer available.

Memory Cards

Although it may seem obvious, let's state it for the record: buy *only* the memory card format that fits your specific digital camera. If, for example, you own a Sony Cyber-shot DSC-T1, the only type of memory card that it can use is a Memory Stick Duo. Nothing else will fit, period. Of course, you can select different brands, densities, and even regular or high-performance cards, but they must always be the Memory Stick Duo.

Presently, there are nine competing memory card formats. The most common memory card types used in digital cameras are as follows: CompactFlash (CF) Type I/II, SmartMedia (SM), Secure Data (SD), MultiMedia Card (MMC), Memory Stick (MS), Memory Stick Duo, xD Picture card, and PC Card (see Figure 4-1). The ninth card format, a miniSD card, is presently used only in camera cell phones and certain MP3 players, not digital cameras. But that may change shortly.

Although most memory cards are physically incompatible and not interchangeable with each other, SD and MMC cards share the same size, shape, and configuration, and both can be used in any digital camera that has an SD/MMC slot. Another exception is that some digital cameras have dual memory slots. That is, they can simultaneously accommodate a CompactFlash card and, depending upon the brand, an xD Picture card, SD card, or Memory Stick.

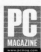

Figure 4-1: A sampling of types of memory cards. (A) CompactFlash, (B) xD Picture card, (C) SD card, (D) SmartMedia, and (E) Memory Stick. It's important to recognize that the physical size of a card has nothing to do with its capacity. (Photo taken with a Kodak EasyShare CX7430.)

Must You Buy a Specific Brand of Memory Card?

Some manufacturers strongly recommend (read: warn) that you use only their name brand or a recommended brand of memory cards and no others. They may even threaten dire consequences, such as voiding your digital camera warranty or risking the loss of data, or worse. Generally, you may safely ignore these heavy-handed attempts to coerce you into buying that company's (usually higher-priced) memory cards.

Having said that, we should point out that there are a handful of exceptions. For example, some older cameras have proprietary drivers embedded in the maker's cards to facilitate certain functions. With these digital cameras, using another brand may be no problem when you're shooting normal stills, but try something special, like recording video or copying from built-in memory to the card, and it may not work. Fortunately, almost all current digital camera models are designed to work with anyone's memory cards, so long they're the right kind and the performance specs match. That latter requirement is especially important with some of the newer models capable of recording full-frame VGA videos at a flicker-free 30 fps (frames per second). Slower cards can't keep up with the faster data stream rate, so your videos may slow down or even freeze while shooting if you don't use a high-performance card.

Tip: Buying Memory Cards

Take your camera's startup guide to the store so you buy only the type of card that fits that model. Ideally, if you can afford it, buy only densities of 128MB or higher, not the smaller 16MB or 32MB cards. 256MB and 512MB card are probably the most cost-effective.

Two quick caveats: before you go all out and invest in high-density 2GB or 4GB memory cards, or spend extra for premium high-performance cards, make certain that your digital camera can use them. Most consumer models can't read or write to cards over 1GB, and many models can't make optimal use of premium cards, so you won't get the added performance boost you're looking for. Fortunately, most advanced amateur, prosumer, and professional digital cameras make full use of both high-capacity and high-performance memory cards.

CompactFlash Type I/II?

CompactFlash (CF) cards are used in about one-third of all digital cameras. You should be aware of the pros, cons, and attributes of the various kinds of CF cards, so you don't buy ones that your digital cameras can't use correctly, or at all.

- *Type I*, the most common variety, fits into all CF-equipped digital cameras. It's available in low (4MB–16MB), medium (32MB–128MB) and high (256MB–1GB) densities, and in regular or high-speed performance versions. Before buying high-performance cards, be sure that your camera is optimized to take full advantage of them.

 Then there are ultrahigh-density, 2GB–4GB Type I CF cards. Such cards use a different file structure (called a File Allocation Table, or FAT) than lower-density cards. Again, be sure that your camera supports such high-capacity cards. Otherwise, even if you do buy a 2GB card, you'll get only 1GB of storage out of it.

- *Type II* CompactFlash cards are designed for even higher performance and higher densities than Type I cards. Physically, they're slightly thicker than Type I cards, and thus, won't fit into the CF slots of most consumer digital cameras. While many Type II cards are solid state devices, there's one other kind, called the MicroDrive, that's actually a miniature hard drive. It's fast and usually less expensive than its solid state counterpart, but it's also fragile. MicroDrives are generally used by pros. Our advice is that if your camera can accommodate a Type II card, and you want (and can afford) the added performance and density, get a solid state CF card and not a MicroDrive.

Batteries and Other Power-Related Accessories

It's an unalterable fact: digital cameras require lots of battery power. The battery or batteries that came with your digital camera, whether of the regular or rechargeable kind, will be fine for a few hours' service. But when you're taking lots of shots, making heavy use of the LCD viewfinder or flash, attaching it to your computer's USB port for downloading images, or frequently turning your camera on and off, your batteries will run down much faster.

We strongly suggest buying at least one spare battery or set of batteries, for swapping out when you get a Battery Low warning. If your digital camera uses AA batteries, buy four nickel-metal-hydride (NiMH) rechargeables and recharger for $14–$20. The price varies according to brand, power capacity, and recharge speed. Get as high a capacity as you can afford (the higher number is better, such as 2200 mAh rather than 1800 mAh). Most rechargers will refresh a set of batteries in 6–8 hours. However, rapid chargers can do the job in just over an hour. How? By literally cooking the batteries. The excess heat juices them up much more quickly, but the tradeoff is a shorter battery life. Typically, a set of NiMH batteries will last a year or so, but the quick charge kind may last only 9 or 10 months.

If your digital camera uses a proprietary lithium-ion battery, we advise buying an exact replacement bearing the camera manufacturer's name. Generics are available, but the pin arrangement might be slightly different, and it may not work in your camera. Also, some cameras come with quick chargers, which won't work as well with generic batteries not optimized for quick charging. While you can probably buy a spare battery at places like Circuit City or Best Buy, you can get the price down by going to a Web site like www.pricewatch.com and www.pricescan.com. Only, make sure that they're the real McCoy and not nameless generics. Nor do you want refurbished batteries; always buy brand new ones. You can use the same charger or charge cord for the spare battery, but you might want a second, so you can recharge both batteries simultaneously.

Tip: Get That Optional Camera Dock

If your digital camera is one of the few models that can take a camera dock or cradle, but it is optional and an extra charge, buy it. The convenience of being able to easily and quickly get your pictures onto your computer, while charging your batteries at the same time, is well worth the extra cost.

Memory Card Readers

Most digital cameras can download their pictures by plugging in a cable from the camera to a computer's USB port. It's fast, easy, and since the cable came bundled with your camera, it won't cost extra. But often, it's not the best way to transfer your images to the computer. That's because attaching your camera puts a heavy strain on the camera's batteries (they can poop out in as little as 15 minutes), and you can't take pictures while your camera is attached to the computer. And unless your camera is USB 2.0 enabled, it might not be the fastest method either.

We have found that, short of using a cradle/charger (available on only a few consumer models), the best method for transferring images files is via a card reader. A card reader is an inexpensive device ($20–$50) that acts as an external disk drive when plugged into a USB port (see Figure 4-2). Some are 6-in-1 or 7-in-1 devices that have slots to accommodate different types of memory cards. This is good if you have more than one digital camera or other devices that use different memory cards. Otherwise, buy a less expensive dedicated memory card reader that works only with your card. Incidentally, if you can't find a memory card reader that accommodates your particular card (such as an xD Picture card), consider buying an adapter ($15–$40) that allows your memory card to plug into a more universal memory card slot.

Depending upon the make, model, and price, a card reader may be USB 1.1 or 2.0 enabled. If your computer or laptop has a USB 2.0 port (almost all units sold since 2002 have USB 2.0 built in), spend

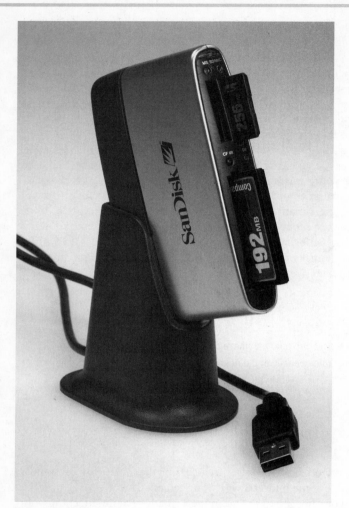

Figure 4-2: This SanDisk memory card reader accommodates several different types of memory cards, which is useful only if you have a variety of devices that use diverse cards. It plugs into the USB port of the computer, which then reads everything on the cards as though it were an external hard drive. (Photographed with a Konica Minolta DiMAGE A2.)

a few bucks extra and get a USB 2.0 card reader for significantly faster data transfers. A handful of expensive memory card readers are FireWire enabled rather than USB enabled. If speed is important to you, and your computer or laptop has an IEEE 1394 port, buy the FireWire rather than the USB model.

Installing a memory card reader usually means plugging it into one of your computer's USB (or FireWire) port. If it's not recognized immediately, you may have to first install the driver that comes with it (usually only on older computers), or you plugged it into an expansion hub rather than directly into your computer or laptop. Rather than plugging the card reader into a hub, insert it directly into the computer's built-in USB port. After taking those steps, if it's still not recognized, try replugging everything in and rebooting your computer. If it still doesn't work, then it's time to call tech support.

Resources for Learning More about Digital Photography

One of the reasons we're writers is that we love to learn. Regardless of how much we know, we are driven to know even more. As photographers, we enjoy talking with other photography experts, for the new insights and perspectives we always discover from the dialogue.

Here are a handful of suggestions for learning more about digital photography:

- Learn insider tips and tricks from top pros like Greg Gorman and Jay Maisel in a series of 12 weekly online videos at the Epson Print Academy Online Experience (www.EpsonPrintAcademy.com, $29.95). Even experts love these well-produced, charming, and informative videos.

- Training videos that you can play on your on TV and interactive tutorials that run on your computer abound. Unfortunately, they vary widely in quality, usefulness, and value. Try to get a preview to determine how professional, useful, and relevant the video/DVD is.

- Numerous photography schools offer week-long, weekend, and weekly courses. Check out your local universities or the International Center of Photography (New York City), Santa Fe Photographic Workshops, Maine Photographic Workshops, and other similar programs.

- If you want to learn Adobe Photoshop, we highly recommend any courses taught by Katrin Eismann. Even after all the years that she has been teaching this one program, she still infuses her classes with excitement and her students with her considerable knowledge (www.PhotoshopDiva.com).

- The various companies involved in digital photography, from hardware manufacturers such as Nikon, Olympus, and Kodak to software vendors such as Adobe and Macromedia, sponsor numerous, information-packed programs specifically designed for novices, intermediates, and even professionals. As is to be expected, they focus primarily on their own products and those of cosponsors or noncompetitors.

- We would be remiss if we didn't mention our own digital photography seminars, which will be held in major cities around the country. For dates and locations, check out our Web sites www.TheWellConnectedWoman.com and www.DigitalBenchmarks.com.

Niceties

Here are some of the optional accessories you might want to put on your desktop or stuff into your camera bag. They're not absolutely essential, but they may help you extend and expand your photography experience, if they satisfy an important need or strike your fancy. We list and discuss them in no particular order.

Lens Shade

Flare is a bright streak across your pictures caused by light entering your camera's lens at an oblique angle. It's an ugly defect that mars your photos. To prevent flare, you could move your position so the

light is coming from a less extreme angle. That's not always possible. Another remedy is to shield the lens as much as possible. The most practical way of shielding your lens is with a lens hood or shade.

Alas, most consumer digital cameras don't have lens threads, so they can't accommodate a lens hood. Some digital cameras, especially prosumer and semipro models, come equipped with a lens hood as a matter of course. For those in-between models that can take a lens hood but for which the manufacturer doesn't provide one, you can buy an optional lens hood from either the manufacturer or third-party companies such as Tiffin (www.tiffen.com) or dc pro (www.dcprodirect.com). Your camera may also require an adapter ring to mount the lens hood. Expect to pay $10–$25 for a lens hood, and if your camera needs one, an adapter ring ($12–$20). Of course, you must know the diameter of your lens thread—it's usually listed in the specs, at the back of the instructional manual that came with your camera.

Once it's installed, we suggest that you leave the lens hood on permanently. It also helps protect the lens from knocks. However, make certain that the lens hood doesn't occlude (partially obscure) your flash, especially when you zoom to wide angle. If your images are partially cut off or have a dark line on the bottom, then you'll have to remove the lens shade whenever you shoot with flash.

LCD Viewfinder Hood

Seeing details in your digital camera's *LCD viewfinder* can be devilishly difficult when you're in bright sunlight. You can sometimes adjust the brightness and contrast of the LCD by paging through the menu. Another solution is to install an external hood onto your LCD viewfinder, shielding it from extraneous light coming in from the sides. These hoods cost $10–$35, depending upon the manufacturer and how large your LCD viewfinder is. Two companies that sell hoods are Hoodman (www.hoodmanusa.com) and Xtend-a-View (www.photosolve.com/main/product/xtendaview). The latter includes a 2X magnifier, so you can see a little more detail, as well as block out the sun's rays.

Key Drives

One of the fastest growing gadgets available is the so-called USB key drive. It's a small, penlight-sized device that, literally, can hook onto a keychain. Depending upon the brand, type, and cost, it can store from 8MB to 4GB of data. Most key drives are now USB 2.0 enabled, though older and less expensive models incorporate the slower USB 1.1 standard. Key drives come in all sizes, shapes, and flavors, and may include extras like biometric access, data encryption, Bluetooth connectivity, MP3 capability, and secure transportability of all your Internet settings and addresses. We use key drives for transferring data from our laptops to our desktops and to back up our work while we're on the road. While they're available in many different densities, we have found that the price/performance sweet spot is 128MB or 256MB ($28–$60).

Recently, peripheral manufacturer Belkin announced a device, called a Digital Camera Link adapter, that automatically mates two USB devices without requiring a computer. We haven't yet tested it, but it seems that it could be a fast, easy, and relatively affordable way to back up your images from your digital camera directly to a key drive.

Printers and Consumables

Chances are that your desktop inkjet printer can generate photo-quality prints, even if it weren't originally designed for that purpose. You may need to buy and install photo inks and use special

photo paper, but the results will probably be quite satisfactory for most purposes. Monochrome printers, such as business laser printers, aren't much good in outputting photos, however. If you are considering a desktop photo printer, we suggest reading Chapter 20 before buying.

Depending upon your brand and model printer, it may be possible to print on canvas, art paper, matte paper, and a wide variety of surfaces and textures. Some papers come as templates, such as party invitations or business cards with blank areas reserved for printing your photos. You can check out some of the different types of papers by browsing the shelves at stationery and computer stores.

Camera Bags

Camera and gadget bags come in all shapes, sizes and colors. In fact, some of the best camera bags aren't designed for cameras at all, but are all-purpose backpacks, army surplus gas mask bags, sports bags, and the like. You'll want a bag that is large enough to carry your camera and paraphernalia, but isn't so large and heavy that you'll always want to put it down rather than let it rest on your shoulder. Waterproofing is a definite plus. If you use a tripod, you'll want a strong bag with straps on the bottom, for slipping in your tripod or monopod. Pockets are always handy for small accessories, such as memory cards and spare batteries. Last, but not least, get a bag that opens easily and conveniently, so you can get to your camera quickly when the shot you want comes along.

Auxiliary Lenses

Except for semi-pro and professional models, all other digital cameras come equipped with fixed, noninterchangeable lenses. While most have zoom lenses, there may be occasions when they don't have a wide enough scope, or you simply can't get close enough to take the shot you really want. Many digital cameras are designed to accommodate *auxiliary lenses*. These are screw-in or clip-on optical devices that attach in front of your digital camera's fixed lens, either directly or with an adapter. Depending upon the lens, the change may be modest or significant.

Auxiliary lenses cost $50 to $500, depending upon the manufacturer and focal length. You can buy generic lenses from companies like dc pro (www.dcprodirect.com) or Tiffen (www.tiffen.com), or, from the manufacturer of your digital camera. Generics are almost always less expensive, but they may or may not be as optically good as lenses specifically matched to your digital camera.

Attaching an auxiliary lens comes with some tradeoffs. The first casualty probably will be image quality. Placing another lens in front of the primary lens usually diminishes overall image sharpness. How much depends upon the optical quality of the lens. It can be negligible or significant; the only way to judge is to use the auxiliary lens and compare photos taken with it to shots taken without it.

Also, most auxiliary lenses will reduce the amount of light hitting the image sensor. More glass plus the greater distance from the end of the auxiliary lens to the image sensor, usually translate into a 1-to-2 f-stop difference (more, with large Coke-bottle-sized auxiliary telephoto lenses). In other words, if your normal setting is 1/500 of a second at $f8$, adding an auxiliary lens will reduce that f-stop to $f5.6$ or $f4$. (See Chapter 6 regarding f-stops and shutter speeds.)

Then there's the problem of matching optics. Often an auxiliary lens, especially one of the wide-angle variety, will not adequately cover the image sensor. This lack of edge-to-edge sharpness is called vignetting—significant falloff (darkening, softening, and rounding) at the edges of the picture. Even lenses by the same manufacturer designed for a specific camera can produce a degree of vignetting. Some better digital cameras get around the problem by requiring the user to select a menu setting

when attaching specific auxiliary lenses, which should prevent the zoom lens from going so wide as to produce vignetting.

Finally, auxiliary lenses will add size and weight to your perfectly balanced digital camera. You probably will have to change the way you handle and shoot your camera, such as holding and supporting it by the lens rather than the body. And using a telephoto auxiliary lens may require you to boost the ISO equivalency setting (you'll get back those extra *f*-stops, but the pictures will be noisier) or use a tripod, for added stability.

If all this gives you the idea that we're not particularly enthusiastic about using auxiliary lenses, you're right. They're big, heavy, clumsy, and involve lots of compromises. However, sometimes they're the only practical and affordable way for you to get the shots you want.

Tip: Buy a Digital SLR

If you find that the zoom ratios available on consumer or prosumer digital cameras don't go as wide or as long as you'd like, consider buying a digital single lens reflex instead of using auxiliary lenses on a fixed lens camera. While somewhat more expensive, a D-SLR gives you the option of true interchangeable lenses, so you can better match the lens to your actual shooting requirements. You won't have to worry about diminished image quality, reduced light, vignetting, or extra weight and off-balance camera handling.

Filters

Generally, we recommend only three types of filters for use with a digital camera: an ultraviolet (UV) filter, a polarizing filter, and a neutral density filter. Most other kinds of filters were designed for film cameras, and their effects usually can be better duplicated and controlled using image-editing software.

- A *UV filter* ($12–$15) is useful for all cameras having protruding lenses with threads (and not lenses that retract into the camera body when turned off). It performs two very different, but important functions. One, it can significantly reduce the haze and ultraviolet light that gives pictures taken at the beach or in the mountains an overall blue cast. In addition, it protects your lens's front element. Leave it on permanently (it doesn't have any exposure or color factor, so it won't negatively impact your photos when it's not filtering out ultraviolet rays). Should you accidentally scratch or break it, the UV filter is a lot easier and cheaper to replace than your camera's lens.

- A *polarizing filter* (about $30) changes the way that light reflects off objects. Rotating the filter causes it to either lighten or darken the subject, resulting in lesser or greater color saturation. Polarizing filters are good for making the sky more dramatic and contrasty without significantly changing the colors of the sky. It also can help reduce glare and reflection off shiny objects, including water (so your picture can show what's below the surface). However, if your camera takes its readings of the light through an external sensor rather than through the lens, you'll probably need to use *exposure compensation* to make sure that you get the right exposure.

- There are times when you're shooting in such strong light that even using a high shutter speed and small *f*-stop may not be enough to keep the picture from overexposing. Or, you

may want a limited *f*-stop, to reduce the *depth of field* (area of sharpness) in a picture, but there's too much light to do it to the degree you wish. Of course, you can reduce ISO sensitivity a bit, apply exposure compensation, or both, but this may still be insufficient in controlling the amount of light that you want. (See Chapter 6 about exposure, *f*-stops, and shutter speeds.) That's when you attach a *neutral density filter* ($10–$14) to your lens. Neutral density filters (which generally come in 2X and 4X strengths) will reduce the amount of light hitting the image sensor in your camera by 2 or 4 *f*-stops, but without changing any other settings, such as color or contrast. They're especially useful in shooting brightly lit snow or beach scenes and can be screwed in front of your ultraviolet filter.

External Storage Devices and Viewers

If you shoot lots of images away from your home or office, or travel for days or weeks at a time and don't want to drag along a laptop, you would be well advised to buy either a mobile storage unit or a CD/DVD burner. It's cheaper than simply buying more memory cards, and it will provide a bit more security. What makes these devices particularly useful is that they don't require a computer, and some are battery-powered portables that you can take with you literally anywhere in the world (and probably the space station, too).

A mobile storage unit is a sophisticated electronic gizmo, ranging in size from a cigarette pack to a paperback book, which combines a tiny, high-capacity hard drive, an LCD viewer panel, one or more memory card slots, and a rechargeable battery. Priced about $250 to $600 (though one pro model costs thousands), they go by a variety of different names, such as portable hard drive or hand-held viewer. Pros love them because they provide fast, high-capacity storage for location shooting. Most also have a USB 2.0 port, for transferring data between it and your computer, although a few of the more expensive models feature FireWire. Depending upon price, the hard drive storage capacity varies from 5GB–50GB, and the LCD viewfinders are sized 1.8″–3″ (see Figure 4-3).

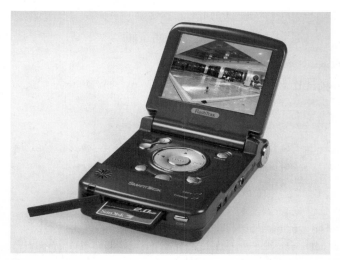

Figure 4-3: During a recent trip to Budapest, we backed up our photo shoot of the spa at the Danubius Thermal Hotel Margitszegit on this SmartDisk FlashTrax's hard drive, and we didn't have to use our computer at all. (Photo taken with an Olympus E-1.)

Mobile storage units offer lots of advantages:

- High-capacity storage.

- Fast data transfers anytime, anyplace.

- A viewer panel that aids in quick-and-dirty image editing as well as immediate sharing.

- Infinitely reusable and rewritable data.

- Storage for any data, not only image files.

- Some models are PictBridge enabled, so you can attach it directly to a printer and output photos without a computer.

- Some models have an earphone jack, to let you download and play MP3 music.

- It can be used as an independent drive, or when attached to the computer, as a normal hard drive.

Another type of external storage is the CD/DVD burner (priced $160–$400). Like the mobile storage units, CD/DVD burners come equipped with one or more card slots, operate independently of the computer, are USB 2.0 enabled, and may or may not be battery powered. A few models feature an LCD viewer panel, though most do not. But they back up their data to CD-Rs or CD-RWs, and a handful can even save to DVDs, instead of a hard drive.

There's a lot to like about CD/DVD burners:

- They're less expensive than mobile storage units.

- CDs and DVDs are permanent archival storage that can't be accidentally erased or overwritten.

- Since most can span multiple discs in a single session, storage capacity is potentially infinite.

- It's easy to make backup CD or DVD copies of the same image files.

- They're more robust and less prone to crashes than mobile storage units.

- If burning a CD or DVD fails, only that disc will be affected.

- Some models come with a variety of extra features, like the ability to play DVD movies, an earphone jack, an MP3 player, slideshow capability, and so on.

- Many can connect to a TV and some to a video projector for group display.

- CD burners can easily serve as regular CD-RW drives for laptops and PCs. A few can double as DVD-ROM drives as well.

Tip: Back Up to Your iPod

Apple's wildly successful iPod MP3 player can be used to record images as well as music. All you have to do is attach Belkin's Digital Camera Link adapter between it and your camera, and then download your images the same way you would MP3 tunes.

Remote Controls

A number of better consumer and prosumer digital cameras come equipped with a wireless infrared remote control unit for operating some of your camera's functions from a distance. Other models are remote enabled (wireless or wired), with optional remote control units that cost extra. They range in price from $40–$75 and tend to be brand-specific. So, buy only the make and model that is designed to operate with your particular digital camera.

Remote control units are useful only if you have a need to shoot from a distance, say, for surveillance work, capturing wildlife up close, or using the remote as a cable release. Frankly, we have had a number of digital cameras with wireless remotes, and we can count on one hand the times we've actually used them. They're usually the first thing to be misplaced.

Tripods, Monopods, and Minipods

The less your camera moves when it's taking a shot, the sharper, crisper, more in focus your pictures will be. The best device for producing rock-steady shots is a tripod. Tripods are extremely useful for shots that require slow shutter speeds (longer than 1/15 second), time exposures (night scenes and other low-light situations), multiple exposure (when you want to composite right on the original image), putting yourself into the picture (when you activate your camera's self-timer), using the remote control (such as taking off-camera portraits), and whenever you want to shoot from the same angle every time (for example, when taking a series of product shots at the same distance and with the same lighting).

While many tripods are heavy, cumbersome, and expensive, you will probably need a relatively inexpensive model ($25–$100) because most digital cameras are lightweight devices. By the way, if you already have a tripod for your camcorder, you can use the same device for your digital camera.

Here are some issues to consider when choosing your tripod:

- How tall do you need it to be? (A tripod that expands to 5–6′ is probably best.)

- Do you want a friction or crank extension column? (Friction is simpler and less expensive; a crank is more convenient and precise.)

- Do you want spikes or rubber legs on the bottom of the poles? (Spikes are best for outdoors, rubber legs for indoors. Some models give you both options.)

- Do you want it to have extra functionality, such as a focusing rail or spirit levels? (These are useful for a handful of applications that require microprecision, but overkill for most common applications.)

- Does the head swing, tilt, flip, or rotate? (So you can position the camera at any position, as well as more easily shoot panoramas.)

- Do you want a tripod with a quick release plate? (They're fast and convenient for mounting and unmounting your camera, but add to the cost of the tripod. Most people don't need them—they're primarily for pros who frequently switch camera bodies during a shoot.)

- Is it small and light enough to attach to the bottom straps of your camera bag? (Most folks won't carry a heavy tripod with them, thereby missing out on important shots.)

If you feel that you may have scant need for a tripod, you might consider buying a monopod or a minipod instead. A monopod ($20–$40) is a single expandable pole that anchors in the ground, and which you steady with one hand. It provides enough stability to prevent camera shake when shooting with a telephoto lens. Most sports photographers and photojournalists use monopods to brace their cameras when shooting with those long lenses that bring the action up close.

A minipod ($6–$20) looks like a miniature tripod, and is rarely more than 8″ tall. It's designed for bracing your digital cameras on a table or desk, against a wall or on the floor, and so on. Minipods are small and light enough to take with you anywhere, and with some improvisation, will often take the place of that tripod you left behind because it was too heavy to carry. This is one accessory you should probably buy and use.

Tip: A Tripod May Not Be Ideal for You

Although tripods are great for rock-steady shots that translate into crisp, clear, sharp images, they are often more trouble than they're worth. Michael Lewis, the photographer for National Geographic's *"Africa,"* admits that "I hate tripods. [They're] one more thing to carry and get in the way. But there are times when having a tripod is invaluable. Even so, if I'm working alone without an assistant, my preference is to go for faster lenses and faster ASAs [ISO equivalencies] if the light gets bad."

Underwater Housings

Want to use your digital camera underwater, either snorkeling or scuba diving? A number of Canon, Olympus, Nikon, Sony, and other models can be adapted for underwater photography by placing them inside what is called an underwater housing. That's a watertight, pressure-resistant transparent plastic or brushed aluminum box designed to fit the camera in such a way that the user can access controls, look at the LCD viewfinder, and shoot pictures underwater. Underwater housings do require some care and attention, such as properly lubricating "O" rings, cleaning between dives, and making certain that all seals and connectors are in place. Depending upon the manufacturer, camera model, and level of sophistication, underwater housings cost $100–$1,000. More expensive housings can be used at deeper depths (typically, 3–5 atmospheres, or 100–160′) and may be able to accommodate auxiliary underwater strobelights or lenses. However, sports divers rarely go below two atmospheres (66 feet) and will usually shoot only with their camera's built-in strobe, so the basic (less expensive) plastic housing will probably do very nicely.

Extended Warranties

When you buy any appliance or electronic gizmo, including a digital camera, the salesperson often tries to bully or scare you into buying a 2-, 3- or 5-year extended warranty on the product before you leave the store. This is from a third-party vendor, and not the original manufacturer. All you need do is fill out the information, pay your money, and give it back to the salesperson or mail it to the warranty firm, and you're supposedly covered for the next few years against breakdowns or malfunctions (but not accidents or willful damage). The warranty may not be cheap—a 5-year policy on a $300 digital camera may cost $35–$50—but then, it doesn't seem terribly expensive either.

Should you buy or pass on an extended warranty for your digital camera? Most digital cameras carry a 1-year parts and labor warranty. The manufacturer will repair or replace your camera if it fails during that period. The average digital camera has a life expectancy of 18–24 months, and because they've gotten much better in the past few years, people are holding onto and using them even longer than that. So, chances are you'll still be using your digital camera long after its warranty has expired.

Digital cameras are complex electronic and optical marvels. While they don't have many moving parts, there are lots of things inside that can go wrong—circuit boards, servo motors, seals, connectors, glass elements, and so on. And even the slightest malfunction may mean an expensive repair job, or worse yet, that the camera is totaled and will need replacement. Because of this, an extended warranty makes good sense. Personally, over the past 6 years, we've used our extended warranties to repair a washer, dryer, and refrigerator, and to get replacements on a CD player, a DVD burner, and a printer. While we haven't had any warranty repairs on digital cameras, we should point out that of the scores of units we've tested over the past decade that manufacturers have loaned us, at least 5 percent have arrived DOA or malfunctioned while in our possession.

Summary

These are key points made in this chapter:

- You may not need the fastest, most powerful computer to do digital photography, but it helps.

- You should have spare batteries and memory cards. Make sure that they are designed to work with your specific model.

- Get a memory card reader that's compatible with your memory cards.

- There are a number of digital camera accessories and peripherals that may make life more convenient, add zest to your photos, increase your productivity, give you more assurance, or help you take better photos. But don't go overboard buying them unless you have a specific need.

Part II

Photography: The Play of Light and Color on the Human Imagination

Chapter 5

Understanding File Formats

W e have quite a large collection of cookbooks in our kitchen. If we were good at following their step-by-step instructions to the letter, we would be able to faithfully recreate culinary masterpieces from all parts of the world, as well as from our own mothers' kitchens. But, of course, we have yet to follow any recipe exactly as it is written, which has led to catastrophic failures as well as magnificent meals.

That's one of the differences between the human mind and the programming behind digital cameras. Give a reliable recipe for a photograph to a digital camera (or, for that matter, to a photo-editing program or utility), and it will reproduce the picture exactly the same way every time. *File formats* can be said to be such a photographic recipe.

Digital pictures are, like any other files on your computer, nothing more than a series of data points organized in such a way that a computer can recognize how to reconstitute them in a predictable and repeatable manner. Essentially, the structure of that organization is the file format.

In this chapter, we will explain the differences among digital camera file formats, how to choose the right one for your needs, and how to use their attributes to your best advantage. You'll also learn about metadata—information about your photograph regarding how and when it was created that is saved within the file formats.

Tip: Do You Really Need to Read about File Formats?

If your digital camera doesn't offer any options for changing your file format, you may wish to skip the bulk of this chapter and just read about metadata on the last few pages.

Why Does It Matter What File Format I Use?

The file format—the manner in which image data are organized—defines exactly how a photo is constructed. To use the cooking analogy again, we can make spaghetti sauce by opening a can, pouring the contents into a container, and shoving it in the microwave. Or, we can select juicy ripe tomatoes, basil, onions, garlic, oregano, sweet peppers, and other farm fresh ingredients; chop them; sauté the mixture in extra virgin olive oil and fine wine; and then simmer it for hours on the stove.

Both sauces will be tasty, and both can be called spaghetti sauce. But the homemade one will definitely have a deeper, more abundant flavor and richer texture than the microwaved prepackaged version.

Still, isn't it wonderful that we live in the modern world in which we can simply open a can and use the microwave to quickly put together an enjoyable meal? No, it isn't gourmet, but sometimes you don't really want, need, or have the time and budget for gourmet.

Some file formats create and preserve higher-quality image data, with greater tonality, texture, and detail. But there's always a tradeoff—in time, convenience, size, and ease of use. For that reason, it is best to understand the pros and cons of each file format, so you may make informed decisions about which one you'll use to save your images.

Your choice of digital camera file format will influence:

- Image quality

- How fast you can take your pictures

- Your ability to use them on the Web, in email, or in print

- Your storage capacity and convenience

- Your ability to open, edit, and view your photos on a computer

- How easily (if at all) you can share your photos with a third party, such as a client or art director

The following section will help you make intelligent decisions about file formats.

An Alphabet Soup of Acronyms

One of the linguistic scourges of the computer age is the proliferation of acronyms. Everything has been abbreviated into what can sometimes seem like a secret language designed to keep outsiders from knowing and understanding what is really being said. For that reason (and because it can be so darn difficult to keep track of all the initials and their meanings), we try to steer clear of acronyms whenever possible. However, with file formats, the identifying acronyms are so entrenched that they have become the *de facto* nomenclature, with the original names all but forgotten.

While there are dozens of file formats that are relevant in one way or another to digital imaging, only three are used in digital cameras for photo capture: JPEG, TIFF, and RAW.

To make things more confusing, when you save a file on Windows systems, the acronymic names of file formats are abbreviated even further to three letter designations called *file extensions*—the letters that come after the dot in the file name. JPEG becomes .jpg, as in *jamie.jpg,* and TIFF becomes .tif, as in *teddy.tif.* Then, there's RAW—each camera manufacturer uses its own type of RAW with a proprietary file extension, so there's well over a dozen different abbreviations used. (More about that later in the chapter, in our discussion of RAW.)

JPEG

The most pervasive photographic file format is JPEG. For the record, JPEG stands for Joint Photographic Experts Group, the committee that originally developed the format. Not only is JPEG built into every

digital camera, in those many models which offer no user-selectable format options, JPEG is the one and only file format.

JPEG has three major advantages:

- It is the *linqua franca* of imaging. Every desktop computer, every printer, and all imaging software we have ever seen (or heard of) can recognize, read, edit, use, and output JPEG images.

- In our testing, we have found that JPEG photos take less time to save, which adds up to faster *click-to-click* (the recycle time before a camera is ready to shoot again) and *burst mode* speeds than TIFF and RAW.

- JPEG files can be compressed so that they don't take up as much space in your camera or computer, and they don't take as long to transmit over the Web or via email as uncompressed files do. But compression has its downside, too. (See the discussion and illustration that follow.)

JPEG is the preferred file format for sharing photos, because it can produce small files while still offering full color quality. More often than not, if you are emailing photos or posting them on the Web, you'll want to use JPEG. (See Chapter 15 for more on posting your photos to the Web.)

Tip

For convenience, speed, and universal compatibility use JPEG.

JPEG COMPRESSION'S NEGATIVE IMPACT ON IMAGE QUALITY

JPEG compression is what as known as *lossy compression*. In other words, it loses, or throws away, data to squeeze the picture down to a smaller file size. When the file is opened, the software reconstitutes the thrown away data according to machine logic rather than human aesthetics. Reconstitution is something like adding water to Tang or Kool-Aid, which has the essence of flavor but not the exact flavor of the original before all the water was squeezed out. JPEG can actually shrink a file to as much as 2 percent of the original size, which is quite dramatic indeed. However, there's always a price to be paid for this economy and efficiency: *The higher the compression, the smaller the file, but the more data that are thrown away, the greater the degradation of image quality.*

Fortunately, most digital cameras allow users to select just how much compression they want to apply to their image files. Less compression, and the image will look better; more compression, and its file size will be smaller. In those digital cameras that allow you to choose compression level, you'll find several different terms used for essentially the same concept. The following are just a few examples:

- Economy, Normal, Fine, Extra Fine

- Standard, Good, Better, Best

- Small, Medium, Large, Extra Large

Tip: Understand What Your Camera Is Saying

Unfortunately, camera manufacturers have never agreed to any standard for resolution and compression terms, which can lead to confusion. Some cameras put JPEG compression settings under a menu heading called "Quality," while other cameras put resolution and compression settings under the same heading. As we discussed in Chapter 2, resolution does not determine quality so much as it does the quantity of data. On the other hand, as Figure 5-1 demonstrates, compression level relates directly to image quality. If the options under "Quality" are listed in numbers, such as 1024 × 768 or 3MP, then it is a resolution setting.

Figure 5-1: The photo on the left is an original JPEG photo of an antique urn. But when it was opened and saved several times, using high JPEG compression settings, details became indistinct, with noticeable pixelization and blurring. This is a severe example of what can happen when too much compression is applied to a JPEG image. Most digital cameras will not compress JPEGs to such a great degree, and the visual effect of light compression may be imperceptible to most people.

One problem with JPEG compression is that it is cumulative. The initial capture in the camera throws away some data when it saves the picture as JPEG. Then, when you open the file in your photo-editing program and resave it as JPEG, it will rearrange and throw out a bit more data. Open and save it again, and you'll lose a tiny bit more image integrity. So, you'll want to be very conservative about the amount and frequency of compression you allow.

Our advice is to never overwrite your original file with edited versions. Instead, archive the original, and save edited versions under new names. Incidentally, when you archive JPEGs to a CD or DVD, they're permanent and will not change or degrade whenever you open them.

If image quality is paramount to you, you will want to do as most professional photographers do—avoid JPEG capture, because of the destructive, degrading nature of its compression. And if you do capture images in JPEG, save them as TIFFs when you download them to your computer.

Tip: When You Plan to Edit Your Photos on the Computer Rethink Using JPEG

Kevin Connor, Adobe's director of product management for Photoshop, recommends that you don't save your image in JPEG at all if you are going to edit it. That's because you'll keep saving it to protect your work, and every save in JPEG will destroy more pixels. He suggests that you use an uncompressed file format (TIFF) during your editing process; then when you have the final version, you can save it as JPEG. If the only file format your camera uses is JPEG, you can convert it to TIFF for the editing process.

WHY DOES FILE SIZE MATTER?

Since compression can hurt image quality, convention wisdom might persuade you to never save to a file format in which images are compressed. But never using compression can be a double-edged sword. At times, you might be willing to sacrifice image quality for the savings in time and convenience a smaller file offers.

Smaller image files have the following advantages:

- They take up less storage space on your digital camera. So, if you have only one memory card or limited memory cards, you'll be able to take more pictures when the files are smaller.

- They take less time to save on your camera. In other words, your shooting and processing speeds will be faster.

- Transmission and download/upload times will be quicker. That includes those for wireless or wired connections to computers, printers, and other devices, as well as emailed photos and uploads to Web sites.

Note: JPEG Compression Can Be Great

Just because JPEG compression is lossy doesn't mean that you should avoid it. Limited compression can be visually imperceptible in most situations, and the resulting smaller file is quite valuable in terms of saved time, easier sharing, and reduced storage needs.

BALANCING JPEG COMPRESSION WITH IMAGE QUALITY

The trick is to balance image quality and file size according to the scene, the subject, and what you plan to do with your photos. Here are some guidelines to help you make intelligent choices about compression settings:

- When you want the absolutely highest image quality, and your camera doesn't offer TIFF or RAW formats, shoot at the lowest (least) compression settings.

- When you simply need to document a visual fact or occurrence, and the small details aren't important, higher compression settings save you time and space.

- If the subject you are photographing has lots of little details that could be easily lost, use lower compression settings.

- If the scene consists primarily of large homogenous areas of solid color, higher compression settings won't impact image quality as much.

- If you plan to make large prints of your photos, choose lower compression settings.

- If your prints will be small, or if you will be displaying only small photos on a computer screen, use a medium to high compression setting, depending on how much detail you need to show.

- If you need to magnify or enlarge portions of your photo, use lower compression settings.

Tip: Experiment with Software to Learn about Camera Compression

In Chapter 15, you'll find an illustrated discussion of JPEG compression as it relates to optimizing your photos in software for email and Web display. Playing around with optimization controls in photo-editing software (such as Photoshop and Fireworks) can give you a greater understanding about using JPEG compression in your camera. That's because optimizing tools provide clear visual feedback on how different levels of compression affect details in your photos.

TIFF

Until recently, TIFF (Tagged Image File Format) had long been the preferred format of just about every digital-savvy professional photographer we know. It offered the highest quality (prior to the introduction of RAW formats), with no compression degradation. Also, TIFF is a universal file format, so it will automatically open in any imaging program. But TIFF also produces a very large and cumbersome file, and that in turn takes a long time to process and save within the camera. For instance, if a JPEG file takes 5 seconds to process and save, the same subject saved as a TIFF could take 30 to 35 seconds, or even more, depending upon the camera. In addition, unless you and the person to whom you are sending have *broadband* (fast Internet connections), TIFF files are way too large to routinely transmit via email or the Web.

As a rule, a TIFF file is roughly three times as large as the megapixel (MP) count of the camera. For instance, with a 5MP camera, the captured TIFF file will usually be at least 15MB. If you think about it, that makes a lot of sense. TIFF saves the full RGB image. In other words, in the preceding example, it will save 5MB of the red channel, another 5MB of green, and 5MB of blue. However, there is usually some overhead data (such as metadata—see the discussion later in the chapter), which can inflate the file size even further. (For more information on RGB, please go to Chapters 1 and 8.)

TIFFs used by digital cameras are *lossless* (as opposed to JPEG's lossy compression). However, in software, you will often have an option to compress TIFF files when you save them. Don't. The compression schemes used on TIFF are not only destructive, they can't be read by all programs.

Besides, the value of TIFF is it doesn't natively compress images, which is what assures higher image quality. Why mess with a good thing?

Bit Depth

Computers are actually very dumb machines. All they can recognize are two opposite states—on and off, or zeroes and ones. What makes them appear to be smart is that they can read, use, sort, alter, and output these *bits* of data so blindingly fast.

In digital photography, the number of colors that can be saved in a picture is measured by its *bit depth*—how many bits are devoted to each primary color (or *color channel*). The following table shows the number of colors available at various bit depths.

Bit Depth	Number of Colors
1	2
8	256
10	1,024
12	4,096
14	16,384
16	65,536

A grayscale image has 8 bits for the single color of black, which means it has 256 levels of gray from black to white. However, the typical digital color photo has three primary colors: red, green, and blue (RGB). And most digital photos (once they are saved and brought into the computer) have 8 bits of color (different hues or shades) associated with each of these three channels (which is what makes it a 24-bit image—3 primary channels x 8 bits each). To calculate the number of colors possible in the full-color RGB image, multiply the number of colors for each primary color. That translates into $256 \times 256 \times 256$ colors for the 24-bit RGB—or approximately 16.7 million possible colors.

The human eye is capable of distinguishing about 12 to 14 million colors, so 24-bit color is considered the minimum for photo-realistic images (also called continuous tone, because the eye can't perceive any changes in transitional gradations from one color or shade to another). Of course, just because you have the ability to capture millions of colors doesn't mean that's what you'll get. A typical photo may have about 5,000 different colors, but that's from an enormous palette of possibilities that adds up to millions or even billions.

What makes bit depth important isn't just the number of colors, but the gradual, seamless gradations between colors that are possible when you have more colors. Imagine a portrait photo. The face should appear to have soft transitions among the many shades of natural skin tones. Otherwise, you would see unnatural hard edges between colors, which would show up as banding (*posterization*) or lines. Color Figure 6 (in the color insert toward the back of the book) clearly demonstrates the difference between 24-bit color with its photo-realistic gradations and 8-bit color posterization.

Inside the digital camera (especially in more expensive professional models), photo data can actually be 16 bit, which adds up to 48-bit depth (billions of different possible colors) for an RGB image. You can't really use all that data for any useful output (print or screen), but Photoshop and a handful of other professional programs can open and edit such large files. Then, the photographer can choose

Bit Depth *(Continued)*

which bits to use and which ones to throw away to create the 24-bit image. That provides a great degree of aesthetic and technical control for those pros who understand how to use it.

RAW files save every bit of data captured, up to 48 bits, which is one of the great advantages of that file format.

Tip

For the highest image quality, use RAW.

RAW

RAW is a descriptive name rather than an acronym. It is the file format that many better digital cameras use to save the raw data that are captured by the image sensor. Now that many prosumer and all professional digital cameras feature a RAW save option, it is the professional's preferred file format, for highest image quality.

All digital images must be processed one way or another. Rather than processing the information to create a photo inside the camera, RAW postpones the processing step until later, when it is done in the computer. In other words, the camera does not apply any of its internal image- or color-processing algorithms when you take the picture. That saves a considerable amount of time while you are shooting, as well as cuts down on the size of the file (when compared to a TIFF). But it also means that you'll have to do the processing in your computer, which makes RAW much more time-consuming in the long run.

Tip: RAW Files Work Best on Powerful Computers

Processing RAW files requires lots of computing power, so the faster and more powerful your PC, the sooner you'll get the job done. This means selecting a computer with a fast CPU and lots of memory. If you are a serious shooter and RAW is your preferred file format, we suggest using Apple's Macintosh G5 with twin CPUs. Or, if you want to use a Windows machine, a 2.8GHz Pentium 4 box with at least 1GB of high-speed RAM is the minimum acceptable configuration. If you're a pro who eats, sleeps, and breathes RAW, then you're a prime candidate for a box powered by 64-bit (or even *twin* 64-bit) CPUs and several gigs of high-speed memory. However, most people can use typical, less expensive desktops for their digital photography.

Getting Your Photo from a RAW File

Unlike TIFF or JPEG, RAW files do not have a universal format. Each camera company has its own proprietary RAW, with unique names, file extensions, and software for opening, editing, and saving the files. For instance, Konica Minolta's RAW files are MRW, Nikon's are NEF, Canon's are CR2 and CRW

(Canon's older RAW), and so forth. But it isn't just the names that are different. The actual structure of the format varies from manufacturer to manufacturer. That means you can't even view the pictures you've shot in any of your imaging programs, unless you have the appropriate software.

All cameras that shoot in RAW ship with the necessary proprietary software. However, some companies (such as Nikon) ship what might best be described as RAW Lite, or, little more than a converter utility, viewer, and minimum editing tools. More robust, versatile versions are optional and at extra cost.

Until recently, shooting RAW meant that you couldn't open up your images on any computer that didn't have the right software for your specific camera. If you were on a trip or in someone else's studio and the PC at hand didn't have the right RAW utility installed, you were stuck, shooting blind, uncertain what pictures you had until after you processed them. This was just like the old days of film, when you couldn't inspect your shots until they came out of the darkroom. Luckily, the newest version of Photoshop now opens most RAW file formats. Better yet, Adobe has assured us that they are working on providing support for all RAW file formats as soon as possible. In addition, other software vendors are moving to support RAW. (See the sidebar entitled "Should I Use Photoshop's Camera RAW or the Camera Company's RAW Converter)?"

Regardless of which brand or model digital camera you are using, the RAW file conversion utility process (though not the steps) is remarkably similar. The software opens the file and inspects it to ascertain what settings you used to take the picture. That's the starting point only, because you then have lots of options to fine-tune color balance, tonality, exposure, and so on. (See Figures 5-2 and 5-3.)

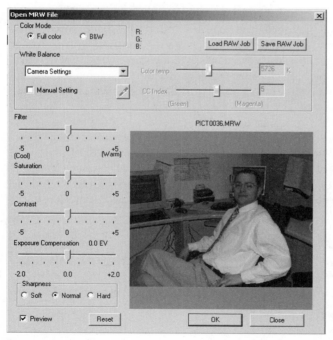

Figure 5-2: Until recently, simply opening a RAW file required proprietary software, such as this Konica Minolta DiMAGE Viewer, which we used to open and process this picture of Jeremy Kaplan (a *PC Magazine* editor), which was shot with a Konica Minolta DiMAGE A2.

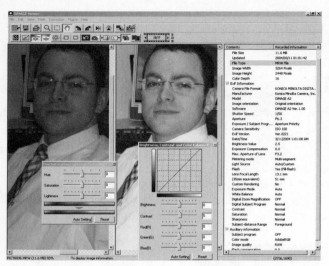

Figure 5-3: Once the RAW file is brought into the RAW processing interface, the photographer has extensive aesthetic and technical control over her photo. In this figure, notice the depth of information available in the metadata to the right, plus the floating boxes displaying two of the DiMAGE software's precision tools for color and exposure.

The problem is that RAW utilities are not created equal, and all require a commitment to master and time to use. When affordable desktop photo scanners were first introduced about 15 years ago, we experienced the same kind of chaos and difficulties with their software. Fortunately, the software improved, and the scanner industry eventually developed a standard interface, called TWAIN, that simplified and standardized the scanning process. Hopefully, RAW will follow the scanner experience. If so, the software needed to process and import any RAW file will be available as a universal Photoshop-compatible filter—which means it would work as a plug-in for any photo-editing software.

What is quite interesting about RAW is that almost all the settings you use in the digital camera simply "throw a switch" to alert the software how you will probably want the file processed once you bring it into your computer. What that means is if you choose to shoot the scene as black and white and save it in RAW, when you upload the photo to your computer, you can actually change your mind and decide, after the fact, that you want it to be a full-color picture. In other words, as long as the file is saved in RAW, all captured data will be saved. However, be sure to use the traditional camera *f*-stop and shutter speeds you want for *depth of field* and action shots (see Chapter 6) when shooting, because those are not really software switches and cannot be altered effectively in software.

Many of the tools used by conversion utilities look similar to those in photo-editing programs (such as Photoshop). But as we show in Figures 5-4 and 5-5, making the adjustments in the RAW utility yields far superior results to doing it later in the photo editor.

After you have finished editing the picture in the utility, you can (and should) output it into a more universal file format, such as TIFF or JPEG.

Tip: Always Save Your Original RAW File

Be sure to save your original RAW file, even after you have converted the image and saved it as a TIFF or JPEG. That way, you can always go back to your original full data photo and make different creative and

technical choices. It's like being sure to save your negative in case you decide you want new prints or enlargements.

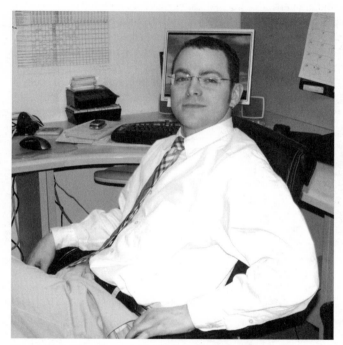

Figure 5-4: This photograph of Jeremy was taken in less than ideal lighting conditions, in his office at *PC Magazine*. Using a Konica Minolta DiMAGE A2, we shot it in RAW, converted it to TIFF using the Konica Minolta DiMAGE Viewer, and then edited it in Photoshop to correct the exposure and color problems inherent in shooting mixed flash and fluorescent lighting. Look at his abdomen. The white of his shirt is "blown-out" with no details. You can't even see the shirt pocket.

Should I Use Photoshop's Camera RAW or the Camera Company's RAW Converter?

The problem for Adobe (and other software companies) is that camera manufacturers don't publish their source code. Given the heightened competition among camera brands, that isn't surprising. But it means that to be able to import RAW files into Photoshop, Adobe had to "reverse engineer" the code for each and every digital camera RAW file format they wanted to support. This unenviable, painstaking job fell to Thomas Knoll, the original creator of Photoshop.

Since so much of the camera's inner workings are hidden, Thomas had to use Adobe technology and his own extensive knowledge of imaging science to create Photoshop's Camera RAW utility. He explained to us that this means that if you plan to bring a camera's RAW file into Photoshop through his utility, it is useless to bother with using any of the camera's exposure, tone, or color settings, because the only one the utility can interpret is white balance. All the rest of the data are ignored.

Should I Use Photoshop's Camera RAW or the Camera Company's RAW Converter? *(Continued)*

In other words, if you want to take advantage of a camera's own controls and the manufacturer's interpretation of them, you'll want to use the conversion utility that came with the camera.

Of course, using Photoshop isn't a second place option. Adobe has some of the best imaging scientists in the world, and their interpretation of color, tone, and all the other aspects of digital photography is no less than superb. But don't bother taking the camera off default (except with regard to *f*-stops and shutter speeds) when shooting RAW files that you'll be bringing into Photoshop via Adobe's Camera RAW conversion utility. Of course, if you use your digital camera's conversion software, you can still edit the image in Photoshop or any other photo-editing program, once it's been converted to TIFF or JPEG.

Figure 5-5: Using the same RAW file, we made the exposure and color corrections in the Konica Minolta RAW utility before converting it to TIFF. Notice the detail of his shirt pocket and of the creases throughout his white shirt. You can even see the individual stitches around his shirt pocket. This version of the same photo has far greater tonality and detail than the one that was edited after the file conversion (Figure 5-4).

Beyond Photoshop

SilverFast (www.silverfast.com), the folks who make the professional software for scanners that we have long reviewed and respected, now have SilverFast DCPro. It supports about 40 different RAW camera formats. Another RAW format import utility has been released by Bibble Labs. (www.bibble labs.com).

As RAW becomes more popular and pervasive, we expect to see an increasing number of third-party utilities. These work either as standalone programs or as *plug-ins* to photo-editing programs, and they all read RAW, provide some editing tools, and export your RAW photos to a more universal file format such as TIFF or JPEG.

However, not all programs read every camera's RAW, so be sure that the software you're considering purchasing supports your particular camera's format. And before you buy new software just for RAW compatibility, check your current photo-editing program's Web site for upgrades, because we expect that many of them will be adding RAW support, too.

RAW PROS AND CONS

The advantages of RAW almost all relate to image quality, editing flexibility, and personal control over how your photo will look. No wonder it's the choice for most professionals.

- RAW image data is original, untouched, first generation data.

- With RAW, your photos are not subject to cookie-cutter-type editing. Instead, you make all the decisions, using tools that have fine, detailed controls.

- RAW exposure and tone controls provide greater flexibility, because they are applied to a higher bit depth. The result is usually much greater detail in highlights and shadows, even in those photos that were shot in less than ideal situations.

- Regardless of what settings you use on your digital camera, all image data is saved in RAW. The camera settings (with the exception of *f*-stop and shutter speed) are simply a starting point that you can reverse without affecting image quality.

But shooting RAW does have its downside.

- Although RAW saves time when shooting, you pay for it in editing time when bringing the picture into your computer.

- All those image-processing choices that a camera makes automatically for the other formats are options that you have to deal with in software.

- Most programs and computers can't read RAW files. You'll need to convert the file (using proprietary or third-party software) to a more universally accepted format before being able to use, edit, output, or share the photo.

- RAW files can't be output using the new direct printers that can process and print photos from memory cards or from the camera without going through a computer. (See Chapter 20.)

- RAW files generally can't be read by kiosks or other retail services. (See Chapter 20.)

- If you use RAW for archiving your photos, you must keep the software (and maybe even the computer) for reading it, even if the software becomes out of date. Ten years from now, who knows if current programs or PCs will support your old RAW files.

Jay Kelbley, World Wide Product Marketing Manager for Professional Digital Cameras at Eastman Kodak, put the difference between RAW and JPEG into terms any traditional photographer would understand. "Having a RAW file is like printing from a film negative; you have all the dynamic range

and extended tone of the original, unprocessed data," he explained. "A JPEG is more like printing from a print; it's second generation data that's already been processed at least once before you get to use it."

RAW JPEG

As we mentioned, one of the problems with RAW file formats is that you need the right software or plug-in to read the image. Some digital cameras now offer a compound file format option to help in these situations. In addition to saving the photo as RAW, it can also create and save a smaller duplicate JPEG file. These JPEGs should be used only for previews and sorting in photo-editing software and image databases, and not for editing. (That's what the RAW is for.) If you need a full-sized JPEG file, either shoot it in that format (instead or in addition to the RAW capture) or convert the RAW file to JPEG and save it under a different name.

Tip: You Don't Have to Stick to a Single File Format

While we shoot mostly in RAW, at times we switch back and forth among RAW, JPEG, and TIFF. It all depends on what we're shooting and how it's going to be used. If we're on deadline and must send high-quality images directly to a client, we often shoot in TIFF. That way, we don't have to sit at the PC and go through time-consuming post-shooting converting and processing or hope that the client happens to have a RAW utility for reading that camera's proprietary format. On the other hand, if we're simply shooting fun stuff, or we know that it's destined for display on the Web and probably won't go out to print, we often save those snaps as JPEGs. All digital cameras with multiple file formats allow you to easily switch between or among file formats, even from shot to shot.

Reality Check: Choosing the Right File Format

Here are some guidelines to help you choose your file format.
Use JPEG:

- For almost all consumer and business photography projects
- For photos that will be emailed or uploaded to the Web
- For photos that will be output using direct connect printers or processed in kiosks (see Chapter 20)
- When time and storage space is more important than image quality

Use TIFF:

- When image quality is your greatest concern, but your camera doesn't offer RAW capture
- For the highest-quality photos that can be read by all computers, printers, and software

Use RAW:

- For the very-highest-quality photos

- If you have the expertise (or the sense of adventure) for using the complex software-editing tools required

- To save time in shooting, though your postponed editing will take even longer

Other Imaging File Formats

While digital cameras capture only JPEG, TIFF, and/or RAW, you will see numerous other file formats used for digital photos. The most common are divided into two camps: universal and proprietary.

- Universal file formats are those that can be read, used, edited, and output by just about all photo-editing programs and printers. These include BMP, GIF, PNG, and many others. However, for digital photography, the universal file formats you'll encounter most often are JPEG and TIFF.

- Proprietary file formats are those that are created by specific programs for the purpose of maintaining the editability of such features as layers, special effects, and so on. (See Chapter 18.) For example, Photoshop uses PSD, while Corel PhotoPaint uses CPT.

Other file formats exist on the periphery of imaging. For instance, HTML is a universal format for Web pages. Adobe Acrobat's proprietary PDF files are used to share documents you want to appear exactly the same on the recipient's computer screen as it does on your own. In fact, a number of digital cameras' user manuals are provided as PDF files, though printed manuals are far more convenient.

We cover more about these other imaging file formats in Chapters 14, 15, and 18.

Digital Camera Video and Audio File Formats

As we discuss in Chapter 10, many still digital cameras can also record video and audio. Therefore, you may encounter multimedia file formats in digital photography, such as WAV, AVI, MOV, MPEG, Motion JPEG, and QuickTime. Be sure you understand the nature of the file format you are using. For instance, a video format such as AVI is great for showing movies, but doesn't have the resolution for anything larger than baseball-card-sized prints. Also, individual movie frames rarely yield good still image quality.

Metadata: File Information That Can Make You a Better Photographer

Ever since the invention of film, photographers have kept notes about how certain pictures were taken: when, where, under what conditions, of what subject, using which film, and what camera settings. The value of such information has been proven time and again. In addition to providing good record keeping, it helped photographers develop greater control over the technology, as well as recreate similar conditions for future pictures with predictable, repeatable results.

In the digital age, we still use paper notebooks to write memos to ourselves about our shoots (though some photographers use voice recorders instead, and some digital cameras even allow you to add a few seconds of audio annotation to image frames). However, we don't need to write down quite as much information. That's because we now have metadata automatically recording many of the details for us.

Often called the "data about your data," *metadata* is information that digital cameras automatically create and attach to every picture file, providing you with information about when and how the image was captured, by what device, under what conditions, with which parameters, and so on. In addition, once a picture is uploaded to your computer and filed using an image database, you might add other metadata about where the photo is stored, what categories and keywords you assign to it to assist in searching for it, and other information. (See Chapter 21 regarding organizing and archiving your photos.)

Fortunately for users who don't want to be bothered by details, metadata is transparent and unobtrusive. You won't see it or have to deal with it, because it simply sits behind the scene in the image file, out of sight—that is, unless and until you want or need that information, and then it is quite easy to retrieve and display.

Learning from the EXIF Metadata of a Single Photograph

EXIF (Exchangeable Information File Format) is the most important metadata in digital photography because all major and most minor brands and models of digital cameras support it. As you can see in Figure 5-6, the amount of information saved with your photos can be considerable. For this specific photo, you can read the facts that we shot the Konica Minolta DiMAGE A2 (with firmware 1.00), in RAW (MRW) file format, which produced an 11.6MB file. Our exposure settings were 1/125 shutter speed and an aperture of ƒ5.6. The flash was set at fill (which we often use for portraits); contrast, saturation, and sharpness were at normal; and white balance and exposure mode were at auto. At a glance, we can view all the technical details of how this photo was shot and when it was "updated" or altered.

It should be apparent from the examples earlier in this chapter, that the original of this photo was underexposed and displayed a color shift typical of fluorescent lighting. We can study the EXIF metadata before going back to the *PC Magazine* offices for a reshoot to determine that we will want to take white balance and exposure off their auto settings. But the sharpness was just right, so we'll keep the aperture at ƒ5.6, while trying 1/60 and 1/30 shutter speeds. However, that means we'll also want a tripod, because, even with the Minolta DiMAGE A2's antishake technology (as discussed in Chapter 2), it's hard to take a steady hand-held shot at 1/30 of a second. (See Chapter 6 to learn more about exposure, ƒ-stops, and shutter speeds.) In addition, we will want to be sure to set the white balance either for fluorescent lighting or manual balance. (See Chapter 8 for information on how to use white balance.) The whole point is that EXIF data (and other metadata) are invaluable to helping you continue to learn and fine-tune photographic skills.

Similarly, printers, software, and other devices in the imaging chain can read the metadata in a file so that their own settings can be automatically correlated to those of the original capture device (the camera or scanner). Metadata helps avoid any "mistranslation" of the data that defines the image. In turn, it prevents the "whispering down the lane" type of distortion that used to be so frequent, especially when dealing with colors. (For information on color management and printing, please see Chapter 20.)

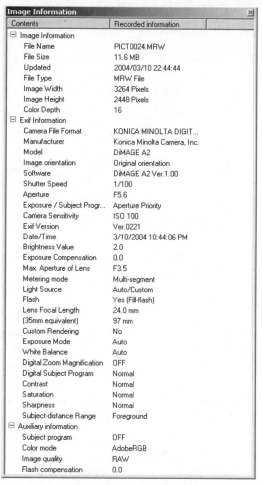

Figure 5-6: In this EXIF interface from the Konica Minolta DiMAGE Viewer, you can see the extensive metadata that was saved with our photo of Jeremy.

EXIF Isn't the Only Game in Town

EXIF is only one kind of metadata in a somewhat crowded field. As you can see in Figure 5-7, Photoshop supports several different metadata types, including Adobe's own XMP. The one most compelling reason that professional artists like XMP is that it can embed copyright and other rights management information into a photo file. But we haven't yet seen the general acceptance of XMP that Adobe originally anticipated.

Other metadata can be used in conjunction with GPSs (Global Positioning Systems) to record exactly where a photo was taken. Metadata can be so important that it is frequently used as admissible evidence by law enforcement agencies, insurance companies, and attorneys in a court of law.

(A) (B)

Figure 5-7: (A) Adobe Photoshop's File Info dialog displays quite a few other kinds of metadata in addition to EXIF. (B) Clicking on the plus signs to expand the display of the TIFF and some of the XMP metadata shows new kinds of information about the file that wasn't evident in the EXIF. Notice the copyright field within the XMP metadata at the bottom of the screen.

In an age in which information is power, metadata will continue to grow in importance. New applications using metadata will provide greater control over photos, as well as more linkages from photo databases to other kinds of applications.

Acronyms Galore

Throughout the digital imaging industry, committees (usually of representatives from various manufacturers) are formed on a regular and ad hoc basis. They discuss "standards," which they hope will smooth the rough spots in digital photography and software, making it easier for consumers to use (read "buy") their products and services. While many groups simply talk for years without ever coming to any consensus, let alone agreement, others have racked up important achievements, such as EXIF metadata and standardized digital camera formats.

Digital photography is only just coming of age, which means that the barrage of new acronyms is far from over. However, we do expect to see a significant growth in standards from new and existing committees, which will make it easier for the rest of us to pick up any digital camera and understand how to use it.

Summary

This chapter covered many issues concerning file formats. Some of the key points included the following:

- The file format you use for shooting and saving your photos will directly impact image quality, speed, convenience, and compatibility.

- JPEG is the one format used in all digital cameras, and it has become the most common photo and imaging format for all kinds of projects.

- TIFF is the highest-quality digital camera format that any computer, program, or printer can read without special software.

- RAW files offer the very highest image quality, combined with faster shooting speeds and smaller file sizes (compared to TIFF). They do this by postponing all processing until the file is uploaded to the computer.

- Metadata is information about your photo that is stored within the photo file. From it, you can learn a lot about the conditions, camera, and settings that were used to take a photo.

Chapter 6

Understanding Exposure

Light is the essence of both film and digital photography. When light strikes film or an image sensor, it creates a photograph. Too much light, and the picture is "blown out" (too bright), with no details that you can discern. (See Figure 6-1a.) Too little light, and it's so dark or muddy looking that you can't really see anything. (See Figure 6-1b.) The trick is to get just the right amount of light to the photosensitive element (the film or *image sensor*) to record the scene accurately. (See Figure 6-1c.) While it's possible to make extensive corrections in an image-editing program, the best way to ensure the highest-quality picture is to get the lighting right in the first place, when you take the picture (see Figure 6-1d). The measure of the amount of light being used to create a photo is called *exposure*.

In addition to making sure you have enough light for a picture, the nature of how the light comes into camera determines two other important aspects of your picture—the *depth of field*, or how much of the picture is in focus, and the *shutter speed*, or the ability to capture moving objects.

In this chapter, you will learn how to control exposure and how to make intelligent choices about the exposure settings that will affect the composition of your photos.

Tip: Do You Really Need to Read about *f*-stops and Shutter Speeds?

If your camera doesn't offer user-controllable *f*-stops and shutter speeds, you might want to skip the following section and move onto the last few pages of the chapter, starting with the section on exposure compensation. Just about every camera has exposure compensation, and it's a great tool to help you make sure you get the best possible photos even in difficult lighting conditions.

Working with Shutter Speeds and *f*-stops

Light enters the camera through the lens. The two mechanisms that control the exposure, or how much light passes through to the image sensor, are the *aperture* (or the size of the hole through which light can pass) and the *shutter* (which opens and closes the light path).

Figure 6-1a: We purposely overexposed this photo of Jamie Bsales, the First Looks editor at *PC Magazine*, to show you how the details are blown out when too much light reaches the image sensor.

Figure 6-1b: This photo of Jamie is underexposed, with so little light that you can barely see him or any other details.

Figure 6-1c: When the exposure is just right, allowing the correct amount of light to reach the image sensor, you'll end up with a pleasing and accurate photograph. (Entire series was taken with a Fujifilm FinePix S5000.)

Figure 6-1d: While Photoshop and other photo-editing programs can do some exposure correction, remember the basic computing rule of GIGO (garbage in, garbage out). In these close-ups of our portraits of Jamie, the one on the left is the underexposed Figure 6-1b, which we tried to fix in Photoshop. Notice the unappealing *noise* (multitude of dots) and lack of clarity when compared to the well-exposed Figure 6-1c. It's far more preferable to start with the best possible exposure rather than hope that you'll be able to fix it later in software.

- In both film and digital photography, aperture is measured in *f*-stops (*f* stands for factorable). The larger the aperture, the more light that will be allowed through, while a smaller aperture restricts or reduces the amount of light.

- The shorter the interval between the shutter opening then closing (the shutter speed), the less light will strike the image sensor. Conversely, a longer shutter speed will allow more light to register on the image sensor.

f-stops and Depth of Field

The amount of light and a photo's exposure aren't the only things that the aperture and shutter control. The size of the aperture determines just how much of your scene is sharply in focus, or its *depth of field*. In other words, you can have control over whether everything from near your lens to the far horizon is sharp as a tack or whether everything other than the photo's central object is softly or substantially blurred.

- The smaller the aperture, the greater the depth of field. (See Figure 6-2.)

- In a reverse logic that confuses matters, the smaller the aperture, the larger the *f*-stop number. Therefore, *f*16 represents a much smaller aperture than *f*2.0.

Figure 6-2: The purpose of this picture was to show Daniel within the context of our vacation in Oregon, so using a comparatively small aperture (*f*8) kept both Daniel and the scenic background sharply in focus. (Photographed with a Nikon Coolpix 5000.)

Your choice of *f*-stop can significantly affect the composition of your photos. One of the distinctions of professional and prosumer digital cameras is that their lenses can have a wider range of *f*-stops, giving the photographer more control over depth of field. (The most basic, entry-level cameras offer no user control over *f*-stops whatever.)

Here are some guidelines for using *f*-stops:

- When you want everything in your picture to be in sharp focus, such as when taking a beautiful landscape photo with a person or an interesting object in the foreground, use a smaller aperture. That means a larger number *f*-stop, such as *f*11, or as high as your camera will go (*f*16, *f*22, etc.). (See Figure 6-2.)

- When you want your photo to focus only on the person or object that is the subject of your composition, use a large aperture (small *f*-stop number), such as *f*3.5, or as low as your

camera will go (*f*2.8, *f*2, etc.). That will soften everything around your subject, making the background (and possible foreground in front of your subject) indistinct. (See Figure 6-3.)

Figure 6-3: In this portrait of Cuddles, our English springer spaniel, the background would have been distracting (and unattractive), so we set the aperture at *f*2.8. (Photographed with an Olympus E-1.)

Reality Check: How Much Difference Will *f*-stops Make to Your Camera?

There's a direct relationship between the size of your image sensor or the film you use and the size (or focal length) of the lens in front of your camera. You get more depth of field with a wide-angle lens, even when it's not stopped down (narrowing the aperture), because of its shorter focal length. On the other hand, depth of field becomes progressively more limited as your lens' focal length becomes greater, even when you use a small *f*-stop.

In a 35mm film camera, *wide angle* is defined as any lens with a focal length between 24mm and 35mm, a normal lens is 45–55mm lens, and telephoto is between 105mm and 150mm. (18mm–24mm is considered ultra-wide angle, below 18mm is usually a fisheye lens, and greater than 300mm is extreme telephoto.)

Digital camera image sensors are much smaller than film (see Chapter 1), so lens focal lengths also are correspondingly much smaller. A typical 4 megapixel consumer digital camera with a 3X zoom lens has as its wide angle focal length anywhere between 5mm and 6.5mm, its normal focal length is about 7mm–8.5mm, and telephoto focal length runs between 17.5mm and 21mm. (However, you may see your camera's focal lengths displayed or represented in terms of their 35mm equivalents.)

What this means is that your consumer digital camera will likely have great depth of field, no matter what its *f*-stop and focal length. That's why background softness is more limited, even in portrait mode, with the lens wide open (using a low number *f*-stop) in consumer cameras. Prosumer and professional digital cameras usually have physically larger image sensors and bigger lenses (though most are not

Reality Check: How Much Difference Will *f*-stops Make to Your Camera? *(Continued)*

as large as 35mm film lenses), so their focal lengths will be correspondingly longer, giving users a greater range of depth of field options. So, if you really want pro-quality portraits or soft, out-of-focus backgrounds, spend a bit extra and get a prosumer or professional model with a large image sensor and a longer focal length lens. (See Chapter 2 on types of cameras.)

Shutter Speeds

Shutter speed is usually measured in fractions of a second or, when you are dealing with long exposures, full seconds. When you choose your shutter speed, you are essentially making a decision about how action will be handled by the composition:

■ A fast shutter speed, such as 1/500 of a second or faster, will "stop" action. Picture a child running. The faster the shutter speed, the shorter slice of time that will be captured by your photo. The shorter the time captured, the smaller the portion of the child's run that will be caught on the photo. That, in effect, can actually catch him at the split moment when he kicks a ball. (See Figure 6-4.)

■ A slow shutter speed will blur the action. For instance, if you take a photo of a speeding car at a slow shutter speed, you will likely get only streaks of color across the frame. (See Figure 6-5.)

Figure 6-4: In this photo of a bird landing on the water, the photographer used a very fast shutter speed and captured the exact moment when its feet touched the water. (Photo courtesy of Corel Corporation and Hemera Stock.)

Figure 6-5: With the camera set at a rather slow shutter speed (about 1/15 second), we tracked Cuddles while he ran, trying to keep his face in approximately the same place in our lens though everything else (including the camera) moved. The result is a photo that conveys the feeling of speed. (Photo taken with a Nikon D70.)

Tip: How Pros Capture the Sense of Speed

If you want to convey a great deal of energy and speed, move the camera at the same rate as the moving object (called "tracking"). It will take some practice to get your timing just right, but the result can be a dynamic image of everything in the photo being a blur of motion with only portions of the central object (such as a car or a running athlete) clearly defined. (See Figure 6-5.) Better cameras will have rear and front curtain sync (see Chapter 9), which creates yet another type of dynamic motion in your photos.

Digital and Mechanical Shutters

Most consumer digital cameras actually have light reaching the image sensor at all times that the camera is turned on. That's why you can preview your scene in the LCD viewfinder. (See Chapter 10

Digital and Mechanical Shutters *(Continued)*

regarding video recording, to learn more about this phenomenon.) When you press the shutter button, the light is stopped in one of two ways, or a combination of the two:

- A mechanical shutter (like the ones in film cameras) closes, to stop the light, then opens briefly to take the picture at the selected speed, and then closes again. (All professional or prosumer and most consumer digital cameras have mechanical shutters.)

- Using digital programming, the image sensor's sensitivity to light is closed down, activated to take the picture for a predetermined fraction of a second, and then closed down. Such digital shutters are sometimes used in conjunction with a mechanical shutter. Only the least expensive digital cameras rely solely on a digital shutter.

SLOW AND STEADY

A slow shutter speed will blur motion. That includes any camera motion or movement. In other words, if you use a slow shutter speed, even the slightest movement or shake of your hand can blur your photo. Think your hands are rock steady? Think again. Just the natural act of breathing will cause your hand to move or shake enough. If your shutter speed is fast enough, the natural shaking of your hand won't significantly affect your picture. But at slower speeds, the slightest movement can cause your photo to look less than sharp and out of focus.

Here are some guidelines for handling your camera at slower shutter speeds:

- For the average person, any shutter speed slower than 1/60 of a second should be shot on a tripod. Some very experienced, rock steady photographers can get away with hand holding at 1/30 of a second, but for most of us, it is generally inadvisable.

- If you don't have a tripod handy, brace your camera on a table, gate, tree, wall, or other solid immovable surface. If you have nothing else available, brace it by locking your elbows against your chest and pressing the camera against your forehead.

- S-q-u-e-e-z-e, rather than press the shutter button. A light touch is far less likely to jolt the camera than a vigorous click. Most cameras have a two-step shutter (pressing halfway freezes exposure and focus settings), and the best way to take a shot is to depress the shutter halfway just before you are ready to shoot, and then lightly depress it the rest of the way to take a picture.

- To eliminate even the tiny bit of shaking that you can cause by squeezing the shutter button, use the self-timer on your camera. (See Figure 6-6.) Most cameras have a 10-second delay (good if you want to be part of the picture), but a number also feature a more useful 2-second delay.

Shutter Speeds and *f*-Stops: a Balancing Act

Shutter speeds and *f*-stops work together, like a seesaw, balancing each other out.

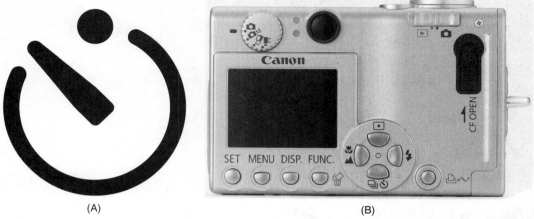

(A) (B)

Figure 6-6: The self-timer function of your camera is usually a button that you activate before pressing the shutter. (A) Unfortunately, where the button is situated varies with every camera model. On some, it isn't even a button but a tool that you access in the control panel of the camera. But it always has the same icon associated with it. (B) On the Canon PowerShot S500 Digital ELPH, the self-timer button is on the back, as pictured here.

Remember, our starting point in this discussion was the need to control how much light reaches the image sensor to make a perfectly exposed picture. Therefore, an adjustment in the aperture requires an equal and opposite change in the shutter speed if you want your exposure to remain the same.

To look at the same concept from the other direction, any of a variety of combinations of f-stop and shutter speed will give you the same exposure. Given a scene that can be photographed with a perfect exposure using f8 at 1/125 of a second, the same scene can have the same equivalent exposure at f11 at 1/60 of a second, or f5.6 at 1/250 of a second. Choosing the right combination is one of the ways that experienced photographers take artistic control over their pictures. (See Figure 6-7.)

See Table 6-1 for guidelines on balancing your f-stops and shutter speeds.

Table 6-1 Balancing Shutter Speeds and f-Stops

Effect	Need	Related Adjustment	Related Effect
Greater depth of field	Higher f-stop number	Slower shutter speed	Blurs action
Reduced depth of field	Lower f-stop number	Faster shutter speed	Stops action
Stop action	Faster shutter speed	Lower f-stop number	Reduces depth of field
Blur action	Slower shutter speed	Higher f-stop number	Increases depth of field

Remember, a higher f-stop number refers to a smaller aperture, while a lower f-stop number refers to a larger aperture.

In those scenes where there's lots of light, increasing your depth of field may not create an obvious blur of the action because the shutter speed may not need to be reduced too far—and vice versa.

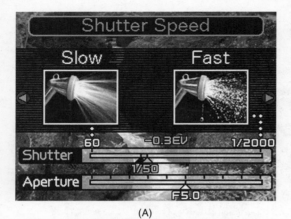

(A)

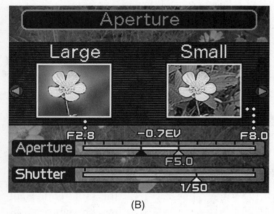

(B)

Figure 6-7: Casio's Exilim EX-P600's on-camera Manual Assist guides provide a nice visual representation of the reciprocal relationship between aperture and shutter speed. (A) Photographing something like flowing water using a slow shutter speed makes the stream of water appear solid. But using a fast shutter speed catches individual sprays and drops. (B) A large aperture (small *f*-stop) blurs everything but the central subject of your photo (the flower in this illustration). But narrowing the aperture (using a high number *f*-stop) increases the depth of field, bringing the background into sharp focus.

Low-Light Photography: Pushing at the Limits

Artists understand that real creativity can be found at the edge of the possible. Bright light and blue skies make for easy photography. But when the sky is dark and cloudy, or the day is just beginning and the sun is barely over the horizon, that's when you can stretch your vision and push at the limits of technology to create great photographs.

Lewis Kemper, the fine art nature photographer (www.LewisKemper.com), prefers to shoot in low light, especially when the shadows are long or the skies glowering. In such conditions, he has to use long exposures (slow shutter speeds) on a very steady tripod if he wants to maintain a good depth of

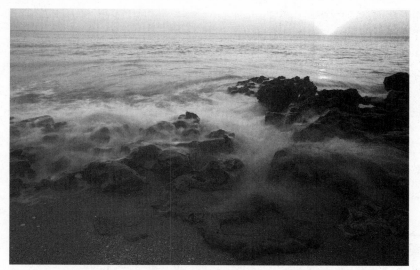

This ethereal photo of the surf at Coral Cove Park, Jupiter, Florida, was shot at a slow shutter speed of 5/8 second and aperture of *f*22 using a Canon EOS 1Ds with a 17-40mm lens. (Copyright Lewis Kemper)

field. As a result, his pictures often have an ethereal atmosphere, especially when water or fog is involved. (See the figure accompanying this sidebar.)

Incidentally, Lewis says that it is in such low-light conditions that digital photography can be truly superior. "With digital," he told us. "I'm getting more detail in shadow areas than I ever got in film."

Determining the Correct Exposure

When Daniel was in high school, one of his most precious possessions was a cigarette-pack-sized Weston III light meter. It was a very expensive professional photographer's tool for reading the light of a scene and determining the appropriate exposure—so expensive for a 15-year old kid that he bought it used. Daniel carried that Weston meter everywhere he went, whether or not he had a camera along with him. At every opportunity, in good weather or bad, sunrise or twilight, he would whip it out and take a reading of the light, training himself to recognize the correct combinations of *f*-stops and shutter speeds. Sounds sort of geeky for a kid, but he still retains the uncanny ability to look at a scene and know the correct exposure settings he'll need to take a perfect picture.

Sally prefers to simply use a light meter and concentrate on her composition. After all, that's what the devices are for.

Digital cameras have sophisticated and highly intelligent light meters built into them that make the Weston seem downright primitive. Turn on your camera, point the lens at your subject, press the shutter button halfway down, and the internal meter will read the scene and set (or suggest) the appropriate settings.

For most consumer digital cameras, all this is done automatically, especially if you are in the default point-and-shoot mode. However, prosumer and professional cameras have various metering options

that you can choose, depending on how even the lighting conditions are. Why bother, you ask? Because more accurate light readings can lead directly to better exposures and superior images that need little or no image-editing corrections.

The most common metering choices are:

- **Matrix metering**—Matrix reads several areas throughout the scene and averages their values. Many (but not all) digital cameras use matrix metering as their default setting. When the lighting in a scene is somewhat even, and when no specific area needs a greater attention than others, this is generally the best all-around mode.

- **Spot metering**—Spot takes its exposure reading from a small section in the middle of your frame, often marked in the viewfinder by a circle or square brackets. Use spot metering when you want to be sure that a certain small area of your picture is properly exposed, such as a portion of a face falling in shadow or backlit. (See Figures 6-8a and 6-8b.)

- **Center-weighted metering**—Center weighted reads the lighting conditions in the general area of the center of your frame, with input from the corners as well. A good compromise between matrix and spot, center weighted is the preferred mode for portraits and other compositions in which the main subject fills a significant portion of the frame.

In more advanced cameras, you can actually move around the center of the area you wish to meter, creating your own weighting of what portion of your photo you are most concerned about being properly exposed. If your camera has this capability, play around with it for a fun learning experience.

Figure 6-8a: Daylight streaming in behind the toy leopard skews the auto-exposure settings to the background, making the leopard too dark.

Figure 6-8b: By taking a spot meter reading on a shadow in the leopard's face, locking down the exposure, then composing and shooting, we get a better exposure. However, the best solution for this photo (so both the background and the leopard would be well exposed) would be to use a fill flash. (See Chapter 9.)

Tip: AE Stands for Auto-exposure

If you are searching high and low on your camera for the metering options, look for an icon or option that says AE. It's a common abbreviation with a heritage that dates back to film photography, and which is replaced in some digital cameras with full names. Similarly, AEL stands for auto-exposure lock, a button that you press to lock in your meter readings while you compose your picture.

Locking Down Good Exposure Readings

So, what happens when your dog is the subject of your picture, but he's positioned in the shadows or backlit and sitting on the right side of the frame? It's a typical problem. Of course, you want him to be fully exposed, so you can see all the nuances of his smiling eyes and soft fur. If you put the meter on matrix, he'll probably be too dark, because it's averaging the shadows where he is with the highlights elsewhere in the scene. If you put it on spot or center weighted, the meter will read the middle of the frame, not where your dog is playing.

The answer is simple. Just use the following technique for any off-center metering (or focusing) situation you will encounter:

1. Choose center weighted or spot meter, depending on how large an area you want to meter.

2. Move your camera so the center of the frame is directly over the area that you want to meter, such as your subject's face. (If your camera allows you to move the metering point in your viewfinder to areas other than the center of the frame, you can use that, too.)

3. Lock in the exposure by either pressing the shutter button down halfway and holding it there or holding the auto-exposure lock (AEL) button, if your camera has one.

4. While maintaining the exposure lock (in other words, don't release the shutter button or the AEL button), move your camera to compose your photo.

5. Press the shutter button all the way down to take the picture.

It sounds complicated, but it quickly becomes second nature. Just point the camera at the most important subject in the scene, lock down the exposure (which also locks down the focus, if you are using the shutter button lock), compose, and shoot. You'll find that adopting this one professional technique will improve your photography considerably.

Using Your Camera's Exposure Controls

Cameras have four modes for setting exposure, though many models do not offer all of them.

- *Auto mode* is the one option that every camera has (except some very high-end studio units). Just point your camera at your subject, lock the exposure and focus, compose, and shoot. Even pros occasionally use auto-exposure, usually with very satisfactory results.

- *Aperture priority mode* allows you to choose your f-stop, and your camera will automatically adjust the shutter speed to give you what it believes is the correct exposure. Use aperture priority when you want to control your depth of field.

- *Shutter priority* allows you to choose your shutter speed, and your camera will automatically adjust the f-stop accordingly. Use shutter priority when you want to control how the picture will handle movement or action (including the need to minimize hand shaking).

- *Manual exposure* hands total control over to the photographer. You set both the f-stop and shutter speed, though the camera will generally inform you if it thinks that you have set it for an under- or overexposed image.

Tip: Grow as a Photographer with Your Camera

While f-stops and shutter speeds might seem confusing at first, they are among the most important concepts behind good photography. If you want to learn how to take control over the creative possibilities of good exposure control, take your camera off auto and experiment. Shoot the same picture using different combinations of f-stops and shutter speeds, then, when you look at the photos on your computer, check out the metadata (see Chapter 5) to see what settings captured which photo. You'll be amazed how quickly you'll be comfortable and having fun with it all.

Finessing Exposure

Your camera's meter, like any artificial intelligence, can get it wrong. And your picture may end up too dark (underexposed) or too light (overexposed). Luckily, with digital photography, you'll know it right away, because you can review your just shot picture in the LCD viewfinder. (Okay, the LCD viewfinder isn't infallible either. But it's better than shooting completely blind, the way we used to with film.)

If you know or suspect that your photo is under- or overexposed, try using the following tools:

- Exposure compensation

- ISO equivalencies (gain)

- Bracketing or auto-bracketing

- Histogram

Tip: EV Is the Acronym for Exposure Compensation

Okay, it isn't really the right acronym, unless you realize that another name for exposure compensation is exposure value. So, if you can't find the exposure compensation options on your camera, look for a button or icon that has EV on it or the 🞉 symbol.

EXPOSURE COMPENSATION

All except the very cheapest digital cameras offer exposure compensation, even if you have a point-and-shoot model with no other features. Essentially, EV will open or close the aperture (the opening in the lens) to let in more light, or cut it down. Any time you suspect that the camera meter isn't reading the scene correctly, or you want to experiment with alternative exposures without changing ƒ-stops or shutter speeds, use various EV values.

Depending on your camera, exposure compensation will be implemented in a variety of ways, including the following:

- Hold down a button (which either says EV or has the 🞉 symbol on it) while turning a dial or pressing other buttons to increase or decrease the value.

- In the menu in the LCD viewfinder, select the exposure compensation option and use buttons to increase or decrease the value.

Exposure compensation is usually represented by a scale (see Figure 6-9) that goes from +2 (or +3) to −2 (or −3) and that is divided often in thirds. However, some cameras simply display the values without the scale.

Here are guidelines on using exposure compensation:

- If you want to increase the amount of light in your photo, use a positive EV.

- If you want to decrease the amount of light in your photo, use a negative EV.

Figure 6-9: In many cameras, exposure compensation is represented by a scale that goes from −2 (or −3) to +2 (or +3) in increments of 1/3 or 1/2 stops.

- We recommend trying several EV values in consecutive shots of the same scene. (See Figure 6-10.) For example, if you think your picture is only slightly overexposed (too bright), try shots at −1/3, −2/3, and −1.

ISO EQUIVALENCIES

ISO (which stands for International Organization for Standardization) is the designation of the scale used to rate film's sensitivity to light. To ease photographers' transition to digital photography, the industry decided to use the same numbers for rating *image sensors'* sensitivity to light and call them ISO equivalencies.

The lower the ISO value, the less sensitive the image sensor (or film) is to light. Therefore, in a low-light situation, you would need a greater ISO value. But, as we explained in Chapter 1, there's no free lunch. If you increase the ISO, you will increase *noise*—digital photography's equivalent to *grain*—and, in extreme situations, it will appear as though the picture is filled with artifacts that look like snow or dust on your pictures. (The left side of Figure 6-1d is a classic example of noise.)

ISO equivalencies vary from manufacturer to manufacturer and model to model. Some cameras may offer ISO equivalencies as low as 50 or 64, and for others the lowest settings are 100 or 200. Conversely, most cameras' highest sensitivity is 400, but other cameras feature ISO equivalencies of 800 to 3,200.When choosing your ISO equivalency, use the same guidelines that you would for film:

- When you have plenty of light, and you want very subtle, smooth gradations, use a low ISO number, such as 64.

- For low-light situations, and/or when doing photojournalism, sports photography, or shooting fidgety kids, use a higher ISO, such as 400 or above. But remember that the higher you go, the greater the amount of noise you'll be likely to encounter.

- For most situations, an ISO of 100 is usually a good compromise and is often the default value.

Unlike traditional ISOs, which were assigned to entire rolls of film, with a digital camera, you can change the ISO equivalencies frame by frame.

(A)

(B)

(C)

Figure 6-10: This series of photos shows how exposure compensation can affect a picture. (A) In this photo, we used an EV of −1, which made it darker than the others. (B) This picture was taken with no exposure compensation. (C) And this brighter photo was shot with an EV of +1. (Photos taken with a Nikon D70.)

Tip: ISO Equivalency Is Really Sensor Gain

For those who care about technical accuracy, there is no such thing as ISO for image sensors. Instead, what we're really dealing with is gain, which involves amplifying the electronic signal. In fact, some digital cameras use the term gain instead of ISO. If you want to know more about the technology behind sensor gain, read Sally's article on Image Sensors at `http://www.extremetech.com/article2/0,1558,15465,00.asp`.

BRACKETING

Technology is indeed a wondrous thing—as long as you don't depend on it too fully. The potential combination of human error and computer (camera) error proves Murphy's Law (*anything that can go wrong, will*) time and again. We don't say that to frighten you, but to convince you that when a photo is really important, don't depend on a single shot taken at exactly the recommended settings to capture that precious moment. Instead, take out a bit of traditional photography insurance and bracket.

Bracketing involves simply shooting a series of photos of the same person, place or scene, using slightly different settings. For instance, if the camera's meter says that the perfect exposure would be ƒ8 at 1/250 sec, also shoot it at ƒ5.6 at 1/250 as well as ƒ11 at 1/250. (Or keep the ƒ-stop fixed and vary the shutter speed.) In other words, bracketing is simply taking one step forward and one step back from the center setting to make sure you really do have the picture.

Many cameras now have *auto-bracketing*, which will automatically take a series of 3 or 5 photos at incremental settings. It's quite convenient and time-saving. What's more, in some of the more advanced digital cameras, you can auto-bracket not only exposure, but also white balance (see Chapter 8), flash (Chapter 9), and color (Chapter 8).

HISTOGRAM

While every other tool and command discussed in this chapter has it roots in traditional film cameras, most photographers discovered histograms in photo-editing software. A histogram is a graph that shows you exactly how well exposed a picture is (or will be). Think of it as a statistical analysis of how many pixels (points of data) represent shadows, highlights, and the midtones in between. (See Figures 6-11.) If your picture is underexposed, the histogram's graph will be too heavy in the shadows and likely entirely missing in the highlights. Similarly, if it is overexposed, the graph will tilt toward the highlights and be weak or nonexistent in the shadows.

While certainly not universal, more and more digital cameras now have histogram displays. Some cameras have it available only in playback mode, to help you read the exposure of photos you've already taken. Others have the option of showing it in the LCD viewfinder or eye-level electronic viewfinder while you are composing the picture. In either case, you can use the histogram information to help you determine if you need to adjust your exposure settings.

Program Modes

Most consumer and many prosumer digital cameras have what are called *program modes*—preset options that automatically choose the right exposure, ƒ-stop, and shutter speed, according to what you are photographing. While the names for these modes can vary widely, depending on the make and model camera, the following are common ones:

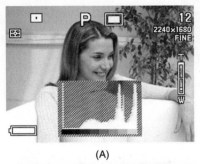

(A)

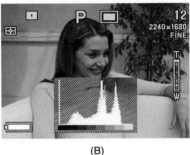

(B)

Figure 6-11: These screen captures from the Casio QV-4000's LCD viewfinder illustrate the direct relationship of the histogram to the photo's exposure. (A) In this overexposed photo, notice how the graph of the histogram is skewed to the right, over the white portion of the scale. (B) On the other hand, this better (though not perfectly exposed) photo has a graph that is better balanced between the dark grays on the left and the pale grays on the right of the histogram scale. A perfectly exposed photo (of a scene that has true whites and blacks) would have a graph that spreads across the entire scale of the histogram, from pure white through the various grays to pure black.

- *Portrait mode* creates the reduced depth of field effect, in which the subject is in sharp focus while everything in the background (and foreground) is in soft focus. (See Figure 6-3.)

- *Landscape mode* stops down the aperture to a high number *f*-stop, to bring everything into sharp focus, from foreground to background. (See Figure 6-2.)

- *Action mode* (or *sports mode*) sets your camera to a high shutter speed, to attempt to capture a fast moving subject clearly. (See Figure 6-4.)

Some program modes also use stored profiles to change the color settings (see Chapter 8), focusing modes (see Chapter 7), and other settings, trying to match the intended photo to some idealized concept of that type of photo. For example, portrait mode may optimize color for more appealing flesh tones, while landscape mode might push colors toward the blues to make the sky, greenery, and lakes more dramatic.

Some consumer digital cameras use program modes to help you learn better photography. For example, Casio's Best Shots are dozens of preset modes that cover a wide range of possible situations such as lake, night scene, flower with dark center, portrait of child playing outdoors, and so on with explanations of how they are set up. (See Figure 6-12).

Figure 6-12: Casio's Best Shot program mode not only automatically adjusts your camera's settings according to the type of scene you are shooting and the effect that you want, but it also provides an education about those settings. It offers suggestions, too, such as the "Keep the camera still!" warning, which is appropriate given that the Night mode uses a slow shutter speed. Of course, keeping the camera still is best done using a tripod or monopod.

Other cameras have specific "killer app" program modes—that is, unusual features that could be the single most important reason you would buy that camera. One case in point is Sony's Night Mode, which uses military-like night scope technology to illuminate and capture a scene, even when it's pitch black. The resulting picture is a sickly-looking green, but, hey, it's a picture that you would never get any other way.

Check out the various program modes your camera offers and even experiment with using them in ways that they were never intended. Not only will it be fun, but you also might learn some new creative tricks and techniques by breaking a few "rules."

Summary

The chapter covered many issues concerning understanding and controlling exposure. Some of the key points included the following:

- When the exposure is just right, allowing the correct amount of light to reach the image sensor, you'll end up with a pleasing and accurate photograph.

- The two mechanisms that control the exposure are the aperture (or the size of the hole through which light can pass) and the shutter (which opens and closes the light path).

- Cameras have four methods for setting exposure, though not all cameras offer them all: auto, aperture priority, shutter priority, and manual.

- You can finesse exposure using exposure compensation, ISO equivalencies, bracketing, and the histogram tool.

- Program modes are preset options that automatically choose the right exposure, f-stop, and shutter speed, according to what you are photographing. They may also adjust focus, white balance, and other settings.

Chapter 7

Focus

When Daniel studied photography at the Philadelphia College of Art (renamed The University of the Arts back in 1987), he learned more than he ever cared to know about such arcane topics as the circle of confusion, hyperfocus, focal length, *depth of field*, depth of focus, and blur. Consider yourself very fortunate that you have never had to memorize the long and complicated mathematical formulae associated with the previously mentioned terms, all of which relate to a camera's optics. Specifically, they affect how sharp your pictures will be.

While you don't have to know about these and other technical aspects of focus, we'll be covering how to produce sharp, crisp, clear images by using your digital camera's autofocus and manual focus controls properly and creatively.

What Is Focus . . . Really?

Focus is when the picture is sharp, crisp, and clear, when the details are highly visible and cleanly delineated. Like real life, picture focus may be selective rather than universal, meaning only parts of an image may be sharp (hopefully, the areas you care about). When done judiciously and deliberately, selective focus can be aesthetically effective, drawing your attention to the main subject.

Technically, focus in a digital image is when there is a sharp delineation of contrast or color between *pixels* along an edge. The fewer transitional pixels, such as gray pixels along an edge between areas of white and black, the sharper the image will be. In reality, the resolution of the image sensor and the resolving power of the lens mean that there always will be some transitional pixels. (See Figures 7-1a and 7-1b.) Actually, some cheap digital cameras will try to trick the eye into thinking their photos are sharp by outlining all objects in their pictures with a thin dark line. You can see it if you zoom in closely.

Figure 7-1a: In our DigitalBenchmarks Lab, one of the ways we quantify a digital camera's sharpness is to take photographs of black horizontal and vertical slanted figures against a white background.

How Focus Works

The reason why focus is an issue at all is because lenses are curved. They have to be, to be able to collect and direct the incoming light reflected from the subject onto the image sensor. Because of

Figure 7-1b: This figure shows a zoomed-in portion of the edge of Figure 7-1a. We zoom into the transition between the black and white to count the number of gray transitional pixels. Every camera has some gray transitional pixels. The fewer, the better the sharpness. (This Kodak EasyShare LS743 has a decent rating in this test.) This is just one of a number of tests we conduct on each camera before rating overall image quality and other aspects.

that curvature, and because you usually aren't photographing curved subjects whose contours exactly match those of the lens, some of that image may be sharp—in focus—and parts of the image won't. It all depends upon how curved and how thick the lens is, and how far it is from the subject and from the image sensor.

Most lenses change and control focus by physically moving the front element of the lens nearer or further from the other lens elements. (Elements are individual pieces of glass mounted together into a barrel or sleeve; collectively, all the elements make up the camera's lens.) Each element controls or compensates for such optical effects as reducing or eliminating distortion, or giving wider coverage or higher magnification. And of course, focus. The simplest lens has a single element, but more complex lenses, such as the zoom lenses on most digital cameras, may have 10 to15 different elements (see Figure 7-2). Each element performs a specific task, such as magnifying the subject or correcting the direction and angle of the light.

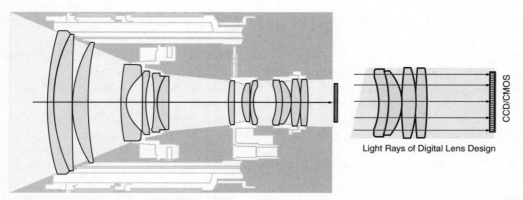

Light Rays of Digital Lens Design

Figure 7-2: A typical lens consists of several elements, each of which affects and directs the light in a different way. This Olympus lens was designed specifically for digital cameras to deliver the kind of light required by image sensors. (Courtesy of Olympus America.)

Hard, Soft, and Other Types of Focus

Photographers feel very strongly about focus and will use very emotive words to describe it.

■ *Hard focus* is increased contrast between areas of color. Sometimes, focus may be *too* hard, minimizing or even eliminating natural gradients and tonality so the photo looks like a

poster rather than a print (which is why it's often called *posterization*). It's an effect that should be used sparingly if you want a realistic, life-like photo. (See Figure 7-3.) However, it's exactly what you want if you are photographing text (like a printed page), machine parts, or any other items that require extreme, almost exaggerated detail.

Figure 7-3: On the left-hand side is a zoomed-in view of a photo of our manikin "Vanessa," which is well focused. On the right-hand side, is a magnification of another photo that is overly sharpened so that the gradations of color have broken down and posterized. While some cameras have a hard focus setting, none that we have tested will go as far as the photo on the right, which we have exaggerated in Photoshop. (Photos taken with an HP Photosmart 945.)

- *Soft focus* is just the opposite: it's where the edges are intentionally blurred for effect. (See Figure 7-4.) Soft focus is often preferable for those subjects we want to appear mysterious, ethereal, dreamy, such as portraits, misty scenes, shots meant to invoke nostalgia, and so on. Out-of-focus is when the edges and details of the part of the subject you are most interested in are not sharp, crisp, and clear, but soft and indeterminate. Soft focus is usually an effect you deliberately create, and out of focus is an unintentional optical error that detracts from the photograph.

- *Blur* occurs when either the subject or your camera moves during the exposure. When the main subject moves during the exposure, you may have a sharp, in-focus shot in the background, but the subject will be streaky, with somewhat indeterminate lines and details. Another effect is created when you move your camera so that it follows a moving object (called "tracking"), such as a car. Then, the background will be blurred, and parts of the main subject (the car, in this example) will be sharp (if the photo is done correctly). When used properly, blur is an interesting effect that can graphically impart motion and speed. (See Figure 7-5.) However, blur may be an unintended, undesirable effect from simply not holding the camera steady, or using too slow a shutter speed, which could result in having the part of the picture you care about may not be in focus.

Using Your Digital Camera's Focus Controls

Depending what digital camera you have, it might offer you several different focus options, or only autofocus. But even if the only choice you have is autofocus, you still can be the one in charge, rather than simply abrogate all photographic control to your camera.

A B

Figure 7-4: (A) This picture of Vanessa is well focused, with all details sharply defined. (B) However, some photographers (and their subjects) prefer a soft focus for portraits, preferring an idealized ethereal reflection of what we think we look like instead of true-to-life close-ups that tend to capture every facial wrinkle, blemish, pore, scar, and defect. In those cameras that have it, portrait mode usually consists of soft focus, with a slight overexposure and an out-of-focus foreground and background.

Figure 7-5: When photographing this fire dancer, we took advantage of the motion of the fire against the dark background to create a motion blur picture that is almost an abstract of light and action. (Shot with a Minolta DiMAGE A1.)

Autofocus

Most digital cameras come equipped with an autofocus zoom lens. Using autofocus is a relatively easy matter:

- Point the camera in the direction of the subject or scene that you want to photograph, making certain that the area that you want to be in focus is in the middle of your viewfinder. (It doesn't matter if you're looking through the *eye-level* or *LCD viewfinder*.)

- Press the shutter button down halfway and hold it in. The lens will automatically attempt to focus on what you see in the middle of the viewfinder. As long as you hold the button in halfway, the autofocus will remain locked on the same distance.

- With your finger still holding the shutter halfway down, compose your photo, which can include moving your camera so the main subject is no longer in the center of the frame. (See Figure 7-6.)

- To take the picture, slowly press the shutter button the rest of the way down.

- On some advanced cameras, you'll have a button marked AF-L, which stands for autofocus lock. It does the same thing as pressing the shutter button in halfway.

By the way, if you're using the self-timer follow the same procedure. The autofocus will lock when you depress the shutter button and will not change during the countdown.

Figure 7-6: We locked our focus onto the seashell by holding the shutter button in halfway, while pointing our lens directly at the shell. Then, while maintaining the focus lock by keeping the shutter button partially depressed, we composed the photo putting the shell into the lower third of the photo. Only when we were satisfied with the composition did we press the button down all the way to take the photo. (Shot with a Nikon D70.)

Tip: Locking Focus Also Locks Exposure

When you lock in focus on the subject you wish by pressing the shutter button, you are also locking in your exposure settings, if you're using auto-exposure. That way, the main subject of your picture is not only properly focused but also correctly exposed.

WHEN AUTOFOCUS FAILS

Any camera's autofocus mechanism, digital or film, can become confused and ineffective when there's not enough light or when the subject isn't contrasty enough. That's because it is looking for a line of demarcation, an area in which there's significant differences in color or contrast, to measure sharpness. Fog, soft lighting, shiny objects that reflect lots of light, a dark disco floor, even a brightly lit snow scene can fool autofocus. You'll immediately know when it's not working when the focus motor endlessly whirrs in and out, in and out, without freezing at the sharpest point. Also, many digital cameras have some sort of signal—a status light, a beep, or both—that informs you when the subject in the center of the viewfinder is in focus.

Should you encounter a shooting situation in which the autofocus won't lock in, here are some possible remedies:

- Switch your camera to manual focus. (See the "Manual Focus" section later in this chapter.)

- If your camera doesn't have manual capability, try focusing on a different, but nearby subject. Once focus lock is achieved, hold down the shutter button halfway (or press the AF-L button) and move the camera back to its original position so that your subject is framed correctly. Then press the shutter all the way down.

- If you can't get a focus lock on any object near to the subject, get a focus lock on another subject that may not be near your subject, but is approximately the same distance away. When focus lock is achieved, point the camera at your original subject. Then press the shutter button fully to take the shot.

- If you are photographing something shiny that is confusing the autofocus, try using a polarizing filter in front of the lens to change the angle of reflection.

- If you can't get focus lock, try setting your camera to a program mode that approximates the distance to your subject. For example, if you think you're about 8–10′ away, put it in portrait mode. If you're shooting something at a distance, select landscape mode.

- If it's very dark and your camera has an AF Assist lamp (see the "AF Assist" section later in this chapter), turn it on. Conversely, if there is a nearby lamp or other light source, move it close to your subject and use it to help you focus.

- If something in the foreground interferes with focusing, such as cage bars in a zoo when you're photographing an animal (your autofocus can't decide if your focus is on the animal or the bars), move closer to avoid the foreground object. In other words, shoot in between the bars.

- If all else fails, and it's possible, move yourself or your subject to brighter or more contrasty light.

Macros and Close-Ups

Taking close-up photos has its own challenges with regard to focusing. Here are a few tips on using macros easily and effectively:

■ Be aware of what your camera's normal focusing range is. By that we mean how close can it focus without going into the macro mode? Don't press the macro button until you're certain that you are too close for normal focus to work.

■ When you press the macro button or initiate the macro command in the menu, you will probably hear the autofocus motor move the lens out into position. Then press the shutter down halfway, until the subject you are shooting pops into sharp focus.

■ Invoking the macro mode will automatically turn on your LCD viewfinder or *electronic viewfinder* on many digital cameras. That's because the *optical viewfinder* is unreliable in macro because of something called parallax (where the closer that your lens gets to the subject, the more inaccurate your optical viewfinder becomes).

■ Be aware that if you're using flash, you might be too close for it to work effectively, and it might blow the picture out (badly overexpose it). If that's the case, you'll see it immediately in the LCD viewfinder, because the subject will look like a white blob. Turn your flash off and shoot again.

■ Because you're in the macro mode and shooting close up, any motion or movement will be exaggerated and result in blur or an out-of-focus condition. Hold your camera extra steady; better yet, use a minipod or tripod, or brace it against a table, chair, wall, or so forth.

By the way, the icon for macro is nearly universal—a small flower—which makes it relatively easy to find the button or menu option to activate it. When macro is turned on, you'll usually see the flower in the *control panel*.

Depth of Field and Focus

As we discussed in Chapter 6, depth of field refers to how much of your subject or scene is in sharp focus. It's important to understand what your depth of field is in a picture, so you can be sure to match your focus point correctly. For example, close-up or telephoto pictures have a more shallow depth of field than wide-angle photos. In other words, if you are using your zoom lens to photograph, for example, a bird in a tree, your depth of field will narrow down to a few inches in front and behind the bird. Everything else in the background and foreground of that photo will tend to be soft, and sometimes very blurred. Therefore, you'll need to be more precise with choosing your point of focus, centering it on the bird. Similarly, your depth of field will tend to become narrower the closer you focus, diminishing to miniscule in macro shots. (See the sidebar figure for an example.)

Recognizing the limits of depth of field, photographers will sometimes focus not on the primary subject, but on something between the foreground and background, in order to be certain that particular areas are well focused. Experiment with depth of field by taking photos of the same scenes at different telephoto and wide-angle settings, with your focus centers on various points. Then, look at the resulting pictures to see how much depth of field each provided. Once you understand the limits of your lens, you can turn them into creative opportunities.

Depth of Field and Focus *(Continued)*

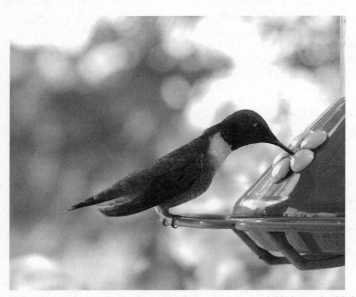

Using a zoom lens at its furthest telephoto, we captured this hummingbird at a feeder in our backyard. However, the depth of field was so limited that the bush just inches behind the feeder is quite blurred. That's why we had to be particularly careful to make sure that our focus was precisely on the bird. (Shot with a Nikon D70.)

Other Autofocus Modes

Better digital cameras often offer several autofocus options. They give users greater versatility, but also require more diligence in actual use. Here are some of the focusing modes your digital camera may feature, plus how and when to use them:

- **Spot autofocus**—Like spot metering, in which a very small portion in the center of the viewfinder is used to determine exposure of the entire frame, spot focus uses a tiny spot (smaller than the usual center area) to determine the autofocus point. Spot focus is especially useful when there is a very important small section of the subject (perhaps a piece of jewelry around a model's neck, or the silver hood ornament on a car) that you absolutely, positively need to have in sharp focus.

- **Predictive autofocus**—A handful of semi-pro and pro cameras allow you to select a predetermined focus point (such as the open gate on a fence or the finish line at a racetrack). When the subject reaches that point, the camera will automatically take a picture. Predictive autofocus takes a fair amount of practice to use properly and is best done with a tripod or monopod so you don't move while waiting for the subject to reach the predetermined point. However, predictive autofocus can be an extremely effective way to get dramatic, razor sharp action and sports shots like the pros.

- **Flex autofocus**—Also called area, or sometimes zone, autofocus, flex autofocus allows you to focus on areas other than the center of your frame. It displays a series of small boxes in various locations in the viewfinder. Then by using the four-way jog button, you select the square closest to the subject or section that you want to be in sharp focus. Zone autofocus is useful when you are using a tripod and in other situations in which you don't want to have to recompose the photo frequently as you check the focus of an off-center subject.

- **Continuous autofocus**—Also called tracking autofocus, it relieves you of the task of pressing the shutter down halfway every time you wish to refocus. In fact, the lens refocuses continuously—there is no focus lock. Continuous autofocus is especially useful when you are following—tracking—a moving subject, such as a football player, a running child, or a hyperactive pet. There are two small downsides to continuous autofocus that you should be aware of. One, because the lens motor is constantly in play, it will drain your batteries slightly faster than normal autofocus. And two, since you don't have to press the shutter button halfway to achieve focus, you may experience significant shutter lag when you fully depress the shutter button to take the picture.

Tip: Remember to Reset the Focus Mode Back to Normal

Once you select an alternative auto- or manual focus mode, your camera may retain that particular mode as its default setting, even after you turn it off. So, don't forget to change the setting back to normal autofocus when you're finished. If you forget to do so, you may discover that all your shots will continue to use that mode, whether or not you intended it to, and that in turn may cause you to take out-of-focus shots.

Fixed Focus and Zone Focus Lenses

Many inexpensive digital cameras, as well as some rather sophisticated underwater models, come equipped with what is called a *fixed focus lens*. As its name implies, the lens is fixed, or frozen, and cannot be focused. Actually, it doesn't *need* to be focused because the focal length (size of the lens) is very small and consequently its depth of field typically ranges from a foot or 20" to infinity. Most fixed focus lenses are also fixed focal length lenses, meaning that they aren't optical zooms. Incidentally, to soften the stigma that cheap fixed focus lenses imply, manufacturers sometimes tout its advantage by calling it, euphemistically, a focus-free lens.

Zone focus is one rung above fixed focus on the optics scale. You can't continuously focus the lens, but by pressing a lever or a slider, you can mechanically move the front element nearer or further to the rear element at a predetermined increment, thereby changing the focus plane. Typically, a zone focus lens will have three settings: macro, portrait, and landscape. Macro is for close-ups (12"–24"), normal is for typical near shots (2'–10'), and landscape for distance (10'–infinity). The only problem is that if you switch to another setting, the lens doesn't automatically return to the previous setting, so lots of photos can end up out of focus if you forget to move the lens to match the distance to the subject.

Program Focus

Program modes are presets coded into your camera by the manufacturer. Usually, they relate to specific types of photographs, such as portraits, landscapes, night scenes, and so on. They will set not only a focus range, but also exposure, white balance, ISO equivalency, and other controls, according to what the camera's designers feel are the best for the situation. Some cameras have dozens of presets, while others have only one or two, or none.

For example, you may have a portrait program mode. Typically, that mode will set the sharpness to soft, put the focus to 8–10′, and adjust the aperture to a low *f*-stop, for minimum depth of field. The fireworks mode will set the lens to infinity, and sports mode will put the focus at between 10′ and infinity.

Using a program mode doesn't mean that your autofocus will stop working. What the program mode does is preset the camera to what it thinks will be the optimum shooting conditions, including distance. But if the subject in the middle of your viewfinder is nearer or further away than the preset focus has been set to, the autofocus will automatically adjust to the correct distance when you press the shutter halfway. So don't be afraid to use a program mode because it might give you the wrong focus. It won't.

Manual Focus

Many digital cameras have an option called MF, or manual focus. It's especially useful when autofocus won't lock in on the subject you want to shoot, or when you wish to control depth of field by focusing the lens in between two areas or subjects. Some cameras activate manual focus via a menu and the four-way jog button or mode subdial, while others have a button or switch that toggles between autofocus and manual focus, and a focusing collar around the lens that you turn until the subject looks sharp.

Here are a few tips on using manual focus:

■ Check to see whether your camera has a distance scale. Many cameras allow you to set distance measurement in either feet or meters—use whichever you feel most comfortable with. The distance scale is useful when it's too dark or foggy to focus accurately by sight alone. It's also great for controlling depth of field, by focusing on two subjects, one after another, noting the distance to both subjects, and then setting the manual focus to a point in between the two.

■ Most digital cameras that are manually focused by rotating a collar around the lens utilize what is called focus-by-wire. It's a motor-assisted manual focus where turning the barrel one way gets you closer, and the other way, farther away. However, focus-by-wire doesn't have a beginning or end point, but turns continuously one way or the other. That's why there's no engraved distance scale on the collar. Once you get to the closest or farthest point, you can continue turning the collar but it won't do anything. So, if your camera has focus-by-wire, it's best to use a very light touch, and resist the temptation to keep turning the collar once the image looks sharp.

■ Some of the better digital cameras with manual focus and a high-resolution LCD viewfinder have the equivalent of a split image rangefinder/microprism in the viewfinder. That's a midsized square window that automatically appears in the middle of the viewfinder when

the manual focus mode is activated. In that window is a 2X or 4X magnification view of the subject, so you can see greater detail and focus accordingly. It's an extremely effective way to assess whether or not the subject is in sharp focus.

- Once you have taken your photo using the manual focus mode, remember to switch back to autofocus. Generally, autofocus is easier, faster, and more accurate than manually focusing the lens.

AF Assist

Some advanced amateur, prosumer, and semi-pro digital cameras provide a way to overcome auto-focus's limitations in low light by providing what is called an AF Assist. AF Assist is, literally, a light, lamp, or signal that illuminates when you press the shutter button halfway. The light may be ruby red (infrared) or white, or it may in fact be a laser beam (Sony cameras) or sonar echo (once used on early prosumer cameras, but now rare). Typically, the lamp is just bright enough to illuminate up to about 8–10′, which is enough to allow the autofocus to do its job.

AF Assist is a mixed blessing. It does work, doing exactly what it's designed to do—so long as you don't have the lens on telephoto and are trying to light up a subject further than 10 feet out. But it's also obvious and obtrusive. Subjects and bystanders can see the lamp on most models, which makes them aware that you're taking photographs. It can be annoying, because to use AF Assist properly, you may have to press that shutter halfway a number of times, framing your shots and lining up your subjects, before you actually take the picture. And when you do take the shot, the flash will fire. All this obvious preparation helps destroy candids, because your subjects are alerted and ready (or resigned) to being photographed.

The other problem with AF Assist is that it helps drain your batteries faster.

Should you use an AF Assist? Yes, if it's the only way you can get the photos you want. No, if you want to shoot natural candids and not stiffly posed pictures. Fortunately, there's always a menu option that allows you to turn off AF Assist, should you want to do without it. To give a boost to your autofocus mechanism, you might consider raising your *ISO equivalency*. It will certainly increase the level of *noise* in your photos, but at least they will be in focus. The other option is to use manual focus and the distance scale on your lens, if you camera has both.

Sharpen and Contrast Controls

Many digital cameras have an option in the menu called Sharpen. Typically, there are three settings—Soft, Normal, and Hard—although some models use a +/− slider (between −2 or +3 and −2 or −3) for numerically dialing the degree of sharpness desired. Normally, the Sharpen default is Normal, but if you want harder, darker edges, you can set it to Hard. Conversely, if you want softer, less defined edges, you would select Soft.

Some of the models that have the Sharpen option also feature a Contrast option. It's similar to Hard, but tends to boost the contrast—lighten the highlights and darken shadows and lines—of the entire image. It works the same way, either with numerical sliders or Lower, Normal, or Increase contrast. Since the human eye perceives increased contrast to be increased sharpness, you might be tempted to up the contrast in your pictures as a rule, but taken to extreme, contrast can reduce the amount of detail you capture in the highlights and shadows of your picture.

Sharpen and Contrast Controls *(Continued)*

Lucikly, the sharpness and contrast controls on all of the cameras we've tested tend to be very lightweight. In fact, many people can't really see much difference between photos taken with increased or decreased sharpness or contrast. But that doesn't mean they aren't affecting the very structure of your photos.

We never use either, preferring to capture and maintain the highest quality, true detail in our original photos. Then, we may alter copies of our originals either using the *RAW* format utility (see Chapter 5) or a *photo-editing program* like Photoshop (see Chapter 18). That doesn't mean you shouldn't go ahead and experiment with them and see how they affect your photos. You might like the effect.

Summary

Here is a summary of key points made in this chapter.

- Focus, out of focus, soft focus, hard focus, and blur all have their role in photography. The trick is to be able to predict and control what kind of effect you want your pictures to have.

- Understanding depth of field is important in understanding how to make certain that the areas and subjects in a picture you care about will be in sharp focus, even when they are at different distances from the lens.

- There are several different kinds of autofocus. Knowing what they are and how to use them can help you take better, more dramatic pictures.

- There will be occasions when autofocus won't work. That's when you can use manual mode or other tricks to get a sharp picture.

- AF Assist is a useful feature for helping your camera's autofocus to work in low-light situations, but it should be used judiciously.

Chapter 8

Using Your Camera's Color Controls

O ne of the great natural wonders is the human ability to see and interpret color. The eye and brain work together to reproduce what we see of the living world, even when viewing conditions aren't perfect. Consider a single red rose in a fluted silver vase on a corner table in a gloomy room. Though there isn't enough light, your brain processes the visual information so you actually perceive the full, bright beauty of that red blossom.

Digital cameras are not that smart. They photograph exactly what they see. In the case of the rose in the dark room, the camera would probably capture something close to black, with varying levels of maroon. Just how much black or dark red is captured will depend upon that particular digital camera's ability to distinguish details in shadows. To make up for their lack of human intelligence, digital cameras have complex internal programming (*algorithms*), plus a variety of powerful interactive tools and features, to fine-tune the way they capture color.

In this chapter, you'll learn how to distinguish the color and quality of light and how to use your digital camera to capture the best and most pleasing colors. For further information about *color management*—getting the colors you expect when you show or print your photos—please turn to Chapter 20.

Cross-Reference

The colors you see may not be the colors you'll get. Unless your computer screen is properly calibrated (adjusted for color accuracy), you can't trust the colors you see on your monitor. Read Chapter 20 to learn more about color management and controlling how your pictures are viewed and printed.

The Different Colors of Light

Every light source has a different effect on photographic color. Even the impact of daylight on a scene changes, depending on the time of day, the weather, the season, and other factors.

To illustrate this point, picture snow. What color is it? And, no, we're not talking about soot-laden drifts in a traffic-snarled city, but a pristine snowy landscape far out in the country where the only traffic is picturesque horse-drawn sleighs and noisy snowmobiles. If you say that snow is white, you

are only partially correct. On a bright, sunny day, at about noon, the snow can be blindingly white, though if an experienced color expert looked closely, she might sometimes discern a slight yellow hue. Snow is often pinkish at sunrise or sunset, but depending on the sky, the pink might have an orange or mauve cast. When dark storm clouds hover, the snow may have a shadowy blue or gray hue. Our brain automatically adjusts for these variations, so that we recognize the white of snow, even in the most extreme lighting conditions. But a camera (film or digital) will capture these environmental variations, and in the process, might disappoint us. That's because the photo isn't exactly what we remembered or expected to see.

The color shift caused by artificial lighting can be even more dramatic. Have you ever taken a photograph at a business meeting where there was lots of light, but the image came out muddy, with a dark greenish-yellow cast that made everyone look rather sickly? That's the result of shooting under the ordinary fluorescent lights that illuminate most offices. (See Color Figure 7 in insert at the back of the book.) Standard light bulbs (which illuminate using incandescent tungsten filaments) add their own unnatural bluish hues. (See Color Figure 8 in the back of the book.) And so it goes, with just about every kind of light bulb. Whether you are shooting under tungsten, fluorescent, halogen, daylight, or any other kind of light (including bonfires and candles), each affects the color of your photography differently. If you have a strong light shining on a painted wall, that too will reflect another color (that of your wall) onto the subject of your picture. Add to this problem the fact that in many situations you will have mixed lighting. For instance, you might have midafternoon daylight streaming in through a window, fluorescent bulbs in the ceiling fixture, a halogen on a desk, various incandescent tungsten lamps around the room—all being reflected across a bright yellow wall.

What makes all these color shifts so important is that they affect the essence of your photographs, especially those "memory colors" that define for most of us just how good a photo is. After all, what use is a portrait if the skin tone isn't appealing? A baby simply must have rosy cheeks, just as an executive can't appear sallow. We also expect the green of grass or the blue of a clear sky to fit within certain parameters. If they don't, the entire picture feels somehow wrong. Artificial. Awful. And if you've paid to have a business logo designed, you certainly want it to be reproduced correctly. Does the Coca-Cola insignia have the same impact on your memory without that specific red that everyone automatically recognizes as representing the dark American bubbly?

Tip: Sunlight Therapy—It's Great for Photography, Too

In the deep of winter, particularly in northern climes, news commentators often rehash the story of daylight deprivation. The shorter the days, the less sunlight we get, which some studies have shown to lead to depression and reduced productivity. The answer, they say, is sunlight therapy—sitting and working under full-spectrum daylight-balanced light bulbs.

We use the same daylight therapy bulbs (which are relatively inexpensive and readily available at hardware superstores such as Lowe's or The Home Depot) throughout our studio. It not only has the added benefit of possibly lightening our moods, it also creates an *ambient light* that is as neutral as possible. And they do provide a better environment for viewing both printed and onscreen pictures.

The daylight fluorescent bulbs we use in our overhead fixtures aren't precisely 5,000 degrees Kelvin (see sidebar on color temperatures). Nor are they perfectly color balanced. So, of course, we make sure that our primary light sources for our photos either overpower them, or that the overheads are turned off while shooting. But at least they don't add extra colors into the mix.

What Is White Balance and How Does It Work?

The problems photographers have with how the different colors of light affect their pictures have been with us ever since color photography was invented in the late nineteenth century. In traditional film photography, colored gels would be placed in front of lights, or filters would be put on or behind the camera lens, to try to bring all the various light sources into balance with each other. It was meticulous work, during which the photographer would take frequent *meter* readings to determine the precise *color temperature* of the light. Once proper color balance was attained, she could then push it toward one end of the spectrum or the other, as an artistic choice, such as giving a portrait a warm (rosy) glow.

One vexing problem was color consistency. Because color dyes used in film (for that matter, color dyes used in virtually every other material) are inherently unstable and virtually impossible to manufacture so that every production run will be exactly like the one before or after it, photographers never could depend on film to always react to light—and therefore reproduce color—in exactly the same way every time. This was true even when we bought only certain brands, speeds, and types of film. Like most other professional photographers, we bought our film in bulk quantities and stored what we didn't use immediately in the freezer, thus ensuring that each roll we shot was manufactured at the same time, using the same dye lots. When we finally ran out and had to buy more film, it was inevitably from another *emulsion* lot. This meant that we had to retest it, measuring color temperature and adding gels or filters, until we found the new batch's proper color balance. Precision color has never been for the faint of heart or shortcut takers.

The *white balance* tools of digital cameras (and their cousins, camcorders and digital camcorders) take much of the time and effort out of this painstaking process. To attain proper white balance, a digital camera analyzes a scene and attempts to determine what areas should be truly white. The operating theory is that if there is, for instance, a 5 percent green shift in the white areas, the rest of the picture probably has too much green in the same percentages. So, subtracting 5 percent of green from the entire picture would (so the logic goes) remove any color shift.

Understanding Color Temperature

While professional photographers will speak about the coolness (blueness) or warmth (reddishness) of light, they must be more precise when they are setting up a professional photo shoot. That's when they take out their color temperature meter or colorimeter and measure the temperature of light falling on their subject. Color temperature is measured in degrees Kelvin (K).

In the mid-nineteenth century, Lord Kelvin sought to establish a temperature scale that would have no negative values. Therefore, the Kelvin scale begins at absolute zero, below which molecular energy ceases. But what are important to photographers are Lord Kelvin's experiments with heating a carbon rod to such high temperatures that it changed colors, becoming red hot and then blue. It is this correlation of color to temperature that is the basis of the photographer's color temperature meter.

5,000°K to 5,500°K is generally considered to be daylight. However, as we mentioned earlier in the chapter, daylight fluctuates. So, 5,000°K to 5,500°K is an idealized value of daylight at midday in June in the temperate zone of the northern hemisphere, rather than a true, constant value. Real daylight (which is a combination of sunlight and ambient skylight) can measure anywhere from about 2,000°K to

Understanding Color Temperature *(Continued)*

30,000°K depending on the time of day, the month of the year, latitude, altitude, and atmospheric conditions. For instance, sunrise (or sunset) can be 2,000°K. One hour later it might go up to about 3,500°K. Noontime summer skies in Washington, D.C., average about 5,400°K. (Source: Kodak.com)

Similarly, unless your lights are rated and guaranteed for a specific color temperature, their values will vary. So, all we can talk about are average color temperatures in typical lighting situations. Incandescent tungsten light bulbs are generally about 2,600°K to 3,200°K (depending on the wattage), and typical inexpensive office fluorescents are about 4,000°K. Candlelight, incidentally, is about 1,800°K.

To make things even more complicated, light bulbs can age, and their color temperatures usually decline as they get older. In addition, electrical current fluctuates and can influence how hot or cool a light bulb burns. So, a 3,200°K tungsten bulb might dip periodically to 2,800°K or peak as high as 3,400°K, and it can change second by second. That's why photographers use line stabilizers and power conditioners to keep the voltage constant, so color temperature won't vary during their shoot.

In DigitalBenchmarks Lab, we use special (and very expensive) full spread spectrum nonflicker 5,000°K Kaiser fluorescent lights on line stabilizers and power conditioners for our simulated daylight setups. Even so, we measure their color temperature before, during, and after all test shoots. If the color temperature is slightly outside our normal parameters, we usually wait for the bulbs to warm up some more. If the variation still persists, we replace the bulbs.

Choosing When and How to Use Your Camera's White Balance Settings

In the early days of digital photography (way back in the early 1990s), we could easily recognize which digital camera had taken which photo by its signature color—frequently a color cast consisting of some shade of blue. Thank goodness Photoshop had already been invented. We'd bring the pictures into that *imaging program* and, before doing anything else, remove the color shift. Then, we could edit the photos and use them.

Digital cameras have come a long way since then. Just about all the major models and many of the minor ones do a good to excellent job with white balance. While in most cases, the average user will be quite happy with the pictures she gets with her camera's default white balance settings, understanding and trying the various white balance options can lead to even better pictures, especially in difficult lighting situations.

Tip: Don't Wait to Get Your Color Balance Correct

Photoshop, Corel PhotoPaint, Microsoft Digital Image, and the many other *photo-editing programs* are technological marvels and great tools for unleashing your creativity. (See Chapter 18.) And, yes, they have powerful, easy-to-use tools for removing color shifts from your pictures. However, we highly recommend shooting your photos with the right white balance rather than depending on correcting them in the computer.

First of all, correcting color in software is very time-consuming and often nearly impossible to get exactly right, whereas it can be quite easy to get it on the mark in the camera simply by changing a single setting.

Second, while the color balance tools in the software may seem similar to those in the camera, there's a world of difference between them. In the camera, you set the parameters before you take the picture, defining

how the image data will be created. On the other hand, photo-editing software can actually destroy data in the process of redefining the colors. We have seen software edits create severe blurring or *noise* (unwanted points of color or artifacts that don't belong in the picture), especially in extreme cases in which the color and/or exposure require a great deal of correction.

To put it in terms our grandmothers would understand, it's always better to do things right the first time than to try to fix them later. Or, put in computer terms, garbage in/garbage out. The one exception is if you are shooting in an environment that the camera's white balance controls can't handle. This is when the software tools may offer more precise fine-tuning. Then, you should try to get it as close to right as you can in the camera and tweak the photo in software.

Changing Your White Balance Settings

Most digital cameras have their white balance options in their menus, which you access on the *LCD viewfinder*. (Please see Chapter 3 about how to navigate through menus and choose options.)

On other cameras, the controls will be found by pressing a button (usually marked WB) and turning a dial. As you turn the dial, different white balance values, icons or numbers, will be displayed, either on the LCD viewfinder or in the *control panel*. When the option you want appears, release the button and the dial.

Whatever white balance setting you choose will usually remain in effect until you turn off the camera. At that point, some cameras will automatically reset to the automatic white balance mode, while other models will retain and use your settings until you change them again.

Unfortunately, no standardized icons exist for the various options (see Figure 8-1). While it's easy enough to recognize a cartoonish light bulb for tungsten or a sun for sunny, other icons may be quite cryptic. The better menus will actually spell it out in English, which makes things much easier. However your camera designates the various white balance settings, it's worth learning them, because, once you start to use them, you'll gain lots of control over the quality and color of your photos. And, hopefully, it will eventually become second nature, because it would be a shame for you to lose out on capturing some of the subtler and more dramatic hues and shades that are made possible by taking the camera off auto white balance.

Tip: Fill Flash for Just the Right Illumination

Before getting into more complex issues, such as changing white balance or exposure settings (exposure is covered in Chapter 6), try shooting the photograph with the fill flash enabled. (See Chapter 9.) Your camera's flash is perfectly color balanced to the device's internal programming. So, adding that light source into your scene may be all you need to get the correct white balance, especially when shooting human subjects. However, be aware that any on-camera flash will have a limited range, which varies with each model and zoom lens setting, but is usually no further than about 6–12′.

Auto White Balance

All digital cameras have some form of auto white balance. The simpler models will apply it automatically for every picture taken, without any user-selectable options. In most models, however, you have the

option of setting white balance to auto or choosing one of the presets. Many models also give you the option of doing a manual white balance.

As a rule, you can trust the auto setting in most situations—but not all. Remember, a camera determines how to set white balance by analyzing a scene and deciding what area should be white, then subtracting any colors found in that area from the entire picture. But what if there is no white in the scene? Then, the camera's "brain" could erroneously decide that something that is really supposed to be, say light pink, should be white. It would remove that amount of red from all the colors in the picture, and your beautiful sunset landscape would look like it was shot at midday. Of course, many digital cameras have become so sophisticated that they now can recognize typical photographic scenes, such as a sunset, and apply the appropriate settings, which in this case would mean to *not* apply white balance. But, what if your particular picture is not typical, but quite artistic, or the camera gets it wrong about what you intended? That's when you'll want to turn off auto white balance. If you're uncertain, you can always take one shot with it on and one with it off.

By the way, we have noted one interesting trend regarding white balance. Some of the more expensive digital cameras, which feature lots of presets and user-definable settings, often do not perform as well with auto white balance as some of the cheaper models. We assume that's because the manufacturers of those particular prosumer, semi-pro, or professional cameras expect their users will want to take control over color rather than depend on any automatic setting.

Figure 8-1: While no universal standard exists for white balance icons, these (from the Nikon D70) are similar to many you'll find. (A) WB is commonly used to identify buttons and other controls for white balance. (B) A is usually an indicator for any automatic feature. In this case, it refers to auto white balance. (C) You'll often find a light bulb icon such as this one representing typical indoor tungsten lighting. (D) Fluorescent white balance is often represented by a symbol like this, which is supposed to look like a long fluorescent tube. (E) A cartoonish shining sun is an almost universal symbol for daylight white balance. (F) This cloud really looks like what it is supposed to be; some cloudy white balance icons are rather difficult to distinguish. (G) The icons for shade are quite varied and can require guesswork to recognize. By the way, shade is an ephemeral white balance value that depends on many environmental and weather factors. (Icons courtesy of Nikon.)

White Balance Presets

Most digital cameras have preprogrammed settings for specific lighting situations. At the very least, you'll probably have three options (in addition to auto): sunny, fluorescent, and tungsten. (Tungsten is the standard type of household incandescent bulb that we're all used to screwing into our lamps.) Other

options may include cloudy, shade, sunrise/sunset, and sometimes more than one type of fluorescent. (See Color Figure 9 in the insert at the back of the book for an example of a fluorescent preset white balance that worked well.)

However, it is important to remember that none of these settings are definitive. The color temperatures of all natural and artificial light are always within a range, and that range can be quite wide. But each of the camera's white balance presets will be assigned a specific temperature. Will the particular value set by the camera match the scene's lighting? Not precisely, except as a lucky accident. But it will be close enough in most cases, and often better than auto white balance. How can you know if the preset is right for your scene? Try it and check out the results on your LCD viewfinder in the playback mode. When you want to be sure, shoot several frames each with a different preset.

Tip: Fun with White Balance

If you're the kind of person who always colored outside the lines in kindergarten, here's something to try, just for the fun of it. Shoot various scenes using the wrong white balance. In the process of learning more about this important concept, you may end up with some interesting, even artistic effects.

Manual White Balance

Professionals and many advanced amateurs don't like letting any computer or camera tell them how to compose and shoot a photograph. For them, the only option is to take control and make their own decisions whenever possible. We agree. Cameras (and computers) are dumb machines, and nothing more. Only a human being can create a work of art. When we have the time to experiment and stretch our creative muscles, we enjoy taking advantage of whatever manual features work for our composition.

Setting manual white balance in those cameras that offer it is remarkably easy. You'll need a white piece of paper or cardboard. (We often use standard photocopy paper, though we make sure it isn't recycled off-white.) Place it in the middle of the scene, with all lights that will be used in the photo turned on. Zoom in on the paper, so it almost fills the frame. Then, select Manual from the white balance menu and, when prompted, take a picture of the white paper. This establishes for the camera exactly what white should look like under the current lighting conditions, and it will adjust its white balance accordingly.

Manual is the one almost infallible white balance tool, because there's no guesswork in it. As long as the camera performs correctly, and the lighting remains the same from the time you set the manual white balance and take the picture, you will end up with excellent results. If you don't, then check to make sure that the white sheet or cardboard is truly white and not off-white and that the lighting remained consistent.

Selecting Specific Color Temperatures

A small number of digital camera models have a white balance option that allows you to choose specific color temperatures. To use it correctly, you'll need a *color temperature meter*, like the Minolta Color Meter II we use in our studio. Measure the scene's lighting with your color temperature meter, and dial in the corresponding, correct figure on the camera.

If you don't have a meter, you can guess and try out different settings. For instance, if you are shooting in an office that is lit primarily with fluorescents, and the camera's fluorescent preset doesn't quite work as well as you hoped, you can take a series of photos with the white balance set between 3,000°K and 4,500°K, until you find just the setting that works for the scene.

Tip: When You're Not Sure What Setting to Use—White Balance Bracketing

When a camera offers *auto-bracketing*, it is usually only for exposure. But a handful of cameras, like the Nikon Coolpix 8700, also offer white balance bracketing capability. When this feature is enabled, pressing the shutter button fires off a series of shots, each with a slightly different white balance setting. For instance, if white balance is set at 5,000°K, bracketing might take photos at 5,000°K, 4,500°K, 5,500°K, 4,000°K and 6,000°K. The number of shots and the degree of each step up or down is sometimes user-definable.

If your camera doesn't have white balance bracketing, you can do it yourself. Simply take a series of pictures, each with a slightly different white balance value.

With white balance bracketing, you'll be more assured of getting one photo that has just the right color balance.

Reality Check: Do You Need White Balance or Simply Better Exposure Settings?

Consider a photo in which the whites are dull, with a slight tinge of blue, and the rest of the picture is dark, with little or no details in the shadows. This can be caused by incorrect white balance or poor exposure, or a combination of the two. Here are a few guidelines to help you decide how to handle the settings for successfully reshooting such a photo.

- If all the colors (including the areas that are supposed to be white) are off the mark, with approximately the same amount and hue of color shift, it is definitely a white balance issue.

- If some of the colors are really good but others inaccurate, it is unlikely that white balance is the heart of the problem. You probably need to consider adding more illumination, such as the camera's own flash. (See Chapter 9.)

- If all areas of the photo are dull and dark, you might want to change the exposure settings, to lighten up the entire picture. (See Chapter 6.)

Of course, it is quite possible that such a photo may need white balance, flash, *and* exposure adjustments. When you aren't sure, take several photos, experimenting with different settings that use one, two, or all three kinds of tools. After all, the only cost for you will be in time and batteries. And the result can be a superior picture plus a greater personal understanding of color and light.

Tip: Camera Calibration If You're a Stickler for Precision

Some professional photographers work hard at being very precise with everything they do. (Others are quite loose and carefree, allowing their creativity to be the only controlling factor.) If you wish to emulate the exacting standards of the precision fanatics, consider calibrating your camera. Similar to manual white balance in that its purpose is to be sure that the color you capture is the true color unaffected by any environmental contaminants or internal misalignments, camera calibration requires using a software utility (like Monaco PROFILER) that analyzes your camera's capture of a standard target of known colors.

Once the camera is properly calibrated (which creates what is known as a profile, identifying how it captures those known colors), then that profile can be used in a color management scheme to ensure that the color you get in displaying or printing your photos is accurate. (For more information on color management, please read Chapter 20.)

While professional calibration software can be rather expensive, if you are using Photoshop, you already have a calibration utility within its Camera RAW dialog.

Using Your Camera's Other Color Controls

The purpose of white balance tools is to remove any color shifts from your pictures, so that the true colors of the scene can be better captured. (Or, conversely, you can use white balance settings to introduce a creative color shift.) Other digital camera color tools are more involved in defining and refining your photo's underlying colors. Many people will happily use digital cameras for years without ever dealing with *color models*, *color modes, contrast,* or *saturation.* Then again, many people live their lives happily eating out only at McDonald's. But once they find out about the added culinary dimensions of seafood, steak, and even Thai or Greek restaurants, dining out becomes so much more interesting and rewarding. So it is with learning to experiment with photographic colors. Not only will it give you a greater variety of options to spice up your photography, but you may also find that one special setting that fits your personality, needs, and artistic preferences.

The Indefinable Essence of Color

What is color? Depending on whom you ask, you'll get a different answer. A mixture of pigments, says the printer. The different wavelengths of light, says the scientist. Impressions, moods, and emotions, says the artist. You know what? They're all right. The problem is that color is an effect of human perception that can only be partially reproduced by technology or described by language.

Physicists and color scientists devote their careers to trying to define color, by describing it in scientific terms (*color models*) that can be formulated, graphed, and reproduced by various technologies. It's a thankless task that has yet to result in any final and universal answer. That's why there are so many color models, each representing the makeup of color in different terms and each relevant to specific devices or purposes. In other words, each printer, camera, scanner, or monitor uses a particular color model to define its color working space.

No matter how good any color model is, the human eye can see so many more colors than any digital camera, printer, computer monitor, TV, film, or book can reproduce.

We covered this subject in Chapter 1 in reference to image sensors and explore it again in Chapter 20 in our discussion of *color management* and how to get colors to print and display correctly. However, for the sake of the current discussion of choosing color settings in your camera, we need to quickly dip into this complex issue with an explanation of one pervasive color model: RGB.

RGB

All digital cameras use some form of RGB (which is based on the properties of light) to define the colors they capture. According to RGB, adding together equal parts of pure red, green, and blue yields white, and the absence of all color is black. The classic example of RGB is holding a crystal prism up to a window and looking at the rainbow-like spectrum of colors that it shines onto the opposite wall. Incidentally, as we explained in Chapter 1, film itself uses RGB to create color images out of what is essentially black-and-white film.

There are several "flavors" of RGB; the two most relevant to digital camera capture are sRGB and Adobe RGB.

RGB Formulas

All color models use mathematical designations to represent the different variations of color. RGB uses 256 (0 to 255) steps for each color. (That number should look familiar to anyone who knows the basics of computers, because 256 points of data is the amount of information inherent in 8-bit data. Since RGB has 8 bits of data for each of the three primary colors, it is a 24-bit color model, because 3×8 equals 24.)

Therefore, red can have a value of 0 to 255, as can green and blue. So, white is written as R255, G255, B255, and black is R0, G0, B0. Every possible color within the RGB color space can be described in this manner. For example, a certain shade of orange is R236, B149, B52.

While you won't need to know about these numbers while shooting, they will be useful to you when editing your photographs, especially should you need to match a specific color, such as a corporate logo. Many image-editing programs, such as Corel PhotoPaint and Photoshop Elements 2.0, have tools for determining the RGB numerical value of any portion of the image.

sRGB VERSUS ADOBE RGB

All digital cameras that we know about use sRGB as their default working color space. Hewlett-Packard and Microsoft developed this color model, which includes all the colors that can be displayed on a typical computer monitor. While it is great for images that will spend their entire existence only in computers or on the Web, it has a limited *gamut*. In other words, it doesn't encompass as many colors as other color models.

Some of the more advanced digital cameras can switch from sRGB to Adobe RGB. Introduced in 1998 for Photoshop 5.0, Adobe RGB was originally designated Adobe RGB 1998, a name that is rarely used today. 5.0 was the first Photoshop to have color management (see Chapter 20), and Adobe RGB was only one of several color models offered in a system that was initially, at best, a hodge-podge based on guesstimates of what should work. According to Adobe, as graphics pros, prepress experts,

and photographers explored the new tools, they found that Adobe RGB was the one color model that worked best for prepress and photography workflows.

Adobe RGB includes a larger range (gamut) of colors than sRGB, especially in the blues and cyans, which is what makes it more appropriate for print output.

Tip: Choosing the Right Color Model

If your digital camera offers the option of changing color models (or color space), use sRGB only for photos that you plan to use on the Web, share via email, or display on a screen. Switch to Adobe RGB if the photo is destined to be printed. If you aren't sure how you'll use the picture, choose Adobe RGB because, in this situation, it's better to have too many colors than not enough.

Color Modes to Change Your Mood

All humans respond to colors emotionally. Green represents a fresh sense of life and goodness. Red is exciting, perhaps a bit dangerous, and therefore sexy. Blue tends to be soothing, with darker blues a steadying, secure influence. Of course, the particular meanings of specific colors are culturally influenced, and individuals have their own interpretations based on personal psychology and memory. Do you feel happy when you see yellow, or do you see it as a warning? Carefully choosing how your photos use color is one way you can determine and control the personal message your pictures convey.

Once you have made sure your camera is correctly white balanced, and that you are using the right color model for your purposes, the next step is to take creative control over your photographic colors.

VIVID VERSUS NATURAL COLOR

About a quarter century ago, Fujifilm introduced Velvia. It was a new kind of film because it was purposely unrealistic. Instead of capturing the true color of a scene, the colors were punchier, brighter, more saturated and exciting. Everything popped out at you, with a dazzling sense of life. Cheeks were rosier, skies bluer, and grass greener. In other words, Velvia's color was better than reality. Many professional photographers hated it, because it wasn't correct. But the cat was out of the bag, and eventually even pros gravitated toward the artificially brighter, enhanced colors that the two of us have since called the Velvia Effect.

Today, many digital cameras (as well as printers and scanners) automatically heighten colors to appeal to modern sensibilities and tastes. Recognizing, however, that Velvia-like colors may not appeal to everyone, your camera may have two different settings—one for vivid colors and the other for more natural colors. Use the natural setting when the true color of a subject is important, such as for a logo or to document visual facts. But when photographing a beautiful landscape or a pretty baby, most people will probably be happier with the vivid color settings.

As you can see in Color Figures 10 and 11 in the color insert in the back of the book, the difference between vivid and natural color can be quite subtle, but in the right photo, it can give you just that little extra punch that can be quite appealing.

SATURATING YOUR COLORS

If your camera doesn't have a vivid color setting, you can get a very similar effect by adjusting *saturation*. Depending on the camera model, saturation may provide you with more control, because rather than just turning on vivid color, saturation is often adjusted according to the amount. For example, when we shot Color Figures 12, 13, and 14 (which appear in the color insert in the back of the book) with an Olympus C-8080 WZ, we were able to dial in saturation values along a continuum that included 10 different settings, from −5 to +5.

BLACK AND WHITE

Among some art photographers, color is considered distracting, even garish. They prefer to pare the image down to its grayscale basics, to more clearly highlight the play of light and shadow, the structure of their composition, and the impact of their subject. For these photographers, many digital cameras offer a black-and-white (b&w) color mode.

Of course, you could just as easily shoot a color photo and then convert it to grayscale in your photo-editing software. That's what photo-editing software is for. Right?

Wrong.

For two important reasons, you will usually end up with a higher-quality image if you shoot it as b&w rather than convert a color photo into b&w.

■ First of all, as we have mentioned before, it is always best to make adjustments to the photo before you shoot rather than after. In the case of converting a color photo to grayscale, you are taking a 24-bit image and *sampling*, or reducing, it into an 8-bit image. (See Chapter 5 to learn about bit depth.) In other words, you are telling the software to throw away two-thirds of the data that defines your picture. (See Figure 8-2.)

Figure 8-2: Using an HP Photosmart 945, we shot the teddy bear in our still life setup in full color. We imported it into Photoshop and converted it to grayscale in the software.

Figure 8-3: Using the same HP Photosmart 945, the only camera setting change we made was to set the color mode to b&w. Notice the greater detail and dynamic range in this 24-bit grayscale image compared to the 8-bit photo in Figure 8-2.

Figure 8-4: Instead of converting the original color photo (the same one we started with in Figure 8-2) to grayscale, we used Photoshop's tools to desaturate it of all color. That resulted in a 24-bit RGB image, but it still doesn't have the same detail and depth as Figure 8-3, which was shot originally as 24-bit grayscale.

▪ What's more, the b&w photo captured by a digital camera is almost always not truly grayscale. As a rule, it is a 24-bit RGB image in which the red, green, and blue are mixed in proportion to produce neutral grays, whites, and blacks. But with so much color data involved, the shades are richer and the picture is more sparkling. (See Figure 8-3.)

Even if you create a 24-bit RGB grayscale image in your photo-editing program by simply desaturating the original color photo, the quality will still tend to be inferior. You'd still be throwing away data—the color information. (See Figure 8-4.)

Tip: Back Up B&W Photos with Color

When you are shooting in black and white (or sepia), consider shooting the same exact scene in color, too. That way, you'll have the full-color version, in case you change your mind regarding the best style for that particular photo. (As we discussed in Chapter 5, if you shoot your b&w photo in RAW file format, you will automatically have a full-color version of the picture.)

CREATING ANTIQUE-LIKE HEIRLOOM PHOTOS

Depending on your camera, you may have any number of other color modes, but the one other that seems to be pervasive is *sepia*. Sepia is what you get when the camera creates a black-and-white image, then tints it with browns so that it looks like an antique photo. (See Color Figure 15 in the back of the book.) The same rules apply to sepia as they do to black-and-white photos. Yes, you can easily create the effect in Photoshop and other photo-editing software. Many programs have a special effect that converts a color image to sepia with a single click. Still, you'll usually end up with higher picture quality if you create the photo using the sepia color mode rather than altering it later.

CONTRAST

Sometimes, all that a photo is missing is a bit of snap. Or conversely, everything is too highly defined. In those cases, the answer may not require adjusting the color. Instead, what the photo may need is more (or less) contrast.

Many more advanced digital cameras have a separate contrast mode that allows the user to select the degree of contrast wanted. Usually, its default setting is zero, or neutral. Plus settings increase contrast, while minus settings reduce contrast.

Interestingly, when a photo has increased contrast, the human eye tends to see greater sharpness. Be warned: you don't want to overdo it. Increasing contrast too much destroys details and can create a *posterized* effect, in which gradations of colors tends to become solid bands or blocks. In addition, too much contrast can create an increased level of noise, with unwanted artifacts like stray pixels or splotches. On the other hand, too little contrast can make the entire scene appear flat, as though it were shot through a piece of diffusing gauze. (See Figures 8-5, 8-6, and 8-7.)

Figure 8-5: The contrast in this photo is set so low that the details appear indistinct, as though it were shot through a diffusing gauze.

Figure 8-6: Here's the same plate photographed at a medium contrast level, which gives a good distinction among the grays, black, and white. Notice how the increased contrast actually makes the photo look as though it is in better focus than Figure 8-5.

Figure 8-7: When we used a high contrast setting, details in the shadows and highlights were lost, especially in the mother's dark hair.

Infrared Beauty: Colors beyond the Visible

Great photography is often the result of pushing against the limits of technology, trying to take pictures of what should be impossible. In those crevices where engineers and camera designers didn't bother to plug the holes is where artists search to discover new visions. Steve Rosenbaum has spent a lifetime in love with photography, starting at the age of nine with a box camera and a home darkroom. Now a press relations consultant (primarily for photo-imaging companies such as Konica Minolta). Steve's passionate quest for photographic beauty still compels him to always carry at least one camera and a thin folder of his current favorite shots. Invariably, the most dramatic of these prints are of his digital infrared photography.

For over 25 years, Steve has been experimenting with infrared photography. "Near infrared is the extension beyond visible light of the electromagnetic spectrum," Steve explained to us. It's the wavelengths of light beyond red. We can't see it, but it's there nevertheless. When you filter out all visible light, a camera can capture the infrared that is reflected by objects. It's this ability to capture infrared that has been such a boon to astronomers trying to uncover the secrets of the universe. But for Steve and other art photographers, it's the strange and wondrous bending of reality that attracts them to infrared photography. Steve is fascinated by "the distortion of the tonality that we've come to recognize as the world that we know . . . it's the challenge of being able to previsualize with a distorted palette that's compelling." Trees, grass, and other green-growing plants reflect a great deal of infrared back to the camera, and the result is what looks like eerily snow-covered bushes and lawns, even in

Infrared photography can add a certain unworldly, ethereal beauty to pictures, as in this picture of the Temple of Love at the Old Westbury Gardens, Old Westbury, NY. (Copyright Steven I. Rosenbaum.)

mid-summer scenes. Depending on the time of day and weather conditions, blue skies will look dark, even black. However, since you can't see infrared, you can't ever be absolutely sure what you will capture until the camera does its job.

In 2001, while working with his client's new Minolta DiMAGE 7, he discovered digital infrared capture. "Digital infrared is so much simpler," Steve said. "I'm glad I shot all those other years with film infrared, but it was a real pain to handle the film." It was so thin and flimsy, and he had to load and unload the camera in absolute darkness. With digital, he can see exactly what he is getting on the LCD viewfinder, and even make adjustments in contrast and exposure before taking the shot.

Digital infrared "exploits a flaw in digital camera design," according to Steve. The image sensor is particularly sensitive to infrared, just as it is to visible light. Some digital cameras, especially the more modern high-end cameras, will incorporate what is called a "hot mirror" filter into the design, to keep infrared from skewing exposure and color accuracy. However, you can still find all kinds of consumer and prosumer digital cameras that remain sensitive to infrared.

If infrared is invisible, how can you tell if a digital camera will be capable of capturing it? (Very few manufacturers list infrared as a feature, preferring to ignore the issue.) Turn it on. Point a TV remote control at the lens, while looking at the LCD viewfinder. Press any button on the remote control—that activates the invisible infrared beam used to communicate with your television set. If you see a small white blinking or steady light on the LCD viewfinder, it's the infrared of the remote control coming through, and you have the right kind of digital camera.

To shoot digital infrared photography, your digital camera lens must be able to accommodate a screw-in or slip-on infrared filter for removing visible light. (Some cameras that don't have threads can

Steve took this picture using default color settings. (Copyright Steven I. Rosenbaum.)

Then he took the same picture through an infrared filter. What is amazing about infrared photography is that it can elevate even comparatively prosaic scenes aesthetically. (Copyright Steven I. Rosenbaum.)

still attach filters by using an adapter.) Steve uses a B&W 093 or Wratten 87C equivalent filter, which are readily available from most full-service camera stores or via the Internet.

Once you start shooting digital infrared, you begin viewing the world differently, because everywhere you look is hidden beauty that only your camera can see.

Summary

This chapter covered many issues concerned your digital camera's color tools. Some of the key points included the following:

- Digital cameras are not smart and will photograph exactly what they see, which is not exactly the same as what the human eye sees, especially when it comes to color.

- Every light source has a different impact on how a camera captures the color of a scene, creating photographic color shifts.

- As a rule, you can trust the auto white balance setting in most situations—but not all.

- Most digital cameras have preprogrammed settings for specific lighting situations, such as daylight, fluorescent, and tungsten, which often work well in correcting environmental color shifts.

- Set your camera to the sRGB color model if your picture is intended only for display and the Web. When your camera has it, use Adobe RGB for photos intended to be printed or when you aren't sure what you'll be doing with the picture.

- Vivid colors, contrast, saturation, black and white, sepia, and other color modes and controls offer interesting creative opportunities.

Controlling and Adding Light

Of all the elements that make up a great photograph—subject matter, composition, color, perspective, exposure—the most important by far is light. Without light, there is no photography, period. Light is infinitely variable and ephemeral, like a stream of water, with its eddies and cascades that can be still and quiet, or rapid and violent. It's the quality, type, intensity, and direction of light that more than anything else will define your pictures.

In this chapter, we'll cover how to read, use, and even control the existing lighting situation you'll find when taking photographs; how to take great shots with your digital camera's built-in flash; and how to create, sculpt, and channel light so you can properly illuminate almost any subject.

Learning to Read Available Light

Available light is the term used to describe the light that's all around you, be it sunlight or moonlight, office fluorescents or home light bulbs, firelight or candlelight, or mixed lighting from several sources. Light is further defined by its quality, source, and intensity. All this matters to your photographs, because unlike your eyes and brain, which automatically adapt to almost any light source, digital cameras need to be told what kind of light is falling on the subject so they can adjust accordingly.

Learning to read available light is one of the more important steps in gaining control over your photography. And we're not just talking about discerning whether you have enough light. Instead, you need to understand how the light is going to affect the picture you are going to capture.

See the world as your lens sees it, as textures of shadows, light, and color (see Figure 9-1). Look for the angles of light that might create interesting shadows or specular highlights. Consider the different levels of contrast between objects and places. Does the sun slant across the tops of trees, giving them the feeling of a halo? Is a face half in shadow in a way that makes it interesting or mysterious? Or do the shadows distort the structure of the face turning it into a grimace?

Once you've learned to read light, you'll know better how to manipulate it with reflectors, flash, and/or other auxiliary lights—and when to not bother snapping the shot because the light isn't optimum.

Figure 9-1: Learn to read how shadows and light will texture a photo. (Photo taken with a Nikon D70.)

Different Qualities of Available Light

While there are many ways of describing the quality of light, the following are the most important to photographers:

- **Soft, diffused, or low contrast light**—Fog is probably the most dramatic and best-known type of diffused light, but it's actually any light where there is no strong differentiation or contrast between light and dark, where everything seems gray, ethereal, indistinct. Soft lighting can be good for portraits and special effects, but for many other subjects, it tends to produce flat, uninteresting photos.

- **Hard or high contrast light**—This is when light comes through clearly, without being diffused or diluted by anything in the atmosphere or environment. It's usually from one or several oblique sources, creating long, strong highlights and shadows. High-contrast light

can be very dramatic, but if you're not careful, it can drop out details in the midtones and produce photos that are too contrasty.

- **Direct light**—When a clear light source shines directly onto the subject, without anything between it and the subject. It may come from the sun, a spotlight, or any other specific source. Like hard light, direct light tends to create noticeable highlights and shadows. Direct light can be harsh and contrasty, but also attractive and dramatic. Direct light is excellent for most types of subjects.

- **Indirect or reflected light**—Light that bounces or is redirected between its source and the subject. Many photographers use indirect light to soften or filter light falling on a subject, to lessen the shadows or increase the highlights.

- **Ambient or incidental light**—Light that exists within a scene that the photographer encounters rather than creates. For example, it is the daylight streaming in the windows and the normal overhead lights in a room. It can change the effect of the light you add to the scene, so you'll want to be aware of ambient light.

The Color of Light: An Emotional Tool

The color of light may not always obvious when you are just starting out, but photographers recognize it as one of the defining aspects of their pictures. That's because we tend to respond subliminally and very strongly to color. Two of the more frequently bandied terms used by pros when talking about the color of light are warm and cold.

- *Warm light* has a reddish hue to it. You'll often find it at sunrise or sunset, or in candlelight. As humans, we tend to react with, well, warm feelings to it. It can impart a sense of romance, comfort or tenderness (see Color Figure 16 in the color insert in the back of the book for an example of warm and cold lighting).

- *Cold (or cool) light* tends toward blue, and it's often found in shadowy areas and under certain types of artificial light. Sometimes we think of cool light as imparting a crisp, antiseptic sense to a photo. When you're talking about machinery and precision, cool is often better than warm, though a warmly lit picture of machinery can defuse antipathy toward it.

Yellow, as the color of sunlight, is also quite important in photography. It makes us feel happy and secure and open to suggestions.

When you're contemplating taking a photograph, consider the color of the light and how it makes you feel. (See Chapter 8 regarding your camera's color controls.)

Reading Histograms

A histogram is a statistical representation of the percentage of highlights, shadows, and midtones in a picture. In many serious consumer digital cameras, as well as all prosumer, semi-pro, and professional models, the histogram is displayed as a graph of the range of tones, where pure whites are on one end and pure black on the other. Ideally, you want a few pure whites, a few pure blacks, and lots of data in the midtones (think of a bell curve). Practically speaking, you'll rarely see the ideal; rather, the

typical histogram is skewed towards the lights (overexposed) or darks (underexposed), or heavy in the middle (flat lighting). By learning to read a histogram, you can immediately tell what kind of light you've captured and how well-exposed the image is. (See Figure 9-2.)

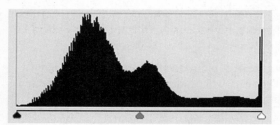

Figure 9-2: This is the histogram for Figure 9-1, as displayed in Photoshop. The shadows are on the left, and the highlights on the right. If you didn't know the photo, at first glance, you might think that it was a bit underexposed, because so much of the data falls in the darker side of the histogram. However, you would also notice that it is far from flat, and that it has some very strong highlights (the spike on the right side). It is the hilliness of this histogram with pixels represented throughout the grayscale range, along with the tendency toward the dark end combined with that highlight spike, which makes this an interesting, lively picture. (©2004 Adobe Systems Incorporated. All rights reserved. Adobe and Photoshop are registered trademarks of Adobe Systems Incorporated in the United States and/or other countries.)

Depending upon your camera, you may be able to display a histogram in real time, right on the LCD viewfinder or in the electronic viewfinder. That allows you to instantly see what sort of light you are getting; if you don't like it, you can change your position or the lighting (or, as we explain in Chapter 6, your exposure settings). Other models display histograms only in playback mode, so if you don't like the light in your just-shot image, delete it and try over.

Learning to read a histogram will help you recognize when your shots are too dark, too light, too flat or too contrasty. But don't forget there may be occasions when, for effect, you actually want your pictures to be overexposed or underexposed, flat or contrasty.

Tip: Study Histograms

If your camera doesn't have a histogram, your photo-editing software might. Open up pictures you like (and others you don't) in the program and look at their histograms. This exercise will help you learn to read and analyze light.

Exposure Controls

After you've learned to read the light, you'll want to take control of it. To a large extent that's the role of your camera's exposure controls, which include *f-stops, shutter speeds, exposure compensation,* and *bracketing.* We cover those subjects fully in Chapter 6.

In the rest of this chapter, you'll learn how to use and augment the light around you.

Night and Time Exposures with a Digital Camera

Most digital cameras can take dramatic low-light exposures. Done properly, dark or moonlit scenes may miraculously appear lighter, displaying details that look pitch black to your eyes. Taking slow or time exposures to capture photos in low light requires a number of steps:

- Autofocus may not work in low light. You'll have to either use manual focus or set the camera to a program mode, such as night mode, if your camera has it. (See Chapter 7.)

- Depending upon your camera, your slowest shutter speed may be 15 seconds, 30 seconds, or 1 minute. (A few cameras have a bulb setting, which means the shutter remains open as long as you hold the button down. But for technical reasons, the longest bulb we've seen in digital cameras goes only 2 minutes.) If you don't have adequate light when your shutter speed is at its slowest (the camera will warn you with a beep or a status light if you are underexposed), you can either select a lower f-stop to admit more light or boost the ISO equivalency, or both. If the exposure reading still says that you're underexposed, take the shot anyway. Many digital cameras have a remarkable ability to capture details in shadow, which you may be able to bring out in editing.

- Taking slow or time exposures generates considerable electronic noise. (Noise usually appears as random color specks throughout your picture.) To minimize noise, most digital cameras have a noise reduction menu option. Activate it when you are taking pictures at shutter speeds slower than 1/5 of a second. If you don't see that option, your digital camera may automatically activate it for slow shutter speeds.

- Because your shutter speed will be anywhere between 1/5 of a second and 60 seconds, you'll need a tripod, minipod, or a place to firmly immobilize your camera.

- Don't press the shutter to take the shot. Rather, activate the self-timer to minimize camera shake and probably get a steadier, sharper shot.

- Use exposure bracketing, if your camera has it. That way you're more likely to get the shot you want.

- If you have an external strobelight, try flashing it a couple times during the time exposure, at the subject, in the background, or wherever you think illumination might add some interest or mystery. The effect of adding selective illumination to your time exposure pictures can be dramatic. If it doesn't work, simply erase that frame and try again.

Don't Light It, Reflect It

There are two kinds of photographers: those who *find* the right light and those who *make* the right light. If you want more control so you can create better illuminated pictures, try using a reflector to put light right where you need it.

A reflector is any light-colored material designed to catch the light from a source of illumination (which can be natural or artificial) and redirect it onto the subject or a specific area of the subject. Used judiciously, a reflector can soften deep shadows, add specular highlights, or lighten a subject. It

also can add a little tint of color to a scene. Depending upon its size, position, and how the light is directed, a reflector can cover a large swathe or deliver pinpoint illumination.

John Isaac (www.JohnIsaac.com), the photojournalist known for his pictures of exotic people and places, prefers reflecting light to adding artificial light. "Ninety percent of the time I use available light," he explained. "Sometimes I use a circular reflector, and sometimes a white cloth. Recently, in Kashmir, I had forgotten to take my reflector, and I used kitchen aluminum wrapping foil to reflect light on the dark side of someone's face. Once I used a car reflector from the hardware store for [the book] *America 24/7*. One time I did an ad for Olympus with a gold reflector. It was evening light and it worked fine—better than the pictures I shot with a strobe. A lot of times I like the warmth of a gold reflector, especially in shade."

There are many different kinds and types of commercial reflectors available; most are thin circular cloth or metallic disks 1–4′ in diameter (they fold up and fit very nicely into their own bag) and cost $15–$75. Commercial reflectors often have one color on one side—usually gold, silver, or white—and a second color on the obverse side. Or, you can make or improvise your own reflector, such as John's aluminum foil or white posterboard. A reflector can be hand-held by an assistant, or for more convenience and stability, mounted on a photo stand ($20–$125). Reflectors are used extensively by virtually every commercial photographer, but because they're lightweight, inexpensive, and relatively easy to use, almost any shooter can improve his photographs by carrying one or two of these handy gizmos.

Your Digital Camera's Built-In Flash

The vast majority of digital cameras have a built-in *flash*. Also called a strobe or strobelight, it works by flashing (strobing) very briefly but brilliantly when a high-intensity electrical charge passes through a tube filled with inert Xenon gas. Unlike a conventional flashbulb, which burns up the wire filament in a single burst of brilliance, the gas-filled strobe can flash many thousands of times. Usually positioned next to the built-in flash is a tiny sensor that measures the light bounced back from the subject. (Some cameras have an internal sensor.) When it decides that there's just enough illumination for proper exposure, it will instantly turn the flash off. Depending upon the make and model, some digital cameras come equipped with certain refinements, such as variable flash intensity (flash compensation), a pop-up flash rather than one in a fixed position near the lens (higher is usually better, for reducing red eye), and a couple neat technical tricks, like front or rear curtain sync. We'll discuss what they are and how they work a little later.

Using your digital camera's built-in flash gives you the following advantages:

- It can provide just the right amount of illumination to perfectly expose your picture.

- It's matched to your zoom lens, so you can use it at any focal length without vignetting (creating a dark halo around the edges of your photo).

- The light it outputs is daylight balanced, so color shift is never a problem when the camera is set in the automatic mode.

- When used in the fill flash mode, it provides just enough illumination to minimize or eliminate the shadows that backlighting (shooting with the sun behind your subject) often produces, without overpowering the rest of the shot.

However, be aware that there's a downside to using a built-in flash:

- It will drain your batteries much faster. The more frequently you use the flash, the fewer shots you'll be able to take before needing to recharge or replace the batteries.

- Pictures may look too contrasty or artificial, the colors too bright or saturated, the shadows and highlights too harsh and extreme. If your subject is near a wall or another object is behind him, you can end up with severe dark shadows outlining him.

- The flash's capacitor must build up a sufficient electrical charge before it's ready to fire, so it takes longer before your camera is ready to shoot again. Depending upon how fresh your batteries are, that can take 5, 15, or even 20 seconds. (Beyond 20 seconds, it's definitely time to replace or recharge your batteries.)

- The distance at which it can illuminate properly is limited by the size battery, capacitor, and flash tube. At normal settings, most subcompact digital cameras' strobes reach only as far as 8′ at wide angle, 12′ at telephoto. Compacts typically reach 10–14′, and prosumer/semi-pro cameras reach approximately 13–20′.

- Depending upon the camera, you may not be able to shoot objects closer than a couple feet without blowing out the scene (severely overexposing it).

- If you don't pay attention to how and what you're shooting, you could end up with unwanted reflections, overexposed details, or subjects with devil-like red or green eyes ("red eye").

- Flash can be obtrusive and unwelcome. At many museums, some public events and private functions, the use of flash may be banned.

- Flash definitely suppresses spontaneity. It makes your subjects more aware and self-conscious, so your pictures may be stiffer, more formal, less candid. Some people are annoyed by flash.

Despite the disadvantages inherent in using flash, it's often the best, most practical, and only way to get the picture you want. But don't let it become a crutch you rely on to ensure that all your pictures turn out with the proper exposure. That would be boring.

Tip: Be Careful of Overlighting a Subject

Shadows are interesting (often defining) components of a beautiful picture. Be careful not to throw too much light into visually important shadows.

Pop-Up Flash

All other things being equal, when you're considering buying a digital camera, you might consider choosing a model that has a built-in pop-up flash on top of the camera over another model with a fixed flash tube on the front. Adding only an inch or two of height can significantly cut down on red eye.

At least one camera—the Panasonic DMC-LC1 (and its spiffed-up version, the Leica Digilux 2)—allows users to bounce the pop-up flash, which greatly reduces harsh shadows and gives more natural looking illumination.

Choosing the Right Setting for Your Flash

Most digital cameras have at least four different flash modes; some have as many as seven. Here's a brief overview of what they are, how they work, and when to use them:

- **Auto**—The default setting on all digital cameras with built-in flash, it's designed to deliver the right amount of light, automatically. However, if there's enough overall light, it won't fire. Auto is probably the best, easiest-to-use setting for everyday use, since it requires no thought or action by the user and it's always ready to shoot.

- **Off**—Think of "off" as a mode rather than a state, because the way most digital cameras operate, if you don't want flash but don't specifically turn it off, the auto mode may trigger the flash regardless. Using off may be the only way to guarantee that your built-in flash won't go off at inconvenient or inopportune times.

- **Fill, or forced flash**—Unlike auto, where the flash doesn't fire if the light sensor doesn't think you need it, fill flash always fires, even when it's bright outside. That's when it pumps out a minimal amount of light, just enough to take the buzz off deep shadows. Fill flash is especially useful for backlit situations, when light does not fall directly on the subject, thereby creating unwanted shadows or underexposure. Fill flash puts just enough light on the subject so it is properly illuminated, matching the background light without overpowering it. Many photojournalists routinely use fill flash when shooting people closer than 10 or 12′, so their faces won't be too dark for recognition or reproduction. (See Figures 9-3a and 9-3b.)

- **Red eye reduction**—Because the flash tube on most digital cameras is situated very close to the lens, the light it produces bounces almost directly back toward the lens This highly directional reflection often produces an unwanted optical effect when photographing eyes: the pupils become bright glowing red (or sometimes green) circles. This phenomenon is called red eye. It can usually be minimized or eliminated by preflashing the strobe a number of times about a second before actually taking the picture. As the theory goes, the rapid, repeated flashes of bright light instantly forces the irises to contract (grow smaller), thereby reducing the curvature necessary to produce red eye. Does it work? Sometimes, but it's also annoying to the subjects, as well as adding time between pressing the shutter button and actually taking the picture. We prefer to shoot, take our chances, and get rid of red eye later at the computer. (Almost all image-editing programs have some sort of red eye elimination tool.) The best way to minimize or eliminate red eye is to have the flash positioned higher away from the lens, as auxiliary strobes are.

- **Rear curtain (also called second curtain or slow) sync**—Normally, using flash sets the shutter to a relatively fast speed—usually 1/125 to 1/500 of a second—to help eliminate what are called "ghost images." Then the flash fires just as the shutter opens at its widest.

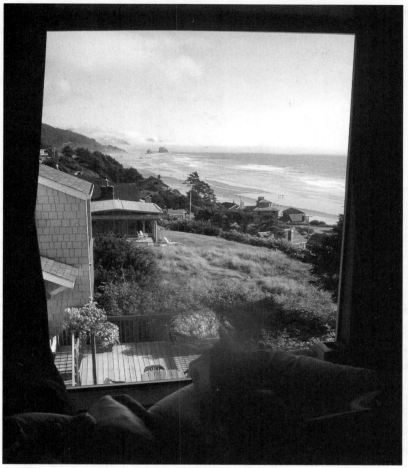

Figure 9-3a: In this scene, the seascape outside is beautiful and bright, while the room itself is dark by comparison. As a result of exposing for the outside, the inside is much too dark. If we had exposed for inside, the view beyond the window would have been quite overexposed. It's a perfect situation for using fill flash.

However, there may be times when you want to combine correct exposure and good focus with blur, where the so-called ghost image is the effect you want. Instead of a fast shutter speed, rear curtain sync typically shoots 1/10 to 1/2 second. This way, the camera records the subject as it moves, producing an underexposed ghost image, or blur. Then the flash fires, after the shutter has passed its zenith, so it will freeze the primary subject with the correct exposure. However, the ghost image streaks remain. Rear curtain sync is difficult to use, but when executed correctly, the effect can be truly spectacular (see the figure in the "Using Rear Curtain Sync Effectively" sidebar for an example).

■ **Front curtain sync**—The opposite of rear curtain sync, the flash goes off early, before the shutter reaches its zenith, so the light illuminates the main subject for a perfectly exposed, sharp picture, but the darkened background continues to register on the image sensor.

Figure 9-3b: In this photo, we exposed for the outside and used fill flash to illuminate the deep shadows of the room. (Both photos taken with a Nikon Coolpix 5000.)

- **Flash bracketing**—Like *exposure bracketing*, consecutively shot frames will each use the flash with a slightly different intensity. That way, you are fairly certain to get at least one shot that has the proper illumination and exposure. One shot is taken according to the readings, one shot is one *f*-stop underexposed, and one shot is one *f*-stop overexposed. However, flash bracketing can be considerably slower than exposure bracketing, because the flash capacitor has charge enough to fire three times.

Using Rear Curtain Sync Effectively

Michael Lewis (www.michaellewisfoto.com), the *National Geographic* photographer, told us, "I don't do a lot of rear curtain, but it's a great technique for conveying a sense of motion."

An effective use of rear curtain sync by Michael Lewis, using an Olympus E-1 (Copyright Michael Lewis.)

Michael shared with us how he took this photo for Harley Davidson's 100th anniversary. "It's very hard to do something like that with a camera on a tripod," he explains. "It's a hand hold situation that works best if you are able to fix your focus on the moving subject. Start with the subject before you shoot—that's what keeps the subject clearly focused. Keep moving with the subject and then pick the moment you want to hit the shutter.

"The shutter speed has to be within a range that will give you a bit of blur but not a lot—somewhere between 1/15 and 1/8 second. Gauge it to match the speed of the subject," he advises. "Make sure the strobe isn't overpowering. Match the ambient light as much as possible, so light is even and pleasing." The Harley photo was taken at 1/5-second shutter speed, f5.6, ISO equivalency of 100 with exposure compensation at −2/3.

John Isaac (the photojournalist and coauthor with his wife Jeannette Isaac of *Endangered Peoples* from Sierra Club) generally eschews flash because he doesn't like its artificiality. However, he will sometimes use second (rear) curtain sync not so much for action but to throw just a little extra light onto a subject. "That way," he explained, "the picture looks natural because it is calculated to the available light. I'll underexpose and then use the second curtain sync. The flash comes in at the last part of the exposure after the ambient light is exposed and the flash goes in and you get a frozen moment."

Flash Intensity Mode

Many digital cameras have a menu option that allows users to adjust the intensity, or the amount of light, pumped out by the camera's built-in flash. It works very much like exposure compensation, in that the user can adjust the amount of light two f-stops, plus or minus (better cameras have a +/− 3 f-stop range), usually in increments of 1/3 of an f-stop. You activate flash intensity mode through the menu, which displays a scale on either the LCD viewfinder or control panel. Then, using either

the four-way jog button or subdial, you move the display marker towards the + (lighter) or – (darker) side of the scale.

For starters, move one full *f*-1pt-stop lighter or darker, and see if the exposure is more to your liking. If not, move the display marker in 1/3 *f*-1pt-stops, until the picture's exposure looks correct (or meets your expectations, which may not be the same thing). You can double-check whether the exposure is light or dark enough by looking at the histogram of the image.

Using Auxiliary Strobes

Better consumer cameras, most prosumer and all semi-pro and professional digital cameras, are designed to accommodate an auxiliary or external strobelight. (See Figure 9-4.) There are many advantages in using an external strobelight over the camera's built-in flash:

- Using an auxiliary (or external) strobelight will add inches of distance between your lens and the flash tube, which in turn minimizes red eye as well as provides better directed light, for more pleasing photographs.

- Usually, the auxiliary strobelight is much more powerful than your built-in strobe, so it can illuminate farther.

- Being independently powered by batteries, an auxiliary strobelight usually recycles faster than your digital camera's strobe. Plus, your camera will recycle faster between shots, since it won't have to charge the flash's capacitor.

- Most auxiliary strobelights have movable flash heads that allow you to bounce the flash rather than simply point it at the subject. Bounce flash helps soften or eliminate the harsh shadows that flash often creates. It also makes the light look less artificial, more natural.

- Built-in strobes are difficult to diffuse, while it's relatively easy to put a light diffuser (usually a translucent plastic baffle, but sometimes just a piece of white paper or cloth) over an external strobelight. Diffusing the flash softens the light and shadows. Similarly, colored filters can be placed in front of the strobelight's head for special effect.

- Most external strobelights can be ported from one model digital camera to another. While some functions, such as TTL (through the lens) capability, are specific to certain digital camera models, the strobe will probably work with any brand or model as a standard flash.

- Strobelights can be equipped with photoelectric eyes, making them wireless slave units. Some are designed to be networked via wire. Networking allows them to be used together as a portable lighting system.

There are a few minor disadvantages to using an external strobelight:

- There's no extra charge for the built-in flash in your camera, but you'll have to spend money to buy an auxiliary unit. Depending upon the make, model, and level of sophistication, a strobelight can cost from $39 for a simple dumb flash up to $600 for an everything-but-the- kitchen-sink TTL unit.

Figure 9-4: Auxiliary (or external) strobelights, like the Nikon SB-600, which fits the Nikon D70 camera, are best when they are matched to the camera and can communicate with its internal intelligence. Notice the strobe head has a removable plastic diffuser and can be tilted at various angles to bounce its light. (Photo taken with a Fujifilm FinePix S7000.)

- They add weight and bulk to your digital camera. Instead of a clean, clutter-free appearance, you'll have an ungainly flash that may actually be larger than the camera. It may also throw your camera off balance, especially when the camera dangles free on a neck strap.

- It's one more piece of equipment to carry, lose, or leave behind.

- It's slightly more difficult to use. With many cameras, you must go into the menu and select the external flash mode for the strobelight to work properly, and then turn it off when you're not using the auxiliary unit.

- Unless it's specifically matched for your camera, its illumination cover might not be wide enough for the lens, or the lens itself might occlude the flash tube. This may produce light falloff at the edges of your picture.

TTL Strobes

Many digital cameras have an external flash sensor, a tiny window near the flash tube that reads the light and shuts off the flash when it gauges that the illumination is sufficient to produce a perfect

exposure. In better digital cameras, the flash sensor isn't an external window; it's inside the camera, reading the light that reaches the image sensor itself. That's a TTL (through the lens) system. TTL is much more accurate than an internal sensor, delivering more precise illumination.

Similarly, better external strobelights are TTL-enabled, designed to intelligently interact with a specific camera's internal light sensor. The camera and strobelight must be matched, however, to communicate. TTL-enabled digital cameras generally have what is called an intelligent hot shoe. By comparison, dumb hot shoes simply trigger the flash with no regard to feedback from the camera's intelligence, so their exposure may not be as accurate. (See Figures 9-5 and 9-6.)

TTL strobelights are more expensive than non-TTL strobes and are both brand and model specific. But if your camera is indeed TTL enabled and you use flash often, like to use bounce flash, or work with slave units, then it's worth the extra money to get a matched external TTL strobelight.

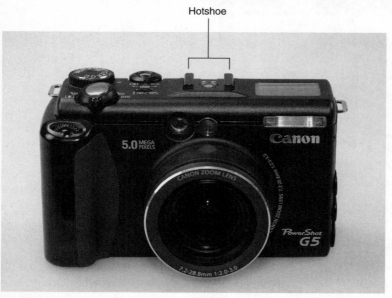

Figure 9-5: Shoes are small double rail slots in the top of a camera where auxiliary strobe units are attached. (Photo of a Canon G5 taken with a Nikon D70.)

Slaves

Except for those single dramatic light side/dark side high-contrast photographs, the best kind of flash illumination is created by simultaneously firing two or more strobelights, thus providing light from multiple sources. This helps reduce harsh shadows, provides more even illumination, covers a greater area, and can be used to create interesting effects. The best, easiest way to network those strobelights together is to use one or more inexpensive slave units or slave strobelights. Slaves can direct light onto the side or top of the subject, more evenly illuminate a group of people, or provide enough light to properly expose a subject positioned beyond the normal range of the camera's built-in flash.

A slave (or remote) unit is a small photoelectric eye ($10–$25) that can be set almost anywhere, and which instantly triggers any attached strobelight (not included in the price) when it detects the camera's built-in flash or external strobelight flash. A slave light ($20–$100) is a battery-powered strobelight

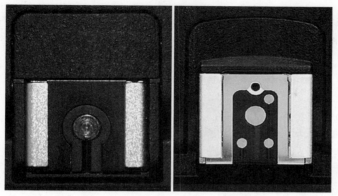

Figure 9-6: On the left is a "dumb" hot shoe (from a Fujifilm FinePix S7000). Notice the single contact (the metal circle in the middle) that the camera uses to trigger the flash. On the right is an intelligent hot shoe for a TTL flash (on a Nikon D70). Intelligent hot shoes have several contacts (the smaller circles) in addition to the large trigger contact. These extra points of contact provide for the two-way communications between the intelligence in the camera and that in the TTL flash.

with a built-in photoelectric eye that does the same thing. The slave unit often has a suction cup or tiny self-contained stand, for attaching to a wall to table, while the slave light is usually positioned with a minipod or light stand.

Using slaves with a digital camera is relatively easy. Place them either facing the subject or tilted towards the background, making certain that the photoelectric eyes are pointed directly at the camera so they can react when the flash is triggered. Depending upon the model, the effective range for slaves is 20 to 60′. Make certain that they are switched on and that the strobelights are charged. Then take the shot. Switch the camera to playback mode and review your pictures to see it worked, or if you need to make any corrections to exposure or the light positions.

Generally, you'll have three options for adjusting a slave's position. Move it closer to the surface it's illuminating if you need more light; farther away, if you need to reduce the light; and/or alter the angle of its light.

Professional Studio Lights

Most pros use a basic four-light system (main light, sidelight, highlight, and backlight) as an effective way to properly illuminate a subject. A set of studio strobelights and supporting equipment range in price from $1,000 to well over $15,000, depending upon the power, versatility, and sophistication of the equipment.

Writing a step-by-step guide on how to set up and use professional digital camera studio lighting would take an entire book. Alas, we have only a few paragraphs, so the best way is to very briefly introduce you to our setup at our DigitalBenchmarks Lab. Like many other pros, we have several different setups:

 ■ Two permanent still lifes that we use to test every digital camera that comes into our lab. One has no lights, because it's for testing a camera's own flash. The other has a rather

expensive (about $5,000) 6-light, 16-bulb nonflicker, full-spectrum fluorescent Kaiser system (www.hpmarketingcorp.com) that emulates daylight.

■ A shooting table for photographing any small object or setup (including photos of digital cameras themselves) with a 4-light, 12-bulb simulated daylight system from APV Inc. (909-788-8081). It's much less expensive than the Kaiser lights because its fluorescent bulbs aren't nonflicker. (See Figure 9-7.)

■ An area for photographing live models and large objects that we illuminate with any of a variety of lights, depending on the color temperature and intensity required.

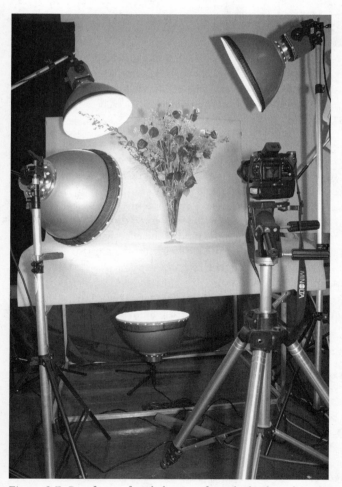

Figure 9-7: Pros favor a four-light setup for a shadowless photo. We position and shine a bright light up through the bottom of our translucent shooting table. By adjusting the main light, sidelight, and highlight, and by diffusing the lights (sometimes we create a translucent white cloth tent or put a semicircle canopy over the object we're photographing) we are able to virtually eliminate shadows. (Photo taken with Nikon D70 using the SB-600 strobe on fill flash to balance the strong lamps and still get the back of the Minolta DiMAGE A2 on the tripod well exposed.)

In addition, we have two Speedotron power packs and four strobe heads (`www.speedotron.com`), replete with light stands and booms (for mounting and positioning the strobe heads), as well as reflectors, umbrellas, barn doors, and soft boxes (to channel, direct, and diffuse the light). Our studio is equipped with light meters, a flash meter and color temperature meter (for accurate exposure and color control), voltage stabilizers (to keep the color temperature of the lights from drifting), opaque blackout curtains (to prevent extraneous light from filtering into the studio), seamless paper rolls and large canvas cloths (for backgrounds), a number of camera stands and tripods (for rock-steady stability while shooting), and lots of clamps, poles, adapters, and braces (to help position the lights and items that we're photographing).

A well-equipped studio lighting system can cost tens of thousands, but you can assemble your own basic setup for about $150. That will buy you a new set of Smith-Victor stands and floodlights (`www.smithvictor.com`). Of course, you probably can get the same thing on eBay for a lot less. Cheaper still, go to your hardware store and buy a set of clamp-on reflectors and 200-watt light bulbs for about $10 each and angle them at your subject. Only, be sure to change the white balance on your digital camera from auto to tungsten.

Summary

This chapter covered many issues regarding reading, controlling and adding light. Some of the key points included the following:

- It's the quality, type, intensity, and direction of light that more than anything else will define your pictures.

- Learn to read the light that you are shooting under, so you can adjust, compensate, or change it to get the picture you want.

- Light has an emotional value that creates a mood, impression, or environment that you can capture or control in your photography.

- There are various pros and cons about using your digital camera's built-in flash to illuminate a scene or subject.

- Using an external strobelight is almost always better than the camera's built-in flash. TTL is the best kind of external strobelight, but only if your camera is TTL enabled and matches the particular strobe.

- Basic studio lighting doesn't have to be complicated or expensive, and it allows you to shoot like the pros.

Chapter 10

Recording Video and Audio with Your Digital Camera

PC MAGAZINE
www.pcmag.com

T he heart of every digital camera is its *image sensor*. Among the many arcane characteristics and specifications buried in white papers and technical descriptions of photosensitive sensors is the fact that *charge-coupled devices* (*CCDs*) and *complementary metal-oxide semiconductors* (*CMOS*) capture image data at the rate of 60 frames each and every second. If the camera receives no instruction to capture a picture (which happens only when you press the shutter release), most of those 60 frames per second (fps) are simply thrown away (though some get diverted to the LCD viewfinder so you can preview what you might shoot).

So what if instead of discarding those many thousands of frames between when you turn the camera on and when you actually take a still photograph you could somehow save and use those wasted frames?

Actually, many digital cameras allow you to do just that. It's called video. Better yet, many digital cameras also allow you to record audio that synchronizes with the video—in other words, *movies*—just like a DV camcorder.

Well, *almost* like a camcorder.

For most users and situations, your still digital camera is capable of capturing usable movie clips that are good enough for displaying over the Web and even on the family television set. Conversely, if you happen to own a relatively new digital video camcorder, you probably can use it to take still images good enough to generate small photo-quality snapshots.

But the fact is that, at least for the present, still digital camera videos are not nearly as good as those shot with a DV camcorder, and the best photographs taken with your DV camcorder are inferior to those captured with a digital still camera.

In this chapter, we'll cover the basics of how to shoot and upload videos, movies, and audio clips with your still digital camera. We'll also discuss the important similarities and differences between a true DV camcorder and a still digital camera and how best to work with—as well as work around—your still digital camera's formidable technical limitations to get the best possible videos, movies, and audio clips.

Can My Digital Camera Replace My Camcorder?

Like many things in life, that's a somewhat ambiguous question that can be answered with a *yes*, *no*, and *maybe*. It all depends on:

- What kind of videos or movies you shoot
- Where and how your videos are seen or displayed
- What your personal expectations and definition of quality happen to be

The answer will be *yes* when you're shooting home-type movies for the Web, since it's likely that your digital camera has the capability to record serviceable clips that will look and sound okay.

On the other hand, *no*, you can't reasonably expect to record the same kind of image and audio quality you're accustomed to getting from your fancy, pricey digital video camcorder that has a three-CCD image sensor, 16-bit sound capability, and a top 20X optical zoom lens that you love to show off on your state-of-the-art 42″ HDTV plasma home entertainment system. Come to think of it, the most expensive still digital camera can't take videos nearly as well as the least expensive DV camcorders.

And the best answer is *maybe*, if all you happen to have handy is your still digital camera when that once-in-a-lifetime occasion or opportunity happens where you want to record movies for posterity or public broadcast (like a UFO landing in your back yard).

Want Video? Don't Buy a D-SLR

Almost all consumer digital cameras come equipped with some sort of video capability, even if it's only recording brief jerky, low-resolution clips without sound. But if you're thinking about buying a semi-pro or professional *Digital Single Lens Reflex* camera (*D-SLR*), sorry, you'll have to forgo video.

Video works in consumer digital cameras because the image sensor is continuously exposed, wide open to the light passing through the lens. You also can preview the image through an electronic *eye-level viewfinder* or *LCD viewfinder* at all times, because some of the data put out by the image sensor is diverted to the viewfinder. When you actually take a photo, an open mechanical *shutter* in front of the image sensor briefly closes, then opens to take the image, closes, and opens again. All this happens within a fraction of a second . . . literally in the blink of an eye.

D-SLRs operate on a different principle, however. The image sensor is hidden behind a lightproof shutter, with all light coming through the lens diverted to the mirror-and-prism system that makes up the optical eye-level viewfinder. When you take a photo by pressing the shutter, the mirror instantly swings up out of the way, the lens closes down to its predetermined *f-stop*, the shutter opens, exposing the image sensor, the image is captured, the shutter closes, the lens *diaphragm* reopens, and the mirror swings down. As with a consumer digital camera, all this happens so quickly that your eye perceives it as virtually instantaneous. The point, however, is that the image sensor is exposed for only a fraction of a second in the D-SLR rather than continuously; therefore, no video is possible.

How Your Digital Camera Differs from Your Camcorder

Superficially, digital cameras and digital video (DV) camcorders are kissing cousins. (See Figure 10-1.) They both have many similar or identical components and features. Both may be capable of recording still images, videos, movies (video with sound), and audio clips. Depending upon the model, both may save to some form of digital tape, a mini-CD or DVD disc, or standard memory cards. Where they part company is how—and how well—they capture, record, and store the images, video, and audio data.

Digital still cameras are specifically designed to capture crisp, sharp pictures every time you press the shutter. The images they produce are usually destined to become prints or be displayed on the Web. DV camcorders are specifically designed to capture motion and sound at 30 to 60 fps, and the movies they shoot will be displayed on a television set or computer monitor, or posted as video clips on the Web. That may sound very similar, but in fact they're quite different.

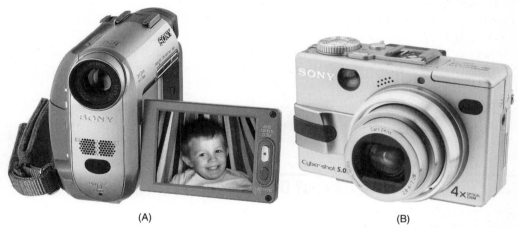

(A) (B)

Figure 10-1: Digital video camcorders and still digital cameras are kissing cousins, but they are definitely different creatures. Note the ergonomics that force you to hold and shoot each one differently. (A) A Sony DCR-H20 MiniDV camcorder with an articulated (swing out) LCD viewfinder. (B) A Sony DSC-V1 still digital camera.

Here are the ways digital video and still digital cameras part company:

■ Even at its highest, most DV camcorders' resolution is much lower than digital camera resolution. Typical resolution is 720 × 480 pixels, though the latest generation of expensive HDTV-capable camcorders can capture up to 1920 × 1080 pixels. But a typical 5MP digital camera has a maximum resolution of 2592 × 1944 pixels. 6MP and 8MP digital cameras shoot at even higher resolutions.

■ Camcorders come equipped with stereo microphones, 12-bit and 16-bit audio recording capability, and most have the ability to accommodate an external microphone. The monophonic microphones on still digital cameras are, almost without exception, of poor quality and badly positioned. Worse yet, the sound pickup (volume, tone, or direction) usually cannot be adjusted.

■ Digital camcorder zoom lenses tend to provide much larger optical zoom capability, such as 12X or even 20X. Providing the same zoom ratios on digital still cameras would require using, as our friend and *PC Magazine* colleague Jan Ozer says, "zoom lenses the size of Coke bottles."

■ Although almost all camcorders offer image stabilization, or anti-shake capability (which is necessary for hand-held pictures taken at extreme zoom), it's a feature that relatively few still digital cameras offer.

■ The ergonomics between the two devices are usually quite different. (See Figure 10-1.) They are even gripped differently for viewing and shooting. Most digital camcorders are long, while most digital cameras are wide. Camcorders are designed to be shot one-handed by slipping a strap around the right wrist, with the right elbow extended. Most digital cameras are meant to be gripped around the right side of the body, with the right elbow bent upward.

■ All DV camcorders have soundproofing built into their bodies, allowing users to zoom and focus while shooting. Few digital still cameras are soundproofed, so most manufacturers deliberately disable zoom and focus capabilities while shooting in video mode.

■ Depending upon the still camera model, autofocus, exposure, and white balance may or may not be frozen when you press the shutter to begin recording, even if lighting conditions change during shooting. Most DV camcorders will continue to adjust autofocus, exposure, and white balance as the scene changes, while you record.

■ Most DV camcorders feature both an eye-level electronic viewfinder and an oversized articulated (swing-out) LCD viewfinder. While many still digital cameras now feature electronic eye-level viewfinders and articulated LCD viewfinders, the latter tend to be much smaller and less detailed that those on DV camcorders.

■ All DV camcorders have a built-in FireWire (IEEE 1394) interface, for fast data transfer to your computer, while many digital still cameras have a USB 1.1, which is very slow going for video transfer. However, some of the newest still digital cameras have USB 2.0, which is almost as fast as FireWire.

■ The feature sets are significantly different. Most DV camcorders come with built-in video-editing and special effects capabilities, while most digital still cameras lack the ability to vary the frame rate, and have only the most rudimentary playback options. On the other hand, most still digital cameras have a built-in flash and other features that most DV camcorders lack.

■ DV camcorders save to DV, Digital 8, MicroDV tapes, or various DVD-recordable formats. A few can save still images to SD or Memory Stick memory cards, and a handful save only to memory cards, rather than tape or disc. Most still digital cameras save only to memory cards, although Sony Mavica digital still cameras save to CDs.

Hybrids: Two Side-by-Side Cameras in the Same Body

As versatile and advanced as still digital cameras have become, they're still far, far away from that magical, mythical technological holy grail called convergence, when your still digital camera will take movies every bit as good as your camcorder, and your camcorder will take really great still photos. A

number of technical differences and operational difficulties between a digital camera and a DV camcorder still defy a practical, affordable solution. Chances are we may never see true convergence.

Samsung's $1,299 DuoCam SCD5000 attempts to eliminate this either/or conundrum with hybrid technology that combines full video capability with full still digital capture. How did Samsung pull off that feat? By building two cameras in one body. One side of the camera is a conventional DV camcorder, with its low-resolution CCD, MiniDV tape storage, and large 10X optical zoom lens, while the other side is a conventional 4-megapixel digital camera with a 3X optical zoom lens, Memory Stick image storage, and conventional digital camera feature set. A user can switch from one type camera to the other in seconds, simply by rotating the unit 180 degrees.

Does it work? Yes. Does it work *well?* The jury's still out on that one. Still images are very good, better than almost any other DV camcorder. Surprisingly, we have read reviews that have found the video image quality somewhat disappointing, especially in low light. One thing to keep in mind is that buying the DuoCam probably won't save you money, because the price is about what you can expect to pay for a separate DV camcorder and a still digital camera. Plus the camera itself is marginally inconvenient to use. However, there is the convenience of having to carry only one device instead of two.

Choosing Your Digital Camera According to Its Video Capability

If video is a vital feature to you, then you should carefully examine the specs of any still digital camera before you buy. They vary considerably. Here's what you should look for:

- **Resolution**—Remember the resolution or size images that your still digital camera captures is going to be much higher than its video capability. So, be sure to pay attention to the specifications for video resolution, too.

 - Many digital cameras offer 320 × 240 pixel video resolution, which is a good all-around size for the Web and emails.

 - More efficient and economical is 160 × 120 video resolution. It takes up less memory, is faster to process, and is easier to upload to the Internet. However, we don't recommend using it because the movies will be displayed only slightly larger than a postage stamp.

 - Better consumer cameras are capable of recording 640 × 480, which produces bigger, sharper, clearer images when displayed on television sets or computer monitors. It looks great on the Web, too, but the files are so large that you and your intended viewers may be frustrated by the long upload and waiting times required.

 - A handful of digital still cameras even can record 720 × 480 pixels at 30 fps, which looks great on an HDTV display.

 - Some still digital camera models allow users to select between or among different resolutions.

- **Frame rate**—How many frames, or pictures, per second (fps) a still digital camera can take is important.

 - Ideally, it should be able to capture 30 fps, because that's slightly faster than the human eye can distinguish continuous motion. But 30 fps, especially when coupled with a high

resolution such as 640 × 480, eats up many megabytes and even gigabytes of storage space and taxes camera and computer resources.

- On the other hand, slower frame rates, such as 10 fps or 15 fps, can produce a noticeable, annoying jerky motion, like watching an old silent movie. But—and there always is a but—15 fps may be a perfectly acceptable frame rate for displaying movies on the Web, and certainly uses less storage space than 30 fps. A few cameras give users the ability to choose between two different frame rates.

- **Recording time**

 - Many digital cameras allow you to record video until you run out of storage space. Others have more limited buffers or slower electronic components and eventually must discontinue recording.

 - Cameras with limited recording time may capture clips as short as 15 seconds, although 60 seconds or 5 minutes are more common limitations.

 - Of course, there's a direct relationship between resolution, frame rate, and recording time, which allows some digital cameras to record at lower resolutions or frame rates until memory space is full, but may limit recording time at high resolutions and frame rates.

Make a High-Quality Slide Show Instead of a Low-Quality Video

Jan Ozer, our fellow Contributing Editor at *PC Magazine* and the author of *PC Magazine's Guide to Digital Video* (Wiley 2004), feels that in some cases you really don't need or want to shoot video with your still digital camera. "Video is terribly difficult to do well," Jan explains. "It can be very time-consuming, and when you're starting with low-quality footage [such as still digital cameras produce], it makes things even harder."

Jan suggests that you might consider shooting a series of high-quality still photos and making a slide show (as we describe in Chapter 19). You're starting with great individual frames (your hand-picked still photos), and slideshow software is both inexpensive and generally easy to use. "In reality," Jan said, "it's easier to create a slideshow with 30 good pictures, titles, background, transitions, special effects and some music, than to shoot 40 minutes of video and edit it down."

Optional Accessories That Will Improve Your Videos

When you buy your digital camera, the salesperson will inevitably try to ring up a higher number on the cash register by trying to convince you to buy a variety of optional accessories. Many you probably don't need, but others are very useful. Here are a few items you might want to consider buying and using if you plan to shoot videos:

- Large capacity, high-performance *memory cards*
- Spare battery
- USB 2.0 card reader

- Tripod or monopod
- Lens shade
- Video light and bracket

LARGE CAPACITY, HIGH-PERFORMANCE MEMORY CARDS TO SAVE YOUR VIDEOS

Videos are memory hogs. Shoot a brief 60-second recording, and you may consume 17 to 30 *megabytes* of memory. Plus saving them can be a major bottleneck, because you can shoot much quicker than many typical memory cards can save. Ideally, you'll want to have cards with the following attributes:

- For video, your memory cards should be as large as you can afford (256MB or bigger).

- High-resolution recording video burns megabytes each and every second, which means you will want even higher-capacity cards, at least 512MB. One gigabyte or 2GB are better. (Don't bother with higher-capacity cards, because most consumer digital cameras don't as yet support the file format needed for cards over 2GB.)

- If you are shooting 640 × 480, 30-fps video, your memory cards should be fast. Both Lexar Media and SanDisk (as well as other card manufacturers) market high-performance cards, for which you will pay a premium. But with video, it's worth it. Just make sure your camera will support them.

SPARE BATTERY BECAUSE YOU WON'T WANT TO STOP SHOOTING

Shooting your still digital camera in video mode will use up your batteries faster than taking still photos. Many digital cameras automatically activate the LCD viewfinder (a major power drain) whenever you go into video mode. What's more, shooting video keeps other components going for longer periods than just shooting still images. While you probably will run out of memory before your batteries die, you should be prepared by having a spare, fully charged battery handy.

USB 2.0 CARD READER FOR TRANSFERRING VIDEO TO YOUR CAMERA

Not only will making a movie fill up your memory cards quicker than you can say "Jack Rabbit," it will make file transfers (pardon our mixed metaphors) as slow as molasses.

Unlike DV camcorders, no current consumer digital camera comes equipped with a high-speed FireWire interface. So, unless your camera has USB 2.0—which at its fastest still will be time-consuming—don't even think about transferring video data directly from your camera to the computer.

We strongly suggest forgetting about making any direct connect and instead attach a USB 2.0 card reader to your PC (assuming that your computer is one of the newer breed that supports USB 2.0). Better yet (although somewhat more expensive), buy a FireWire card for your PC, and attach a FireWire card reader, such as Sandisk's FireWire ImageMate.

A TRIPOD FOR KEEPING EVERYTHING STEADY

Unless you want to create a *cinema verite* impression with obvious hand-held movements as part of the effect, you'll want to hold your camera as steady as possible. The best method is to use a tripod or monopod (see Chapter 4 about tripods and monopods, plus Chapter 6 on how to brace your camera when you don't have a tripod). An added advantage is that with your camera on a tripod or monopod, you'll be able to pan and zoom smoothly without distracting shakes and jumps.

A LENS SHADE

Because you may be shooting outdoors, and panning in and out of sun and shade, you'll want to avoid lens flare as much as possible by using a lens shade. Unfortunately, most compact digital still cameras don't have threads or an adapter that allows you to attach a hood to the lens. If you can't fit a hood to your lens, you might consider holding a black umbrella overhead, or even a black or gray piece of paper a few inches above the camera itself.

VIDEO LIGHT AND BRACKET

Shooting inside in low or mixed light often causes exposure problems. You can brighten your movies by boosting the *ISO equivalency* (which may create noisy movies speckled with lots of miniscule dots), or you can use a movie light.

Video lights and brackets are relatively inexpensive and available at many places that sell camcorders. The more expensive ones are battery powered and completely portable, while other movie lights are corded and must be plugged into a nearby wall outlet.

When using an optional video light, your camera may have difficulty automatically adjusting to the lighting and could produce a *color shift*, such as a bluish tint, in your pictures. We suggest putting exposure on auto, but if your camera permits it (and most do), forget about auto white balance and instead take a manual white balance reading (See Chapter 8 about white balance). If your camera doesn't feature manual white balance, try instead selecting the incandescent (tungsten) preset. The icon is usually a cartoonish shining light bulb. ☀

BUT YOU PROBABLY DON'T NEED ADDITIONAL VIDEO SOFTWARE

Most, but not all consumer digital cameras with video capability come bundled with some sort of video editor program. It's probably adequate for basic editing—splices, transitions, loops, a few special effects. If you want a more polished, professional look, you will likely want to buy more robust software.

However, as Jan Ozer said to us, "If and when you reach a point when inexpensive ($29 to $99) third-party software isn't adequate for the movies you to do, it's probably time to switch over to a DV camcorder to shoot your videos."

Creating Light in a Pinch

You want to shoot a video in a dark, dingy room, but you didn't bring along a movie light. Don't worry: you probably have something nearby that you can use in a pinch. Turn on all the lights. If there is a handy floor or desk lamp, remove the lampshade and move it close to the subject. Open the blinds or curtains, if it's still daylight out, and let the sunlight stream in. If you still can't put enough light onto your subject, consider asking the subject to move where the light is much better. And if you still are getting dark pictures, you can try the following techniques:

- Boost the ISO equivalency (see Chapter 6).

- Put exposure compensation ⊠ at its maximum plus setting (see Chapter 6).

- If your camera allows it, reduce the resolution or the frame rate. This may allow more light per frame to fall on the image sensor.

- Try all three remedies.

Tip: Practice Run

Before you shoot that all-important video, make a few short trial runs. Try shooting three or four 10-second clips and then viewing and listening to them in playback. This will allow you to check exposure and white balance, because if it doesn't look good in the viewfinder, it's going to appear lousy on the Web or television. Keep shooting tests until you think they look right and then delete them before taking videos you want to save.

Before You Start Shooting Your Video

The first two things you'll want to check before you start are memory card capacity and battery status.

- If you don't have any images already saved on the card, it's always a good idea to refresh it by reformatting the card. If you do have images on your memory card, you might want to briefly review them and delete as many superfluous or marginal pictures as possible to free up the maximum amount of storage space.

- If you can, have a spare memory card or two in your pocket, so you can continue recording when the first card runs out of space.

- Many still digital cameras have a countdown on the LCD viewfinder that displays the approximate number of minutes and seconds of memory left for video recording. Always check it before you start so you have an idea of how much time you will have before you have to swap memory cards.

- Your batteries should be freshly charged, with a spare set at the ready.

Shooting Videos

Recording movies isn't all that different from shooting stills. Fortunately, most of your settings will be on auto, so you won't have to fiddle with exposure controls. In fact, when shooting video with digital still cameras, many of the camera's settings won't be user-changeable. But you will have to pay extra attention to framing (composing) your subject, because most still digital cameras won't let you focus or zoom your lens while shooting video.

The first thing you must do is put your camera into video mode. On many cameras, this means rotating your mode dial or pushing a switch to the little movie camera mode. (See Figure 10-2.) Other cameras put their mode controls as a menu item on your LCD viewfinder or control panel.

Figure 10-2: This video icon, which is used in Kodak cameras, is quite similar to those used by other manufacturers. Essentially, video is usually represented by an icon that looks like a movie camera.

Once you are in movie mode, you'll discover that your menu options have shrunk considerably, with lots of features and functions either grayed out or not displayed. In many cases, this is because you're not taking still photographs, so those settings related to still capture aren't necessary. However, in other cameras, features are crippled when shooting video because of the limitations of using a hybrid technology.

Depending upon your make and model, you may have the following options available:

- **Exposure compensation**—Most movies are shot in less than ideal lighting situations, and many movies turn out underexposed. If your videos look darkish on playback, try raising the exposure compensation to +1 or +1.5, or even +2. However, if you're shooting outdoors and everything is washed out, set exposure compensation at −1.5 or −2. (See Chapter 6.)

- **ISO equivalency**—Auto is good, lower settings may not provide sufficient light, and higher settings will increase *noise*. Given a choice of bad exposure or boosting the ISO equivalency, always opt for the latter. (See Chapter 6.)

- **White balance**—You must get the color right, or else your movies will have a blue, yellow, red, or brown cast to them. Use auto white balance outdoors, but try to use manual or preset white balance indoors, in mixed lighting, or when shooting with movie lights. (See Chapter 8.)

- **Digital zoom**—Making movies is one of the very few times that you should use digital zoom to get up close and personal. Since the frames you're shooting are small, the loss of picture quality won't be too noticeable.

- **Resolution**—Some cameras allow you to choose among 640 × 480, 320 × 240, or 160 × 120 pixels. Choose the one that corresponds to your intended output: 640 × 480 for computer monitor or television viewing; 320 × 240 for Web display; 160 × 120 for emails.

- **Self-timer**—This can be useful if you want to include yourself in the movie and have your camera on a tripod. Remember, though, you'll have to turn the camera off manually, by pressing the shutter button.

- **Night movie**—Probably the only unfamiliar feature in this list, night movie on some cameras automatically sets the lens at its lowest *f*-stop, raises the ISO equivalency, and activates an anti-noise algorithm. All this helps produce the best possible image quality under adverse lighting conditions.

Once you are in video mode, pressing the shutter begins the recording and pressing it again ends recording.

Tip: You Can Mix Videos and Stills

While you are shooting videos, if you see something that would make a good print, change your mode dial to camera and grab a few still shots. That way, you get those pix at full resolution, rather than having to lift a tiny frame out of the video (which, in any event, can be time-consuming and disappointing). Then switch back to video mode. There's no penalty for switching back and forth between modes, since both video and stills are saved to the same memory card, but use different formats.

Tips for Capturing Good Video

All the rules of proper exposure and good composition for photography (see Chapters 6 and 12) apply to video, too. But other tips are particular to movies:

- The key to taking good videos is to be as smooth as possible, and that means panning the camera s-l-o-w-l-y when you are moving position.

- Always try to keep the camera parallel to the ground, so you don't get off-angles that people have to tilt their necks to view properly.

- Pace your clips. Long, continuous videos are usually very boring. Besides consuming lots of megabytes of storage space, they tend to turn off viewers. On the other hand, very short

clips are teasing, tantalizing, or just plain annoying, because you never have any time to follow any of the action.

Recording and Playing Audio

Built into most still digital cameras is a digital tape recorder. No, it's probably not called that in the instruction manual that came with your digital camera, but that's what it is in many models that can separately record audio.

There are three ways that still digital cameras record sound:

- As part of a video

- As audio only, separate from a picture or video

- As an attached annotation to an image

In many digital cameras, even if you want to, you can't turn off the sound recording when you're shooting video. So, if you want silent movies, either cover the microphone with a band-aid or cellophane tape or kill the audio when you are editing the clip in your computer.

Tip: Getting Good Sound

Most still digital cameras have a tiny microphone on the front of the camera, near the lens, although some have it located on the top or even on the side. Wherever it is, you can be reasonably certain that the sound quality will be soft and tinny. There's no way to adjust the recording quality or sensitivity, so the only way you can improve the sound is to get closer to your subject. Ask your subjects to speak directly into the camera. And try to minimize background noise, such as turning off air conditioners or fans, stereos, and TV sets.

Using Your Camera as a Voice Recorder

Some still digital cameras allow users to record sound as WAV files. This feature is almost always accessed through the menu options, and records sound in place of images. Once this feature has been selected, you start recording by pressing the shutter button and end it the same way. How long you can record depends upon the memory card. For instance, a 16MB memory card can record hours of uninterrupted audio, and a 256MB card can get 17–18 hours. Since the image sensor is turned off, the batteries should last much longer than usual.

How good is your recording? About the same audio quality as an inexpensive 8-bit digital tape recorder. We confess that we've used a digital camera to tape interviews when we forgot to take along a digital recorder, or when the digital recorder we had wasn't equipped with removable memory or a USB port to transfer WAV files to the computer. (Audio is easier to edit, store, and transcribe in the computer than constantly pushing stop-and-go buttons on a recording device.) And because the camera saves images, video, and audio on the same memory card, we also could take a few shots of

the person whom we were interviewing. Back at our studio, we then could replay the interview simply by removing the memory card, transferring the files, and listening to them on our computer.

Recording Your Notes about Your Photos

Interestingly, some digital cameras position their microphones on top of the camera, not so much to capture the voices and sounds of the subject, but primarily to record the photographer's comments and notations about the photo being taken. Better digital cameras give the user the ability to attach 5, 10, or 15-second audio notes, called annotation, to still images. This allows you to accurately identify and describe in some detail the picture you've just taken. Metadata is fine for reviewing how you took a particular picture (see Chapter 5), but useless for recording vital information, such as the names, addresses, phone numbers, ages, and so on, of the person or people in the shot. Or, you might record something detailed like "I took this series of shots outside Madison Square Garden in New York City. Hundreds of teenagers, with a lot with spiked hair and punk clothing, were lined up for autographed posters from a group of WWF pro wrestling superstars. It was a cool sight!"

With most cameras having annotation capability, you activate it with a menu setting, and depending upon the make and model, you just begin speaking after the exposure, speak after a light or beep prompts you to begin recording, or press a button after the exposure and begin speaking. In playback mode, there's usually a menu command that prompts you to push a button and begin speaking if you want to annotate a saved picture.

Annotations are saved as separate WAV files, but have the same name as the image file (though a different extension) and are automatically attached to its corresponding photo. You'll see some sort of indicator in playback mode that tells you there's an annotated file. Both files are transferred together to your computer. Depending upon the viewer software you have installed, the audio will either automatically play when you open the image file or will play with a mouse click. Some programs will allow you to edit, delete, or expand the audio file. Other software can include those annotations as part of a slideshow. And some programs can even embed audio inside an image file rather than save it as a separate WAV file. This is useful if you want to permanently affix the audio to a particular image, and plan to use it in making a slideshow presentation.

Tip: Check Your Controls

Many still digital cameras provide rudimentary audio controls, such as playback volume control, the ability to mark specific segments, and settings for voice or music. Check your camera's documentation to see what controls you have available and how to activate them.

Music from Your Digital Camera

If your still digital camera has a built-in speaker (most do), you probably can play music through it. All you have to do is record some tunes on the memory card, either on your computer or any handy MP3 device, slip it into your camera, and put it in playback mode. Most cameras recognize and play WAV files that were recorded elsewhere. The sound quality may not be great, but hey! You have a handy music box built into your camera.

Certain models are specifically equipped to play MP3 music. These cameras actually have a phono plug for inserting a pair of miniature stereo earphones. Such combo cameras usually offer very few photo-taking features, but they also tend to be fun and funky, with strange shapes and stylish bodies, designed primarily for teens and twenty-somethings. Picture quality isn't great and resolution is generally 2 megapixels or less, but they're relatively cheap and built to take abuse.

Summary

This chapter covered a variety of issues concerning recording video and audio with your still digital camera. Some of the key points included the following:

- Most still digital cameras can capture movies with sound, though not as easily or as well as DV camcorders.

- Still digital cameras and DV camcorders have much in common, but they are so very different that convergence will be difficult, if not impossible, to achieve.

- If making movies with your still digital camera is an important consideration, be sure to check the specs of any model that you may consider buying, and don't buy a digital SLR.

- Making movies with a still digital camera isn't all that different from taking still shots, requiring attention to good composition and proper exposure.

- Every user making movies with a still digital camera should consider adding certain accessories, such as high-performance memory cards, tripod, extra batteries, and other items to assist in productivity and convenience.

- Some still digital cameras can record sound, make annotations, and even play music.

Chapter 11

Digital Photography Tips and Tricks

When we first moved to the Pocono Mountains, we loved getting in our car and taking off, not knowing where we were going. The smaller the dirt road, the better. Getting lost was part of the adventure; around each curve might be a festival or quaint town or vista we'd never seen. But because the area eventually became familiar, it's more difficult for us to get lost in our own neighborhood. When we take dirt roads these days, it's usually because we know from experience that they're convenient (and pleasant) shortcuts to where we want to go.

Learning digital photography can be a fun adventure. When you have the time to explore, that's exactly what you should do, trying unknown commands and features without quite knowing what the results will be. But when you need to get a particular photograph or reach a specific project goal, you'll need to know what shortcuts will work quickly and efficiently.

In this chapter, we'll share some of the shortcuts we've learned over the years from experience and from talking with other photographers. These tips and tricks will get you where you need to go with your camera faster, easier, and with better results, while still having fun with the photography. Most importantly, some of them may help you get the shots that otherwise might have gotten away.

Tip: Know Your Camera

Only when the technology becomes so familiar as to be transparent can you really be comfortable with your camera and explore the full potential of digital photography. Don't be intimidated by the buttons and menus; experiment with them. Take your camera wherever you go, as though it were your cell phone or wallet. Shoot everything you see until all the controls and menus become second nature to you. Soon, you'll be like the pros who consider their cameras extensions of their minds and hands, the glasses they hold up to their eyes to see the world more clearly. This, more than any other tip we can offer you, is the key to developing your own skills as a photographer.

Shooting on the Fly

Essentially, photography can be divided into two types. Some photographers plan meticulously, working out every detail beforehand exactly and precisely, leaving as little as possible to chance. Such shoots

are usually, but not always done in a studio. Then, there's real-world photography, in which even if you plan carefully, life will conspire to challenge and surprise you.

Here are some suggestions to help you when you can't plan, because you can't know for certain what the next moment will bring:

- When shooting, you're very dependent on the feedback you get from the *LCD viewfinder*. But how much can you trust what it is telling you about the scene and the photos you take? Get to know the truth about your camera's LCD viewfinder. Does it tend to display photos as darker or brighter, more red or more blue, than what you see when you upload the pictures to your computer or print them out?

- Few *eye-level viewfinders* are truly accurate. As a rule, digital cameras capture more than the eye-level viewfinder displays. (It's almost never the opposite.) Frame your pictures with that in mind, but don't depend on it. If there's something your composition requires you to capture within your framing, move until you get the entire object in the viewfinder.

- The most important tools you have for getting the picture you want are your mind, your eyes, and your legs. Get up and move to get the picture you want, rather than depending upon your zoom lens.

- Don't use your camera's built-in flash for anything over 15' away; it just won't illuminate properly past that point.

- On consumer cameras, keep the *fill flash* turned on in most shooting situations in which the subject is close enough for it to reach, even in bright sunlight. It will provide just enough illumination to minimize or eliminate harsh shadows, especially when photographing faces. Of course, if you are looking for artistic shadows, turn the fill flash off. (See Chapter 9.)

- Learn to read the light of scenes. Are the edges between the shadows and light hard or soft? What is the angle and direction of the light? How do the colors of light change through the day? See the world as your lens sees it, textures created by color, light and shadow, and you'll start to see and capture new kinds of photos. (See Chapter 9.)

- The best photographs are usually taken when light is dramatic, when the sky is glowering, and/or when light is at an angle (such as early morning or late afternoon).

- Do you find that you are frequently using certain combinations of settings in a particular type of shoot? Many digital cameras allow you to save what are called custom defaults. Press a button (or choose it in the LCD menu), and those favorite settings are automatically invoked for you. (Typical settings would include your preferences regarding flash, metering, white balance, focusing mode, exposure settings, and so on.) Depending upon your camera, you may be able to save from one to six different sets of custom defaults (that is, if your camera has it at all). You can use those extra settings for different shooting situations, such as one for low light, another for action subjects, yet another for portraits, and so forth.

- If your camera has the lens threads to accommodate filters, use a polarizing filter to remove reflections from glass and water in your photos. Turn the outer element of the polarizer until you can see through the window or below the water's surface. If you want a slight glare, turn the filter back in the other direction just a little. Polarizers are also great for making your skies look more dramatic.

■ If your LCD viewfinder has the ability to magnify its view, it may not be only for playback of photos already taken. Depending upon your make and model the camera, you may be able to use it to magnify your subject and confirm how sharp your focus really is before you take the picture.

Making the Shoot Last Longer

Photography has always been dependent on supplies to keep going. It used to be that we would load our camera bags with extra film and batteries (and, for the really old-fashioned cameras, with flashbulbs) so we could keep shooting as long as we saw pictures we wanted to capture. With digital photography, we're dependent on memory cards and batteries. Run out of memory or battery power, and you're dead in the water.

Here are some suggestions for preserving battery power:

■ Turning your camera on and off frequently will actually use up more power than leaving it on. Most cameras have a sleep mode that will take over when you don't shoot for a set amount of time. Pressing the shutter button wakes up the camera from its sleep mode in less time than it takes to turn it on, and it uses less power, too.

■ Many cameras allow you to adjust sleep modes. Adjust it to one minute rather than larger increments and your battery will last longer.

■ If you're anywhere near an outlet, recharge your batteries even if it's just for a few minutes. With some cameras, that means plugging in the dedicated AC adapter; others require that you use the separate battery charger. Whichever it is, topping up the power in your rechargeable batteries will give you that much more shooting time.

■ Batteries don't function well in extreme temperatures, running out of power more quickly in severe cold or heat. Generally speaking, batteries like to be about room temperature. If it's very cold outside, take the battery out of the camera and put it in your shirt pocket until you're ready to shoot. In fact, in cold weather, do the same with your memory card. If shooting in very hot climates, carry along an ice pack in a cooler for your batteries. By the way, don't do the same for your camera. It needs to be acclimated to the ambient temperature, whatever it is. Otherwise, you might end up with condensation on the lens and viewfinder.

■ If you're running low on battery power, limit your use of the zoom (unless it's a manual zoom), LCD viewfinder, and flash. All three are major power drains.

To help you save on memory card capacity, try some of these tricks:

■ Balance image quality requirements against how much space you have left in your memory card. True, JPEG compression is not as high quality as TIFF or RAW, but JPEG will take up much less space. Sometimes, the only way you're going to get the photo is if you take it in JPEG. Besides, for many applications (such as small prints 5″×7″ and under, or email and Web photos), JPEG is probably preferable.

▪ Carry a portable CD/DVD burner or mobile viewer/hard drive storage unit. (See Chapter 4.) You can dump your photos from your memory card directly to these devices without connecting them to a computer. For those all-important shoots, they offer a secure backup, too.

▪ Always carry extra memory cards, even when you think you won't need them. And buy as high-capacity cards as you can afford. For safety's sake, carry them in the small plastic boxes they came in, or get a wallet made for storing memory cards.

▪ If you bracket your shots, taking the same subject at different exposure white balance or a variety of other settings (which is good insurance to make sure you get your photo), review the series and delete the obviously bad ones. (Of course, we come back to our first tip. You need to know how much you can trust your camera's LCD screen.)

Keeping Your Camera Steady

No photo will look sharply focused if the camera moved while you were taking the shot. Unless you are shooting at a fast shutter speed (see Chapter 6), you will want to find ways to steady your camera. Here are some ideas that may help you achieve maximum stability:

▪ For those cameras that allow it, set your zoom lens to maximum wide angle. That way, camera shaking will be minimized.

▪ Brace the camera against your body by pressing your elbows into your chest, using your bent arms to hold the camera steady, while you bring it up to your eye or in front of your face.

▪ The most assured solution is to use a tripod, monopod, or minipod. There will be little or no side-to-side motion. If you have a tripod, you probably can make use of its ability to pan (or track), from left to right or right to left. This allows you to smoothly follow action.

▪ If you have the camera set up on a tripod, use the self-timer to avoid even the small amount of shaking introduced by pressing the shutter button. Self-timers work either as a button that you press or as a menu option. (The former is much preferable.) After a few seconds (typically 2–10 seconds) during which there's usually a countdown and an accelerated beeping, the camera's shutter release is automatically activated, taking the picture. (This is also how you get yourself into the picture even though you're taking it.)

▪ If your digital camera has some sort of anti-shake or image stabilization technology (a few models with large zoom lenses do), then by all means turn it on—that is, unless you are using a tripod, in which case anti-shake technology is entirely unnecessary.

▪ If you don't happen to have a tripod handy, look for a desk, rail, table, windowsill, or some other nearby solid object on which you can place or brace your camera while shooting.

Often, the most important thing to help ensure that your camera is steady is knowing how to hold it correctly. Because there are so many different sizes and form factors (that's the industry buzzword that means shapes), we can't give you specific advice on the best way to hold and handle your make and model digital camera. But there are a few basics that you should keep in mind:

- Regardless of how you hold your camera, make certain that none of your fingers blocks the lens, flash, or any of the sensor windows.

- Always keep a firm grip with your right hand, and loop the strap through your wrist or around your neck. A weak grip makes it easier to accidentally drop the camera if it is jostled. But don't hold it so tightly that your muscles are tense, because that can cause another kind of shakiness, as well as make shooting unpleasant for you.

- Many cameras are designed for easy one-handed shooting. Even so, you should, whenever possible, hold the camera with both hands.

- If you are shooting a full-sized camera, grip the side and back firmly with your right hand, and place your left hand underneath the camera or around the lens barrel for the best possible support.

- Always squeeze the shutter rather than jabbing it down with your finger. Counterbalance pressing the shutter by gripping the camera back tightly with your thumb. Squeezing the shutter will always produce sharper pictures.

Then again, maybe you want the freedom of expression of not having a steady camera. Sometimes, a blurred photo is just the ticket for conveying motion and vitality. However, be certain that you are capturing blur because it was what you intended and not because you couldn't help it.

Exposure

As we discussed in Chapter 6, getting a picture is all about getting the right amount of light onto your *image sensor*. Here are some helpful hints we've learned over the years regarding digital camera exposure:

- Digital cameras are much better at capturing details in shadows than in highlights. Therefore, if you can't get the exposure just right, err on the side of a slightly dark picture rather than one that's overexposed.

- If you are shooting in low light and don't have a tripod or can't easily brace your camera, then it's time to bite the bullet and boost your *ISO equivalency*. Yes, it will increase visual *noise*, but if you really want the photo, it may be the only way to get it. Other options are to slide *exposure compensation* to its highest + setting, and/or, with the camera on *aperture priority*, open the lens to its lowest *f-stop*. (See Chapter 6.)

- If taking pictures of sports, kids, and other action shots, you'll usually want to set your camera to *shutter priority*. When shooting landscapes, buildings, close-ups, and portraits, you'll probably want it on aperture priority (see Chapter 6).

- If you can't be sure that you have the correct exposure, shoot RAW (see Chapter 5). That will allow you to actually change the exposure setting after the fact. But that's not the same thing as having the right *f*-stop (for *depth of field*) or shutter speed (for capturing action). To be sure you have those settings correct for the composition, bracket your shot. Many advanced cameras have *auto-bracketing*. But if yours doesn't, all it requires is taking a series of photos of the same scene, using incremental settings.

How to Protect and Clean Your Camera

Dust, dirt, and fine grit are your camera's natural enemies. They can seep inside motors, seams, and electronics, building up heat, damaging fine micro-movements, and obscuring lenses and sensors. Left unchecked, dirt and dust will reduce performance and efficiency, diminish overall image quality, and probably shorten the life of your camera.

■ Very few digital cameras come with a case or bag, and even those that do, often they're inconveniently shaped, ugly, or virtually useless. And yet, a case or bag is the best way to protect your camera from dust and dirt. In a pinch, you can use any small and soft bag-like cloth, like a sock, mitten, or hand mitt. You might even consider putting your camera in a plastic Ziploc baggie.

■ The best way to clean your digital camera is with a damp, lint-free cloth. We find that an old washcloth works best. We dampen it very slightly and store it in a Ziploc bag, so it's ready to use anywhere. DON'T ever use alcohol or any other cleaning solvents on digital cameras. That's because most digital cameras have plastic parts, rubberized gaskets and "O" rings that can break down when subjected to caustic solvents.

■ You'll hear lots of contradictory advice on how to clean your camera's lens. Some swear that you need lint-free photo tissue paper and a special cleaning solvent, while others are convinced that the only way to clean a lens is with a hand-squeezed dust blower and a camel's hair brush. Personally, we have used a very soft lint-free handkerchief for many years, on very expensive Leica and Hasselblad lenses, with excellent results. Rather than use a solvent, we breathe warm, moist air to fog up the lens, and then use that to wipe off grit. In a pinch, we have occasionally used lint-free tissues. So long as you don't wipe your lens with a hard, abrasive cloth or paper, or use high-pressure air directly on the lens, you should have no problems in cleaning the lens.

■ One other thing you might consider cleaning from time to time are your memory card contacts. You can use a pencil eraser on the gold contacts of SD and SmartMedia cards. Or use a cotton swab with a little bit of clear isopropyl alcohol on it. Wipe the contact with the damp end, and then use the dry end of the swab to dry the contact. With either, be sure to use a very light touch, and with the eraser, carefully brush away all the rubber bits. But it's better to avoid having to clean contacts altogether by keeping your spare memory cards in the clear plastic shells they came in, or buying an inexpensive memory card wallet if you usually carry a half-dozen or so with you.

If you have a camera with interchangeable lenses, one problem you may encounter is getting dust and dirt inside the camera and especially on the image sensor. Here are some tips on keeping the inside of your camera clean.

■ Use your body cap on your camera, whenever you don't have a lens mounted.

■ Check the inside of your lens and of your body cap for dust and dirt before putting them on your camera.

■ Shield your camera from the wind when changing lenses. Preferably, move inside. When that isn't possible, use any structure or your own body to block wind.

■ We advise against using any of the commercial image sensor cleaners on the market. They're not easy to apply, and you could permanently damage your camera's image sensor if you don't follow the directions to the letter.

■ If you have dust on the image sensor, DON'T use pressurized air to clean it. A squirt of canned air is so cold that it could conceivably crack the image sensor. Use a hand-squeezed rubber bulb instead.

■ If all else fails, contact the camera manufacturer and arrange for a factory cleaning. They'll do it right, and check out the rest of your camera at the same time.

In-Camera File Management

Inside every digital camera is, essentially, a miniature computer. What that means is your camera has the circuitry and intelligence to help you manage your files of photos. Here are some of the processes you can do within the camera:

■ Many digital cameras allow you to set up different folders for saving your photos. If you need to keep different projects separate, that's very useful. However, we have found that naming them can be a real bother. Instead, we like to use separate memory cards for each project (or each user of a camera).

■ It's very easy to delete your photos while they're in your camera . . . almost too easy. (Most cameras have a two-step delete procedure in which you have to confirm you really meant to hit the trash icon.) Luckily, in many models, you can also easily protect your files from being erased. If you have taken one of those "perfect moment" shots, go into the menu and mark it as undeletable or protected.

■ In those cameras that have dual memory card slots (supporting more than one type of memory card), as well as those that have internal built-in memory plus a memory card, you can actually copy from one to the other. It's like copying from your computer hard drive to a floppy disk.

■ After you have transferred your photos to your computer, you can use the computer's operating system to erase the card—but DON'T reformat it. Reformat it only in the camera, to be assured of the full compatibility of the file structure.

Summary

These are some key points made in this chapter:

■ Learn your digital camera. Experiment with it until using it becomes second nature to you. That way, the technology will become transparent to the photographic experience.

■ In real-world photography, even if you plan carefully, life will conspire to challenge and surprise you. But you can arm yourself with techniques and knowledge to help you get the photos you want and need.

- Digital photography is dependent on memory cards and batteries. So, you need to learn to conserve and extend both battery power and memory, if you want to keep shooting.

- If you want your photo to appear well focused, you'll need to learn various techniques for keeping your camera steady.

- Getting a picture is all about getting the right amount of light onto your image sensor. But if you can't get the exactly correct exposure, digital photography has techniques for helping you get the picture anyway.

- Keeping your digital camera safe and clean is vital for good photos and your camera's continued proper functioning.

- Your camera is like a miniature computer, with the circuitry and intelligence to help you manage your files of photos.

Part III

Photography with a Purpose

Chapter 12

Principles behind Great Photography

Here's a trick question for you—What camera will give me great pictures? The answer is none. Truly great photos are created by talented, skilled photographers, not by their equipment.

In the past, when we shot film, our equipment consisted of Leicas, Nikons, and Hasselblads—top-notch systems indeed. We traveled around the world on assignment, taking photographs that appeared in numerous glossy magazines, often with our own articles. But from time to time, we didn't have one of our professional units with us when that one great photo opportunity occurred. That's when we'd pull out our trusty pocket-sized Rollei, or on very rare occasions, we would buy a disposable film-in-a-box camera. And, yes, we did get some great photos with both—pictures that would sometimes be published in the same spreads as photos we'd taken with our expensive professional equipment.

In this chapter, we'll explore what it is that makes a great photo and share some tips from top pros for creating wonderful portraits, scenics, sports pictures, and other photos. Additional tips for specific situations are available throughout this book. For example, for guidelines on photographing kids and pets, go to Chapter 13, and for hints on photographing product shots, see Chapter 15. (Check out the Table of Contents for numerous other photo guidelines.)

Tip: An Amateur Takes a Photo; a Pro Makes a Photo

What is the essential difference between an amateur and a professional photographer?

An amateur sees something appealing, puts his camera up to his eye and presses the shutter button.

A pro considers a scene, walking, bending, or even climbing to get just the right angle. Then, he puts his camera up to his eye, and adjusts his position once again to get the composition just right. When he is satisfied with everything he sees in the viewfinder, based upon his sense of aesthetics, expertise, and personal style, only then does he press the shutter. What's more, he's able to do all that over and over again, instinctively and so quickly that he doesn't lose the moment.

What Makes a Great Photo?

No question about it; technology is what enables us to take pictures. Even back when photography was only chemical based, it was how good and how precise the camera and its lens were that established the foundation of the art form. The more control and mastery you have over exposure, focus, and other technical aspects of your camera, the more confident you can be of getting a good photo—or at least one that is well exposed, in focus, and reliably similar to what you saw in the viewfinder.

Still, technology should not and does not define art. Art is based upon an individual's creative vision, his way of looking at the world and then finding some means or method of communicating that same viewpoint or conclusion to others.

The good news is you can take great photos right now, while you're still learning about your camera's controls and features. In fact, you can ignore technology all together, using a simple point-and-shoot digital camera, and end up with truly artistic, creative images you would be proud to frame and hang on your wall. The trick is to start looking at the details, seeing beyond the obvious, and learning to view the world the way professional photographers do.

Tip: Study the Old Masters

Want to better understand the secrets behind great photography? Study the greats. We're not just talking about famous photographers, but great artists working in all kinds of media. Go into a bookstore or library and leaf through art books. Better yet, spend some time at a museum, viewing and analyzing just a handful of pictures. Ask yourself what it is about a certain Picasso that makes it one of your favorites. Why are you intrigued by the strange angles of a Chagall? What is it about the light and shadows of a Rembrandt portrait that so clearly captures personality or the poetry of a moment? Then go out with your camera and try using some of their composition techniques in your own photography.

The Basics of Good Photography

Before we talk about great photography, let's look at the common sense basics of good photography.

BE AWARE OF THE DETAILS

The number one problem that mars many amateur pictures is that the photographer is so intent on the central subject he doesn't pay attention to other details. You need to be aware that everything you see in your viewfinder will likely be in your photo. Particularly, be sure to look for the following:

- Are objects sprouting from your child's head, such as a telephone pole?

- Do other lines and objects intersect with the central subject in a distracting manner? (See Figure 12-1a)

- Who or what is in the background and foreground, in the corners and along the edges? Are you sure you want all that in your photo? (See Figure 12-1a.)

▪ Check just beyond the periphery of your composition. Is anything you don't want in your picture about to enter it, such as a person walking into your scene?

If you see anything in your viewfinder that shouldn't be in your photo, move, and take the photo from another angle. (See the next section.)

Figure 12-1a: This photo of Daniel has several extraneous elements that distract from the composition. (A) A plaque in the background wall is growing out of his head. (B) The upper edge of the booth behind him intersects with his cheeks. What makes this particularly unappealing is that the bench dramatically contrasts with the rest of the background, drawing the viewer's eye to it. (C) The edge of a banner pulls the eye to the upper-right corner.

Tip: Turn Off Your Mind's Filters

Certain things are so obvious to us, we tend to ignore them. That's because our minds filter reality, keeping us from being distracted (or driven crazy) by trivia. But the camera sees everything. When you look through your camera's viewfinder, you must see the world as though it were for the first time. Only then can you predict and understand what your camera will capture.

WHAT'S YOUR ANGLE?

Changing the angle of view of your camera can make all the difference in the world. Here's a fun exercise for you to try. In the early to mid-morning or late afternoon, when the sunlight is at an

Figure 12-1b: Given how fair Daniel is, the photo is much better when the entire background is darker, with no details at all. So, Sally did some Photoshop magic with it (including giving him a less unruly haircut). Better still would have been to shoot it with some soft lights, to add interesting shadows, and to frame the photo closer into Daniel's face. (Photo taken with a Minolta DiMAGE Xg.)

obvious angle, take a series of photographs of a friend. Have the person stay in one position, while you walk all the way around him, taking photos from every angle. (See Figures 12-2a and 12-2b.)

After you've made a full circle around your friend, walk to the right or left, bend down, sit on the ground, climb up onto a rock or even up a ladder (being sure it is steady, safe, and will hold you).

Pay attention to everything in the viewfinder, and not just your friend. Notice how shooting from various angles and positions changes the entire feeling of your picture. The changing angle of the light creates new shadows with each shot. Some photos will become more interesting, others will be more unappealing, but none of them will be quite the same.

Save all these photos on your hard drive and study them from time to time. You'll be amazed how coming back to them can be an ongoing learning experience.

Tip: Boil Everything Down to Geometry

Practice seeing everything in terms of geometric shapes. A face may be an oval with polygonal planes (cheeks), a pyramid (nose), arcs (eyebrows), and so on. Similarly, a scene can be viewed as consisting of rectangles (buildings), triangles (roads converging at the horizon), arcs (windows and flags), cones (mountains), and other shapes. Really interesting compositions often start with creating contrasting, conflicting, and/or complementary relationships among these various underlying geometric shapes.

Figure 12-2a: While this portrait is of an interesting woman, the composition is unappealing and boring. A streetlight pole and parking meter are sticking out of Mary Jo's head. The cars and man crossing the street are distracting. And the sidewalk pulls the viewer's eye away from her into the far horizon where there's nothing of interest.

SIZE: A MATTER OF PERSPECTIVE

Here's an obvious fact: anything that is close will look larger than things far away. A corollary is that if you are on the ground looking up, things above you will tend to look very large, even if they aren't really. Similarly, if you climb a tree and look down, everything below you will look smaller. What is interesting for photography is that the close/near large/small rule applies when you are looking up and down too, and that can create more energy and drama in your images.

Varying your camera's angle in relationship to your subject and scene will change the camera's perspective. And that, in turn, can alter the entire focus of your composition, making one object larger (and more important) than another. (See Figure 12-3.)

Figure 12-2b: By moving around Mary Jo and shooting from slightly above, we have a very different, much more dynamic photograph in which the entire composition conspires to focus the viewer's attention on our main subject. Notice how all the major angles, such as the flag, the black metal border around the lawn, the convergence of the two sidewalks, even the vines on the building, pull your eyes back to her. She also appears more relaxed (because of the angle of her body), and the shadows on her face now give her a happier countenance. (Both photos taken with a Nikon D70.)

(A)

(B)

Figure 12-3: (A) In this photo, the trees blend into Mt. Hood, making the sky a block of color that just sits in the picture taking up space. (B) By moving closer and to the left, then bending down, Sally forced the trees to appear larger, broke up the skyline, and gave greater strength to the trees within the composition. It also brought the sculpture-like old wood further into the foreground. However, it would have been an even better picture, if she had walked more to her left, so the old wood could have been pushed a bit to the right rather than lining up exactly with the mountain top. A few clouds in the sky would have helped, too. (Both photos taken with a Nikon Coolpix 5000.)

Tip: Choosing between Horizontal or Vertical Compositions

Turning your camera on its side will alter the physical impact of your photo. Do you want your picture to be wider than tall or taller than wide? It's common to shoot landscapes wide and portraits tall, but the creative needs of every photograph are different. (Besides, shooting the uncommon can be an important step toward making a work of art as opposed to a prosaic photo.)

Don't let your camera become rigid in your hand. Instead, experiment by holding it one way then the other for the same picture. You'll soon develop an eye for knowing what the composition you have in mind will require.

ANGLED LINES CREATE DRAMA

Whenever you can, avoid vertical and horizontal lines within your composition in favor of edges and shapes that are angled. (See Figure 12-4.) Angled lines create visual tension that pulls the viewer's eyes around your picture. One exception is the horizon (where the sky meets land or sea), which should remain definitively horizontal. However, we have seen some very exciting compositions with slanted horizons. The trick is to realize when you're breaking the "rules" of good photography, and to do it purposely, to change the feeling and/or meaning of your picture.

Figure 12-4: This photo of our cat Rascal captures the dynamic energy of his attempt to get through the blinds and even the window screen. That's because he's all angles, with his head tilted toward the upper-right corner, one leg angled toward the lower-right corner. Both paws are visually larger because they are reaching outward (closer to the camera). The bend of the Venetian blinds curves around him, focusing your eyes on the main subject. (Copyright by Noel J. Wiener. Photo taken with a Kodak EasyShare DX3500.)

━━━
Tip: Keep Shooting

Even when you think you have the photo, don't stop trying new angles or settings. That will improve your chances of getting that one perfect picture. And when you do get that great photo, don't let anyone else see the ones that didn't work. On a typical assignment a pro will shoot thousands of frames, and the client will see only a few dozen of the most stunning successes.

━━━

Going beyond the Basics

Greg Gorman, the renowned celebrity portrait photographer (`www.GormanPhotography.com`), enjoys using digital equipment for a number of reasons. But he particularly likes the freedom that the immediate gratification of the preview gives him to explore new possibilities. "Once I know I have the picture," he told us, "I want to push myself further, get a little bit more."

Here are some ideas for you to explore as you experiment and push yourself and your photography further.

- **What is the subject and purpose of your photo?** When a pro creates a photograph, he has a vision in mind that includes knowing what he wants the picture to say to others. Be sure you know what the subject and purpose of your photo is, and then compose it accordingly.

- **How will others look at your picture?** You can actually control what other people will look at first and how their eyes will travel around the photo. How? By using size, perspective, light, color, and angles to make one object or area more important or dramatic than anywhere else. Then use the same techniques to guide viewers where you want them to look next. Their eyes should be attracted to move from and/or to the main element.

- **What is the quality of light around you and how can you best capture it?** Be aware of how the light in your scene makes you feel when you look at it, and be sure that is the feeling you want for your photograph. Choose the type and placement of light in your picture (direct, back, or angled light, rosy or blue, soft or harsh, and so on) and make sure your camera is set appropriately for it. (See Chapter 6 about exposure and Chapter 9 about controlling and adding light.)

- **How do the colors, patterns, forms, and textures interact and relate?** Explore how the interplay of patterns, forms, textures, and colors affect your photo. Balance or disassemble them, create clashes or harmonies, use them to increase tension or soothe.

- **Are you using shadows artistically or just letting them fall where they will?** Shadows add contrast, definition, and texture to your picture. Use available and auxiliary light (see Chapter 9) to paint creative, dramatic, and/or appealing shadows. For example, a face partially in shadow is often much more interesting than one that is brightly and evenly lit. (See Figure 12-5 later in the chapter.)

- **Do you understand how your camera settings will affect the resulting photo?** Masterly photography, in the end, also means mastering your equipment. Learn how *f*-stops and shutter speeds will change your entire composition. (See Chapter 6.) Try different focus modes to see how they alter the effect of your picture. (See Chapter 7.) Experiment with your camera's color controls (see Chapter 8), program modes (see Chapter 6), and other commands.

- **Are you following your own personal vision?** Go ahead and break all the rules, to find out what is possible. Try all kinds of wacky or impossible shots just because they say something to you, and don't worry about what other people think. The point is to take control and make your photos be what you want them to be.

Tip: Every Photo Should Have a Focus

We're not talking about the clear focusing of a lens, but the point in the picture that draws the eye and defines the meaning of the composition. Be sure that it is a strong graphical element, which might mean that it is sharply focused and well lit, a strong color, a greater sense of movement, the nexus of converging lines and angles, or somehow stands out from the rest of the photo.

Photographing People

People—they're the one subject that, more than anything else, defines photography for the majority of camera owners. So, let's look at some ideas for getting great people shots.

Portraits

Some "primitive" tribes have the firm belief that when you take a photograph of a person, you are stealing that person's soul. In a way, they are correct.

When a good photographer looks through a lens at a person, the photographer sees who that person really is, what he feels, fears, cares about, needs, and dreams. Portraits are probably the most personal photography you can do, and some of the most satisfying when done well.

Here are a few guidelines for capturing a meaningful portrait:

- Take the time to know the person you are photographing before you even pick up your camera. Otherwise, how can you know what the photo should be capturing? Besides, it's less invasive, more natural, and certainly more pleasant for the both of you.

- Talk to your subject while you are shooting her—about anything that will catch her interest. Make her feel comfortable about being with you, and help her feel at ease in front of a camera.

- Stand just behind your camera lens, look over the camera body, and make eye contact with

your subject, so that she is looking directly at you through the lens. That human connection between you and your subject will make the picture come alive.

- If you want a smile, talk about something or someone she loves or enjoys, such as a child or pet or sport.

- If you'd rather have a serious expression, keep your conversation intriguing and thought-provoking.

- If talking doesn't give you the portrait you envision, try absolute silence, using constant eye contact to keep her eyes on you and your camera.

Portraits should be exercises in minimalism, with nothing extraneous that could distract from the power of the personality. (See Figure 12-5.) While they are generally cropped quite close, including only the head and shoulders, some really great portraits are so framed that they cut out everything except the eyes, nose, mouth and cheekbones. On the other hand, if your subject has great hands or posture, or if a definitive aspect of her personality is revealed by something she might be holding, using, or doing (such as a dancer), then pull back to show as much as is necessary to capture her true personality—and no further.

Figure 12-5: In this Greg Gorman photo of the actor Jonathan Jackson, Greg uses shadows and direct eye contact to paint a sensual portrait that rivets the viewer. (Copyright by Greg Gorman.)

Tip: A Master Portrait Photographer's Perspectives on Faces

More than almost any other kind of photography, portraits require that you take control over light and shadows, as well as the angle of the camera. "The first thing I do is sit and talk with them, while I consider what I'll need regarding light and angle," Greg Gorman explains. "Each face is like a canvas and should be addressed differently. If a person has a smaller eye, put that eye closer to the camera. If a person has a nose that bends, shooting into the bend will straighten it. For a long face, shoot up; a wide face, shoot down. If the eyes are small, shoot from above to get them to open their eyes wider. With heavyset people, don't turn their face, because that will accentuate their double chin. Instead shoot straight into their face. If someone is balding, put a flag to darken the forehead and scalp. But the eyes are the most important thing. Always make direct eye contact."

Parties and Group Photos

Groups often make the most difficult photographic subjects. When you finally have the kids sitting quietly and looking at the camera, Grandpa sneezes or Aunt Gertrude blinks. The answer? Accept the realities and stop trying to control everyone. If it's a party or some other celebration, what you really want are photos of people enjoying themselves and doing the things that are most memorable about that event. This might include such things as cutting the cake, toasting each other, laughing, dancing, flirting, and generally being themselves.

Here are some guidelines to help you with those group photos:

- Shoot lots of pictures, one right after the other, to increase your odds of getting that one great photo. It will also get folks used to seeing and hearing the camera, which means they'll start ignoring it and be themselves.

- Be amusing and fun-loving. It will help to make you the center of attraction with all eyes pointed at you and your camera. What's more, it will keep the mood light and be more fun for everyone, including you.

- Keep your *fill flash* turned on, but realize it won't reach further than about 12′ (though that varies with each camera, settings, and position of the lens). If you wish to extend your area of illumination, consider using a slave flash unit(s) somewhere in the room. (See Chapter 9.)

- Move (or position your subjects) so the shorter people are closer to the lens and the bigger folk are behind them. This will help you to avoid cutting off heads.

- Put a few feet between people and the wall. Otherwise your flash will create harsh shadows.

- Use your optical zoom to get in close to a face, a conversation, or an activity that's meaningful to you. It will also help crop out distracting or unappealing elements.

- Use your widest angle lens (or zoom out) to capture the entire room, with all its distracting, fun-loving elements, for a photo that will evoke a memory of the entire experience.

- Whatever you do, don't shoot people when they are rigidly rooted in place with hands at their side. Better to have motion blur in your pictures than to have a static photo.

Tip: When Digital Outshines Film

Peter Read Miller, the *Sports Illustrated* photographer, has found that the transition to digital has been great for the day-in, day-out shooting of sporting events. "I now have much more freedom from technical concerns and can concentrate on the shooting. And the pictures of night games are amazing . . . the kind of shots we never really could get with film." In fact, every pro we know acknowledges that digital has given them more latitude to get many of the photos that used to be so difficult if not impossible with film . . . especially when light is minimal or problematic.

Sports

How do the great sports photographers get those incredible photos? To some extent, it *is* their equipment—top-notch, fast-shooting cameras with great telephoto lenses. You don't have to spend a fortune or be a camera expert to get great sports pictures. However, you do need to use the right camera.

If you plan to do lots of sports photography, you will have to spend a bit more to get a camera that has the following attributes (for more details, see Chapter 2):

- **A fast shooter**—The last thing you want is shutter delay, those interminable fractions of seconds between when you press the shutter button and the time when the camera actually captures the picture.

- **A great burst mode**—The ability to shoot lots of photos one right after another means that you can keep your finger on the shutter button through an entire sequence. For example, if you are photographing a basketball layup, using burst mode means that you will be more likely to get the shot of the ball leaving the player's hand for the hoop.

- **Tracking autofocus**—This focus mode allows the lens to continuously follow the action and adjust accordingly. It helps you automatically anticipate where the running player or the galloping horse will be when you press the shutter.

- **A bright, clear viewfinder**—If you're tracking action, you need to be able to see it without difficulty.

- **A long optical zoom lens**—Remember optical (and not digital) is the only relevant and useful type of zoom. While most digital cameras come with a 3X optical zoom, you no longer have to spend thousands of dollars to get an 8X, 10X, or even 12X optical zoom.

Tip: Choosing between a Fast Shooter and a Long Zoom Lens

Some of the newer digital cameras with long zoom lenses have a problem focusing really quickly. If you have to choose between having a very long zoom lens (such as 10X) and a fast-shooting lens, and you plan to photograph action-filled random events where it is difficult to guess where things will happen next (making it next to impossible to prefocus), choose the fast shooter. It may have no more than a 3X zoom, which would

mean you'd need to get closer to the action, but at least you'll be less likely to miss the shot. If you can't get closer, you can try shooting high-resolution photos and then cropping them closer in your photo-editing program. (See Chapter 18.)

But with sports, as with any photography, a great camera won't get you that great photo. Only you can do that, by taking control over your equipment, developing pro-like habits and learning to see the game the way a pro sees it.

Here are some guidelines for shooting sports:

- Turn off your flash. Every pro laughs at the sight of thousands of flashes going off in a stadium. The strobelight simply will not reach from the grandstands to the playing field.

- Try different shutter speeds. While a fast shutter speed will capture a crisp action shot, sometimes the slight blur of a slower shutter speed conveys a greater sense of action. (See Chapter 6.)

- Track action. Practice following the ball or a player with your lens. Learn how to read the action so you can tell where the player will run next. Keep the camera up to your face and follow the game through it, keeping your lens on important players. And keep clicking while tracking. However, remain aware of what is happening outside the periphery of your lens.

- Prefocus. If you can guesstimate where the action is about to happen—such as home plate when a player is running the bases—then you can prefocus on that spot and capture that slide into home, even if your camera doesn't have a tracking focus mode. Here's how. Point your camera where you expect you'll be taking the picture (that is, home plate). Press the shutter button halfway down and hold it there (or use your camera's focus lock button, if it has one) and then move your camera to follow the player. As he slides for the plate, press the shutter button the rest of the way down.

- "Learn the habits and style of play of the players," suggested Peter Read Miller, the *Sports Illustrated* photographer. "The more you know the sport and the players, the better you can predict what they will do. Just that little bit of extra information enables you to cut through the typical bread and butter pictures that others are getting. Instead, you can approach it from a new, more interesting angle."

- Be active. Otherwise, you'll get a series of boring, static shots that all look alike. Get out of your seat, move closer, or climb higher. Leave the grandstand. Go to other side of the field. Try different angles; shoot some horizontally, some vertically.

- Don't stop shooting. Things happen so quickly in sports, and you won't get a second chance to capture a split-second play. If you are photographing, that's what you do for the entire game. If you prefer to watch the game, then you'll be much less likely to get that one great photo (unless you're very lucky).

- Even though everything happens so quickly in sports, you still need to pay attention to the basics of good composition. (See earlier in this chapter.)

Tip: Shoot Up So the Athlete Can Tower over You

Peter Read Miller said that he always like to shoot athletes from a sitting or kneeling position. That perspective, of looking up at them, gives the player "heroic stature. And with kids, it's even more important, because you certainly don't want to shoot down on them and accentuate their comparative small size."

Powerful Light

According to Lewis Kemper, the fine art nature photographer (www.LewisKemper.com), when you're taking pictures, "you're really doing only two things . . . capturing light and putting a frame around something that exists in the world. If light is 50 percent of the equation, you have to be there when the light is good." Lewis prefers early or late in the day, or when the weather is bad. "Fog, clouds, anything that adds atmosphere will make your photo more powerful than 'bald-headed skies,' which is what Ansel Adams called blue clear skies." (See the accompanying figure.)

While amateur photographers might curse the cloud cover over El Capitan, Lewis Kemper uses the clouds to define a sense of atmosphere and eerie isolation. (Copyright Lewis Kemper.)

One trick Lewis uses to make clouds more dramatic is to place a polarizing filter on his lens, especially on bright days. He also suggests that if you are out when the light isn't dramatic, to be aware of the direction and location of light. Side lighting and back lighting are more interesting than light that shines directly onto the front of a subject. "You need to become a student of light," he explained.

Landscapes and Landmarks

For decades, Kodak Picture Spot signs have dotted the American and European landscape. Wherever tourists might wander, to see the Statue of Liberty, the Eiffel Tower, the Grand Canyon, or even Disney World, Kodak put up signs instructing amateur photographers to "stand here" to take that one best, most memorable picture of the famous scene. Untold rolls of film were sold to the many millions of tourists who shot nearly identical pictures from the same lookout points. Others chose, instead, to buy the inexpensive picture postcards, which were often also taken from the same vantage point, though sometimes at a different time of year and/or in better weather.

If you want your photos of landscapes and landmarks to stand out from the millions that were shot before you, you'll need to break the mold and make the scene something that is truly personally your own.

Here are some suggestions for getting great photos of landscapes and landmarks:

- **Get off the beaten path**—Walk away from the road; get out of sight of other tourists (taking care to remain safe, of course). Look for views and places others have never seen.

- **Try interesting angles**—Sally recently photographed a scene from her childhood: the bronze goat at Rittenhouse Square in Philadelphia, where generations of children have played. So, she lay down on the ground on her stomach to shoot from the viewpoint of a child.

- **Look at the scene in new ways**—When everyone else is standing at a lookout, pointing their cameras in the same direction, turn around and try to discover what they are missing. Sometimes, it's a photo of the group, all with their cameras in front of their faces.

- **Find the small details that define the moment**—Is it a tiny flowering berry bush? Then, get on ground and shoot the scene from the viewpoint of the bush, with it in the close foreground. (You'll need to use a narrow, large number *f*-stop for such a picture, as we explain in Chapter 6.) Or, see what interesting shapes the shadows carve in a rock face.

- **Use telephoto to zoom in on a great graphical element**—When others would use wide angle, try the opposite. "Isolate an interesting item," suggested Lewis Kemper. "Use the telephoto and eliminate foreground and background and distraction. Open up the lens to a fairly wide aperture." (See Chapter 6 about *f*-stops.)

- **Use people and animals in photos to give scale** —When we were on assignment in Antarctica, we found it difficult to give a sense of scale in our pictures. Is that clump of ice in the ocean a small floe or an enormous iceberg? The problem is there's no human dimension

in that most alien place on earth. If a seal were sunning itself on an ice floe, it suddenly made it easy to understand the size and scale of everything else in the picture. We use people as graphical elements in the same way. However, remember, you need to decide what the subject of your picture is. If it's the person, put him or her in the foreground and use a fill flash. (See Chapter 9.) If it's the scene, reduce the impact of his presence by putting him in the background or midground. However, don't let his placement appear accidental. It should be part of the entire composition, in terms of texture, color, light, contrast, and tension.

Tip: Use the Rule of Thirds

Lewis Kemper suggested that you should imagine drawing a tic-tac-toe grid in your viewfinder. (Some cameras can display such grids, but you don't need the display for this exercise.) Where the lines would intersect are called the "power points" of composition. Then, put the most important element in your photo at a power point instead of dead center. This applies particularly to placing a person or object within a scene or landscape.

Take Your Time with Wildlife Photography

The three most important requirements for great wildlife photography are patience, patience, and still more patience. First, you need to find a likely spot where the animal you want to photograph might show up. Then, hide where you won't disturb it. And make yourself comfortable, because you may have to wait a long time before anything shows up . . . if it ever does. Alternatively, you can take your camera to the zoo.

All the guidelines regarding light, shadow, texture, colors, and details we've discussed apply to wildlife photography, too. Because things happen very quickly and unpredictably with animals, you'll want a long telephoto lens with a fast, responsive autofocus mechanism. Remember, when you zoom in closely and fire off dozens of quick shots in succession, sometimes zoom out a bit and give your photos some flavor of the habitat.

Summary

Here are some of the key topics covered in this chapter:

- Cameras don't make great photos. It's the person handling the camera that does.

- The trick to learning how to create great photos is to start looking at the details, seeing beyond the obvious, and learning to view the world the way professional photographers do.

- Experiment with the angle of view of your camera in relationship to your subject. Move around, climb, get on the ground. Play with perspective to explore new ways to photograph the same things.

■ Great photos require an understanding of the qualities of light around you, how colors, patterns, forms, and textures interact, and the use of shadows to add contrast and definition.

■ Though you can make great photographic compositions without mastering camera technology, the more control you have over your camera's commands, the more masterly your photos can be.

■ Eye contact, personal (and personable) interaction, and the creative use of light and shadow are elements of great portraiture.

■ When shooting sports, turn off your flash, be as active as your subjects, track the action, prefocus when you can, and keep clicking away.

■ For landscapes and landmarks, don't let your pictures look like the millions of others that have been taken of the same (or similar) location. Get off the beaten path, experiment with angles, perspective, and zoom.

Chapter 13

Family and Fun Photography

Who doesn't have the boxes, albums, and frames filled with pictures of friends and family, weddings and birthdays, vacations and reunions? Photographs are the milestones of our memories. They become the points of reference of who we are and what we've done, the people we've loved and the meaningful events of our lives. No wonder photography is the world's number one hobby.

In this chapter, we cover how to capture great personal photos, especially of kids, pets, and vacations. (For tips on sports and other kinds of photography, see Chapter 12.) We also discuss creating panoramas and appealing portraits for posting on singles Web sites. Then, once you have your photos, you'll learn about using them in personalized greeting cards, calendars, and other crafts projects. We also offer suggestions on how to have a digital party, because more than anything, digital photography is about having fun.

Capturing Great Memories

Having photographs of memorable moments and people you love is wonderful. But getting them should be part of the joy and adventure. And with digital photography, it is. Now that we have the ability to immediately see and share pictures when we take them; photographs have gone beyond the way we record our life, becoming part of the experience and not just reminders of it.

Tip: Shoot Eye Level to Your Subject
To capture the full power of your subjects, get on their level. That means being down on the ground with toddlers and pets, but also crouching or bending over for adults who are sitting. Of course, as with every rule in photography, this one is meant to be broken, but only for a reason. For example, if someone has small eyes, shooting from slightly above will force him to open his eyes a bit more (see Chapter 12).

Photographing Kids

Surely, more pictures are taken of children that any other subject. We don't know the official statistics, but consider the untold billions of photos of newborns and toddlers, kids getting their first haircut, learning to ride a bike, at the dance recital, on the way to the prom Is there any moment in a child's life we don't yearn to capture and hold forever before it disappears?

The number one mistake parents and others make when photographing kids is trying to control the situation. After all, it's the very spontaneity of childhood that makes it most charming. Here are some guidelines to help you capture those precious moments:

- Never tell a child to smile. Instead, give them something to smile about. Marilyn Sholin (www.MarilynSholin.com), author of *Studio Portrait Photography of Children and Babies* (Amherst Media 2002), suggests, "With very young children, have something hidden behind your back that is their very favorite thing. Then, when you are ready to take the photo, show it to them, and you will get an expression immediately."

- If your child has chocolate all over his face, don't try to rub it away. That's the photo that will have more meaning to you in future years than any in which he is pristine and perfect.

- Don't pose children. If you try to force an unnatural position or attitude on your kid, the photo will be stiff and certainly won't represent who he really is. What's more, children are usually naturally graceful, and even when they aren't, sometimes it's the awkwardness of the moment that makes the picture.

- To help make your child more cooperative about getting his picture taken, have him take photos of you, of your pets, of anything he wants. He isn't likely to break your camera, and maybe some of the photos will come out nicely. Even 4- or 5-year-olds aren't too young to start taking photos with a digital camera.

- Be ready to take a picture at a moment's notice. Have the camera nearby, with batteries charged and a memory card with lots of storage space left.

- Sometimes, the quiet times of the day will yield the most beautiful photos. When he's concentrating on tying his shoe, or tasting a new flavor ice cream, or sleeping, the expression on his face can be priceless. Learn to be a quiet, unobtrusive photographer, and you'll capture those precious times (see Figure 13-1).

- If the child doesn't know you, help him learn to be comfortable with you. You'll need to read his personality. Let him play on his own if he prefers, or join him in playing. Some children are often most comfortable on a parent's lap, and you can get great pictures that way (see Figure 13-2). Marilyn Sholin recommends, "Don't thrust yourself onto children. Never shove things at them or come on too strong. With shy children, the quieter you are, the more they will give you and the further you can go with them."

- Many children react well to out-and-out flirtation. And if you do it from behind your camera, they'll be fascinated enough to look directly at you through the lens (see Figure 13-2).

- Enjoy the moment with your child. If you're not stressed, he won't be either, and that will lead to a better picture. Besides, if the photo doesn't turn out the way you hoped, you can erase it and try again. But you can't erase the memory of a time that could have been fun and wasn't.

Figure 13-1: The everyday world of children is filled with peaceful moments that can yield the most precious photos. (Copyright by Marilyn Sholin.)

Tip: For Great Candids, Keep Your Camera on Burst Mode

Burst mode, the setting that allows your camera to take several photos in quick succession, isn't only for sports photography and capturing other fast moving subjects. (See Chapter 12.) Burst mode is great when you're shooting candids. Facial expression can change in the blink of an eye. A kid's mood can alter as quickly as he moves. When you use burst mode, you increase your changes of getting that one great photo out of the whole series. Then, you can delete all the others.

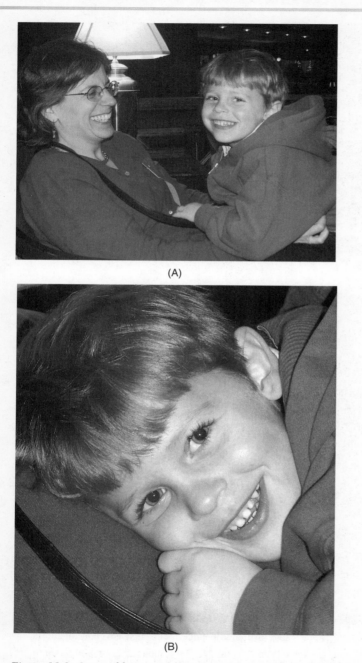

(A)

(B)

Figure 13-2: Sam and his mom have a great relationship. So, Sally photographed him on Judith's lap (A). That gave us a series of great photos that we then cropped in Photoshop to yield some very focused portraits (B). That he's a bit of a flirt certainly helped. (Photos taken with a Minolta DiMAGE A1.)

Taking Pet Portraits

Taking pictures of pets is quite similar to photographing children, because they can't be forced and need to be engaged. Here are some suggestions on getting great pet portraits:

- To get them to look into your lens, make an intriguing sound or say their name, just as you press the shutter button (see sidebar figure).

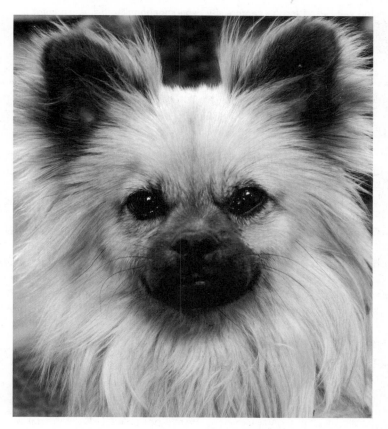

Sally got on the ground to be at eye level with this Shih-tzu. Then, she quietly composed the photo, making sure her exposure and other settings were correct. Only then, did she make a soft clucking sound, which caught his attention so he looked straight at her. (Photo taken with a Nikon D70.)

- Dogs are easily bribed. Keep a treat on your camera, and he will stare at your lens with great interest.

- If a dog is well trained, you can pose him. But we prefer photos in which our animals are being themselves.

- Cats are more difficult. You have to let them control the situation. So, just have a camera ready to shoot when they look particularly cute.

Tip: Experiment with Shutter Speeds and *f*-Stops

As we explained in Chapter 6, the *f-stop* and *shutter speed* combination you choose will define how much of your photo is in sharp focus and whether or not the picture stops or blurs action. Play with the camera's controls, taking the same portrait or scene using different settings. Then, once you have the photos in your computer, study both the ones that you love and those that failed, checking their metadata (see Chapter 5) to see what shutter speed and *f*-stop were used for the capture. By experimenting like this, you'll learn a lot about photography, as well as increase your chances of getting one great photo out of the entire series. Professionals call this *bracketing* and use it as an insurance policy on important shoots. Some digital cameras have auto-bracketing capability.

Vacation Photography

Context and points of reference, always key concepts behind memorable photography, become even more important for great holiday pictures. That's because without a sense of your own experience in your capture of exotic or simply unfamiliar locations, the photos will be no more meaningful than anonymous picture postcards. Therefore, good vacation photography involves discovering the key places and people that will resonate for you. Is it your child scampering among ocean waves or a certain lookout point reached only after a two-hour hike? If it's a landmark, such as the Statue of Liberty, does it have as much meaning for you on its own, so that you want to explore new perspectives of it, or would your photography have more value if it included the people who shared the experience with you? (For tips on photographing landmarks and landscapes, see Chapter 12.)

Digital cameras have made vacation photography more fun and more foolproof. But they have also added some new challenges. Try some of these tips for getting more out of your digital camera when you're away from home:

- Take more and/or larger memory cards than you think you'll need (see Chapter 4).

- Be sure to have extra batteries, plus a battery recharger that will work on the local electrical current (see Chapter 4).

- Nothing is more ephemeral than digital data. Consider using a portable CD/DVD burner or hard drive to back up all your photos, which will then allow you to reuse your memory cards for more pictures (see Chapter 4).

- Pack your camera's video out cable. That way, you can review and share the day's pictures on almost any TV set (see Chapter 19).

- Don't forget to pack your camera's instruction manual, even if you think you know your camera inside out.

- Take advantage of the digital photo kiosks that are in nearly every mall, as well as many hotels, amusement parks, and cruise ships. Insert your memory card and get prints and/or CDs that you can share with your fellow vacationers (see Chapter 20).

Tip: Be Zen-Like with Your Photography

John Isaac, the renowned photojournalist (www.JohnIsaac.com), told us his understanding of the Zen lesson of "stop, look, listen" is one of the keys to his successful pictures. "Now when I do my photography, I look back to see what I've missed. Turn back and look," he told us. "When I went to the Grand Canyon two years ago, every two seconds everything was changing, the light, the clouds, the movement of people and animals. You have to sit and wait and create your own picture."

Panoramas

Panoramas are created by combining of a series of photos that will then provide you with a wider and/or taller view of a scene. Though the procedure has been around almost as long as photography has existed, it is so much simpler now with digital cameras and stitching software.

Stitching software seeks out similar areas and shapes in each photo then automatically fits them together. To give the software enough visual data to work well, you'll want to be sure to stand in the same position for the entire series, holding the camera in the same way (preferably on a tripod with a rotating head), then turn only slightly, so each photo overlaps the previous by about 30 percent. Some digital cameras have panorama guides in the viewfinder, which assist with aligning a proper overlap. You don't need the guides to create the photos you'll use in your panorama, but they certainly help. Beware of the fake panorama modes that some film and digital cameras have which simply crop the top and bottom off a photo; you'll end up with less data and detail as opposed to the greater resolution and information in a stitched panorama.

Our friend Ben Gottesman (executive editor at *PC Magazine*) enjoys creating panoramas, especially from his vacations. An avid photographer, he says, "Panorama sees more like what the human eye sees." But, he reminds us, "Don't just think of panorama for landscape. It's great when you're in a small room and there's no way you can fit the things you want into a single frame." When he was on a cruise with his family, he put together a very appealing panorama of their two sons asleep side by side in their small cabin. It's a photo that would have been impossible otherwise.

Ben offers the following tips for assembling great panoramas:

- Make sure there's something clearly definable in the overlap area.

- The light can change while you're shooting a series, which can cause hard transitions in the final panorama. Consider using manual exposure and set it according to an average exposure reading of the entire scene (see Chapter 6).

- No stitching software is perfect. Ben's favorite, Enroute PowerStitch, is no longer available. He usually starts with the PhotoStitch software that came with his Canon Digital Rebel. However, he's found that Photoshop's Photomerge sometimes works better. What's more, Photoshop gives him something unusual. "What's nice about Photomerge is you're not just stitching in one direction, but can do grids to go across and up."

Ben also suggests using panorama software when you need to copy a large document that won't fit in your photocopier. "However," he advises, "be sure your software lets you tell it that it's a flat item."

Panoramas *(Continued)*

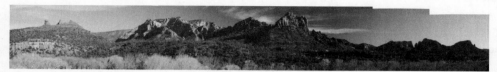

Ben shot this panorama near Sedona, Arizona, by taking a series of seven photographs. After each shot, he moved the camera slightly to another position. In the computer, his stitching software analyzed the overlapping areas of each photo to determine which ones fit in what position. Then, the software automatically assembled all the pictures, using various tricks to smooth any transitional edges and distortions. Note that the upper-right corner looks eaten away. That's because those couple of photos captured slightly less sky than the others in the series. (Copyright Ben Gottesman.)

Eye-Catching Singles Portraits

Matchmaking has gone digital in a big way, with online registries (like `www.AmericanSingles.com` or `www.JDate.com`) that offer to help you find Mr. or Ms. Right. They all work similarly, giving you the opportunity to describe yourself and what you seek in a mate. Thousands of other singles will look the page over, and decide if they like what they see. And that's the rub: you have to post a photo.

Quite a number of our unattached friends have asked our advice about the kind of photo they should use for these Web sites. Of course, the problem taps into deep-seated insecurities about physical appearance and appeal, compounded by uncertainty regarding the whole digital aspect of it.

The ideal photo for a dating/matchmaking site is one that gives a sense of you as a person. Therefore, stay away from boringly traditional headshot portraits. Have the picture taken by someone you like and feel comfortable with, because that will make it a happier, more appealing photo. And take it in a location that is part of your life and represents who you are and what you enjoy. Choose your clothes carefully, to be sure the subliminal message you are giving is the one you want. Are you all business, or tailored but relaxed, or a "just folks" kind of person? While it's acceptable to do a small amount of editing to, for example, remove a pimple or correct the exposure of the photo, don't let your picture lie about what you really look like. That always backfires as clearly as if you were to be dishonest about the kind of job you have.

Alas, none of our friends has yet found their perfect mate through a Web site. But then, we met through a blind date and are very happily married. So, we're the last to disparage the potential.

Tip: When You're the Photographic Subject

When you have your photo taken, look through the lens at the person behind the camera. Relate to the photographer. As Sally's mom always said, if you think to yourself that the person you're looking at is interesting or wonderful, your face will show your interest, and your smile will become truly genuine and appealing." In other words, be an actor for a few moments, even if you have to lie to yourself. When you see the resulting photo, you'll be pleased you did.

Using Your Personal Photos in Fun Projects

One of the biggest differences between film and digital photography is that once you had your film developed, you'd have to jump through hoops to do anything with them. But with digital photos, once you get them into your computer (see Chapter 17), you're limited only by your imagination. (To be fair, you can do everything we describe in this section with film-based photos, but only after you've scanned them or had them burned onto a CD.)

We can't possibly describe all the hundreds of projects you can do with digital photos, but here is a small sampling:

- Create personalized greeting cards, invitations, calendars, banners, gift tags, and all kinds of other printed novelty items, featuring your photos and your own text.

- Design a slideshow that you can share with family and friends via email, on a CD or DVD, or post on the Web (See Chapter 19).

- Illustrate school papers and projects, business presentations and brochures, program flyers and desktop published newsletters, and so on (see Chapter 14).

- Create an illustrated family tree.

- Make photo-based crafts, such as boxes, T-shirts, scarves, jigsaw puzzles, and so forth.

- Throw a digital party (as is discussed later in this chapter).

What makes such projects so appealing is that they're social creative activities that can bring family and friends together in an entertaining and memorable way.

Tip: Give Your Kids Their Own Digital Cameras and Let Them Loose

An inexpensive, but good-quality digital camera can cost about the same as an Xbox game system. However, while games focus kids' minds inward into the box, a camera will have them looking outward beyond themselves, exploring new ideas. John Larish, the author and consultant, gave his granddaughter a digital camera to see what she might do with it. "She created a great scrapbook of her junior year in high school, a collection of her memories in a very attractive composition," he told us. "Doing it, she developed visual and verbal storytelling skills and furthered her ability with digital technology."

Producing Your Photo Projects

When producing your photo project, you have the option of doing it all yourself, simply ordering from a retail shop or online service, or a combination of the two. Here's how it works:

- If you have project software like Print Shop (www.Broderbund.com), Print Artist (www.SierraHome.com), or any of a few dozen other craft or greeting card programs, you

can create all kinds of novelty items. Many consumer image-editing programs, such as Microsoft Digital Image Suite or, Roxio PhotoSuite (see Chapter 18), also have project templates. Then there are specialty program, such as Mountaincow PrintingPress, whose templates are focused on party invitations or other areas of interest. (See Figures 13-3a and 13-3b.) When finished, your project can be output on your desktop printer, or uploaded to a Web site for printing.

■ Or, you can simply upload your photos to a photo-sharing site, such as Shutterfly.com or Ofoto.com (see Chapter 19). Then, you can order the same kinds of cards, clothes, and crafts that you could create at home (without the effort and time doing it yourself requires). Plus, they offer other kinds of items, such as photo cookies, coffee mugs, mouse pads, and so on.

■ Most retail photo stores can take your photos or completed project files and create whatever project items you wish, just like the Web sites can.

By the way, seriously consider having holiday cards or party invitations printed professionally when you are sending out more than, say, 50 or 60. It will cut down on wear and tear on your printer, save you time, and may even cost less in the long run.

Figure 13-3a: All the craft and image-editing programs that have photo projects provide templates for greeting cards, posters, brochures, and many other novelties, such as these in Microsoft Digital Image Pro. You can customize the templates (as much or as little as you wish) by inserting your own photos, changing the text, and in most programs, completely redesigning the layout. (Courtesy of Microsoft Corporation.)

Figure 13-3b: Here, we personalized a Mountaincow PrintingPress Platinum wedding invitation template with a photo of our dog, a new border, and our own text, and even changed the font. Usually all it takes to change text is to select the current text and type. To change the graphics, select the item in the template, choose a command to edit it, then replace it with clip art provided by the software or browse to one of your own photos, and click on OK or Done or similar button. (© 2004 PrintingPress™ Software by Mountaincow™.)

Tip: Turn Your Photos into an Heirloom

Every other month we hear about yet another product or service for using your photos. One of our current favorites is TreasureKnit's photo blankets (www.TreasureKnit.com). Your photos are woven into a blanket, rather than just printed onto it. Alas, the photo is only monochrome, not full color—at least for the present.

Specialty Papers Give Your Photo Projects That Professional Look

Go into any stationery or office supply store, and you'll see shelves filled with specialty papers. Sometimes, it feels as though every color in the rainbow is represented, plus some that nature never intended, such as the embossed metallic trim that has become so popular. You'll often also find

Specialty Papers Give Your Photo Projects That
Professional Look *(Continued)*

matching envelopes and card stock. Other papers are simply white or off-white but of higher quality and weight, or a different texture than the typical media you would usually use for, say, a letter. And then there are the die-cut papers and card stock, with their perforations in standard sizes, such as those for business cards or CD-labels.

Using these specialty papers will lend a professional touch to your at-home printing. Just be sure that the paper and card stock is suitable for your particular kind of printer. Otherwise, the inks may not adhere properly, and/or you could end up with less than satisfactory image quality.

By the way, you don't always have to print on paper or card stock. Some stores even have cloth that can go through a desktop printer, for making scarves or squares that can then be sewn together. (Sally fantasizes about someday making a photo patchwork quilt from these.) We can't vouch, however, for how well they will clean (if at all).

Throw a Digital Party

Taking pictures has always been part of the party experience. But, with digital photography, so is sharing those photos. This is especially true now that more and more people bring their own digital cameras when they go visiting, which means any party will usually have several cameras floating around. Why not take advantage of that to provide some additional entertainment? Here are some suggestions:

- Set up at least one computer with project software. Your guests can upload photos to it, edit them playfully, and output them to your printer.

- Set up a snapshot or inkjet printer, preferably one that can take direct input from memory cards, and just crank out photos of the party to give out as favors (see Chapter 20).

- As the party winds down, connect a camera filled with pictures to a TV so that you can show the group all the photos. (See Chapter 19.) Of course, use another camera to shoot everyone around the TV, laughing and relaxing.

- Burn CDs of the photos that you can give out to your guests as they leave.

When the party is over, try some of these ideas:

- Upload the pictures to a photo-sharing site. (See Chapter 19.)

- Use your project software to create thank you notes that can match the original invitations but with photos from the party inserted.

- For great gifts, create personalized crafts with photos of your friends that you took at the party, such as coffee mugs with each guest's picture or a 12-month calendar.

Summary

This chapter covered many issues concerning family and fun photography. Some of the key points include the following:

- Digital photography can be fun for everyone, because with the ability to share the pictures when we take them, photos have become part of the experience and not just reminders of it.

- The number one mistake made when photographing kids is trying to control the situation. Let kids be themselves and you'll get more memorable photos.

- Don't hog the digital camera. Hand it over to your kids to take photos of anything they want. They aren't likely to break it, could learn something from it, and maybe some of the photos will turn out nicely. Even 4- or 5-year-olds aren't too young to start using a digital camera.

- Be sure to pack enough memory cards and batteries, and have a plan for backing up your pictures while on vacation.

- Once you have your digital photos in your computer, you can do all kinds of projects, such as create personalized greeting cards, posters, or slideshows; add photos to newsletters and school reports; design photo-based crafts; and so on.

- Throw a digital party that uses digital photos not only for the invitations, but as part of the entertainment and thank you gifts.

Chapter 14

A Business Tool

Business success requires being savvy about digital communications. Whether it's creating compelling presentations or brochures, effectively and efficiently documenting events and facts, or simply using email, word processing software, spreadsheets, and desktop publishing, how you support your arguments visually can often be as important as what you say. No wonder digital graphics—and especially digital cameras—have become important tools in the business world.

In this chapter, we will provide guidelines on choosing and using digital cameras for business, including for specialty applications such as real estate, forensics, insurance, and so on. We'll cover how to shoot and use digital photos for print, presentations, and the Web. In addition, we'll discuss using your digital camera as a presentation device, a portable photocopier, and voice recorder.

Tip: Give Your Employees and Associates Digital Cameras

Don't limit the use of your company's cameras to a select group of employees who earn them, treating them as perks. Instead, give them out to everyone whose productivity or profitability could be increased when they use a camera. Yes, digital cameras are still exciting enough to be considered perks and actually make great incentives and gifts. But the fact is they're invaluable for providing immediate visual information, which could translate into a better bottom line.

Cameras That Are All Business

When a digital camera is purchased for business use, it's a very different matter than selecting a personal camera. That's because it has to prove its worth beyond the function of capturing a good picture.

Before you can choose the camera, you need to decide how it will be used in your business and how much training you are willing to provide to your employees and associates who will be using it. (See Chapter 2 for details on the following types of cameras and other purchasing considerations.)

- A point-and-shoot camera will require no real training or skill, and can be handed to anyone in the company to use. The purpose isn't to get great photographs, but to capture visual information and documentation for internal use.

- You'll want an intermediate consumer camera for photos intended to be used in publications, newsletters, reports, and for pictures that will be seen internally by people whose opinion matters. The person who uses it should have a basic familiarity with photo

235

techniques. If she doesn't, you should be prepared to provide training for at least a half day. (See Chapter 4 on learning digital photography.)

■ We don't recommend advanced amateur cameras for most business uses. If a company has the need for that much control over its photography, it might as well go one step further to have the capabilities of a prosumer or semi-professional camera.

■ Use a prosumer or semi-professional camera for photos that are intended for external consumption by the media, stockholders, potential clients, and others whom you wish to win over. These pictures include product shots, meeting photography, head shots, company views, and so on. Ideally, such photography should be done by a professional, but because of time, budget, or other considerations, you now wish to do it in-house. The photographer must have solid photographic skills and a working knowledge of good composition, or you must be willing to give her some concentrated professional training. (Again, see Chapter 4.) Choosing between prosumer or semi-pro involves determining if the subject matter requires a full range of interchangeable lenses and accessories. If it is repetitive shooting such as product or head shots, a prosumer camera will probably suffice. If it's location work with a variety of subjects, or requires a studio setup, then a semi-pro system may be better. However, a lot also depends on the sophistication of the person using the camera.

■ If your business photography is going to require professional equipment, then its time to hire a professional photographer.

Tip: Choosing between a Digital Camera and a Camera Phone

Digital cameras' primary purpose is to capture photographs. Therefore, their pictures and resolution can give you more information and detail and generally provide more controls for higher-quality image capture than camera phones.

Camphones' primary purpose is communication, which includes delivering a quick-and-dirty photo as soon as it is captured. The image quality is generally so-so, but nothing gets the picture to the home office faster as long as you're in an area with good reception. (See Chapter 16 for more on camera phones.)

Shooting for Business

Words are time-consuming. With all the information we are required to absorb and understand, most people have little or no patience for reading long documents. But a good picture can provide information, verify facts, and support positions. What's more, it is comprehended and remembered easily, with minimum effort and in short order.

Getting the Right Business Photo

A good business photo must convey and support the meaning you need and intend, without adding any unwelcomed subtext. Everything in your photo should have a purpose, or it shouldn't be there.

Here are some guidelines for creating successful business photos:

- Pay attention the basics of good photography as described in Chapter 12.

- Keep the composition simple and unambiguous. Clarity of concept is much more important than artistic expression.

- The background should be uncluttered or even empty. Or conversely, the background must be entirely representative of the concept behind the image, providing context and a sense of location.

- If it's a product shot, be sure that everything is sharply focused. (See Chapter 15 for guidelines on product photography.)

- If it's a lifestyle photo, meant to show people involved in the kinds of activities you are espousing, be sure the people are appealing for the audience you wish to reach. This often means that they look healthy, comfortable, happy, and nicely dressed.

- As a rule, use primary, clear colors and good contrast to convey a feeling of crispness for photos intended to promote your company or your concept.

- Be careful with shadows, making sure they add to rather than distract from your purpose. (See Chapter 9 regarding controlling and adding light.)

Photographing Meetings

Taking pictures at business meetings can be quite difficult for several reasons:

- Executives are usually too busy with other matters to be cooperative or patient.

- Space is often confined, which means that when you use flash (which you should), you could get harsh shadows. (Again, see Chapter 9.)

- The background may be filled with extraneous and distracting elements and other people.

- Photography is often considered disruptive to the meeting; people may become more uncooperative just when things begin to get lively.

Despite all that, the photos must show executives as interesting, active, and involved individuals, who happen to look really good while they do business. Here are some suggestions for getting the best possible shots under these difficult conditions:

- Talk to the people you want to photograph. It's not only courteous, but also they might be willing to help you get the kinds of photos you want. For example, a speaker might be willing to pose at the podium just before or immediately after her talk. (See Figure 14-1.)

- Always use *fill flash*. If possible, also place slave units where extra light is needed. (See Chapter 9.)

Figure 14-1: Rather than disrupt Sally's panel at the annual American Society of Journalists and Authors conference, Daniel took this photo when everyone else was headed to lunch. That enabled him to minimize the harsh shadows (which are still evident because the podium is so close to the wall) and to shoot from a position that would have blocked the audience's view. Unfortunately, Sally forgot to take her reading glasses out of her hair. (Photo taken with a Kodak CX7430 Zoom.)

- Use your *optical zoom* to frame your pictures, cutting out unnecessary background and people.

- As with party photography (see Chapter 13), be on the lookout for the animated moment that defines the event.

Executive Portraits

While most photographic portraits involve the full cooperation of the subject, executives often view sitting for a portrait as a necessary evil, something to be put up with because of orders from above or the situation requires it. They want to get it over with quickly so they can get on with their real work.

On the other hand, shooting a really good portrait can be time-consuming. You need to get the lighting just right. Hair (and makeup, if it is used) must be just perfect or appealing. Clothes have to fall nicely, with creases and folds adding to rather than detracting from the portrait. And you have to take enough shots to make sure at least one of them captures the right facial expression and posture.

In other words, the subject and the photographer could end up being at cross-purposes with each other, which can be counterproductive to getting a great shot. The answer is to get the executive on your side. Therefore, capturing a good executive portrait often requires that you employ a sense of office politics and fundamental psychology.

One thing you can do to help you navigate through this potential mine field is to prepare everything (including yourself) as much as possible before the executive arrives to be photographed.

- Set up and test the lighting before the executive arrives. Have an assistant sit in for the executive—preferably someone who is approximately the same size and coloring as the executive.

- Spend some time studying the exec before the day of the shoot. Know the geometry of his face, his coloring, any facial expressions you wish to avoid or encourage. (See Greg Gorman's suggestions on portraiture in Chapter 12.) Does he have a better side or a chin that needs to be minimized? Is one eye larger than the other?

- Know what habits and mannerisms will best represent her and capture who she really is. Are her hands particularly expressive? Does her smile win her a lot of negotiations, disarming opponents, or is it a particular stare that she has refined to an art?

- Study his personality, too; learn something about him ahead of time and prepare subjects of discussion that will help you connect with him.

Marilyn Sholin, the portrait photographer (`www.marilynsholin.com`), said that photographing men and women executives can be very different. "If it's a man, you need to engage him, not unlike the ways I work with children, but with more respect. For men, what they care about is that you give them total respect and recognize that their time is valuable," she explained. "If it's a woman, however, you need to find out what's more important to her. Is she worried about her hair, her suit, or her need to get to the next meeting? Women executives will be very precise with what they need, while men need to be handled."

By the way, an executive portrait doesn't have to always be the same old traditional head shot. Consider composing a portrait that captures more about the person and the company, by having the executive involved in a definitive activity related to his role and to the company's strengths, which he clearly represents. (See Figure 14-2.)

Specialty Applications

These days, a well-equipped briefcase contains a digital camera. But what a businessperson will do with a camera varies widely depending on the business or profession engaged in. The following is a short alphabetical list of types of business applications, tips on getting the pictures each requires, and suggestions for the kinds of cameras appropriate for them. While not a comprehensive list of specialty shooting, you'll find information appropriate to many other kinds of applications in this section.

Figure 14-2: An executive photo can be an interesting composition, which conveys information about your company. This photo of Daniel shows him in our DigitalBenchmarks Lab, actively involved in testing cameras. Everything in the photo relates to the concept of precise testing and analysis that is one of the primary missions of the company. (Photo taken with an Epson PhotoPC 3000Z.)

AERIAL PHOTOGRAPHY

With aerial photography, depth of field isn't as important as the speed of your lens and shutter. (See Chapter 6.) Everything you are shooting is background (as opposed to near foreground) and so far away as to be perceived as flat or almost so. Definitively, you'll want a long lens, with a good *burst mode*. If your camera doesn't have image stabilization, you might consider using an auxiliary gyro stabilizer or, at the very least, an inexpensive steadycam brace. One of the biggest problems is that distance diminishes the distinction between objects, which can be countered by increasing contrast. Since everything is in motion, shoot the fastest possible *shutter speed*.

Tip: For the Best Photography Platform in the Air, Catch a Blimp

Our favorite aerial shooting platform is a blimp, with its steady, gentle ride and open windows. The pilot can tilt the airship at whatever angle we indicate and hold it there, staying in nearly the same spot for long minutes. If you know that a blimp will be in your area, go to the airfield and see if they have room for a photographer. If they have room, and if they like you, you might luck out.

FINE ART AND MUSEUM PHOTOGRAPHY

When photographing fine art, image quality is paramount. You'll want a camera with at least 5MP resolution, manual *white balance* and exposure, great optics, and probably the ability to sync with external *strobes* or studio lights. If you are shooting three-dimensional objects, such as sculpture, be sure to use a small (high number) *f-stop*. (See Chapter 6.) Always use a tripod or camera stand to keep everything steady and use the *self-timer* to avoid even the slightest shaking of the camera. A spirit level on your tripod head will help keep the camera lens parallel to the object being photographed, which aids in avoiding distorted perspectives.

FORENSICS

Photography has long been used as evidence in police work. Digital photography though initially suspect is now accepted, and most police departments have or are in the process of retiring most of their film cameras in favor of digital equipment. Some shoot with Sony Mavicas because they record to CDs immediately, which means that the photos can't be edited. For forensics, you'll want a camera with a great *macro* lens, good flash or auxiliary flash, one that is rugged and will function well in poor conditions and bad weather. Ideally, you'd want a camera with true wide angle and audio annotation.

Use Metadata for Verification, Documentation, and Management

Metadata (see Chapter 5) is nonvisual information automatically attached to the files of your photos by your digital camera. This includes the date and time the photo was taken, with what camera and using what settings. And if the camera is Global Positioning System (GPS) enabled (using satellite reception), metadata can record where the photo was taken. What makes metadata particularly valuable is that you can view it in many of the programs you use to work with your photos. (Usually, it can be found by selecting the photo and then choosing a command similar to File Info or Properties.)

But you can take metadata even further. Here are some suggestions:

- Manually add to the metadata to provide information about who took the photo, where, and under what conditions.

- Insert *keywords* and descriptions to help with future searches and use of the photos. (See Chapter 21 regarding digital media asset management.)

- Have an ASIC (application-specific integrated circuit) in your camera(s) programmed to include additional critical information automatically at the time of capture.

In essence, any information that can be organized into categories can be developed into image metadata, and that's an invaluable tool for image verification, documentation, and management.

INDUSTRIAL

Digital cameras are used extensively to document processes, such as assembly and construction, and to help analyze the strengths and weaknesses of the process. In other words, the photos are used to determine how something is done, to prove it was done, and/or how it might be done better. Artistic composition is not as important as accurate capture. Depending on the subject, you might need a steady platform, such as a tripod or camera stand (especially for macro shots). If you are using *time*

lapse photography, consider tethering the camera to a computer (wired or wirelessly) for immediate and continuous download of images as well as remote control. The wide range of potential subjects in this category makes it difficult to offer specific shooting suggestions or camera recommendations. However, one generalization tends to hold true: it does require sophisticated photographic skills and significant training to develop the analytical ability to design the appropriate shoot.

INSURANCE

Every insurance agent carries (or should carry) a basic point-and-shoot digital camera for documenting claims. It doesn't require much skill, great image quality, or high performance. One concern, however, is keeping the photos for each claim separate while still on the road. This can be done by creating separate folders on the camera or swapping out memory cards for each case. (See Chapter 11.) Generally, wide angle is more important than telephoto, though macro has its value for showing details of damage. Audio annotation can be very helpful for small descriptions or explanations that are attached to the image file.

PHOTO IDS

Photo IDs were one of the first business applications to embrace digital photography wholeheartedly. The savings in film, processing, and time made the comparatively poor image quality of those early days unimportant. Today, the pictures are much better, but the setup is essentially the same—the camera in a fixed position on a tripod or stand, with lights permanently in place, all settings usually on auto, and a computer connection for processing the pictures immediately. In fact, all shooting may be controlled by the computer, too, using a mouse click rather than by pressing the shutter button. Don't bother with high resolution because these pictures are going to be either tiny prints for a badge or ID card, or little more than thumbnails for a database. However, you'll want a heavy duty camera that can take the day in/day out constant shooting, which means that a serious amateur or prosumer camera for their superior construction and extended duty cycle.

REAL ESTATE

These days, success in real estate can depend on good, representative photographs that can be quickly put up on the Web and displayed in ads. Consider creating panoramas and interactive walk-throughs (see Chapters 13 and 15) for the Web, too. A 3 megapixel point-and-shoot or intermediate camera is quite sufficient, though one with panorama guidance is very useful. Folders or extra memory cards can keep different properties separate until you can get the pictures downloaded to your computer. (See Chapter 11.) Take advantage of audio annotation to highlight special property features.

Tip: Automate Processes with Templates and Macros

For many businesses, similar photos are repeatedly taken and used in the same way, and that lends itself to considerable time and effort savings with templates and *macros*. For example, in real estate, the front door overview shot is almost always placed on the top of the Web page and as the first picture on a broadsheet. The kitchen shot when used would be a smaller secondary photo. Setting up the automation may be time-consuming, but once developed, it cuts the costs and time involved in sorting, editing, and using the photos. (See Chapter 18.)

SCIENTIFIC/MEDICAL

Digital photography doesn't simply document phenomena and enable make diagnoses, but postulates "what ifs" and extrapolates known data into feasible hypotheses. From taking pictures of the smallest to the largest items in this universe, to shooting the invisible and otherwise unknowable, digital photography has opened up new realms of discovery. Most devices used are specialty cameras, but in some cases, a common everyday model is quite appropriate. For example, Sally's father, a retired orthodontist, often took photos of his patients' jaw and bite to help him analyze what angles and relationships among teeth needed to be adjusted and by how much. Cameras for these kinds of purposes should have great optics and high resolution for zooming into details. Other features and properties would be specific to the subject and phenomena being photographed. But one fact is unassailable; doctors and scientists (especially men) will buy the best, most stylish camera they can afford as a status symbol. If you're the budget keeper for such professionals, you need to distinguish what's really needed photographically and technically for the project. (See Chapters 2 and 3.)

SECURITY

Most security digital cameras are sold as part of an entire package of the type that falls outside the purview of this book. An exception to this are models used for surveillance.

The camera should provide manual controls and have a long, fast telephoto lens, which means that it would be heavy and would require sophisticated photographic skills. You should brace it either with your body, on a ledge, or with a monopod or tripod (see Chapter 11). Image stabilization of some sort would be a definite plus. Sony stands out in this field because some of their cameras have the ability to actually frame and take photos in the dark with a special night mode, which is based on technology similar to the army's night scopes.

Incidentally, while you might be tempted to use a still digital camera capable of time lapse photography for premises security, in most situations a video camera would probably be better.

Tip: On-the-Road Data Protection

Digital photos are ephemeral; one small glitch in your camera or laptop, and an entire shoot can vanish. You'll want to be sure to develop a backup strategy to use on the road. This may include saving your photos to more than one place, such as multiple memory cards, key drives, your laptop, or so on. One great type of device to consider carrying with you is a portable hard drive or CD/DVD burner that will take data from your memory card (without requiring a computer) and save it onto a hard drive or burn it to a disc (see Chapter 4 for more information about these devices).

Photography for Digital Makeovers

From personal beauty to architecture, digital makeovers provide virtual views of what could be if you go through with the project. "Before" photos are imported into computer programs where rooms and furnishings can be rearranged or replaced, a new facial structure tried, trees and bushes moved or added, and so on. You'll need detailed photos, which means a camera with at least 4 megapixels.

Photography for Digital Makeovers *(Continued)*

A viewfinder that displays gridlines will help avoid shooting at an angle and introducing distorted perspectives. Consider assembling a series of still images into a panorama or a 360-degree interactive QuickTime movie for a great sales tool. (See Chapters 13 and 15.)

Using Your Business Photos

Capturing your photos is only half the story; how you use them is an important key to their value and effectiveness. Yet this critical issue, which was once the bailiwick of graphics designers and publicity specialists, is now often left in the hands of executives or their assistants. The thinking behind this trend is that it is now so easy to place photos into all kinds of documents, presentations, and communications that anybody can do it.

Of course, that's true. But it does require an awareness of design and logistics to do it well. Some concerns you need to consider include:

- Making sure that your photos are the correct size for the purpose
- Ascertaining whether photos from different shoots really belong on the same page
- Placing and arranging your photos effectively and attractively

Tip: Almost Every Business Program Can Use Photos

Nearly everyone knows they can put pictures and graphics into desktop published documents and PowerPoint-type presentations. But did you realize that you can insert photos into nearly any document created with businessware (software used in business)? For example, consider using photos to supplement your spreadsheet figures and charts. There's something about a photo that captures and conveys a concept with great clarity in a way that words and numbers never will.

Sizing Your Photos Correctly

You need to be sure that your photos are the correct size for your purpose. If they are too large, they'll take up too much space, be more difficult to use, and may cause image degradation. If they are too small, they won't provide enough data for good image quality and could lose details and information.

- Photos that will be inserted into printed documents should be the physical dimensions they will take up in the document (such as 2″×3″) at about 300 *dpi* (dots per inch).
- Photos that will be put into presentations or any other projected documents should be the physical dimensions (in relationship to your computer monitor) at about 120 dpi.
- Photos for email or the Web should be the physical dimensions at about 100 dpi.

See Chapter 15 for guidelines on how to measure image sizes and how to shoot and edit photos so they are the correct size.

Tip: Does That Photo Really Need to Be in Color?

Photojournalists and artists have long recognized that black-and-white photography can be more effective than color, especially when contrast, lighting, and shadows are used creatively. It focuses the viewer's attention more fully on the subject and composition, undistracted by the emotional overtones of color. Besides, b&w documents are much cheaper to print than color.

Photographic Matchmaking

When you place several pictures in a document or presentation, or on the Web, be sure they look good together. Photos taken at different times, under various conditions, and/or using dissimilar equipment will tend to look or feel different. A novice might not know what bothers him about seeing two such photos on the same page, but subliminally it will strike a discordant note.

To develop your eye for recognizing when photos will look good together, spend some time studying and analyzing brochures, newsletters, catalogs, and Web sites that you feel do a good job with photos, as well as those that don't work in your estimation. Try to understand what attributes of the pictures are clashing or out of sync with each other. As a rule, any two pictures that you plan to put onto the same page or in the same document should have the same level of contrast, sharpness, and *noise*. The nature of their light, shadows, and color should be quite similar (see Color Figure 16 in the color insert in the back of the book).

In many cases, you can edit photos to bring them closer to each other in terms of contrast, color, and *dynamic range* (the percentage of highlights and shadows). However, some things, such as the direction and type of light may or may not be correctable in photo-imaging software (see Chapters 9 and 18).

Tip: Don't Forget to Transfer the Photo Files

When you move a presentation or other document from one computer to another (such as to your laptop), be sure that all the embedded images are also moved. While some programs will package all the needed files automatically, others require that you do it manually. If you don't, then when you give your presentation, you'll have holes or ugly placeholders where you expected to see your graphics.

Placing Photos in Your Documents

Whether you are using your pictures in a PowerPoint presentation, a newsletter, or any other document, getting it in position is generally quite similar, though the nomenclature may vary depending on the software.

- Use a Place or Insert Picture command, which is usually found in the File, Insert, or Image pull-down menu at the top of your screen.

- Navigate or browse to the photo you want to place and select it.

- Click Done, OK, or similar button.

Now that the picture is in your document, you can click and drag to move it to the exact position you want it. On a Windows system, a right mouse click on the photo will probably open up a menu of a variety of options. (On Macs, you might use one of the modifying keys, such as Command in conjunction with your mouse button to open similar menus.) For example, in many programs, you can choose how the text in the document will wrap around the photo. (See Figure 14-3.) Or, you might be able to align it in relationship to the margins, attach it to a paragraph (so as you edit and the paragraph moves, the photo does, too), put it behind or in front of another picture, interactively resize it by dragging on a corner, and so on.

Figure 14-3: In many programs, you can select how text will wrap around your photo. This Text Wrap dialog from Corel WordPerfect shows some of the most common options. More advanced desktop publishing programs, such as Adobe InDesign, may also allow you to choose the distance between the wrapped text and the picture (which may be called the envelope or picture container). (© 1996-2004 Corel Corporation.)

Tip: Emailing and Posting Photos to the Web

Many business photos are useless unless they are shared immediately with the home office, potential clients, and so on. Some cameras can tag photos when they are taken, so they are automatically emailed or uploaded to a Web site when the camera is connected to your computer. (See Chapters 15 and 19.)

More Than a Capture Device

While digital cameras are specifically designed to take pictures, the technology underneath the hood easily lends itself to other functions and purposes. Some digital cameras also double as MP3 players, tape recorders, world time clocks, and so on. You can also find some business-focused capabilities that add functionality and value to a company digital camera.

Using Your Camera as a Presentation Device

Presentation projectors have gotten much smaller physically; some can even fit into your briefcase. But if you have a digital camera, you might not even need a projector (which can cost $1,500–$5.000).

You can save your slideshow to a memory card, insert the card into your digital camera, and then, using the camera's video out port, connect it to a TV. When you page through your slides on the camera LCD, they will be displayed on the TV. Of course, that presupposes that a TV is available, and the meeting is small enough (and the TV large enough). Some digital cameras have more extensive slideshow capabilities that make them more suited for this purpose, such as individually timed frames, special transitions and wipes, and so on. Also, some digital cameras have oversized LCD viewfinders, which, while much smaller than a TV set, can be seen by several people at a time.

Another option is the various new generation projectors that can take direct input from your memory card, bypassing your laptop. If you need to use a projector, try to find out ahead of time the size of the room and of the screen to make sure you have the appropriate device.

A Document Copier

If your digital camera has a text mode and macro capability, you can use it to copy documents any time, any place. Some cameras even adjust their built-in flash to properly illuminate text and other close-ups.

Here are some guidelines for using your camera as a portable copier:

■ Shoot at the highest *shutter speed*, best *resolution*, and lowest *compression*.

■ Be sure the camera lens is parallel to the document. Shooting at an angle can introduce a distortion or cause a glare that might obscure the text.

■ Don't use the flash if it isn't properly optimized for close work.

■ Almost any light source will work; you can even bring a table or desk lamp close to illuminate the document. However, even lighting is very desirable, especially if you plan to use optical character recognition (OCR) software to convert the image of the page into editable text.

■ OCR also requires a straight on, steady photo, such as what you get with a stand, and at least a 5MP camera for a letter-sized document.

■ If at all possible, use a copy stand to ensure a steady, parallel capture. (See Figure 14-4.)

Audio Recorder

Audio annotation allows you to record information (such as names, titles, claim numbers, and so on) about the photo you are taking at the time you take it. In addition, many digital cameras can record sound without taking a picture. Depending on the memory card and the camera's capabilities, you might be able to record several hours of sound. It won't be high quality, and the mike will be small and tinny and has to be directed close to the speaker. But in a pinch, it will work.

Figure 14-4: We were involved in developing this desktop copy stand for Forrestal Digital (www .ForrestalDigital.com), which we designed to accommodate various digital cameras and to place them at the optimum relationship to the paper being copied, while taking up little desk space. In this picture, a Nikon Coolpix 2500 is fitted into the head. (Photo taken with Olympus E-10.)

Summary

These are some of the key points made in this chapter:

- Before you can choose a digital camera for business, you need to decide how it will be used and how much training you are willing to provide to your employees and associates, as well as who in your company will be using it.

- A good picture can provide information, verify facts, and support positions.

- A business photo must convey and support the meaning you need and intend, without adding any unwelcome subtext.

- Placing photos in presentations, brochures, newsletters, and other documents is quite simple and similar in most programs.

- When you give presentations, you can leave your laptop at home. You can connect your digital camera to a TV to show your presentation. Or, use one of the new projectors that takes memory cards.

- The black-and-white text mode of a number of digital cameras can be used as a portable photocopier.

Chapter 15

Photography for Email and The Web

W e challenge anyone who claims that computers heralded the "paperless" office to guess what the surface of Sally's desk looks like. It's buried under more papers than ever. However, for a large number of photographers (pro and amateur alike), the paperless studio has become a reality. Many photos never become anything more than pixels on a computer monitor, spending their entire existence as digital files. We edit them, use them in business documents and presentations, include them in holiday greetings, post them on ecommerce Web sites, use them as evidence and to support or refute arguments, and send them to relatives and friends across the globe without ever bringing them into the real, analog world by printing them on paper.

The Internet and email are two of the most important driving forces behind the popularity and dramatic growth of digital photography. For business and personal pleasure, our society displays and shares pictures electronically at a prodigious rate, without ever needing to print them out. That has created a whole new set of rules regarding how to take and handle your pictures.

In this chapter, we'll cover the special considerations involved in shooting and processing digital photos intended for display on the Internet or for sharing via email. We'll also provide guidelines for producing great product shots for ecommerce and online auction sites (including eBay), tips on optimizing photos for email and the Web, and other issues that are particular to this very new aspect of photography.

Size Matters

The other day, a representative of a digital camera manufacturer unwittingly sabotaged our computer network. Anxious to show us what her client's best and newest models looked like, she sent us an email with several photos and a large Acrobat document attached. Because we don't yet have high-speed Internet access out here in the country, it took nearly a half hour for our system to download the pictures and memo. During that time, everything else slowed down to a crawl, and we couldn't send or receive any other email.

In this economy of super-sizing everything, even photography can suffer from the attitude that more is better. We have explained before how the number of *megapixels* a camera is capable of capturing is primarily an issue of volume, not of quality. It is precisely that excess volume of data in large image files that can cause problems on the Internet—both for email and for Web pages.

Not only will large photo files slow down email, but posting a picture onto a Web page that is too big bogs down access, increasing the amount of time it takes for the page to open. In addition, if the files are too big for the Web page, the computer will either have to throw away data to make it fit or will display the picture as too large, often overflowing the space available on your screen. Even if the Web site automatically resizes any picture when it is viewed, giving the system too large a picture to handle means that the person viewing the page will have to be patient while the software does its job preparing the photo to be viewed. Many Web sites resize the photos only once, when you upload them, so your viewers' patience isn't taxed. But that is still allowing a machine to make qualitative decisions about your photos. (See the section on optimizing later in this chapter.)

In other words, taking control over the size of your photo files matters a great deal when they will be used, viewed, or sent via the Internet.

Tip: The Right Camera for the Web

If you plan to use your photos only for displaying on the Web and/or sharing via email, don't waste your money buying a digital camera with very high resolution. A 3 megapixel camera should be quite adequate for most Web or email photographs. (See Chapter 2.)

If you expect you'll need to crop (cut out) smaller sections from a larger picture on a frequent basis, you might want more megapixels. But a better alternative would be to use an *optical zoom* lens to get closer. Better yet, simply move closer to your subject the way a pro would. (See Chapter 12.)

If you expect to be taking lots of pictures of very small objects, be sure your camera has *macro* capability for taking close-up photos. (See Chapter 7.)

Email Etiquette

The majority of people who are connected to the Internet do not have *broadband* or high-speed access. In other words, their Internet connections are slow and often unreliable. But even for those who have the highest speed connections, large image files still can be problematic. So, a new etiquette has evolved regarding sending photos to friends, family, and associates.

- Photos sent via email should never be larger than a few hundred *kilobytes* unless you have checked with the recipient first.

- No photo should be sent via email without first getting permission from the recipient. In addition to being respectful, it is acknowledging the current realities regarding emailed computer viruses. You should treat any file attached to an email memo as automatically suspect, that it's malicious and potentially contains a virus or worm, even if the sender's address appears to be from a friend. Therefore, if you don't notify the recipient before sending a photo, you risk having it being deleted out of hand, as part of their or their server's routine security. It's so easy to first send an email mentioning that you wish to transmit a picture and asking if they would like to receive it.

- Just because a friend, relative, or associate expressed interest in seeing one photo doesn't mean that he or she wants to see your other pictures on an ongoing basis.

As with all rules of etiquette, this is all based on common sense and courtesy. Just think before you attach a picture to an email. Does the recipient have a burning interest in seeing this photo? Has she told me she wants to see it? Will it slow down his system or otherwise cause any inconvenience?

Measuring the Size of Your Photo

Before we discuss the correct size for photos intended for the Web, here's a quick refresher on how to measure the size of your photo.

The size of digital pictures can be described in three different ways:

- The pixels per inch (*ppi*), which is often also referred to as dots per inch (*dpi*), plus the actual dimensions of the picture, such as 3″×5″. When measuring a photo using this scale, you must have both elements—how much data are in each inch and how many inches there are.

- The dimension of the photo stated in *pixels*. This is the result of simple arithmetic applied to the above description. You take the ppi number and multiply it by the inches in each dimension. Therefore, a 3″×5″, 300 ppi photo can also be described as 900 × 1500 pixels.

- The total file size, such as 6MB (*megabytes*) or 200K (*kilobytes*), in which kilobytes are smaller than megabytes. (1,024 bytes equal 1K, and 1,024K equal 1MB.)

If you really want to know how megabytes are related to pixels (and if your eyes don't glaze over when numbers and formulas are discussed, here we go Multiply the measurement of the two dimensions in pixels (900 × 1500 in the preceding example), multiply the result by 3 (for the three primary colors of *RGB*: red, green, and blue), divide by 1 million (or if you want to be precise, divide by 1,048,576, which is 1024 × 1024), and then add a little bit extra for the overhead data that are always attached to the picture information, especially the metadata. Therefore, in the preceding example of a 900 × 1500 pixel photo, the file will be approximately 4MB—if it is uncompressed. (Please see Chapter 5 regarding the JPEG file format and metadata, and this chapter's section on "Optimizing for the Web" for discussions of compression.)

```
(Width in pixels x height in pixels x 3) / 1,048,576 = megabytes
```

Technophiles will note that the formula for the image size in megabytes (before adding the overhead data) is actually the one used for determining the number of megapixels on an image sensor. That's because pixels are a type of byte, being the smallest piece of data that defines a digital photo. (See Chapter 1.)

The Right-Sized Pictures for Email and the Web

Sending large pictures via email is simply discourteous. (See sidebar on email etiquette) Posting large photos on a Web page is counterproductive. Both bog down all uploads, downloads, and Internet navigation; tax your computer and network resources; and are generally very inconvenient. Luckily, reducing your photos to an appropriate size doesn't mean that image quality need be diminished.

Most pictures that are sent via email or posted on a Web page are intended to be viewed on computer monitors. (We will deal with sharing printable photos later in this chapter and in Chapter 20.) The resolution requirements for displaying photos on a monitor are far less than a printer's. In other words, a screen doesn't need nearly as much data to display a sharp, good-looking photo.

SIZING YOUR PHOTOS FOR EMAIL

Use the following guidelines to size your pictures for email:

- For emailing photos to people who don't have a fast Internet connection (known in the industry as POTS, for plain old telephone service), try to keep your picture files (and other attached files) under 500K.

- If you have verified that the recipient has a fast Internet connection, 1MB is the usual upper limit for the typical communication. However, be sure to first clear sending such a large file before attaching it to a memo. (See sidebar on email etiquette earlier in the chapter.)

SIZING YOUR PHOTOS FOR POSTING TO THE WEB

The rule of thumb for photos meant to be posted to (put onto) a Web site is that they should have the average *resolution* of a typical computer monitor (about 100 ppi) and have the physical dimensions (width and height) that you actually want it to use when it is displayed on the monitor. In other words, if you want to show a picture that is $3'' \times 5''$, you will want your photo to be precisely $3'' \times 5''$ at 100 ppi, or $3 \times 100 \times 5 \times 100 \times 3$, or 450K. (Please note that the actual size of your viewed photo will depend on the size of the recipient's monitor and its display settings.)

Emailing Directly from Your Camera

An increasing number of consumer digital cameras offer emailing options right inside the camera, a very convenient feature pioneered and popularized by Kodak EasyShare and HP Photosmart cameras. The following is how it works in general terms on these and similar cameras.

- Cameras that have the email feature typically connect to the computer via a dock. (See the figure in this sidebar.) So, first install the software, get any software updates that are available from the manufacturer's Web site, connect the dock (to the USB port on your computer), and put the camera into the dock. (Do all this in the order suggested by the camera instruction sheet, documentation, or setup wizard.) Also, make certain that the dock's power cord is plugged in. Usually, the dock automatically turns the camera on, but if not, switch the power on manually.

- Follow the software instructions for listing the email addresses of the people you tend to send photos to on a regular basis (such as grandma and dad).

- Follow the on-screen instructions to upload the email addresses to your camera. (Usually it's little more than clicking on a button icon in the software.)

- Take lots of photos of the subjects you want to share.

- Use the dedicated button on your camera to mark the pictures that you want to share with someone (or several people) via email.

- When you put the camera back into the dock, it will either automatically email the pictures (at the correct size for email), or it will ask you if it should send the emails.

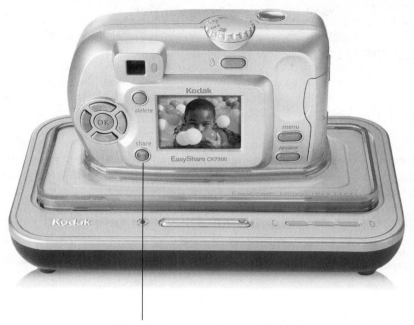

Share button

A Kodak EasyShare CX7300 camera on its dock. As with other EasyShare cameras, various HP PhotoSmart cameras, and other manufacturer's cameras, the dock is a simple method for connecting the camera to your computer. (See Chapter 17.) The dock stays on your desk, always tethered to the computer. When you want to connect your camera (such as to transfer your pictures to your computer), all you do is put the camera down into the dock. Notice the Share button. When you take your photo, simply press the button to mark the picture for sharing. On this camera, it is a red button, but on other cameras it may have an icon of an envelope. When you put the camera in the dock, the photo may be automatically emailed to the person(s) you already selected or the software will ask you first. (Courtesy © Eastman Kodak Company.)

What's great about the cameras we've tested that offer this feature is that they all pride themselves on their ease of use . . . and they deliver. So, following the basic wizards or instructions for setting up and using email (and their other features) will be simple and straightforward, even for novices.

Resize or Shoot Small?

Most digital cameras can be set to take photos at different sizes, with smaller resolution settings designed particularly for the Web (typically, 640 × 480 and/or 1024 × 768). However, we seldom use this option, because we worry about changing our minds once we see the picture. What if the photo is really good? We wouldn't want to limit our options of how we could use it. When dealing with ecommerce and business Web sites, the ability to repurpose a photo (use it in more than one way)

becomes even more important. After all, you might want to produce a brochure or presentation that has the same look and feel (and pictures) as your Web site, creating a professional appearance of continuity among all business communications.

If you take a photo using a camera's lower resolutions, you have limited your options. A 4″×6″ photo may need only 100 ppi to look good on your computer screen, but to get a good print of the same size, it should be 300 ppi.

That's why we generally shoot every picture at the highest quality and then resize copies of the picture for email or the Web. That keeps our options open, so we can use the photo in any manner possible. You can always make a photo smaller. But using software to enlarge a digital photo usually leads to less than satisfactory image quality. (See the sidebar on "Interpolation and Sampling.")

The one exception is when you are taking advantage of the direct email options with Kodak EasyShare, HP PhotoSmart, and other brand cameras. (See the sidebar on "Emailing Directly from Your Camera.") Then, we use the camera's own tools for making sure the pictures are the correct size for emailing.

Tip: Always Archive Your Original Photo

Whenever you resize or otherwise edit a photo, save your original under a unique name, and don't overwrite it with the edited version. That way, you can always go back and use the full, original data.

Interpolation and Sampling

The tools for resizing pictures that you'll find in various photo-editing programs are remarkably easy to use. But don't let their simplicity fool you. These are powerful commands that alter the very fabric of your pictures.

- *Sampling* changes the number of pixels that define your photos.

- *Subsampling* reduces the number of pixels. Therefore, if you have a photo that is 3MB in size, for example, and you want to email it, you might subsample it down (throwing away data) to about 350K.

- *Interpolation* will enlarge an image file by analyzing the data that already exists and inventing new data. It's nothing more than guesswork on the part of the program and usually involves simply duplicating data. Although, you'll end up with a larger file, image quality is not only *not* improved, but can actually be diminished.

In other words, reducing the size of a photo file can be a worthwhile process, making sure a picture isn't too big for applications such as emailing or Web site design. Increasing the size of a photo is generally not recommended. But when done correctly by a good interpolation program, it might take an expert to discern the difference that a *small* amount of interpolation makes.

Using Software to Resize Photos

The commands for resizing photos are remarkably similar in most photo-editing programs. Often, the biggest problem is finding the command, because it is called various names in different programs. The one constant you can depend on is that it is usually found under a *pull-down menu* at the top of your screen. Pull-down menus may also be called *cascade menus*, because they cascade out of the header word. (See Figure 15-1.) Here are some examples of the nomenclature used:

- In Adobe Photoshop and Photoshop Elements, click on the Edit pull-down menu and select Image Resize.

- In Corel PhotoPaint, click on the Image pull-down menu and select Resample. (See Figure 15-1.)

- In Microsoft Digital Image Suite, click on the Format pull-down menu and select Resize Image.

Other programs will use similar kinds of names, though we've often been surprised at how inventive some software engineers can be with their naming conventions.

Figure 15-1: Corel PhotoPaint's pull-down menu is similar, but not identical to those found in other photo-editing programs. The biggest difference is often the nomenclature used to describe common commands and options. (A) Pull-down menus are the words at the top of the software screen, such as File, Edit, Image, Help, and so on. (B) To get to the resize image dialog, click on the word Image, and then Resample. (© 2003 Corel Corporation.)

Once you have opened the photo resize dialog, you may have several options, depending upon the program. (See Figures 15-2a, 15-2b, and 15-2c.) The most important are the following:

- Change the width and/or height of the picture, which may be expressed in pixels, inches, centimeters, or other units of measure. (The unit of measure can always be changed, usually by just clicking on the current one and selecting another in the displayed drop-down list.)

Figure 15-2a: In this Corel PhotoPaint Resample dialog, we have taken a 300 dpi 3.93″×2.9433″ photo and reduced the resolution to 72 dpi. Because the Maintain original size option isn't checked, the dimensions did not automatically increase in response to the lowering of the resolution. You will notice that the original picture was approximately 3.125MB in size, and that the resampled photo will be approximately 180K, which is a dramatically reduced picture indeed. (© 2003 Corel Corporation.)

Figure 15-2b: Bringing the same picture into Adobe Photoshop, we used the Image Size dialog to reduce the resolution from 300 dpi to 72 dpi. Notice that the Maintain aspect ratio command in PhotoPaint is called Constrain Proportions in Photoshop. Similarly, leaving the Maintain original size command in PhotoPaint unchecked is the same thing as checking Photoshop's Resample Image. One interesting thing is the slight difference in original image size, which is probably related to how the two different programs handle metadata. (© 2004 Adobe Systems Incorporated. All rights reserved. Adobe and Photoshop are registered trademarks of Adobe Systems Incorporated in the United States and/or other countries.)

- Decide whether or not to maintain the original proportions (*aspect ratio*) of the photo. If yes, then changing one dimension (width or height) will automatically change the other, to keep them in proportion. If no, then each dimension can be changed independently of the other.

- Change the resolution, which may be expressed in dpi or ppi. (See "Measuring the Size of Your Photo" earlier in this chapter.)

Figure 15-2c: Other programs have much simpler dialogs for resizing, such as this one from Microsoft Digital Image Suite. Here, we have "locked" the width and height dimensions and have changed the resolution to 72 dpi. Because Digital Image Suite is meant more for novices, the dialog doesn't provide as much information or choices, but it still does the job of reducing the picture so it is more appropriate for use on the Web. (Copyright Microsoft Corporation.)

■ Choose whether or not to maintain the original file size. Remember, that the total file size is based on its dimensions (width and height) and its resolution (ppi or dpi) times 3 (for each of the primary colors). So, if you don't want the file size to be altered, then lowering the resolution will increase the dimensions and vice versa. In other words, a 2″×4″ 300 dpi image is 703.1K in size. If you choose to maintain its file size and decrease its resolution to 75 dpi, then the dimensions will automatically be increased to 8″×16″. That doesn't create any new data, just adjusts how it's spread out, because the total pixels of both versions of the same image is 600 × 1200 pixels.

Other options will vary depending on the program you use, but those are the most important when resizing your photo for the Web.

Tip: Fun-House Effects with Image Resizing

When you resize a photo, you have the option of maintaining proportions (aspect ratio) or resizing the width and height of your picture independently of each other. Be careful of changing proportions, because it can create a fun-house mirror effect, making things in your picture fatter and shorter (when the width is increased without a proportionate increase in the height) or taller and thinner (increasing the height more than the width). The result can be a distortion that might be fun, but it won't be accurate or realistic. On the other hand, if Aunt Mabel is always complaining that your photos of her make her look too fat, perhaps a slight distortion to help her feel better about herself might be just the trick.

Photo versus Canvas Resizing

Every major photo-editing program (and most minor ones, as well) have two very different resizing commands. You'll want to be very careful to choose the correct command for your needs. While the names may vary, the concepts are the same.

- One command resizes your photo so that the picture itself is bigger or smaller.

- The other resizes the canvas that holds your photo. If you use this command to enlarge the canvas, it will increase the borders surrounding your picture. (See sidebar Figure C.) If you use this command to make the canvas smaller, it will actually cut away portions of your picture. (See sidebar Figure F.)

Figure A: We start with this soulful picture of our English springer spaniel Cuddles. (One of the few pictures of him in which he isn't smiling. Maybe it's the haircut.)

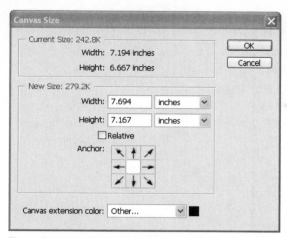

Figure B: Using the Photoshop Canvas Size command, we increase each dimension (width and height) of the canvas by 1/2 inch. In the tic-tac-toe type graphic labeled "Anchor," we have highlighted the center box to make sure that the original photo stays in the center of the new, larger picture. Notice that we have chosen a custom color of black as the canvas extension color (the black square next to "Other" at the bottom of the dialog). (Dialog © 2004 Adobe Systems Incorporated. All rights reserved. Adobe and Photoshop are registered trademarks of Adobe Systems Incorporated in the United States and/or other countries.)

Figure C: The resized canvas has a 1/4 inch black border around Cuddles' photo. (That's 1/2 inch for each dimension, shared equally on all sides.)

Figure D: Starting with the same original picture of Cuddles, we click on the upper-left square in the Anchor graphic of the Canvas Size dialog. Notice that we checked the relative box to make it easier to define the canvas extension as 1/2 inch for each dimension. (Dialog © 2004 Adobe Systems Incorporated. All rights reserved. Adobe and Photoshop are registered trademarks of Adobe Systems Incorporated in the United States and/or other countries.)

Figure E: The photo of Cuddles is now in the upper-left corner of the enlarged canvas, which reflects our choice of the upper left square in the Canvas Size dialog. The 1/2 inch of black added to each dimension fills the right and bottom areas of the expanded canvas.

While resizing the photo is done to create a different size file, resizing the canvas is an artistic and production tool. Use the resize canvas command for the following purposes:

- To create a border around your photo. (See sidebar Figure C.)

- To make extra space in the picture for pasting in elements from other files, such as when you are creating collages. (See Chapter 18.)

- To create extra space in the picture for adding text or special effects.

While resizing the canvas can cut the edges of your photo (sidebar Figure F), an interactive *crop* tool is much more precise and simpler to use.

Figure F: In the Canvas size dialog, we reduced both the width and the height of our photo to 5". That caused the edges of the picture to be cut. We prefer using the crop tool found in all photo-editing programs for this kind of task), because it is interactive, more precise, and simpler to use. (Photo taken with a Minolta DiMAGE 7.)

Optimizing for the Web

We have three Web sites: www.DigitalBenchmarks.com details the work we do in testing, evaluating, consulting, and writing about digital cameras, scanners, printers, imaging software, and other imaging products; www.Grotta.net represents our services as writers and speakers; and www.TheWellConnectedWoman.com highlights Sally's work as a technology expert and debunker. Being professional photographers, we want to be certain that the photos on our Web sites are high-quality, interesting, appealing images. But we certainly don't want to display large image files that would take so long to open that people will click away before they can see them.

Therefore, we compress our photos to shrink the file sizes. However, *compression* actually throws away data, which means that if you compress a photo file too much, you can severely degrade image quality.

The trick is to find a good balance between effectively reducing the size of the image files and maintaining image quality. In other words, we optimize our pictures for the Web.

Optimizing is nothing more than a special kind of save dialog that allows you to preview the effects of various options on the image file you are saving. You'll find it under a command such as Save for Web or other similar names.

Optimizing tools are quite similar in those programs that offer them, such as Macromedia's Fireworks, Adobe ImageReady (which is part of Photoshop), and Corel PhotoPaint. Using either a 2-up or 4-up side-by-side preview, you can try various file format and compression settings and compare, or preview, how they will affect image quality and download speeds. (See Figures 15-3a and 15-3b.) That way, you can make intelligent decisions about just how much compression you are willing to use and what it will mean to the quality of your photo and the download times.

Reality Check: Email or Photo-Sharing Web Site

The Internet abounds with Web sites for sharing your photos with friends and families. Many of them are free, though some involve some kind of fee. As a rule, your photos are entirely private, viewable only by those people you invite in to see them.

Here are some guidelines on choosing between emailing pictures or using one of these sites:

- If you want to send a photo large enough for the recipient to be able to get a decent quality print, seriously consider uploading it to a photo-sharing site. Sending such a large file by email would bog down both your system and your friend's.

- If you want to be able to refer to your photos periodically in communications with friends and business associates, having them reside online on a photo site is much more efficient and professional. This is especially true if you are dealing with either a photographic portfolio or supporting visual information for a business relationship.

- If you find you are emailing lots of photos, recipients might eventually become annoyed at being bombarded with your pictures so frequently. Besides, with all the problems of viruses and email security settings that limit attachments, emailed photos may be blocked by the recipient's network administrator. Sending an email pointing them to a Web site is certainly less invasive and more likely to get through security filters.

- However, emailing provides more immediate gratification.

These Web sites usually also offer the advantage of allowing you and your invited guests to order novelty items with selected photos on them, such as mugs, calendars, note cards, jigsaw puzzles, or even cookies, as well as professional prints and, sometimes, posters. (See Chapter 19 for more about photo-sharing sites.)

Whatever you do, don't depend on these sites for archiving your photos. Sites have been known to go out of business or periodically purge their systems. Always save your pictures on your own PC or laptop, preferably backing them up on some semi-permanent media. (See Chapter 21 on organizing and archiving your photos.)

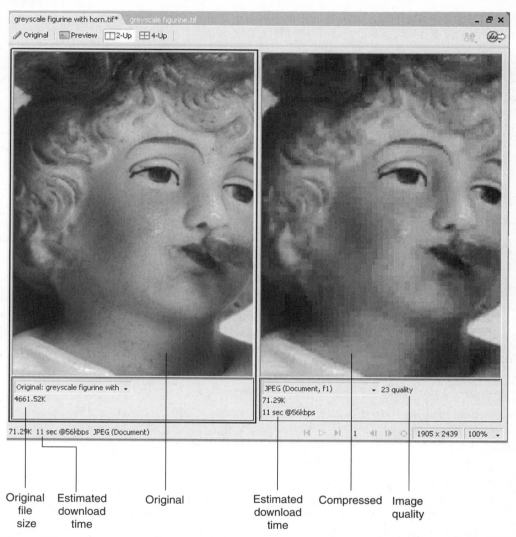

Original file size **Estimated download time** **Original** **Estimated download time** **Compressed** **Image quality**

Figure 15-3a: Here is Macromedia Firework's optimizing tool, set at 2-up (that is, showing only the original and one edited version). Our original photo (on the left) is a 4.6MB TIFF file that would take as long as 15 minutes to download on a 56.6 kbps modem (a nonbroadband phone connection to the Internet). As we see in the preview on the right, converting the file to a JPEG and compressing it with a quality setting of 23 percent, we might end up with a download time of only 11 seconds on the same modem. However, at such a high compression, image photo quality is quite poor, showing obvious pixelization (the blocky pixels). By the way, if we had used the 4-up option, we could have seen side-by-side previews of three different settings compared to the original. (Dialog copyright by Macromedia.)

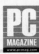

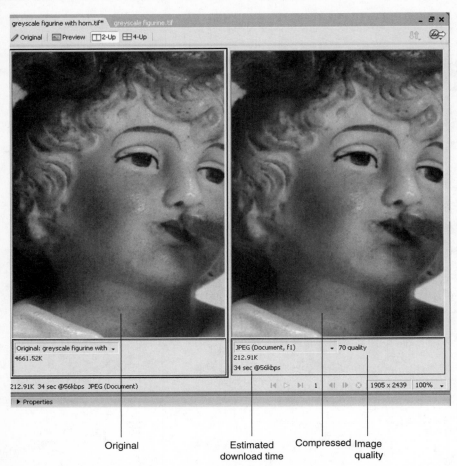

Original Estimated Compressed Image
download time quality

Figure 15-3b: If we set the JPEG compression to 70 percent quality, the download time is changed to 34 seconds on the same modem, and the image quality only slightly affected. A perfectionist will note, however, that the photo on the right (which is JPEG and compressed at 70 percent) is less sharp than the original TIFF image on the left. Usually, such slight softness is not very noticeable on the Internet. But if it bothers you, you can set the compression to 80 percent quality (1 minute download), 90 percent (2 minutes), or better. (Dialog copyright by Macromedia.)

Taking Pictures for Web Sales or Promotions

While the principles for good photography that we discussed in Chapter 12 apply to anything you might shoot, composition for the Web requires additional and special considerations, particularly when your photos are intended to convince someone to spend money or make a business decision. These include pictures you'll put up on an online auction site like eBay or post onto an ecommerce site or other business-related Web site.

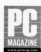

Effective product or promotional photos for the Web need to stand out from the page while still remaining part of the design. Basic rules of Web composition include:

- **Simplicity**—You want people to focus their attention on a single item: your product. So, keep your background simple and free of any distractions or clutter. (See Figures 15-4a and 15-4b.)

- **Clarity**—It should go without saying that the picture must be sharply focused. But also remember that if you are photographing something small (perhaps in macro mode) or an object with lots of depth, be sure to use a small *aperture* (high f-stop number) and a tripod. (See Chapter 6.)

- **Contrast**—Your product shouldn't blend into the photo's background or into the Web page, so be sure to use contrasting (though complementary) colors. (See Figures 15-4a and 15-4b.)

- **Isolation**—Make sure nothing in the background or foreground intersects visually with your product. Don't have any telephone poles or wires or other shapes elsewhere in the picture. The photo should be of your product and nothing else.

Figure 15-4a: Can you determine which item is for sale in this picture? Is it the vase or the figurine? Notice also the lack of contrast and all the empty space surrounding both items. This boring photo won't catch any but the most determined buyers who are specifically looking for what you're offering, that is, if they can figure out what it is that's for sale.

Figure 15-4b: Cropping closely so the figurine fills the full frame and placing it by itself on a contrasting cloth creates a better defined, easier to view product shot that might appeal to even the casual shopper. (Both pictures taken with a Minolta DiMAGE A2.)

- **Tightly framed**—Have very little empty space surrounding the product. That means framing your photo so that it fills your viewfinder, using your camera's *optical zoom* if necessary. For small items, be sure to use a camera with *macro* ability to shoot close-ups. Then, use the *crop* tool in your *photo-editing software* (See Chapter 18) to remove excess.

- **Appeal**—Remember, the whole purpose of posting the photo is to encourage people to want to do business with you and possibly buy this item. Be conscious of the subliminal message your composition imparts. If your photo isn't attractive, they might simply click away. (See Figure 15-5.)

Tip: Think Big for Web Site Photos

Grant Myre, a Web designer with Corel Corporation, suggests to "always think big." In other words, have your subject fill the frame. "You don't want a lot of small details that might not translate effectively to the Web," he explained. "And be sure your picture is colorful enough with good contrast (against the page background) so it is clearly viewable. Shooting the right photo and taking care with it will help you make the sale."

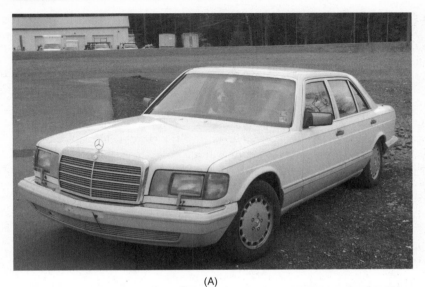

(A)

(B)

Figure 15-5: Selling your car online? Drive to an attractive location to take the photo if you want to get the best price. (A) In this photo taken in the parking lot of our local supermarket, too many things distract (such as the building, trucks, and the line of uneven pavement). But the worst part of it is the subliminal message that this car comes from a work-a-day unappealing environment. Would you want to buy a Mercedes that hadn't been pampered? (B) By driving to nearby Promised Land State Park, we were able to capture an entirely different message about comfort, leisure time, the road not taken, and natural beauty. Which car would you find more appealing? (Both photos taken with a Nikon D70.)

Tips from eBay Experts

eBay.com is the number one auction Web site. If you are planning to sell on the Internet, it's likely you'll use eBay at one time or another. But even if you don't, what applies to photos for eBay can also work for other online product shots.

Jim Griffith, Dean of the traveling eBay University and author of *The Official eBay Bible* (Gotham Books 2003), suggests that when you are editing your photo, "you don't want make the item look better than it really is (such as brightening an old carpet's washed out colors), because it can get you in trouble with the buyer. However, do use a critical eye to look at your pictures before uploading. If you're not happy with them, your customers won't be happy with them."

Adam Hersh, an eBay Trading Assistant (whose business involves selling for others on eBay, www.adamhersh.com) said, "eBay is 98 million users who are strangers to each other. You have to prove yourself and that your item is what it is. So, it's imperative that if there is any damage, you show it in a picture. Don't worry; it will still sell. Conversely, if it is a new item, take a picture of the tags or packaging."

Shoot a number of photos of your item for sale from different angles, including close-ups of hallmarks, important features, and, yes, of damage, too. But don't use more photos than is necessary to give your potential customers a clear idea of what it is they are buying.

Putting your pictures up onto eBay is easier than ever these days, especially if you use eBay's picture services, which at its most basic is free. It will automatically make sure your pictures are the right size and file format and are posted correctly. Plus, there's a slew of resources to help you, including classes (such as eBay University), books, online chat rooms, and eBay-registered Trading Assistants like Adam Hersh who can take care of it the whole process with you.

Tip: Use a Scanner for Documents

When posting pictures of documents or other flat items, such as certificates or antique photos, you'll probably get a clearer, more legible photo with less fuss from a flatbed scanner than from a camera.

Creating Animations from Still Photos

Remember the flip books you used to play with when you were a kid? Each page was a slightly different variation of the same scene. When you held the book by its spine and fanned the pages really fast, the slight differences would translate into a moving animation. Using the same principles, you can create QuickTime or GIF animations from your digital still photos, which you can post on the Web.

We use a Kaidan turntable (www.kaidan.com) to take photos of cameras and other items. (See Figure 15-6.) Because it has ratcheted stops every 10 degrees, we can take pictures at fixed intervals as we turn it the full 360 degrees of a circle. (See Figure 15-7.) Then, we use VR Worx software (www.vrtoolbox.com) to stitch the sequence of photos into a QuickTime movie that viewers can rotate interactively. It's a great way for prospective customers or clients to inspect a product from all angles.

Figure 15-6: When we use a Kaidan turntable like this one to shoot a sequence of photos to create our 360-degree interactive QuickTime movies, we put seamless paper on top of the turntable, with the center screw protruding. That way we can anchor the item onto the turntable. We also use a tripod to steady our camera and make sure the subject remains in the same exact place in our viewfinder as we ratchet the turntable 10 degrees at a time.

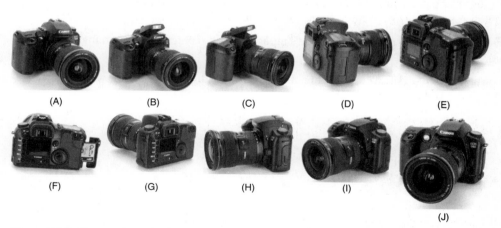

Figure 15-7: These are samples from a sequence of photos we took of the Canon D60, using the Kaidan turntable. Our actual shoot consisted of 37 separate pictures. The more incremental pictures used for the interactive QuickTime movie, the smoother and more natural the transitions. Notice how we opened and closed both the flash and the memory card door during our shoot, which then translated into them opening and closing in the animation as the viewer turns the camera with her mouse button.

A similar technique can be used to create interactive panoramas (which are great for showing off a room or a scenic view). However, for that purpose, the setup is the reverse of the movie previously described, with the camera rather than the object moving. To create the sequence of stills needed for a move that pans the scene, put your camera on a rotating tripod head (available from various sources, including Kaidan).

Other popular Web animations that you can create from still photos include slide shows that can feature text, music, transitions, and a whole slew of special effects. (See Chapter 19.)

Summary

This chapter covered many issues concerning photography for email and the Web. Some of the key points included the following:

- Photos that will be used, viewed or sent via the Internet should be much smaller than those you'll print out.

- The new email etiquette requires that any photo attachments you send via email be less than 500K (for typical delivery), though if someone is expecting your picture and has broadband, you might stretch that to 1MB.

- Some cameras (such as the Kodak EasyShare and HP Photosmart cameras) can set up the automatic emailing of photos when you shoot them.

- You can resize photos in software to make them appropriate for emailing and the Web, but archive the original larger photo.

- Putting your pictures on a photo-sharing Web site is a viable alternative to emailing your photos, especially if you want to share pictures that are large enough to print out well.

- Basic rules of Web composition include simplicity, clarity, contrast, tight framing, isolation, and attractiveness.

- You can create QuickTime or GIF animations from your digital still photos, which you can post on the Web.

Chapter 16

Camera Phones

Cell phones equipped with built-in digital cameras have eclipsed even digital cameras in the speed and growth of their popularity and proliferation. The statistics are staggering: industry experts estimate over 80 million camera cell phones—called camphones—will be in use in this country by 2005. Given their ubiquity, it's very likely that in only a few years' time, you'll have difficulty finding a cell phone that doesn't take still and video pictures.

Camphones have already changed the social and even political landscape. Unlike digital cameras, which often sit on shelves or in drawers, camphones are with you always. See a shot, whip out your phone, and *voilá!* Within seconds, you can easily email or upload it to the Web where many millions can see it. You don't even need a computer, printer, or complicated software.

Because camphones can take pictures any time, any place, civil rights advocates lament at the increasing lack of personal privacy. They're banned in most country club locker rooms, forbidden in many classrooms, and illegal to use on all military installations. On the other hand, camphones are wonderful tools for promoting justice and human rights, because it's much harder for wrongdoers to get away with crimes like harassment and brutality. Aside from social and political issues, camphones are really nothing more than easy-to-use cameras whose photos will go anywhere and everywhere.

In this chapter, we'll explore some of the issues related to selecting and using your camphone, plus tricks and techniques for capturing, printing, storing, and sharing your camphone pictures.

Selecting a Camphone and Wireless Service

If you already own a camphone that you plan to hold onto for a while and are happy with the wireless service you presently subscribe to, you may wish to skip to the next section. But if you're looking for your first camphone, or a better, more versatile device to replace that first generation model you bought last Christmas, or you don't like the quality service you're presently experiencing, read on.

What to Look for in a Camphone

For better or worse, the camphones being sold in the United States are several generations behind those used by many millions in Japan and Europe. We're still dealing with somewhat primitive, low-resolution camphones, relatively slow communications, and limited wireless digital imaging services and can only dream, hope, and wait until we catch up with our Asian and European counterparts. But improvements will be coming to our shores faster than any other technology.

When you shop for your camphone, key issues you should consider are:

- Resolution
- Viewscreen
- Memory
- Ergonomics
- Features
- Price

RESOLUTION

A camera phone is a cell phone first with a camera added on almost as an afterthought—to make it sexier, more fun, and, oh yes, it can sometimes enhance communications by providing visual information. You'll take pictures differently with your phone than you will with your digital camera. Certainly more often and more casually, but also with less discrimination and not so much to preserve memories as to create them. In other words, most camphone pictures will never be printed or even saved. Therefore, your resolution requirements will probably be much less than those for pictures you'll take with a digital camera.

Most present camphones offer what is called VGA (640 × 480 pixels) resolution. That's more than enough data to transmit a decent photo to another camphone, and quite adequate for emailing small photos. If you want to print it, you'll have enough data to produce a 3.5″×5″ color print. But if you try to make it larger, the picture will look like mush.

The top-resolution camphones currently available have *1.3 megapixels* (MP), which will produce 4″×6″ prints. 2MP camphones are expected to reach our shores by the end of 2004, with 3MP devices not far behind.

Get as high a resolution camphone as you can afford if you plan to print your photos. But don't bother with the extra cost if all you want to do is send snaps to your friends and family.

Tip: That Zoom Lens Doesn't Really Zoom

The marketing materials for your camphone may boast the ability to take zoomed photographs. At present, no camphone in the States, or announced for the next year, has a true zoom lens. Instead, they manipulate the file digitally to make a smaller portion of your photo appear bigger. This kind of *digital zoom* actually degrades image quality and should be used very judiciously.

Incidentally, the only *optical zoom* on a camphone, for sale in Japan only, isn't a true continuous zoom lens, but one in which the focal length is doubled by manually sliding an extra, magnifying element into the lens path.

VIEWSCREEN

Now that your phone is a camera, your viewscreen (*LCD viewfinder*) needs to provide much more information and detail, with better color and brightness than before. Look at three technical specifications for your viewscreen:

■ **Type**—Most current camphones come equipped with a TFT (thin film transistor) or OLED (organic light-emitting diode) screen. While the new, slightly sharper OLED screens are more expensive than TFT screens, they don't have to be backlit, which means they use less battery power.

■ **Number of colors**—Viewscreens can display 256, 4,096, or 65,536 different colors. The more colors, the better the image, but more colors are also more expensive. ·

■ **Size**—Measured along the diagonal like TVs, viewscreens are usually 1.5″– 2.5″. The larger screens display more detail more clearly, but they also will cost more and suck more battery power.

MEMORY

Most camphones come with 3–10MB of built-in memory. For greater versatility, convenience, and storage capacity, you should consider buying a model that will allow you to use removable memory cards, like the popular miniSD card, to save your pictures and other data.

ERGONOMICS

A phone becomes part of your public persona, a statement of style, a device that is with you almost every minute of every day. Therefore, how well it fits your hand and the way you like to function with technology are key issues in selecting your camphone. Luckily, you'll have a range of models and designs from which to choose.

■ Do you want a rigid phone that's always ready to take pictures, or a clamshell design that's generally smaller but must be flipped open when you want to use it? (See Figures 16-1 and 16-2.)

■ Do you want a clamshell model that has a second monitor on the outside cover, for viewing when you're taking a self-portrait?

■ Are the buttons and controls accessible, well marked, and easy to push?

■ Do you want the convenience of having a (more expensive) model that recharges and interfaces with your computer's USB port by plugging into a cradle?

Tip: Shop for a Camphone the Way You Would for Shoes

Would you buy a pair of shoes without trying them on and walking about the store? When you shop for your phone, try out each model you're considering. Play with the buttons, take pictures, and set up a couple of addresses in the address book. (Of course, erase those addresses and numbers from the demo units when you're finished.) Do the menus and icons make sense to you? How many times do you have to press a button to get anything done? Then, view the pictures and send one to a friend. How easy or difficult, how fast or slow was it to transmit your pictures? Finally, make a phone call to someone whose number you stored. Can you hear them clearly, even in the noisy store? In other words, try the camphone on to see how well it fits you.

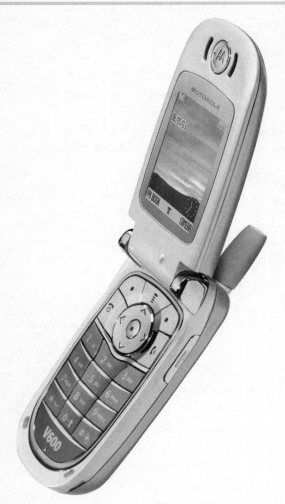

Figure 16-1: A flip camphone like this Motorola V600 opens up like a clamshell. (Courtesy Motorola.)

FEATURES

A features war in camphones is about to explode, which means we can't possibly list all the features that you should consider. But avoid getting caught up in the more-is-better trap. Some features are worth paying extra for, because you'll actually use them. Others simply sound cool, but you'll never really use them. Only you can decide what fits into which category. The following are ones you might feel are important:

- Is it Bluetooth or infrared enabled? Highly recommended, if you want wireless communications with a PC, printer, PDA (personal digital assistant), printing kiosks, or other devices (which also bypasses carrier transmission charges).

- Does it have video capture capability? How fast is the frame rate? How high is the video resolution?

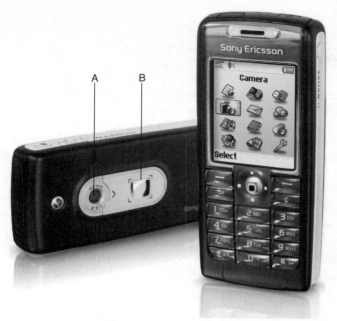

Figure 16-2: A rigid phone is always ready to shoot, though it is usually somewhat larger than the typical flip phone. Pictured here are two views of a Sony Ericsson T637—the back (lying on its side) and the front (with all the buttons). On the back, you can see the (A) lens and (B) a tiny mirror for taking self-portraits. Some cameras have small digital viewscreens next to the lens for self-portraits. (Courtesy of Sony Ericsson Mobile Communications.)

- Does it have a built-in light/flash for illumination when shooting in low light? Quite frankly, the flash on these phones is quite limited, but you might feel it's better than nothing.

- Do you want "smart" phone functionality, combining your camera cell phone with a PDA, QWERTY keyboard, and so on?

- Can you customize it with your favorite photo as wallpaper or picture caller ID or create a slideshow with music?

- Does it come with all the standard cell phone features and conveniences you have come to expect, such a voice recognition, MP3 capability, instant text messaging, easy-to-use menus and icons, downloadable ringers and tunes, and so on?

Tip: An Electronic Billfold

Your camera-equipped cell phone not only can take pictures and download them to your computer or the Web, but it also can upload pictures from the same sources So instead of stuffing your wallet with dog-eared snapshots of loved ones that you can whip out and show to friends and strangers, move them over to your phone and display them on your viewscreen, individually or in a slideshow.

PRICE

Here, we're talking about the cost of the phone itself and not the service (which we cover in the next section). Of course, you may be able to get a free or nearly free camera cell phone in exchange for committing to a service contract. But you will probably have to fork out some bucks for the better camphones. Be sure to pay attention to what you're really paying for and if you're getting the features you really need or want. Is Bluetooth built in or extra? Does it come with accessories, such as a memory card and hands-free headphone? Are there any specials or discounts available?

The one important advantage you have in shopping for a phone is that if the deal they offer today isn't what you want, you can walk to the next store or return the next week. At present, it's a buyer's market, and some one is offering specials of some sort or another at any particular time.

Tip: Believing Is in the Mind of the Beholder

If you are thinking of buying a cell phone for your kid for the added security and peace of mind, it does make sense getting a camphone rather than a regular cell phone. But if you're hoping it will guarantee that you'll always know where he is and with whom, you should realize that most camphones don't send live images in real time. If he sends you a photo of the library to prove that's where he is, the photo could have been shot hours or even days earlier.

Will Camera Phones Replace Digital Cameras?

The short answer is no—certainly not any time in the foreseeable future.

To make camphones as small and portable as possible, as well as give them long battery life, lots of technical compromises have to be made. For example, the lenses and *image sensors* are tiny—far smaller than those on digital cameras and DV camcorders. That means the optics can't capture as high-quality images as bigger lenses, and the sensors will generate more *noise*. In addition, camphones lack a superior mechanical shutter; plus there's not enough battery capacity to adequately power a robust built-in flash. For these reasons, phone image quality will probably always be inferior to that of a dedicated digital camera—at least those cameras in the mid- to high range.

While camphones may never produce the print and video quality better digital cameras and DV camcorders can, don't underestimate the public's ingenuity when it comes to adapting. Many times before, we changed (lowered) our standards of excellence and our definitions of quality to accommodate the technology, rather than the other way around. But for the time being, if you want great print quality, use a digital camera, and if you want beautiful video, shoot it with a DV camcorder.

Camphones will give you adequate quality prints and videos, and that may be enough for your purposes and satisfaction. Besides, it's the one device you'll always have with you, which means you'll be getting pictures and videos you never would have captured otherwise.

Choosing Your Service Provider

As we all well know, the price of a phone is only the beginning. The real cost to you will be related to how much your wireless carrier charges you for sharing your photos. Every major wireless carrier

now offers some sort of camera cell phone service. What service you choose shouldn't depend entirely upon how well or poorly it supports photo taking and transmission, but it is an important issue. Here are some things you should keep in mind when you're thinking about selecting a phone service for that new camphone you're considering buying:

- **Cost**—You have probably been through the mill (as we have) with all the many different kinds of plans offered by cell phone service companies. Now add to that profusion of fine print the options related to photo sharing. Does your service offer free or reduced price photo transmission capability? How many free photos can you send each month? Is there a monthly data storage plan? How much does it cost per megabyte? Some plans bundle text messaging and photo messaging together; others sell them separately.

- **Transmission quality**—In major cities, this isn't an issue, but in the mountains where we live, it's a paramount concern. Voice and data transmissions often break up but may eventually go through even if the signal is weak. However, photos usually bomb when the signal begins to break up. Choose your service based upon where and how many towers are near where you live and drive.

- **Transmission speed**—Keep in mind that if your service doesn't offer a high-speed, broadband, or high-compression transmission capability (look for acronyms like G3, EDGE, GSM, and UTMS), it will probably cost you a little more money to send each photo, because the transmission times will be seconds longer.

- **Contract**—For that free or nearly free camphone, do you have to sign a 1-year or 2-year service contract? Longer? Can you change plans during the contract, or are you stuck with whatever terms you agreed to when you got your phone? How much is the buyout? If you decide to change carriers, will they pay off the balance of your service contract to get your business?

- **Service**—Unfortunately, we have found that the quality of service we have experienced from wireless service providers varies widely, depending on which store we walk into or whom we get on the phone. But most people, when spoken to nicely, have been helpful. You'll want them to not only set up your camera's phone number, but also the MMS (photo messaging), email account, Internet access, and other optional services.

- **Support**—Does the wireless company support the camphone phone you want? There is a difference in the way various brands of camphones function, and one may fit your hand, photographic style and personality better than others. So, if you have your heart set on a particular Motorola, Nokia, Sony Ericsson, or other model, that may influence whether you'll sign up with a specific wireless service provider.

The Economics of Camera Phones

How can phone companies give away free camphones, or sell them for a proverbial song? That's easy. They expect to make their profit not on equipment sales, but on transmission time. The more photos you shoot, send, and share over your wireless network, the more billable minutes the phone company collects from you.

The Economics of Camera Phones *(Continued)*

Some entry-level camera phones send their pictures only through the phone network, which means that you'll pay air time whenever you transmit a photograph to a printer, in email, to the Web, and so on. Better camphones use Bluetooth to transmit images (for free) to other devices. Do the math. It's likely that spending a few bucks upfront for a Bluetooth-enabled camphone will probably be cheaper in the long run.

Tip: How Many Photos Can You Take?

Unlike digital cameras that tell you the approximate number of photos your memory card has room for, many camphones report the percentage of memory (resources) left or used. What that means will vary with each brand and model phone, so you'll have to learn from experience how, say, 25 percent of resources relates to the number of pictures you can still take.

Shooting with Your Camphone

Camphones are basic point-and-shoot digital cameras. Taking a picture usually follows the following steps (though some models may differ):

1. Find the button that corresponds to or has the camera icon and press it to go into photo mode.

2. Compose your photo in the viewscreen (see Figure 16-3.)

3. Press the camera icon button again to take the picture.

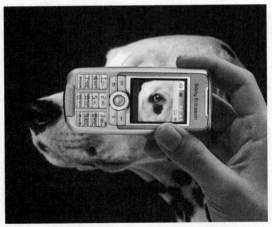

Figure 16-3: When you compose your photo in your viewscreen, you'll be looking at the operating side of the phone. (Courtesy of Sony Ericsson Mobile Communications.)

In all the camphones we have tested, the picture we'd just taken was immediately and automatically displayed in the viewscreen, with options to save, send, and/or delete it. (We cover sharing your photos from your camphone later in this chapter and in Chapter 19.)

And that's all there is to it. Unlike digital cameras, camphones have no provision for changing exposure, increasing contrast or color saturation, or doing anything similar to improve or enhance photos when you take them. They're more or less WYSIWYG—What You See Is What You Get.

Even so, the same principles for taking good photographs with any type of camera also apply to camphones. Here are some guidelines for getting good pictures, some of which are a quick refresher regarding photography in general, while others are specific to camphones:

- Hold the camphone firmly and securely to minimize shake.

- Frame your shots carefully by lining the subject up in the viewfinder.

- Squeeze rather than push the shutter button. Most camphones have a fixed focus, non-zoom lens, so there's no two-step shutter to worry about.

- If you can't see it in your viewfinder, it's too dark to take a picture. Move to another position where the light's better or adjust a nearby lamp to throw some illumination on your subject. If your camphone has a built-in flash, turn it on. But remember that it probably won't reach further than 4–5′.

- Vary your shooting angles. The viewscreen allows you to hold the camera high above your head, down toward the ground, or as far as your arm can reach in any direction. Interesting angles of view can lead to really neat photos—or very bizarre ones. But what the hey!—if you don't like the picture, you can just delete it.

- Follow the action. Since you can't select a faster shutter speed for action subjects, track it by moving your camphone parallel to the subject.

- Delete any shots that didn't turn out to free up the limited memory and preserve your reputation as a good photographer.

- Timing is everything. Wait for the smile or expression of delight, the peak of the action, the gesture that says everything, the moment of perfection when a picture is truly worth a thousand words.

Another thing to keep in mind with more advanced camphones is selecting resolution to match the intended output. SVGA (320 × 240 pixels) is all you want if you're transmitting pictures to another camphone, and VGA (640 × 480 pixels) is the best resolution for sending emails or posting to the Web. Save the highest resolution settings for print output only. When in doubt, shoot at the highest resolution. You can always resize the pictures later if you want to transmit rather than print them.

Tip: Clean That Lens!

Since your camphone will probably rest in your pocket or purse until you need it, the lens might easily become dusty or dirty. That will significantly reduce image quality. We suggest having a clean handkerchief handy so you can quickly wipe the lens before use.

Sharing Your Phone's Photos

For most people, the whole reason to use a camphone is the opportunity it presents for immediate sharing. Sure, it can provide visual documentation of critical events and can even be useful in many business applications. But the truth of the matter is if the event or business is so important that it requires photography, you'd probably be better off using a digital camera for better, more assured pictures. The one thing that camphones do better than cameras is provide an easy, almost automatic way to instantly share your pictures with a widely scattered audience.

Essentially, camphones can share photos five ways, though not all phones have all five options:

- Photo messaging
- Email
- Web photo sharing
- Wireless transmission
- Memory cards

Photo Messaging

MMS is the acronym you'll see bandied about, and it stands for Multimedia Messaging Service. But it's also called photo messaging, which calls to mind the very similar and more familiar text messaging. Have a photo you just shot that you want to send to your friend's camphone? Display the picture on your viewscreen, click on Send, choose MMS as the method of sending, then dial her phone number (or pull it up from your address book), and let the system do the rest. Within seconds or minutes, your picture will appear on her camphone's viewscreen.

At the time of this writing, there is an unfortunate bugaboo in all this that should start to disappear soon. The various wireless services can't yet send photo messages outside their own network. Therefore, if you have, say, AT&T Wireless and your friend is signed up with Verizon, the two of you can't presently share photos via MMS.

Intercarrier MMS will begin to be enabled by autumn 2004.

Emailing Your Photos from Your Camphone

On the other hand, emailing is fully supported by every wireless service provider and has been for years. For the sake of photo sharing, you'll probably want a second email account just for your camphone's photos. That way, when you send and receive photos, you'll be able to direct them to your phone rather than sometimes to your phone and other times to your computer.

Sending photos via email is as simple as sending them via photo messaging. The only real differences are that you choose emailing as the method of transmission and you send to an email address rather than to a phone number. Otherwise, it works basically the same way.

Web Photo Sharing

As we discuss in Chapter 19, online photo sites like Shutterfly.com, dotPhoto.com, Ofoto.com, and so on provide great venues for photo sharing with friends and family. And, yes,

you can send photos directly from your camphone to your online photo albums, in one of two ways:

- Through your phone's Internet browser, emulating the computer experience we discuss in Chapter 19

- By email

At the time of this writing, not all photo-sharing Web sites support email uploads, and of those that do support it, each do it slightly differently. For example, Smugmug.com wants you to put your password in the Subject line, while dotPhoto.com wants the name of the album where the photo should be saved. But the general process remains the same:

1. Set up your account at the Web site.

2. Be sure your phone's email address is registered with your account.

3. If the site requires a password, create one that is easy to input in a phone keyboard (in other words, using the first letter of each key so it doesn't require pressing any key more than once).

4. Display the photo you want uploaded, and follow the general guidelines for emailing discussed earlier in the chapter. Of course, you'll want to include the information that your site requires in the memo or subject field.

5. Some Web sites allow you to reorganize photos among your various albums, while others won't. We highly recommend sticking with the former if you're going to upload from your camera phone. Then, once you get to a computer, you'll have a large screen for better viewing and organizing your photos.

We expect it to become more common for wireless service providers to include online albuming as part of their camphone service plans.

Wireless Transmission

The two wireless standards preferred for photo transmission are infrared and Bluetooth. (A handful of camphones also offer 802.11b, but it isn't widespread yet.) What infrared and Bluetooth do is transmit to and receive data from comparably equipped, nearby devices. That's what your cell phone does when you make a call, only it goes through the service provider's network and you get charged for the minutes you use. Infrared and Bluetooth are freebies, so to speak, because there's no transmission charge when you send or receive data, no matter how long it takes or how long you are connected.

Both have certain drawbacks: limited range (usually no more than 12' for infrared, 30' for Bluetooth), limited speed (they don't have the bandwidth of other wireless standards, such as 802.11g), plus the need to have nearby comparably equipped receiving devices.

Generally, you'll probably want a Bluetooth-enabled camphone. That's because infrared is line-of-sight technology that requires that your phone be facing the infrared device you are sending to. Bluetooth sends a radio signal, so it operates anywhere nearby and doesn't require direct line-of-sight. But the biggest difference between the two is that infrared is a far less pervasive and widespread technology. Only a handful of printers and other devices (most notably TV remote controls) are

infrared equipped. By contrast, Bluetooth seems ubiquitous—printers, wireless earphones, PDAs, home entertainment systems, printing kiosks, digital cameras, and so on. We strongly suggest voting with the majority, because you don't want to have a camphone that won't interact with most of the wireless devices and peripherals out there.

Bluetooth is a fairly well-established standard that is both easy and automatic to use. Put one live Bluetooth device near another (like a camphone to a USB Bluetooth receiver plugged into your computer), and they'll start talking to each other. You don't have to push any buttons or issue any commands for them to begin communicating or handshaking with one another. Then, follow the instructions on the phone, computer, or other device for downloading or uploading pictures. It's reasonably fast, unless you're transferring lots of data at one time. In that case, at least it's not costing you a penny in transmission time.

Memory Cards

If your camphone saves photos to a memory card, then you can use it to physically transfer your still images and videos to other compatible camphones, as well as to computers, PDAs, and other devices. But you'll need to be sure that the memory card is either an industry standard or has an easy-to-implement adapter that will allow it to fit into a standard memory card slot and be recognized by the other devices.

One useful appliance that we keep attached to all our computers is a memory card reader. It's a relatively inexpensive device ($15–$50) that plugs into any USB port (you won't even need to install a driver if you have Windows XP on your computer) and acts as a disk drive when you insert your memory card in the appropriate slot. Then you simply drag and drop the files into the hard drive and folder where you store pictures or use your image management software to move them (see Chapter 21).

By the way, though you can reformat the card when it's in the computer, don't. Instead, delete the images from the card after you've transferred the files to your computer. That way, you'll free up the card so you can take more shots. Always reformat the card *only* in your camphone. Your computer may format slightly differently from your camphone, making the card unreadable by your phone.

Tip: Recharge Your Batteries

Because battery power and cell phone efficiency have improved so dramatically over the past couple of years, you are probably used to plugging your phone in about once a week to recharge it. Camphones, however, require a lot more power to operate. Get into the habit of plugging in your phone nightly, so your battery power won't run low when you're taking lots of photos.

Printing from Your Camphone

Analysts predict that five billion prints will be made from camphone photos over the next year. That's a tiny percentage of the tens of billions of camphone photos that they say will be taken, but still an impressive number.

It's important to remember that your camphone prints will never be as good as a better than average digital camera print. (See "Will Camera Phones Replace Digital Cameras?" earlier in the chapter.) First of all, the prints from your camphone will be smaller, because the photo files have less data (see Table 16-1). Then, there's the fact that the optics aren't as good, control over exposure and color is nonexistent, and the pictures tend to be noisy in low light—in other words, you're not dealing with top-quality photographic technology.

Table 16-1 Camera Phone Photo Print Sizes

Resolution	Approximate Print Size
SVGA (320×240)	2″×3″
VGA (640×480)	3.5″×5″
1–1.3 megapixel (1024×768–1280×96)	4″×6″
2 megapixels (1280×960)	5″×7″

You have several options for printing photos from your camphone:

- **Through your computer**—Of course, you can simply transfer your photos to your computer (see earlier section on how to share) and output them to the connected printer.

- **Memory card transfer to a direct printer**—Many inkjet printers have memory card slots for printing directly from your card without a computer. (See Chapter 20.)

- **Wireless transmission to a printer**—An increasing number of desktop printers have infrared or Bluetooth, which means that you can beam your photos directly to a printer.

- **Printing kiosks**—As we discuss in Chapter 20, vending-machine-type photo kiosks are sprouting up everywhere. Many can take input from memory cards and output lab-quality prints. We expect that a high percentage will soon be enabled with Bluetooth and/or infrared for printing directly from camphones.

- **Online printing**—Once you get your photos up onto a photo-sharing Web site, you can use their printing services. In fact, just as we were finishing this book, www.dotPhoto.com announced an email upload printing service for camphones, which we expect others to quickly emulate. After setting up your account on the site, simply email your picture to print@dotPhoto.com.

Camphone Etiquette

Just because you *can* take a picture any time, any place with your camphone doesn't mean that you *should* take a picture. Good taste, common decency, respect, and reciprocity should be your criteria for whether or not it is the right or nice thing to take a picture. Are you catching the subject unawares in an embarrassing, awkward, or compromising position? Will your taking a snapshot hurt someone? Most importantly, would you want someone taking *your* photo in the same circumstances? So, think before you whip out your camphone and begin clicking away. Privacy is precious, and so is dignity.

Summary

This chapter covered many issues concerning camera phones. Some of the key points included the following:

- At least in the foreseeable future, camphones are not likely to replace your digital camera for quality photographic prints.

- When considering which camphone to get, check out resolution, viewscreen, memory, ergonomics, features, and price.

- When considering what wireless service to subscribe to, check out price, transmission quality, transmission speed, service contract, service, and support.

- It's easy to share your camphone pictures, via photo messaging, email, Web photo sharing, wireless transmission, and memory cards.

- Print size is limited by your camphone's resolution, and print quality won't be as good as you get from your digital camera.

Part IV

I Have My Pictures, Now What?

Chapter 17

Getting Your Photos out of The Camera

We hear it time and again, from friends, family, readers, and strangers—the most daunting and intimidating part of digital photography, even to experienced users, is transferring pictures from the camera to the computer. In fact, the fear of downloading pictures is the number one reason why people resist making the switch from film to digital. Ironically, it is probably one of the easiest functions to perform—that is, once you select and set up your connection.

In this chapter, we'll look at the various ways you can easily transfer images from your digital camera to your computer. By examining the pros and cons of each method, you can decide which approach (or approaches) will probably work best for you. Once you understand how it's done, if you become dissatisfied with the way you are transferring pictures, you can easily switch to one of the other image transfer methods.

Different Types of Transfers

Fortunately, there isn't one single way to transfer image files from your camera to a computer. Nor is there a "best" way either. You do have choices, which you may be able to select according to your highest priority, be it speed, ease of use, convenience, or versatility.

Here are the ways you may be able to move image files from your camera to a PC or laptop. Keep in mind that your particular camera may not support all of these methods:

- Direct connect

- Camera dock

- Memory card reader

- Wireless

Connecting Your Camera Directly to Your Computer

Most digital cameras are designed to connect directly to a computer by way of a cable. The cable is almost always included, though with the few cameras that have dual ports, one cable might be

included and the other optional and extra. Depending upon the model, that connection could be *USB* 1.1 or 2.0 or *FireWire*. (See Figure 17-1.) USB is by far much more common than FireWire. Two other connections that are now outmoded are serial (RS-232) and SCSI (Small Computer System Interface).

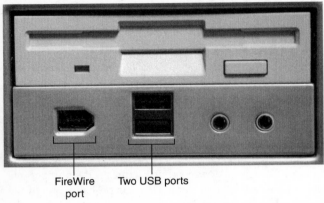

FireWire Two USB ports
port

Figure 17-1: The two ports most commonly used for connecting a digital camera to a computer are USB and FireWire. You'll find the ports on the back and/or front of your computer. Pictured here are the ports on the front of one of our test systems (under the floppy drive). Whenever we buy a new computer, we specify that both ports must be on the front (as well as the back), to make it easier to connect cameras and other peripherals. (Photo taken with an HP Photosmart 945 camera.)

USB

USB (Universal Serial Bus) is ubiquitous, currently used in over 1.5 billion devices. Besides digital cameras, USB is used for connecting printers, scanners, keyboards, pointing devices, network adapters, key drives, and just about every computer peripheral imaginable. In fact, every Mac and PC built after 2001 comes equipped with one or more USB ports (See Figure 17-1). Newer computers now feature the latest version, USB 2.0, which, with a maximum data transfer rate of 480 megabits per second (mps) is many times faster than the original USB's 12 mps.

Almost all consumer digital cameras are USB-enabled devices. All USB-enabled cameras are compatible with the slower USB standard, and many are now USB 2.0 compliant. This means that they can transfer data at speeds only dreamed about just a few years ago.

Here are some reasons why to use USB to transfer your images:

- It's cheap. Everything you need comes bundled with the camera.

- It's reasonably fast, especially if both your camera and computer are USB 2.0 enabled.

- It's quick and easy to install and set up.

- It's intelligent. USB is designed as a plug-and-play interface that is automatically recognized and initialized by current model Macs and PCs when the device is plugged in and turned on.

- The USB connection actually makes your camera look like a hard drive to your computer, giving you direct access to all the files on it. (This capability is known as *USB storage class*.)

■ You can opt to have the photo-transfer software automatically activated as soon as you connect your camera via USB—if your camera offers such a capability (many do).

■ It's hot swappable. That means you can plug, unplug, and turn on or off the device at any time without crashing or frying your computer.

■ USB can be expanded. Theoretically, by daisy chaining hubs, or expansion boxes, you can attach up to 127 different devices to a single USB port.

■ With direct connect, you may be able to automatically update your camera's *firmware* (internal programming).

■ Some cameras allow users to operate their cameras directly from the computer via direct connect.

While the reasons for direct connect USB are compelling, it has a couple important (but not insurmountable) disadvantages:

■ Direct connect will rapidly drain your camera's batteries (unless you have an AC adapter, which is optional and extra on most digital cameras).

■ Installing USB on an older computer requires additional steps (see sidebar "If Your Computer Doesn't Have USB").

■ If you don't properly set up the software and you have a high-capacity hard drive, you might have difficulty locating your automatically downloaded photos.

If Your Computer Doesn't Have USB

Older PCs that lack USB, but have an empty PCI expansion slot, can easily and inexpensively be retrofitted by plugging in a readily available generic USB card. However, Windows systems older than Windows 98 Rev B do not support USB and must first be upgraded to a more modern operating system. What's more, older Windows versions may not have the latest drivers, so you'll have to install software first rather than use a no-brainer plug-and-play approach. The ease of USB connection, as well as the support for it that more modern operating systems offer, is one of the most compelling reasons to buy a newer computer.

Tip: Use a Hub; Keep That Cable Permanently Attached

If you decide on USB direct connect, there's no reason why you can't leave the camera cable permanently dangling from your computer and simply attach the other end to your camera when you need to download image files. If you don't have enough USB ports available to keep the camera cord always attached, consider adding a powered USB hub to one of your ports. A USB hub will give you 2–5 additional ports for attaching other peripherals, and if it's powered (which costs a little more than an unpowered hub), you don't have to worry about losing connection if there's not enough voltage. Incidentally, you can daisy chain hubs, so a single USB port can support dozens of USB devices. One caveat: some digital cameras, for whatever technical reason,

simply do not work when plugged into a hub. If you can't get your camera communicating through a hub, try plugging it in directly to the computer.

SETTING UP YOUR USB CONNECTION

Here are some basic rules for setting up and using USB-enabled cameras:

- Use only the cable that came with your camera. USB cables may look identical, but inside, their ability to carry the correct signal at the proper voltage and distance may be different.

- Unless your camera documentation says differently, always install the software before attaching the cable and camera for the first time. You may have to reboot (restart) your computer after installation before the software is properly activated.

- The order for connecting your camera to the computer is as follows: (1) Attach the USB cable to your computer; (2) plug it into the camera; (3) turn the camera on. (In some cameras, you'll need to turn the mode dial to Connect.)

Most digital cameras have a separate USB port somewhere on the body, usually located on the side under a plastic or rubberized flap, and probably shaped like a tiny trapezoid. Some cameras use instead a round port, especially if it combines the USB and video out interfaces. Whatever the shape or location, look for the letters USB or the universal USB symbol. (See Figure 17-2.)

Figure 17-2: When looking for the USB port on your camera, you might find it labeled with this symbol, which is the universal USB icon. Or it simply might say "USB."

Tip: Get an AC Adapter

The greatest problem with direct connect is power: it drains the batteries faster than anything else. While you may be able to shoot for a couple of hours, you could lose your connection after only 15–20 minutes. If your camera didn't come with an AC adapter (many do, because they're part of the battery charger), and you plan to transfer primarily by direct connect, invest an extra $29–$49 to buy the AC adapter designed for your model. Avoid the temptation to buy a much cheaper generic adapter, because you must make certain that the voltage, amperage, polarity, and plug configuration are 100 percent compatible. Otherwise, you could fry your camera and instantly void its warranty.

FireWire

All DV camcorders and most professional *Digital Single Lens Reflex* cameras (D-SLRs) use FireWire (or IEEE 1394) for data transfer. Though FireWire was once the fastest connection, USB 2.0 theoretically has a faster rate of data transfer. However, FireWire often gives better throughput and hits fewer bottlenecks. In other words, FireWire has a consistently fast speed, from beginning to end, while USB 2.0 can peak at a faster speed, but often slows up during the transmission. No consumer digital camera presently on the market comes equipped with a FireWire interface.

How useful is FireWire in advanced amateur and pro D-SLRs? Actually, not very. Most professionals, for greater throughput and convenience, opt for some sort of external transfer, such as a memory card reader. And although a few models use FireWire for off-camera control, most of them also are USB equipped and assign control via the USB port. On the other hand, because of its overall speed, FireWire is considered the most practical method for downloading DV camcorder movies into your computer.

Attaching a camera physically to a computer via FireWire is similar to the process you use for USB. However, the software can be quite different. So, follow the instructions that came with your camera or camcorder.

Should You Configure Your Digital Camera as a TWAIN Device?

TWAIN is an industry standard for importing images from scanners and digital cameras, which has been around for a long time. (TWAIN actually stands for Technology without an Interesting Name.) While still a common method for connecting scanners to computers, TWAIN tends to be more complex than using your camera as a USB storage device (that is, as a virtual computer hard drive). Quite frankly, we haven't used TWAIN for digital cameras in quite some time because it's no longer necessary and adds extra steps. We do, however, depend on it when we work with scanners.

Camera Docks

Attaching and detaching a USB cable to your camera and computer can be a hassle. Charging batteries can be a hassle. Even finding a safe and secure place to always park your digital camera when it's not being used can be a hassle.

Canon, Casio, Fuji, HP, Kodak, and other manufacturers offer a nifty solution to these problems: the camera dock, or cradle. A dock is a small device with a molded frame designed to accommodate the camera itself, attaches to the computer via a USB port, and is powered by an AC adapter. Simply slip the camera into the dock's frame, and instantly, a connection is made, the software initializes, and the images are transferred into the computer. With most models, while the camera sits in the dock, the batteries are automatically recharged. (See Figure 17-3.)

The time you spend on reading the instructions for configuring your camera and dock will be well worth it. Options may include determining whether you want pictures automatically saved onto your computer and where, setting up automatic emailing (see Chapter 15), and choosing whether or not

Figure 17-3: Connecting your camera to your computer can be as easy as putting the camera onto its dock. Would be that all digital cameras came with docks! Pictured here is the Casio Exilim EX-S3 in its dock. (Photo courtesy of Casio Corporation.)

to automatically print out photos you had previously selected for output (see Chapter 20). Kodak even has snapshot printers with docks that allow you to print directly from their EasyShare cameras without using a computer.

Camera docks are wonderful no-brainer devices, with lots of advantages and almost no drawbacks. It takes only a second or two to place the camera in the dock, and from that point on everything happens automatically. Unfortunately, docks are available for relatively few makes and models, and even when they are, the docks may be optional and extra. If all other things are equal, buy a dockable digital camera over one that isn't. You won't regret it.

Memory Card Drives

Memory cards (see Figure 17-4) are really solid-state floppy diskettes (except for microdrives, which are literally tiny hard drives). They are formatted exactly like floppies, and data can be saved, modified, or erased. (See Chapter 4.) Of course, the image files stored on a memory card can be transferred by attaching the camera with the card to the PC, but it's often faster and easier to remove the card and insert it into what is commonly called a memory card drive.

Memory card drives (also called card readers, although they can write data, too) come in a variety of sizes, shapes, and configurations, priced about $10–$60. They're available everywhere that computer peripherals are sold. Most card readers are external, unpowered USB devices with a number of slots to accommodate different types of memory cards (CompactFlash, SD/MMC, Memory Stick, SmartMedia, and so on), like the SanDisk ImageMate pictured in Figure 17-5. A few are dedicated to one type of card only, and a handful connect to the computer via FireWire rather than USB. Other memory card readers resemble a floppy disk drive designed to fit inside your PC in any available drive bay.

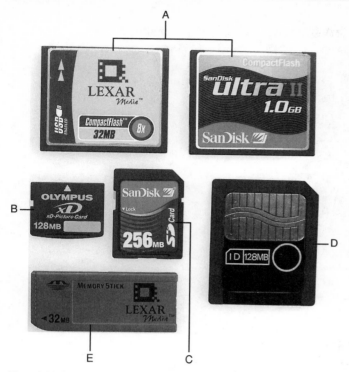

Figure 17-4: Memory cards come in a variety of types. Pictured here are (A) CompactFlash, (B) xD Picture card, (C) SD card, (D) SmartMedia, and (E) Memory Stick. (Photo taken with a Kodak EasyShare CX7430 and transferred to our network using a memory card reader.)

Unless your digital camera happens to come with a dock, we strongly recommend using a card reader as your primary method of transferring images to your computer. In fact, every computer in our studio has a SanDisk ImageMate card reader attached to it. We also have portable card readers in each of our laptop bags. Unless you are using an older operating system, most card readers don't even need a separate driver to install—just plug it in, and the computer will automatically recognize it. Then, when you insert a memory card into it, the card is mounted onto your system as a hard drive, with all files accessible as if they resided on your computer.

Here's some hard-earned advice on selecting and using card readers:

- Spend a little more money and get a USB 2.0 unit rather than USB 1.1 (assuming that your computer is USB 2.0 compatible).

- For optimum speed, attach the card reader directly into your computer's USB port rather than into a hub, and preferably a port built into your computer's motherboard rather than a peripherals board.

- Generally speaking, you may safely insert and remove memory cards whenever you want. But if you want to unplug the card reader, be sure to unmount the drive (on Macs) or click

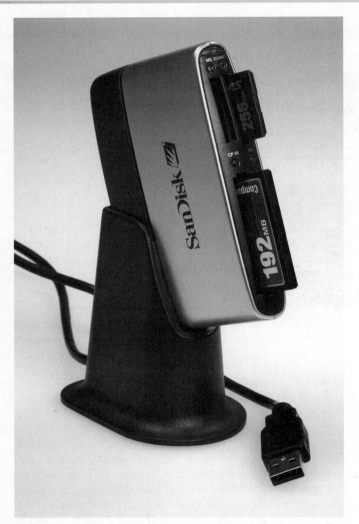

Figure 17-5: This SanDisk ImageMate card reader can accommodate a variety of memory cards including the CompactFlash and SD card that are currently in it. Notice the USB plug it uses to connect to the computer. (Photographed with a Konica Minolta DiMAGE A2.)

on the Safely Remove Hardware icon (Windows) before detaching it. Otherwise, it may not be automatically recognized when you plug it back in.

- Be careful putting a memory card into the reader. If it's not in the right direction or if you use too much force, you might damage both the card and the reader.

- If your computer tells you to Insert a Disk in Drive *x* rather than recognizing your memory card, try reinserting the memory card into the reader. If that doesn't work, you probably need to reboot your computer.

Tip: External Storage Devices Offer Interim Transfer

See Chapter 4 regarding portable hard drives and CD/DVD burners that will take photos off your memory card for safe storage while on the road. Then, you can attach the drive to your computer or use the CD or DVD to transfer your pictures to your computer.

How to Transfer Your Pictures to Your Computer

Whether you are using direct connect or a dock setup as a USB storage class device or are using a memory card reader, as soon as your camera or card is connected, it will be recognized as a hard drive by your computer. So, when you use the File/Open command in any program on your computer, or inspect your system folders, you will see and have access to all the files on your computer—as though they were physically already in your computer.

You then have three options for physically transferring your photo:

- On a Windows system, open Windows Explorer, or on a Mac, work from the desktop view. Then simply do a "drag and drop" of your photo files from the camera folder to where you want to save them on your hard drive.

- After opening your photos in a program on your computer, use a Save As command to save them where you wish to keep them on your hard drive.

- Use a digital asset management program, such as ACD Systems ACDSee, as we do. (See Figure 17-6.) One major advantage of this kind of software is the previews of all your images, which you can then easily and intelligently drag and drop individually or collectively into the folders where you wish to save them. (See Chapter 21.)

Conversely, if your camera has transfer software, you might not even have to do that much. As stated earlier, such software can be set up to automatically transfer your pictures as soon as a computer connection is established.

Tip: Don't Forget to Physically Transfer Your photos to Your Computer

When you use direct connect, a dock or a memory card reader, it's so easy to view, edit, and use your photos directly that you can forget that they may not have been physically transferred to your computer. Be sure to either use a Save As command in the program you're using or do a physical transfer if you don't want to lose the pictures.

Figure 17-6: One of the easiest ways to preview, transfer and organize your image files is to use a digital asset management program such as ACDSee. On the right are previews of all our pictures from a CompactFlash card that we inserted into a memory card reader. On the left is a hierarchical list of all the folders on our network. To move (or copy) the pictures from the card to a computer on our network, we simply select them (with a mouse click) and then drag them to the appropriate folder. Notice how we organize our photos into folders based on subject. Therefore, these photos from the American Society of Journalists and Authors annual conference will be going into the ASJA folder, in a subfolder marked the 2004 conference. For more on using this kind of software to organize your photos, see Chapter 21.

Wireless

Still in its infancy, wireless digital photography may eventually become a popular means of transferring data from your camera to a computer. No wires or even a cradle is required. Wireless certainly is appealing, but for now, it presents some formidable technical challenges, both for camera manufacturers and users.

Actually, a few pro models have offered wireless options for the past few years. One version actually allows the photographer to simultaneously shoot and transmit pictures on the fly, a very useful capability for photojournalists and sports photographers on deadline. However, these wireless units are expensive and difficult to operate, especially in less than optimum conditions.

With the proliferation of camera phones and the push to free the user of digital entertainment from the tyranny of wires, there's a major impetus for wireless. In fact, we've been told we should see some digital cameras implementing the new high-speed wireless USB by early 2006.

Summary

These are the key points covered in this chapter:

- Unlike working with earlier digital cameras, getting pictures from today's cameras into the computer is a fairly easy process.

■ You have various ways to transfer image files from your camera to a computer or laptop—via direct connect, memory card readers, camera dock, or wireless transfer—each with its advantages and tradeoffs.

■ Most consumer digital cameras have a built-in USB port for transferring data into the computer via the direct connect method

■ Camera docks are the easiest and most convenient method for file transfer, for those models that support a dock. Memory card readers are probably the most practical means of data transfer.

■ Don't forget to transfer your pictures to your computer rather than leaving them on your camera or in your memory card. Otherwise, you could lose them.

Chapter 18

Editing Your Pictures

Half the fun of digital photography is what you can do with your pictures once you get them into your computer. (For help in uploading them to your computer, see Chapter 17.) Perfect the exposure or color, remove wrinkles or an ex-boyfriend, combine elements from various pictures taken at different times into a single image, create a scene that could never occur in nature—from making your photos more realistic to creating fantastical visions, you can do it all in the computer, if you have the right software.

In this chapter, we'll help you determine what photo-editing software is right for you and help you better understand what you can do with it.

Tip: Relax, Enjoy, Experiment

You aren't going to break your computer or your software. So have fun with your pictures, experiment with all kinds of edits and special effects by just exploring the various commands and features. If you're not sure what to do, try using any tool at whatever setting at hand. It's the one way to learn how to use software, and the best way to find those fascinating nooks and crannies where your own personal creativity might lurk. However, we do suggest that you save the original version of your photo under one name and your edited versions as differently named files. That way, if your edits get so bizarre or ugly that you can't undo them, you can always start over with the original.

Playing with Pictures

Sally used to love playing at the edge of the beach where the sand was moist, because she could do so much more with the castles she'd build there. Unfortunately, it also meant that her castles were always the first to be wiped out by incoming waves. Still, it was the malleability of the wet grains of sand that gave her the most artistic freedom (and fun) as a child. It's the same with digital photos. The further you push them toward the edge, the more you can do with them. Happily, unlike sand castles, as long as you save a copy of your original (see Chapter 21), nothing you do will wipe out your photo.

Photo editing (also called image editing or imaging) can be as complex and sophisticated or as simple and direct as you wish, depending on the software you use and how deeply you delve into its features and tools. Later in this chapter we'll discuss specific programs and how to choose the right one for your needs, skill level, interests, and budget. But first, let's look at typical photo-editing tools.

The basics of all imaging programs are quite similar, though they vary in where they put their controls, and some have more features or depth than others. As a rule, the functions fall into the following general categories:

- Photo correction

- Image alteration

- Collaging

- Painting and drawing

- Image preparation

Photo Correction

In a perfect world, every photo would be flawlessly exposed, with bang-on colors and focus. In fact, as we explained in Chapter 5, getting the picture right at the time of shooting will yield a superior photo than editing it afterwards. But this isn't a perfect world, and often photos will need some tweaking.

Typical photo correction tools include:

- **Exposure**—When correcting exposure, you're more likely to get details out of a dark shadowy area when you lighten it than you'll get from a too light area when you darken it. In either case, exposure tools can't invent data that weren't originally captured, such as in an area of blown-out highlights in which all you can see is bright light. Exposure tools also correct those photos that look dull or too contrasty, which has to do with what is called *dynamic range*, or the balance of highlights, shadows, and midtones. (See Figures 18-1a and 18-1b.)

- **Color**—The color of a photo is determined by the kind of light it was taken in. For example, if you take a picture in an office with fluorescent overheads, but use your camera's daylight setting, your photo can end up with a sickly yellowish green cast. (See Chapters 8 and 9.) But most times, the color needs only a small adjustment, such as giving a child rosier cheeks. If a photo's colors are off, such as flesh looking too sallow or a red rose that appears orange, you'll want to use the color or hue tools to adjust it. But if the colors are simply not strong enough (or too strong) try changing the Saturation level instead. (See Color Figures 12, 13, and 14 in the color insert at the back of the book.)

- **Sharpness**—Unfortunately, it's very difficult, if not impossible to make a blurred photo look like it has sharp focus. The opposite—softening a photo—is easy. (See Figures 18-2a, 18-2b, and 18-2c.) Still, we have found that a tiny bit of sharpening (especially with a tool called an Unsharp Mask) can be great for making really good photos a touch better.

Be forewarned: these tools (especially those for exposure and sharpness) can be quite destructive. The higher you push the settings to apply stronger edits, the greater the negative impact on image quality. Use the preview capabilities of most programs to judge just how much of an edit is too much and adjust the settings appropriately. And remember to always keep an original, unedited copy of your photo, in case your edits don't look good and you can't undo them.

Figure 18-1a: This photo is dull because there's not enough contrast between the highlights and shadows.

Figure 18-1b: The only edit we did to the photo was to increase its contrast and that corrected the exposure, giving the picture "snap."

Figure 18-2a: In this portrait of Sally, the background is distracting. Professional photographers will often purposely blur portions of a picture to limit its impact on the overall composition.

Figure 18-2b: We used an elliptical selection tool to select her face, and then we inverted it, so everything other than her face was selected.

Figure 18-2c: Then, when we applied a blur filter to the picture, it worked only on the area that was selected, and not her face. The result is a portrait that more fully focuses on the subject—Sally—but lends a softer feeling to the overall composition. (Photo taken with an Olympus E-10.)

Tip: Use Selection Tools to Limit the Area Affected by Your Edits

Sometimes, you want to edit only a portion of your photo, such as brighten a face or alter the color of a car, but you don't want anything else in your picture to be changed. Use your software's selection tools to draw a line (a "mask") around the area you want to change. Then, when you apply the edit, only the selected area will be affected. (See Figures 18-2a, 18-2b and 18-2c.) These are the same tools you'll use to select portions of images to be copied into a digital collage (see "Collaging" later in this chapter). The basics of selections are rather easy to learn, though it will take a lot of practice and patience to master their incredible power.

Image Alteration

Image alteration includes some of the most prosaic (though important) editing tools, as well as some of the sexier ones. Among the former are those that alter the shape or size of your photo, such as *cropping* (removing excess portions to create a smaller picture), rotating, or resizing your pictures.

Then there are the many special effects that can change the very nature of your photo, distorting it, adding textures, turning it into something that looks like a sketch (see Figure 18-3) or a fun-house mirror reflection.

Here are some suggestions for working with special effects filters:

- Before using an effect on your photo, increase its contrast by at least 10 percent. Most effects filters work by analyzing the edges between colors, and this will heighten the differences among your colors, giving the filter more to work on.

- Play with the effects and their settings to see what they do to your photo. You can always undo anything you don't like, or save versions of what works.

- Use the program's selection tools to restrict the effect to only portions of your photo, while the rest remains untouched.

- Copy the filtered version of your photo onto the original (preferably using the layers palette), and then change the opacity (or other attributes) of the upper layer. (Or, in a variation on the experiment, put the original on top and the filtered version on the bottom.) You'll be amazed how artistic the results can be with very little effort. (For information on layers see the "Collaging" section later in the chapter.)

Figure 18-3: Using a special effect filter, we turned this portrait into a whimsical sketch with just a couple of mouse clicks. We often do something like this at the start of an imaging project, to give us an interesting canvas for painting. (See the section later in the chapter on "Painting and Drawing.")

Collaging

We have a nineteenth-century scrapbook in which an anonymous craftsperson cut portions of illustrations from magazines, broadsheets, and labels and pasted them together into wonderful pastiches of her life or, more likely, her fantasies. Collaging (also called compositing) is certainly not new, but with digital imaging, it has become less messy and more adventurous. Cut (or copy) and paste pieces of different images into a single composition, moving them around as you wish, adding text, shadows, and special effects, using a clone or other brushes to paint additional elements into your picture. The most basic collages simply add a person or object to a photo, such as putting yourself onto a Hawaiian beach without having to pay airfare. But it is also a highly sophisticated process used by fine artists (see Figure 18-4).

Figure 18-4: This composition of Sally's (which she calls "Fantasy Man") consists of several elements collaged together in Photoshop: the portrait of Daniel and Sally (taken by Peter Trieber), a photo of a computer board, a picture of the sky, a color gradient (which you can't see in this greyscale version), plus a few colors digitally painted onto the brush in Sally's hand.

Figure 18-5a: This collage consists of three elements: a photo of our creek, another of our cat Rascal, and some type.

One of the most important, even critical software features for serious collaging is layers. Think of layers as a series of transparent acetate sheets placed on top of each other. Each element (text, a part of a photo, a piece of clip art, and so forth) sits on its own layer, but you can see all the other elements under and above it. By keeping each piece of the composition separate, you can go back and edit, move, resize, tweak or delete it at any time without affecting any other piece. You can also sort the order of your layers, determining what sits on top of what, adjust their opacity or transparency, and in some programs, control exactly how they combine with other layers (see Figures 18-5a and 18-5b). The power and versatility of its layers is one of the determining factors of how advanced an imaging program is.

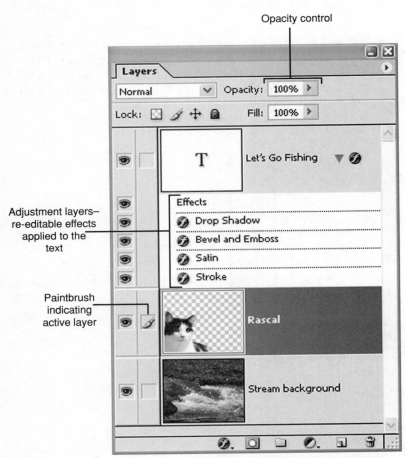

Figure 18-5b: As you can see in this Photoshop layers dialog, each of the three elements sits on its own layer, What's more, the text layer has several Adjustment Layers related to the re-editable effects we applied to the type. Notice the opacity control at the top of the palette. One of the biggest problems novices have in working with layers is understanding which layer is currently selected. Notice the paintbrush in Rascal's layer, which indicates it's the active layer at present and that all edits done at this time will be applied to Rascal's picture and to nothing else in the collage. (©2004 Adobe Systems Incorporated. All rights reserved. Adobe and Photoshop are registered trademarks of Adobe Systems Incorporated in the United States and/or other countries.)

Tip: Edit the Elements of a Collage So They Belong Together

Photos taken at different times under varying circumstances can have very dissimilar attributes. If you are combining pieces of several photographs into a single collage, use your program's exposure, sharpness, color, and noise tools to edit them so that they will look good together.

Cloning

Want to get rid of telephone wires that mar an otherwise beautiful landscape photo, or did a pimple ruin a wedding photo? Conversely, perhaps the flowers in your garden picture are looking sparse and you'd like to add a few plants here and there. The clone tool (also called a rubber stamp) is a special kind of digital brush that uses portions of your photo to paint away or add elements in your picture. In other words, it's a type of grafting tool that works so well (when used properly) that you can't tell what changes were made. (See accompanying sidebar figures.)

In this photo of Cuddles as a puppy, the broken box, chair leg and chrome table leg are distracting.

Cloning *(Continued)*

Using a clone tool, we painted away the box and furniture legs. It's easy to do, as long as you're careful. First, define the area you'll be using as the source of your color, texture, light, saturation, and so on. Then, pressing your mouse button and moving your cursor around will apply those image attributes to a new area.

Painting and Drawing

Many photo-editing programs have two sets of icons that may look quite similar. For example, you might have a rectangle selection tool and a rectangle drawing tool, both represented by a rectangle-shaped icon. But how they work and what they can do in your digital photos are very different. To explain this, we must digress a little into the nature of computerized pictures.

Computer graphics are divided into two categories: vector (or object) and *pixel* (or bitmapped). Digital photos are made up of pixels, tiny points of information that, when combined with millions of other points, blend into a picture, not unlike the grains of sand in Sally's childhood castles. Photos are edited by changing the nature of each pixel, though it is done so quickly that the entire picture will be changed at once.

On the other hand, vector pictures define a shape by its mathematical formulae (see Figure 18-6). To follow the sand castle analogy, in a vector composition, a shape is like Sally's bucket rather than the

sand inside it. In other words, in photo editing, a circle would be a multitude of dots aligned in such a way as to appear to be a circle. If you zoom into the outer line of the circle, it will break up, becoming pixilated (showing a staircase-like blocky edge). A vector circle, on the other hand, is defined by the simple formula πr^2 and by the colors of its outline and fill. No matter how far you zoom into the edge of a vector circle, it will always be a solid line.

Figure 18-6: Often used in poster art and other kinds of illustrations, vector art is made up of shapes and text that are defined mathematically by their outlines and fills. It's called *resolution* independent because it can be printed as large as you wish or zoomed into as far as your software allows, and the lines and shapes will retain their solidity and integrity. (Created in Adobe Illustrator.)

The nature of photos as a mass of organized pixels cannot be changed. Therefore, only bitmapped tools can edit photos. However, vector illustration programs such as Adobe Illustrator or CorelDRAW can use photos by placing them into a composition, much as you might put a photo into a desktop published newsletter.

Now that technical digression is over, let's look at the pixel-based painting and object-based drawing tools you may find in your photo-editing software.

PIXEL PAINTING

Most imaging programs have some kind of paintbrush, which is usually bitmapped. The most basic is a tool that paints color lines of various widths. More sophisticated ones can emulate natural media, such as watercolor, oils, charcoal, and textured canvases. The most advanced brushes are pressure sensitive (see the Tip discussing pressure-sensitive tablets) and fully customizable according to a whole range of criteria, such as the texture, number of bristles and how close together they are, amount of paint splatter, the shape of the brush tip, and so on. And the very best are the tools in Corel Painter, which is, hands-down, the top digital painting program.(See Figure 18-7.)

Tip: If You're Really into Painting, Get a Pressure-Sensitive Tablet

The best digital paintbrushes react to your hand like real world artist's brushes. When you bear down, it will put more paint on the "canvas." Or you can control the flow by varying your speed and direction. But to take advantage of that ability, you'll need to use a pressure-sensitive tablet with a stylus instead of a mouse for all your painting. We use Wacom tablets, as do most other serious digital artists (www.Wacom.com).

Figure 18-7: A large number of professional digital artists use Corel Painter. Some start with a blank page and just start painting. Marilyn Sholin (www.MarilynSholin.com) starts with a photograph that she then recreates as a work of art using the program's natural media brushes, textures, and canvases. "Painter opened up a whole new creative expression or vent that was stalled for me in photography," Marilyn explains. "It allows me to take the photos further, into a fantasy area. The big advantage is you can't make a mistake. You can be as experimental as you want, and you will never have to clean a brush or wipe a canvas." (Copyright by Marilyn Sholin.)

VECTOR DRAWING

In recent years, more and more photo-editing programs have been adding vector-drawing tools. You won't use them to edit your photos, but you can use them to add shapes and text to your compositions (see Figure 18-8). At the very least, you will want your type fonts to be vector rather than bitmapped, because it will make whatever text you put into your pictures look smooth and professional. Many programs include clip art vector borders, shapes (such as stars), or even cartoon-like figures, or you may wish to draw your own.

As we mentioned, vector (or object-based) shapes and text are defined by their outlines and fills. This has traditionally meant that the transitions between them have always been hard edged. But that's not the case with modern tools that include soft edges, drop shadows, gradient fills, and textures.

Figure 18-8: Vector shapes, such as clip art, borders, and text, can add interest to a photo collage. (Project created in Microsoft Digital Image Suite, base on a photo taken with a Nikon D70.)

Tip: Editing a Photo from inside a Nonbitmapped Program

If need to edit a photo that is in a vector composition or has been placed in a document, double-clicking your mouse button in the photo will often bring up photo-editing tools or launch your photo-editing program.

Image Preparation

Photo-editing software can prepare your photos to be used elsewhere. This includes changing the file format (see Chapter 5), resizing, optimizing for the Web (see Chapter 15), or batch processing a series of photos.

Batch processing (when a program has it) is particularly useful for digital photography. For example, when a digital camera creates and saves a photo, it automatically gives it a name, which is usually a meaningless alphanumeric, such as DSC_00112.jpg. When you bring those photos into your computer, it would be much more helpful if their names made more sense, such as Jennys_birthday_00112.jpg. With batch processing, you can select a group of photos and have all of them automatically renamed with the same root (adding sequential numbers so each has a distinct name). Actually, any overall edit you can do to a single photo (such as exposure or color adjustments, rotation, resizing, and so on) is a candidate for batch processing. It depends on how and if your program implements batching, and whether the task you want will be available. By the way, this is one kind of automated edit that is often found in image database programs, too (see Chapter 21).

Save Time and Effort with Macros, Templates, and Styles

Once a computer does anything, it can repeat it, exactly, and faster than would be humanly possible. Some of the tools photo-editing programs can use to take advantage of this repeatability include *macros*, templates, styles, and batch processing. (Not all software offers all these tools.)

Save Time and Effort with Macros, Templates, and Styles *(Continued)*

- Use *macros* to automate any series of edits you tend to repeat. For example, if you have a monthly newsletter in which the lead photo is always edited in the same way—same size, color, special effects, and so on—that process would be a good candidate for a macro. In those programs that have macros, it is a simple matter of telling the software to record your edits as you do them. Then, when you open a new photo to which you wish to apply the same edits, just replay that macro.

- *Templates* are a kind of fill-in-the-blank blueprints. Consumer-level programs often have photo project templates, such as party invitations (see Chapter 13). However, you can save any design as a custom template that you might then open up and adjust (changing photos, type, colors, and so forth).

- Almost every tool you will use has variables. For example, you might customize a gradient fill to look like a brass pipe, using hues of yellow, gold, brown, and white. If you plan to use that specific custom gradient again, save it as a *style* rather than recreate it anew every time. The same is true of brush strokes, type, and almost every other tool you can customize.

Choosing the Right Photo-Editing Software

The field of photo-editing software can seem as crowded as that of digital cameras, and it's often more confusing. In this section, we'll discuss several different kinds of programs, providing specific examples. Our purpose here isn't to provide a comprehensive list, but to help you better understand how to differentiate among the many programs available and choose the right one for you.

Essentially, there are five categories of photo-editing programs:

- Photoshop
- Other high-powered imaging programs
- Prosumer software
- Consumer-level applications
- Basic photo editors

Tip: Try Before You Buy

Many software companies offer free trial versions of their software on their Web sites. We can think of no better way to find out if a program fits your needs and personality than actually having it on your computer and trying it on your own photos. However, important features (such as the ability to print or sometimes even save) may be disabled until you actually buy. Even those companies that don't offer free trial versions usually provide features tours or even tutorials on their Web sites, though some are better and more helpful than others.

Photoshop

The granddaddy of all photo-editing software, Adobe Photoshop is the one application all graphics professionals know and use. A powerhouse program, it is complex, rich, and textured with all kinds of tools that can take your photos farther than any other. If you're a pro or you want to gain control over every nook and cranny of your images, then the steep learning curve and high cost of this top-notch program will be well worth your time, energy, and budget.

And, yes, it can be a budget buster. The standalone version (which includes ImageReady, for preparing photos for the use on the Web) costs $649. For $999, you can get Creative Suite Standard, which includes Photoshop, plus Illustrator (the professional drawing program), InDesign (desktop publishing), GoLive (Web page design software), Version Cue (a great file management program especially if you're collaborating on a project with others), and various utilities. That's actually a bargain, because each of those programs is an important professional tool. An even better deal is the $1,229 Creative Suite Premium, which also includes Adobe Acrobat Professional. However, for most people, all this power is overkill and intimidating as well as unnecessarily expensive.

We are devoted daily Photoshop users and have been since the early days of digital photography. Though we have used almost every other program out there, it is Photoshop that we keep coming back to, because it gives us just about everything we need, and then some. However, we do this professionally (www.Adobe.com).

Tip: Go to School

To get a good sense of what you can do in photo-editing software, nothing beats spending a day in a class-room with an expert. One of the best teachers is Katrin Eismann. Her creativity, down-to-earth sensibilities, and great enthusiasm have smoothed the path to digital imaging for thousands. Though she specializes in Photoshop, what she has to say can be applied to other feature-rich programs, such as Corel PhotoPaint or Jasc Paint Shop Pro. Check out her teaching schedule, to see if she'll be in a city near to you sometime soon. (www.PhotoshopDiva.com)

Other High-Powered Photo-Editing Programs

If you are serious about your photo editing, but you don't need to speak the *lingua franca* of pros and don't want to spend the money for Photoshop, various other programs offer similar power, though often with a specific focus that sets it apart from its competitors.

COREL PHOTOPAINT

Corel PhotoPaint has long played second fiddle to Photoshop. And yet, its photo editing is, in many ways, just as powerful and versatile, while offering more easily accessible guidance for the neophyte. PhotoPaint has almost all the photo-editing capabilities anyone could want or need, a sizable library of special effects, the best paintbrushes outside of Painter, and excellent typesetting-like text tools. PhotoPaint is available only as part of the CorelDRAW Graphics Suite, which includes the very sophisticated CorelDRAW illustration software and a handful of utilities. However, at $399, the entire CorelDRAW suite costs less than Photoshop by itself (www.Corel.com).

MACROMEDIA FIREWORKS

Fireworks is to Photoshop as a zebra is to a horse; they're really different animals that will often do similar things. Focusing entirely on preparing and optimizing photos and other graphics for use in Web pages, Fireworks is very nicely integrated with its sister program, Dreamweaver (the Web page designer), but it doesn't have the print-related functionality of Photoshop. We tend to use Photoshop for all our print and traditional photographic work and Fireworks/Dreamweaver for most of our Web work, because that's what each of them does best. Like Adobe, Macromedia bundles its most powerful programs—Fireworks, Dreamweaver, Flash (for great Web animations), and FreeHand (illustration)— in a suite that sells for $899 (www.Macromedia.com).

ACD SYSTEMS CANVAS

Before the merger with ACD Systems, Canvas ($349.99) was known as Deneba Canvas, and it has been around for a long time. We've known folks who love Canvas, swearing it is the only program that suits all their needs, while others swear at it, because it doesn't seem to function quite like other imaging software. But that's the point; it isn't really like the others. Canvas is primarily a precision tool, more suited to the minds of engineers than artists. And yet, we've seen some very artistic work done with it. Canvas combines illustration and photo-editing tools in one interface, and it excels with architectural or engineering renderings that include photographic elements (www.ACDSystems.com).

Prosumer Imaging Programs

Prosumer imaging programs are generally best suited to the advanced hobbyist or business user who want or need pro-like control over his photos and is willing to put in the time and effort necessary for mastering the tools. However, he doesn't need the most advanced tools such as those related to professional reproduction, nor does he want to spend a premium price for top-of-the-line pro software.

ADOBE PHOTOSHOP ELEMENTS

Photoshop Elements is one of the category-straddling programs, providing prosumers with power and novices with guidance, templates, and photo sharing. If you want to understand what the pros are doing and talking about, or hope to someday graduate up to the full Photoshop, at $99.99, Photoshop Elements is the one to beat. It's based on Photoshop code, and in the advanced mode, most of its interface, commands, and functions are identical. And yet, you can operate it in an easier-to-use basic mode, so you won't have to tackle Photoshop's traditional steep learning curve to get pro-like results. Because you get most of the tools its big brother offers, you may never need to upgrade (www.Adobe.com).

COREL PHOTOPAINT

Yes, we included PhotoPaint among the high-powered programs. However, it is one of those applications that spans two categories, being very suited to the prosumer market because of its ease of use coupled with its power.

ULEAD PHOTOIMPACT

Among PhotoImpact's ($89.99) most noteworthy attributes are its extensive styles libraries for great special effects and Web graphics (such as Web buttons and menu bars). It also has impressive vector

tools and excellent paintbrushes. You can even use it to create full Web pages. Though its photo-editing tools are advanced, versatility is its strongest suit (www.Ulead.com).

JASC PAINT SHOP PRO

Paint Shop Pro focuses primarily on photo editing with powerful and sophisticated tools reminiscent of Photoshop's exposure and color controls. That means it has a steep learning curve. But if you're serious about getting into the nitty gritty of digital photo editing, at $94, Paint Shop Pro provides a worthy alternative to the Adobe products (www.Jasc.com).

Consumer-Level Photo-Editing Programs

Every month we hear about yet another entry into the consumer photo-editing market. Seeking to make the process of working with photographs easier and quicker, these products tend to offer guidance in the form of wizards and extensive help systems. They are also more task-oriented than the pro and prosumer programs, with step-by-step guidance for specific functions, such as sharing your pictures, creating collages, using templates for projects such as greeting cards, and so on. (See Chapters 13 and 19.) Unfortunately, it is often more difficult to differentiate among the many consumer-level programs, and what you end up loving can be based more on personal preferences and reactions than power and available tools. Don't forget to check out a program's Web site for free trial versions, tours, and tutorials before buying.

ADOBE PHOTOSHOP ELEMENTS

Elements spans two categories—prosumer and consumer. If you keep the interface set at basic, it is in direct competition with the others we reference in this section. While Elements offers a task-oriented interface, you can easily break out of the step-by-step procedures and "do your own thing."

MICROSOFT DIGITAL IMAGE

Actually, Microsoft has two Digital Image products that fit this category. Pro ($89.95) is the photo editor, while the Suite ($129) includes Pro plus Digital Image Library (for easy photo organizing and archiving to CDs or DVDs) and Photo Story (for creating and sharing photo slideshows). If you are new to digital imaging, these Microsoft products provide easy entry without all the confusion of traditional photo-editing interfaces. While previous versions tended to frustrate experienced users with their focus on hand holding, Digital Image is now working at breaking out of that straightjacket and has easier access to more advanced photo tools for exposure and color. If you buy any Microsoft imaging product, check their Web site for rebates. For example, you might be able to get up to $60 off on the Suite if you buy a digital camera within 30 days of purchasing the software (www.Microsoft.com/products/imaging).

ROXIO PHOTOSUITE

PhotoSuite ($49) doesn't have as many pro-like photo editing tools as Elements, and its paintbrushes are quite limited. However, it does a nice job of guiding the user through photo-editing, template-based projects, and sharing with intelligent tips and guidance. One "killer app" feature (that is, one component that may be the single reason you might buy this product) is its StoryBoard, which creates highly sophisticated slideshows with still images, video clips, audio tracks or custom narration, text and transitions, and motion picture-like zooming and effects (www.roxio.com).

Tip: Buy Your Camera Before You Buy Your Software

Most digital cameras manufacturers include software with their cameras. Two popular programs for such bundles are Photoshop Elements and PhotoSuite, though they may be earlier or lighter than the current retail versions. Don't choose your camera based on what software is included. However, if you are undecided between two models, take a look at what software is included.

Basic Photo Editors

If all you want to do is the most obvious editing, such as fixing red eye, rotating or cropping your photos, and then print, email, or post them online, all the software mentioned above is overkill. What you really want and need is a basic photo editor.

If you're not content with the editor provided with your camera (because it's too complex or too simple, or just doesn't fit your personality), try a downloadable free program, such as Kodak EasyShare software (www.Kodak.com) and FxFoto (www.FxFoto.com). They will get you started right away with photo editing and sharing, without requiring any special knowledge or shelling out a few bucks.

Or, consider purchasing one of the many basic editors available for sale. Why would you spend money when you can get it for free? Perhaps, the package has something the free ones don't. For example, Microsoft Picture It! ($49.95 minus a $15 rebate) includes a version of Digital Image Library for organizing and archiving your pictures. In a similar manner, several image and media asset databases (such as ACDSee and Picasa) include basic editors (see Chapter 21).

Other Types of Digital Photography Software

Photo-editing software is only one type of program you'll use in digital photography. Others include:

- RAW utilities for converting RAW file formats into editable and usable images (see Chapter 5).

- Image or media asset databases for organizing, managing and archiving your photo library (see Chapter 21).

- Project software for creating greeting cards, T-shirts, invitations, albums, and all kinds of other novelties and crafts with your pictures (see Chapter 13).

- Web graphics software for optimizing and preparing your photos for use in Web pages (see Chapter 15).

- Programs for creating slideshows, movies, animations, and other special ways to view your photos (see Chapters 15 and 19).

- Upload applications for putting pictures on a photo-sharing site (see Chapter 19).

- "Photoshop-compatible" plug-ins or filters (which actually work with just about any photo editor) for special effects, import, export, and other add-on functionality.

- Drivers, the programs that plug into your computer's operating system to tell it how to work with devices you've attached to your computer, such as a printer, memory card reader, scanner, and so forth.

- Then there's the multitude of programs that can use photos and other graphics, placing them into other types of documents, such as in desktop publishing or word processing software, spreadsheet and presentation applications, and so on (see Chapter 14).

Summary

Some of the key concepts covered in this chapter include:

- Photo editing can be complex and sophisticated or simple and direct, depending on the software you use and how deeply you delve into its features and tools.

- Typically, photo-editing software tools fall into five categories: photo correction, image alteration, collaging, painting and drawing, and image preparation.

- Macros, templates, and styles will save you time and effort by automating often repeated designs and processes.

- Try before you buy a photo-editing program and select a program sufficiently complex (professional or prosumer applications) or simple (consumer and basic editing programs) based on your needs, budget, and how deeply you want to get into editing your pictures.

Chapter 19

Display, Show, and Share

Photography has always been about communications—showing others way you see the world. But until the digital age, sharing your photographic vision was rooted to the physical printed page. Now, with the Internet, email, CDs, DVDs, and other digital innovations, we are handling, capturing, and sharing electrons and *pixels*, which means that all the barriers have been pulled down.

In this chapter, we cover sharing your pictures with folks near and far, by displaying your photos on the TV, creating and sharing slideshows, and sharing them via the Internet.

Big Screen Photo Shows

Of all the electronic marvels in our homes, the one that has held our interest and attention the longest and continues to fill more hours of the day than anything else outside of work is the television. We all know, love, and sometimes loathe the TV, with its big screen and bright colors. Perhaps, one reason computers were so readily accepted by the public was that their monitors looked like souped-up TVs. So, it should come as no surprise that one of the more convenient and popular ways of displaying digital photos is on the family TV set.

Connecting Your Digital Camera to Your TV

Displaying your photos on your TV is almost as easy as reviewing them on your digital camera's LCD viewfinder. Here's how:

- Most digital cameras have a Video Out port, also called the AV port (see Figure 19-1). Plug the RCA video cord (which came with your camera) into its AV port.

- Plug the other end of the cord into the Video In port of your TV. (You can also plug it into the Video In port of your DVD or VCR player, which is attached to the TV).

- Turn on the camera and then the television.

- In some cameras, you'll need to tell it that you're connected to an external monitor. Others will simply send the signal when the cord is attached.

- Put the camera into playback mode and use the arrow jog buttons on your camera to page through your photos.

- If your camera has a slideshow playback option, you can set it up and it will play continuously (without your having to manually page through the photos).

- If you plan to let the slideshow run for sometime, we recommend plugging the AC adapter cord into the camera to avoid running low on battery power.

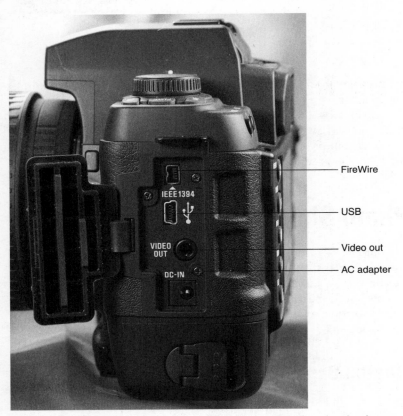

Figure 19-1: Your digital camera's Video Out port is usually found with other ports under a plastic door or rubber flap on the side of the camera body. In this photo of a Sigma SD10, the DC-in is below the Video Out port. Plug your camera's AC adapter into the DC-in port to run the camera off electricity rather than battery power. Also pictured are the USB port (just above the Video Out) and on the top the FireWire (or IEEE 1394), both of which are used to connect the camera to a computer. (Photo taken with an Olympus E-1.)

Beyond the Basic TV Slideshow

If you want to do more with your photos when you display them on your TV, consider purchasing a digital photo viewer, or set top box, which connects to your television and, well, sits on top of it.

Devices like Visioneer PhotoPort TV 100 can take input from your digital camera and/or your memory card to give you more control over how the photos play and display on your TV. You can customize the slideshow, often adding captions, controlling transition times and effects, and other options. Then, relax, sit back with remote control in hand, and enjoy the show.

Conversely, if you're a gadget-loving geek, you might want a media player, which streams digital photos, audio, and other media through an entertainment system connected to your TV. To us, it seems like overkill and too complicated, at least with current generation technology. Perhaps, as things become more streamlined and more user-friendly, we'll eventually agree with Bill Gates' prognostications that everything in our home will ultimately be wired together, from our refrigerator to our stereo to, yes, our digital cameras.

Creating and Sharing Slideshows

Want to take your slideshows further, so they become animated, intriguing, and informative, with documentary-style titles, Hollywood-like special effects, personal narrations, and cool transitions? Then, you're ready to import your digital photos into a slideshow program. Slideshow software ranges from basic programs easy enough for novices, to powerful applications used by video professionals.

Simple programs like PhotoShow Deluxe (www.SimpleStar.com) and PhotoParade Essentials (www.PhotoParade.com) guide you through choosing, ordering, and captioning your photos, adding sound and applying template designs. You will quickly create a slideshow you can save to CD or DVD, send via email, or post on the Web. (See Figure 19-2.)

At the professional end of the spectrum are extensive video-editing programs, such as Adobe Premiere (www.Adobe.com), which can include still photos in an overall multimedia experience.

Between those two widely separated categories are the many other midrange programs with various levels of controls and help. Some of the common issues and concepts you may encounter in slideshow creation are the following:

- **Transitions**—Slideshows display still photos, one after another. Many programs have creative effects for transitioning from one picture to another, such as a flip (as if a page were turning), a wipe (in which the new photo is revealed starting at a corner or side of the current slide), and so on. Usually, you can use a different transition for each slide if you wish.

- **Sound**—All the slideshow programs we know allow you to add sound. The most basic will play some music throughout the show. More advanced programs can associate specific audio files with each photo. You may also be able to add your own narration or sound (such as a child's laugh for the slideshow you're sending grandma).

- **Special effects**—Consider the special effects that you can apply to a still photo, such as turning a color picture to black and white or making it look like a watercolor painting. Some slideshow programs have similar kinds of effects, altering the picture over a time duration, which makes it appear to be animated.

- **Zoom and pan**—A popular effect in documentaries that intersplice still photos with video (think of Ken Burn's *Civil War* documentary); zoom and pan act as though the movie camera is moving in closer to details in the photo and then pans to other areas.

Figure 19-2: Simple slideshow programs like PhotoParade Essentials tend to be quite intuitive. Simply drag and drop your photos to put them in the order you want, click Edit to add captions, titles, or do basic photo editing. Next, choose a template design. Then, click to create your slideshow. (PhotoParade is a trademark of the Callisto Corporation.)

- **Timeline**—In many programs, you can control how long each slide or transition remains on the screen. More advanced programs give you precise control over the relative timing of all elements, including transitions, sound tracks, special effects, and so on by using a multitrack timeline. (See Figure 19-3.)

- **Compatibility**—When you're ready to share your slideshow, you'll want to be sure the program can export it to a common file format or as a runtime module that doesn't require any special software. That way, it will be readily viewable by anyone, regardless of whether they have the program that created it or not.

Tip: Check the Software You Own before Buying a Slideshow Program

Many photo-editing programs and media asset databases include slideshow functions. So, before you buy new software, go into the Help menu of your current programs to see what they offer.

Figure 19-3: For precision control over the relative timing of various elements in a slideshow, advanced hobbyists and professionals use timelines, like this one in PhotoSuite (www.Roxio.com). (A) This is the timeline that defines when everything occurs in this slideshow. (B) The photos are placed in the upper track, where you can also designate how long each will remain on the screen and what the transition effects will be. (C) We have three different recorded sound narratives, which will begin to be heard at the same time as the slides that are right above them. (D) The third track holds special effects that will be applied over time to the slides above them. (E) And rolling text credits will fade in and out at certain times. (Courtesy of Roxio, Inc.)

Sharing Photos via the Internet

Digital photography and the Internet were made for each other. Actually, industry analysts consider the growth and general acceptance of each as a significant factor in the dramatic growth of the other.

Generally speaking, Web photo sharing is achieved in one of three ways:

■ Emailing

■ Photo-sharing Web sites

■ Specialized photo-sharing software

The Pros and Cons of Emailing Photos

In many ways, emailing photos is the easiest sharing method. All you have to do is find the attach command in your emailing program, navigate to where you saved the photo, and click OK. Then, address and write your memo and click Send. In fact, many consumer and prosumer photo-editing programs have a Send command, which automatically attaches a photo to an email memo.

However, emailing pictures has its difficulties:

■ You must be sure that the photos are the correct size and format for emailing (see Chapter 15).

■ It's easy enough to attach one or a few photos to emails, but when you want to share a lot of photos, it can be a cumbersome process.

■ Writing out the address of each recipient can be time-consuming and produce errors. The alternative is to learn how to use an existing address book to create a list of recipients.

■ Are you sure your friends and family really want to see your latest photos?

- Many networks block email attachments for fear of computer viruses.

- And what if you and your friends want prints? The emailed photos won't be large enough for high-quality prints (or they shouldn't be).

Photo-Sharing Sites

Do a Google search on *digital photography*, and it will return over 2 million Web addresses for online digital photography Web sites. Many are support or sales sites, and others will help you learn more about how to better take and use pictures. That still leaves a multitude for sharing your photos with friends, family, associates, and clients. A handful of the most popular ones include `Shutterfly.com`, `Ofoto.com`, and `SmugMug.com`. There are many, many others.

HOW PHOTO SHARING WORKS

The essentials of photo sharing are the same among all the sites we know:

1. Register to use the site. That may or may not require paying a fee. (See below about choosing between free and fee-based sites.)

2. Prepare your photos for uploading, which may involve as little or as much editing as you wish.

3. Upload your photos either to private albums (which may or may not be password protected) or to public galleries.

4. Invite friends and family to view your photos.

5. Order prints and photo novelty items.

Of course, the details of what all that entails can vary widely, depending on the site you choose to use.

Tip: Get Your Film Photos Online

If you or a family member is still shooting with film, you can share those photos online, too. Many photofinishers and a number of photo-sharing sites will process your film and put your pictures online.

CHOOSING YOUR PHOTO-SHARING SITE

Choosing the right photo-sharing site can be a daunting task, given how many there are. In the end, it will prove to be personal matter, with a lot of serendipity thrown in.

Your first decision is whether you want to use one of the many free sites or pay for a premium service. The folks who run photo-sharing sites aren't doing it as a charity; they need to generate income one way or another. While all make some money from selling prints of your photos (and often other novelty items), that doesn't usually cover the considerable costs of running the site. They must get additional income either from advertisers or from you. While it seems counterintuitive to pay for something that you could get for free, often the real value isn't about money.

Choose a free site if:

- All you really want or need is to get your photos up on the Internet without much fuss, in any way that works.

- You've become inured to pop-up ads.

- You aren't really interested in maintaining a sizable library of your photos online, but just want to get them up there for a while. (Many free sites will keep your photos on their servers for a set number of days or weeks, or only as long as they continue to generate sales of prints.)

Fee-based sites have a number of advantages over the free ones (see Figure 19-4). Consider shopping for a fee-based site if:

- You are using the site to promote your photos professionally or in some other business-related manner.

- It bothers you that nearly every page of the free sites will barrage you and your visitors with advertising and pressure to buy prints.

- You want to drag and drop your pictures so that they are ordered in a particular manner, you want to change the background colors or thumbnail sizes, or otherwise wish to take control over the displaying of your photos beyond the basics.

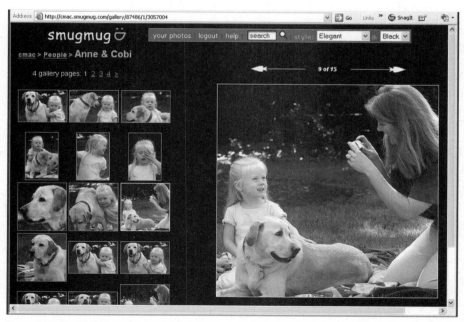

Figure 19-4: While free photo-sharing sites usually have ads on every page, fee-based sites (such as www.Smugmug.com) tend to avoid them. How much you can customize your pages, removing the site's branding info (such as the Smugmug navigation bar on the top), replacing it with your own, often depends on how much you're willing to pay for the service. Professional photographers and other businesses can pay for the right to fully customize their pages. (Courtesy of Smugmug.com.)

- You want to share (and/or sell) high-resolution images.

- You wish to maintain your library of photos online for the foreseeable future (or, at least, as long as you pay the annual fees).

- You require the extra security that some sites offer, including customizable passwords.

- You want an easy to recognize and remember personal Web address for your photo site.

Not all those options are available at all fee-based sites. So, you'll need to compare services and costs. For example, some may have unlimited storage of as many photos as you wish, while others have sliding scales, with prices dependent on how many photos (or how many *megabytes* of data) you wish to store. We have even seen free sites offering unlimited storage.

Incidentally, just because you choose one free site this week doesn't mean that you can't try another next week. Photo sharing is like banking (though not with the same level of security). Sure, it can be inconvenient to set up a new account, but that doesn't stop you from changing banks when a new one offers a better deal or a specific service you need or want. We recommend experimenting with various sites, until you find one that fits your personality and needs. Or, do as we do, and use different ones (free and fee-based) for different purposes.

Sharing Photos from Your Camera Phone

The whole idea behind camera phones is being able to instantly share your snapshots. *"Hey, guys, look where I am . . . and with whom!!"* Current camphones can send photos via email to anyone or post them onto the Internet. At the time of this writing, photo messaging (which is similar to text messaging) is still rudimentary and limited to subscribers of the same service. But by mid-2005, we should be able to send photos directly to any other camera phone regardless of what company is carrying the signal. For more information about sharing your camphone photos, see Chapter 16.

PREPARING AND UPLOADING YOUR PHOTOS

Putting your photos up on the Web may be done in several ways:

- The simplest process is to go to the Web site and follow their instructions. After you indicate whether you want it put onto one of your existing albums or a new one (which you can name, such as "Jane's birthday party" or "our Hawaiian vacation"), they'll take it from there.

- Some sites offer basic photo editing, such as rotation, red-eye reduction, cropping, some exposure correction, and so forth. In fact, the extent and ease of photo editing, captioning, and other options (including choice of background, design of page, and so on) are one of the important dividing factors among the sites.

- If you decide to use the site's editing software, another option is whether you use the program while connected to the site or download it to your own computer and work offline (which is preferable if you don't have a fast Web connection). If you use downloaded software, it will usually automatically connect to upload your photos. Again, you'll usually have a choice of which of your albums you want the photos to go.

■ All consumer and many prosumer photo-editing programs have a command for putting your photos up on the Web. That means you can edit your photos using the software you know and then use it to upload your pictures. While most programs will ship with connections to specific sites already enabled, if you prefer another site, you can probably change the program's preferences to link to it.

However you decide to upload your pictures, most sites work hard at making it easy for you. The greatest difficulty you may encounter is if you have a slow Internet connection, which could mean it might take a long time to upload your pictures. If you have any other problems (related to functioning well with the service), then you may be using the wrong site for your personality and skill level.

Tip: Always Keep Your Own Copies of Your Photos

Photo-sharing sites are simply that—places to share your pictures. Regardless of what they promise, never depend on them to save and archive your photos. Companies go out of business and/or change their policies. If your pictures are precious to you, be sure to keep copies on your local system and develop an archival system to keep them safe (see Chapter 21).

SHARING YOUR ALBUMS

This is generally the easiest part. All you need is to know are the email addresses of the folks you want to invite to see your new album. In many cases, the site will store your address book. Then, click on a Share button, and the site will send emails to the people you indicate with a link to your album. When they get the email, they simply click on the link and their Web browser will open your album.

At this point, you'll encounter some additional differences among the sites, including:

■ **Does sharing one of your albums with someone give them access to all your albums?** The better sites will allow you to choose what albums can be seen by whom. Some sites will permit your invited guests to invite others to see your albums, which you may or may not want.

■ **Do your invited guests need to register with the site to be able to access your album?** Some people object to having to give their contact information when they were invited. It's like having a bodyguard stop you at the door, when you had received a personal invitation to dinner. Others prefer the sense of privacy and security.

■ **What kind of interaction does the site offer your guests?** You might have a guestbook where they can leave you messages and discuss the photos. At the very least, you'll probably want some kind of indication of who visited and viewed the album.

■ **If you put your photos up on a public gallery where anyone can see them, what kind of feedback and security does it provide?** For example, you might not mind having strangers look at your photos, but may prefer they can't download or print them.

ORDERING PRINTS AND PHOTO NOVELTIES ONLINE

One of the primary income generators for the free sites, and a frequently requested service on the fee-based sites, is the ability to make high-quality prints from your photos. What's great is that the cost

has come down and the quality has gone up, and online printing of digital photos is now competitive with traditional film processing. To prove it to you, many of the sites offer free prints just for signing up for their service. In addition, on many sites, you can also order neat photo novelties, such as T-shirts, photo cookies, coffee mugs, calendars, and so on.

The basic rule of thumb in digital photography, as in everything to do with computers is GIGO, which stands for "garbage in, garbage out." Be sure that the photo you're ordering is worth spending the money on to have printed. Most of these sites will do their best, but if the picture is terribly underexposed or soft or otherwise inferior, the print could be a disappointment.

Do a Test Run

Since choosing the right site is a very personal matter, we recommend creating a small album before you commit to a site. With the free sites, all you have to do is sign up and you'll have access to their services. Many fee-based photo-sharing sites also offer trial memberships, too.

Here are some suggestions for your test:

- Don't spend too much time on the test album—only enough to check out what it's like to upload your photos, how the software works, how much customization it allows, and if you are comfortable using it.

- After you've created an album, send an invitation to yourself, so you can see what the experience would be like for your invited guests. Then, when you receive the invitation, log in under another name to see what they will see and what they'll have to do to interact with your site.

- Most free photos sites (and some fee-based ones, too) will give you free prints just for signing up. Take advantage of those offers to find out which sites provide the best prints, options, and service according to your own personal criteria.

The Future of Photo Sharing

Recently, a whole slew of new programs have come onto the market which bypass photo-sharing sites while still allowing you to share photos over the Internet. These range from programs like Picasa's Hello (www.Hello.com), which allows you to share photos in an instant messenger milieu, to OurPictures (www.OurPictures.com), which works on a peer-to-peer network formula.

The photos reside on your computer, usually in an organizer with some basic editing capabilities. Choose the photos you want to share, send them, and they'll arrive, full-sized, on your friend's desktop. As a rule, both the sender and the recipient must have the same software installed (though some programs will upload to a Web site as an alternative, if the recipient doesn't have the application). Some systems require that both you and your friend be logged in at the same time to work, while others don't.

This type of software uses rather innovative programming to make it work, but we're still only at the beginning, with many applications in their infancy. Over the next year, we expect there'll be a swarm of software vying for your attention and loyalty, trying to outdo each other with features, speed,

quality, and promises. Keep your eyes and minds open; the impact could change the way you share your photos.

Another concept gaining ground involves Wikis, freewheeling collaborative software that allows all participants to add to and edit each other's work. The ultimate example is the Wikipedia (`http://en.wikipedia.org`), an online encyclopedia to which thousands of individuals have contributed. While Wiki is primarily a document-based process, we expect it will spread into the photo-sharing market soon.

Summary

Some of the key concepts covered in this chapter:

- Displaying your photos on your TV is almost as easy as reviewing them on your digital camera's LCD monitor.

- Slideshow software, which can make your photo shows more animated, intriguing, and informative, ranges from basic programs easy enough for novices to powerful applications used by video professionals.

- Web photo sharing is achieved in one of three ways: emailing, photo-sharing Web sites, and specialized photo-sharing software.

- Photo-sharing sites can be free or fee-based, and there are reasons to consider both.

- The comparatively new category of photo-sharing software bypasses photo-sharing sites while still allowing you to share photos over the Internet.

Chapter 20

Printing Your Photos

Despite all the convenience and fun of taking, editing, sharing, and viewing digital pictures, nothing beats holding a photo in your hands. The tactile, visual reality of the memories it evokes, plus the value in communications of being able to share something that requires no technology to view or use, is still unsurpassed. So, at some point, you will want to output your digital photos onto paper.

In this chapter, you'll learn the differences among the various kinds of color printers; how to choose the right one for your needs, interests, and budget; tips on getting good prints efficiently; alternatives to making your own prints; and how to get the colors right when you print.

Tip: Be Sure You Can Really Afford That Free Printer

Often a computer manufacturer will throw in a free printer when you buy a system, or you may be offered a rebate that makes the purchase of a printer free or almost free. It may be a good deal, but first check out the cost of the ink and matching paper (*consumables*). We have seen several printers selling for as little as $19.95, but the replacement ink cartridges for them cost $34 each.

Printers: A Multitude of Models

Go into any computer or appliance store and you'll see color printers of all sizes, shapes, and prices from under $50 to over $2,500. All claim to output photos beautifully. What's more, all of them really can print pictures, though some better than others. The trick is to use the right printer for your needs, expectations, volume of prints, and of course, budget.

Printers fall into categories, based on the technology they employ and on how they will be used. In this section, we will cover the various technologies. Later in this chapter, we'll guide you through discerning how you will use your color printer which will, in turn, help you decide which kind you should consider buying.

The most commonly used technologies for printing photos include:

- Silver halide
- Inkjet
- Laser

- Thermal dye transfer
- Phase change

Tip: Continuous Tone Is the Gold Standard of Photo-Realism

When you look at a good traditional film print, all the colors smoothly blend into each other, with no breaks in transitions or gradations. This is known as *continuous tone*. On the other hand, a poor digital print has obvious banding (breaks between colors), or you can easily to see dot patterns. Really good digital prints are either near or true continuous tone, which means that they are considered nearly or truly photo-realistic in nature.

Silver Halide

Silver halide has been used for many decades to make film prints. While it is no longer the only viable method for creating great photos from digital cameras, it remains the standard against which all the other technologies are compared. Unless you have your own darkroom (or are using a Polaroid instant printer), the only way you can get silver halide prints is from a commercial photo lab or minilab, drug store, online print service, or other retail operation. Silver halide still has some major advantages over digital printers. By definition, it offers true photo-realistic continuous tone, with usually a great *gamut* (range of colors and tones) and more accurate colors. Unlike some inkjet prints, silver halide photos are waterfast—the colors do not run when the print gets wet. Last, but certainly not least, professionally produced, archival-quality silver halide prints tend to be longer lived (that is, the colors do not change or fade) than other technologies. All these reasons help explain why most museums and galleries prefer silver halide prints. One added bonus: silver halide is initially less expensive to the consumer (you don't have to buy a printer) and easy (because someone else is doing all the work).

Inkjet

The ubiquitous inkjet printer employs dozens, scores, or many hundreds of tiny nozzles to propel tiny ink or dye droplets onto paper. Literally millions of these droplets are clustered closely together to make up a single picture. While inkjets are available in a wide variety and price ranges, including some of the best professional photo printers around, as a rule, they are inexpensive, low-maintenance items. However, the cost of the inks and paper—consumables—are relatively expensive, and the devices are disposable in that most have to be replaced rather than repaired when they malfunction. So many different makes, models, and types of inkjets are on the market that it's difficult to generalize about them. (See later in this chapter for more information on the different kinds of inkjets.) Depending on the device, inkjet may offer near or true continuous tone, adequate to great gamut, and very short-lived or archival colors.

Laser

Laser printers use a laser beam to sensitize or "paint" the electrically charged, photosensitive drum in such a way that it collects toner and deposits it onto paper, which is then fixed by heat. When you

output a letter, business presentation, school project, or any other printed document, the text is almost always beautiful, nearly indistinguishable from the typeset quality found in books. Any color laser printer that also outputs photos usually does so as a secondary consideration, which means photo image quality may or may not be up to the level of the other technologies listed here. However, if you want to include photos in a professional-looking printed presentation or document, or if your project requires fast or high-volume output, you need to use a photo-capable laser printer. And when you use good paper, you will end up with a photo that looks pretty good. Laser printers tend to be initially expensive when compared to inkjet, and the units are more complicated and may need more servicing. On the plus side, laser toner and paper are much cheaper per page.

Thermal Dye Transfer

Thermal dye transfer (dye sublimation or thermal dye sublimation, though the term is technically inaccurate, since no sublimation takes place) has been around for decades. It employs heat to melt cellophane-like color ribbons and then migrates the dye to the special (usually glossy) paper. Using three- or four-color ribbons (see the discussion later in this chapter regarding CMY and CMYK), each color is laid down individually, which means the paper passes through the printer three or four times. So don't try to grab it as it comes out of the paper slot, until the print is completely ejected. Most modern dye subs add another layer, of laminate or UV protection, to protect the print and increase its longevity. The colors meld into each other, creating a true continuous tone, and dye sub photos tend to be among some of the most brilliant, beautiful prints, often are used for exhibitions. The media is relatively expensive, and colors will tend to shift or fade within a few years.

Phase Change

Phase change (or solid ink) heats resin blocks of color ink to liquid, which then resolidifies when applied to the paper. Though not continuous tone nor archival in nature (the colors eventually fade), when working on a properly color managed system (see the section later in this chapter on color management), the colors are quite close to what comes off a printing press. That makes phase change a great technology for prepress proofing. If you are doing a lot of business graphics as opposed to photos, phase change will produce very appealing results, and at one of the lowest consumables costs of any color printer technology.

The other important advantage to phase change is speed: it's one of the fastest color technologies among desktop printers. Depending upon the model, phase change printers can spit out full-color prints at the rate 24 prints each and every minute. Also, its duty cycle makes it very suitable for a busy office or graphic arts studio environment.

What Is Gamut and Why Should I Care about It?

Gamut is the range of colors that a printer can output. (Actually, it's the range of colors that any digital technology can capture, reproduce, or output.) The wider a printer's gamut, the more colors it can reproduce, which can add up to smoother gradations between shades. In other words, the wider the gamut, the more the printout of your picture will appear photo-realistic. The best printers have a gamut that will create photos that are indistinguishable from traditional film enlargements.

What Is the Right Printer for You?

Now that you understand the basic technologies, let's step back and analyze what kind of printer you really want and/or need. Consider the following questions:

- **Do you want your photo printer to also do text and general documents?** If yes, then steer clear of dedicated photo printers. Instead, consider a general-purpose inkjet or color laser printer.

- **How big are the pictures and documents you plan to print?** Snapshot printers are great for making traditional 4″×6″ photos. But if you want a variety of sizes, almost every other technology can output to at least 8″×10″ paper. If you need tabloid, poster, or larger prints, check out specialty printers or professional printing services.

- **How many prints do you make a week, a month, a year?** If you print out no more than a few hundred sheets a month, then almost any technology will do. However, if you plan to crank out lots of prints on a regular basis, you'll need a solidly built, high *duty cycle* printer, which will cost more. Depending on your answers to other questions, it might be a heavy-duty inkjet, a color laser, or a phase change printer. Or, you might be better off using a commercial print service.

- **What will you do with your photos?** If you need to insert them into business presentations or newsletters, you'll want inkjet or color laser. If you plan to exhibit them as works of art or show them off as photos, you'll want a photo inkjet, dye sub, or other specialty photo printer. If speed and convenience don't really matter that much or you don't need the best image quality, an inexpensive inkjet may be adequate for your needs.

- **Is photo quality more important than cost and convenience?** Your answer to this is probably: it depends on how costly, how high the quality, and how difficult and time-consuming it is to use. But for top photo quality, don't settle on color lasers, phase change, or dual-purpose inkjets. Buy a photo inkjet, dye sub, or photo snapshot printer.

- **How much does speed matter?** Laser printers and phase change printers are the fastest, able to output 3–24 8.5″×11″ color prints per minute. Dye subs are relatively slow (because they require 3–4 passes), usually taking 2–4 minutes per 8.5″×11″ print. Inkjet speed is directly related to how much you are willing to spend. Inexpensive inkjets may take 5–6 minutes to output a single 8.5″×11″ print, while better inkjets can do the job in one-third that time.

- **Are you willing to spend a little bit more on the printer, to spend less on the consumables?** Generally, the less you spend up front for a printer, the more the

consumables will cost. However, dye subs are the exception here, both being expensive to buy and requiring expensive consumables.

- **Would you rather leave the printing to someone else entirely?** If yes, then consider using an Internet or retail print service. Or, as a compromise, check out the new self-serve kiosks.

Keep your answers to these questions in mind as you read the rest of this section about the different kinds of printers. They will help you select the right printer for your needs, interests, photography preferences, and budget.

Evaluating Printers

The following are terms you will need to understand as you choose among various printers:

- **Resolution, or how many dots per inch it will put on the paper**—The more dots, the closer to photo-realistic continuous tone. (However, the number of dots refers to inkjet and laser printers only, since thermal dye transfer printers use far fewer dots, but in such a way that they are much sharper.)

- **The number of color inks or dyes it uses**—Generally speaking, the more colors, the better the print quality and the closer its appearance is to a traditional photo print.

- **Speed, or how many inches, pages, or prints it can output in a minute**—Or, for slow printers, the measure is how many minutes per page.

- **Cost per page of consumables**—This includes the inks, ribbons, and papers used to create the print.

- **Duty cycle, which is how many prints per month a device can output without straining or reducing its effective life**—If you plan to do a high volume of prints on a regular basis, you'll want a printer with a high duty cycle.

Table 20-1 provides general guidelines on how the five main kinds of photo printers stack up. However, please remember that individual models may fall outside these typical parameters.

Table 20-1 Comparing Photo Printers

	Resolution	# of Colors	Speed	Cost per page	Duty Cycle
Dual-Purpose Inkjet	720 × 720	4	2–8 minutes per page	$1.50	500
Photo Inkjet	4800 × 4800	4–8	1–3 minutes per page	$1.25	1,200
Color Laser	1200 × 1200	4	3–12 ppm	$0.15	5,000
Dye Sub	300 × 300	3–4	2–4 minutes per page	$2.50	1,000
Phase Change	600 × 600	4	12–24 ppm	$0.15	5,000

ppm stands for pages per minute.

Cost per page is an approximation, based on an average 8 1/2″ × 11″ photo.

Types of Inkjets

Inkjet are by far the most common printers, with the widest range of prices and capabilities. Essentially, the many models fall into three distinct types of inkjet printers:

- *Dual-purpose inkjets* are usually the least expensive. In fact, like the traditional razor and razor blade sales strategy, the manufacturers of these printers are often willing to lose money on the printers themselves because they'll make their profit from selling the consumables. Great for families who need business documents and school reports, but print only occasional pictures, these four-color printers do an adequate to good job on text and photos. However, some inexpensive dual-purpose inkjets generally require having, maintaining, and swapping two sets of inks—one set for text and a different black cartridge for photos. Dual-purpose printers have the lowest duty cycle of all inkjets, but they do have the advantage of being comparatively small and taking up limited desk space. If you're going to print a lot, we suggest spending a bit more money for a better built, more robust printer that will last longer, be faster, and for which the consumables will generally cost less.

- *Photo inkjets* are optimized for photo quality, and they often have more ink color cartridges to help produce a wider gamut (a greater range of printed colors). Generally they are faster and more robust than dual-purpose inkjets, have better duty cycles, and the consumables are usually less expensive. However, you'll also tend to use better (more expensive) paper because you'll be more pleased with the quality of the prints. Many now offer archival inks and paper, which means your prints will last much longer than traditional inkjets (if stored and cared for properly, that is). When you use the right inks and paper for the printer, you'll be very pleased with your photos. They also tend to do a very good job with text, too. It's important to look for the word "photo" in the printer's name to help you distinguish photo inkjets from dual-purpose models, because the two types may look very similar. (See Figure 20-1.)

- *Professional-quality inkjets* are often the most coveted printers among artists and professional photographers. Depending upon the model, you can output exhibition quality prints (even continuous tone) and/or large photos. They are less expensive than in the past, and it's possible to buy a great professional inkjet that prints poster-sized photos for under $1,800; tabloid-size printers can be had for as little as $500. Professional floor-sized models have wide carriages for still larger prints, such as enormous posters or even sections of billboards. Generally, the more expensive the printer, the more economical the consumables, because large printers have correspondingly larger ink reservoirs. In addition, each color ink reservoir is replaced individually when it runs dry, rather than having to replace the entire multi-ink cartridge most inexpensive inkjets use when one color runs out. Pro printers are heavier and better built, with a much greater duty cycle than the smaller photo printers.

Tip: Don't Use Your Best Paper for Your First Print

When you output your first photo, use inexpensive paper and a smaller size, just to see what your print will look like. Then, when you're satisfied, you can switch to better paper and a larger photo. Most $8\frac{1}{2} \times 11''$ photo-quality prints on good paper will cost $1 and up in consumables. That is certainly cheaper than a traditional silver

halide print of comparable size, but it can add up if you end up throwing away your first few attempts until you get it the way you want.

Figure 20-1: This Canon i9900 is a photo inkjet printer with eight color inks, which gives it wider, photo-realistic output than an ordinary dual-purpose device. But from the outside, it looks like any ordinary inkjet. That's why you have to look closely at the specs of an inkjet to determine whether it is a dual-purpose or a photo printer. (Canon and Powershot are registered trademarks of Canon Inc. in the United States and may be registed in other countries. All rights reserved. Used by Permission.)

How Long Will My Inkjet Prints Last?

Desktop color printers were not initially meant to produce fade-resistant, color-fast pictures. However, we are now outputting some of our most precious memories and even expensive works of digital art using them. So, the longevity of those prints has become a major issue.

As a rule, unless you use special archival inks and paper, your photos will fade, and the colors will change—some as quickly as within a couple of months. Also, many inks, especially those used in cheaper and dual-purpose models, are actually water soluble and can smear.

Archival inks and paper cost more, may not be quite as bright and brilliant as regular inks and papers, and in any event are available for only some printers. But they have been rated to last as long as 50 to 100 years. In fact, the archival media used by the Epson Stylus 4000 and similar devices is being used by galleries for signed works of art that are sold for investment purposes as well as for their intrinsic beauty. Other manufacturers offer archival technologies, though they may use other terms for it. Look for substantiated claims of longevity on the packaging and marketing materials. But, as with all print media, specific archival inks and paper will work only with matching printers that were designed to use them.

How Long Will My Inkjet Prints Last? *(Continued)*

To put all this in perspective, look at color photos only a couple of decades old now lying in your family albums, shoebox, or drawer. They too are faded, with colors that have changed. At least with digital, we can now also archive the original files and output new, perfect-looking prints whenever we want them—as long as we hold onto the software and computers that can read those files. That's going to be a major problem as the technology evolves. (See Chapter 21 regarding developing an archiving strategy.)

Should I Buy Generic Inks and Papers?

If you have email, you get spam. It's a fact of our modern life. And it seems that a significant percentage of all that spam is from someone trying to sell you cheap inks and paper for your printer. So cheap that it's almost too good to be true. And in many cases, it is.

If you want optimum quality from your printer, you should buy brand-name matching inks and paper. That doesn't necessarily mean that it has to have the same brand name as your printer, but that it should come from a source that is a known name.

But if you don't really care what happens to the print a year from now—and if good is good enough—you might be tempted to try off-brand media. Before you do so, you should be aware of the following factors:

- Some of the very inexpensive inks are actually counterfeits. They may be made without lubricants, using a different chemistry basis and might actually damage or destroy your print head.

- Manufacturers won't honor the printer's warranty if it has been damaged by generic ink.

Another option is to try refilling ink cartridges using the kits sold via email and on the Internet. These work by injecting new ink into the cartridges using what looks like a hypodermic needle. Yes, it can save you money, but it's very messy and, like the generic inks, generally isn't something supported by your warranty. Again, you must be sure of your source because some inks are bad.

Laser Printers

A laser printer is practical for an office environment in which several people are using the same printer via a network. Many units can have multiple trays with different kinds of paper in it, so you can print out a photo and then a document by selecting the correct tray in software. (You can use inexpensive plain paper for laser photos, but you'll get better quality photo prints using premium or glossy paper.)

When considering a using a color laser instead of an inkjet printer, you should be aware of the differences between the two technologies:

- Lasers are much faster. In fact they're faster than most desktop technologies, capable of printing 3–12 color prints a minute. Expensive, high-speed models can crank out up to 35 ppm.

- Relatively few lasers are designed to output photo-quality prints. An ordinary office color laser can print photos, but not on special photo paper, the gamut is much reduced, and details may appear mushy or indistinct. On the other hand color lasers specifically designed to output photos onto glossy paper can produce very good to excellent photo-quality prints.

- Built to last and work hard on a regular basis, laser printers have much heavier duty cycles than typical inkjet printers.

- While all but the most expensive inkjets are usually replaced rather than repaired, many lasers are sold with an on-site service contract for a year, which you can pay to extend to a few years. On the other hand, lasers have lots of parts, requiring moderate to frequent attention and maintenance, and some parts must be replaced periodically, such as the drum and toner cartridge, or emptied, such as the waste discharge bottle.

- With a laser printer, you can print on the back of the photo, with some units doing it automatically (duplexing). But the print may bleed through, depending on how dark the text and photo are and the quality and thickness of the paper. Inkjet prints are rarely double-sided.

- Laser printers tend to be bigger and heavier than comparable inkjets. You'll need a larger, more substantial desk, or even a printer table to accommodate it. (See Figure 20-2.)

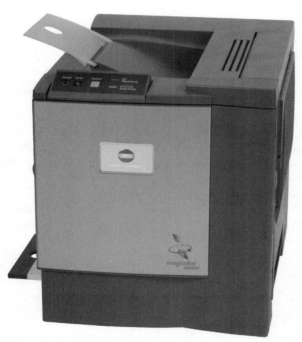

Figure 20-2: Most color lasers are business printers, optimized more for text and business graphics than photos. But they are great for presentations and other documents that need to include photos. Built to last, they are heavy-duty devices that are also quite big. Pictured is a Konica Minolta magicolor 2300, which at the time of this writing is priced below $500. (Photo courtesy of Konica Minolta.)

- While most inkjets are cheap to moderate, with more expensive consumables, the initial cost of lasers is moderate to expensive, but the cost per page tends to be less expensive.

- Put a laser photo next to an inkjet photo, and depending upon the make and model, you may see a difference, with the laser falling behind in quality. Still, for newsletters, quick proofs, and other documents that include photos, the laser printer can do an adequate to nice job. And lasers specifically designed for photo output can produce truly excellent images.

- Unlike inkjets, no laser printer can produce an archival photo. The colors will eventually change and fade.

- Laser printers tend to last longer than inkjets.

- For photo output, you may have to maximize internal memory in your laser, which will cost you additional money.

Laser versus Phase Change Printers

When choosing between a laser and a phase change printer, keep in mind that phase change printers are best suited for business graphics, illustrations, and prepress output, but can also generate excellent text. Lasers are best at text, though some can produce photo-quality prints, too.

Snapshot Printers

Do you simply want photos that look like those you are used to getting when you had your film processed? Growing in popularity are small snapshot printers that output . . . well . . . snapshots (usually about 4″×6″) using inkjet or dye thermal technologies. In addition, Polaroid snapshot printers offer instant silver halide output.

Optimized to be bright, saturated, happy photos rather than accurate, they are near or true continuous color and look great on refrigerators and in letters to grandma. Put their prints side by side with your film prints, and only an expert will be able to tell the difference. You can even choose between border or borderless, just like you can at the minilab. Of course, when you print, you can specify whether you want one, two, or more copies at a pop.

Snapshot printers are generally low maintenance, easy to use and to set up. Strictly designed for photos, they can't output documents or text, and their consumables are more expensive than inkjets printing the same size, averaging between $0.25 and $0.50 per print. What's more, they have no archivability and tend to have a rather low duty cycle.

But for printing photos, they're great, and a number even automatically add a laminate layer to protect your pictures from moisture and rapid fading. Some are so small that they can fit into a briefcase and may be battery powered.

Incidentally, there are expensive professional printers, usually costing between $600 and $3,000, that output snapshot-sized prints. They're generally used in labs, hospitals, schools, government facilities, photo labs, photo studios, and any other businesses that require a high volume of small prints, for example for documentation or quick and dirty photo proofs. They're bigger and heavier than amateur snapshot printers, usually print much faster, and have significantly higher duty cycles. Consumables tend to cost about the same, but you usually have to buy them in much larger units. Just thought you might want to know.

Direct Connect and Memory Card Printers

An increasing number of snapshot and inkjet printers can now print directly from your camera or your memory card without using a computer. Just attach your camera via a cable to the printer's USB port, insert your memory card into the appropriate slot in the printer (see Figure 20-3), or, in the case of Kodak's EasyShare printer, put your matching camera into the dock on the top of the printer. (See Figure 20-4.) Then, you press a few buttons, and within a couple minutes, you'll begin to output attractive-to-gorgeous photo prints.

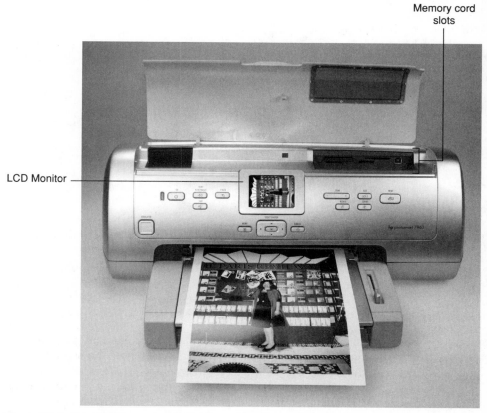

Figure 20-3: This HP Photosmart 7960 printer, like other memory card printers, can print either from a computer or directly from memory cards. Simply insert a memory card into the appropriate slot, preview your photos on the LCD monitor, and use various buttons to select your photo and apply one of the handful of commands available. Many of these printers are also PictBridge-enabled for those who want to print by directly connecting their camera rather than removing and inserting a memory card. (Photo taken with a Konica Minolta DiMAGE A2.)

Depending on the make and model, the printer may have a small LCD monitor where you can view your photos, make decisions about your prints (such as the number, size, and orientation), and sometimes even do some minor editing.

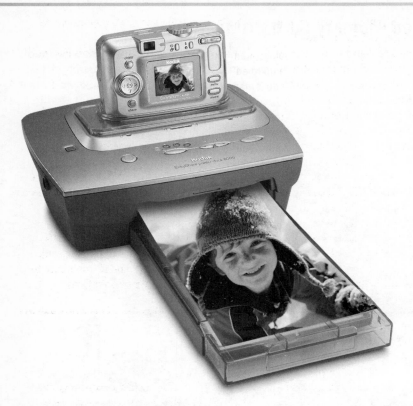

Figure 20-4: A Kodak EasyShare CX7430 camera in its printer dock. (See Chapter 17 regarding camera docks.) This setup allows you to print directly from the camera, while recharging batteries and providing automatic download of your photos to the computer. (Courtesy © Eastman Kodak Company.)

Direct connect and memory card printers are among the great innovations of recent years, making digital photography much more fun and more accessible. However, keep in mind that when you use them, you are also bypassing all the editing capabilities of your computer. What's more, it makes it easier to forget to save, organize, and archive your photos, so you'll be able to use and view them again in the future. (See Chapter 21 on developing a photo storage strategy.)

Basic Printer Maintenance

To help your printer give you satisfactory service for as long as possible, you'll want to practice some basic good printer housekeeping.

Inkjet printers work by shooting tiny droplets of ink out of nozzles in the print head. Those nozzles can get clogged, especially if the printer isn't used regularly. Luckily, the printer driver (the software through which you send your photos to your printer) almost always has a very easy to use utility that will clean the nozzles for you in a way that won't require you to physically touch the printhead or nozzles. Just follow the software instructions, which involves clicking your mouse a few times, and the printer will take care of the job itself. If you use your inkjet on a regular basis, clean the heads about

once a month. If the printer isn't being used frequently (which means the ink has more opportunity to dry in the nozzles), clean it every couple of weeks.

Almost all color printers, regardless of the technology, come with some sort of alignment utility that makes certain that the different colors of ink will line up to each other correctly. Most printers automatically adjust alignment, but you may want to do it manually when you change a ribbon or a cartridge, or when the colors look out of place.

Laser and phase change printers have waste receptacles that must be emptied periodically. Otherwise, the printer simply will stop working. Should that happen, don't worry; there's no real damage because your printer will function normally after you empty the waste receptacle.

Paper often flakes, rips, shreds, and tears as it goes through the printer. Toner dust coats and collects inside the printer. Rollers and paper grabbers become slick with use. This is why you will want to regularly clean inside your printer. For removing unwanted dust, chaff, and anything else that leaves a residue, consider buying a small hand-held vacuum cleaner (available at most computer and stationery stores) and periodically suck out everything that doesn't belong. For rollers and other surfaces that come in contact with paper, you can use either commercial cleaning swabs or cotton cue tips dipped with isopropyl alcohol (unless your printer specifically warns against it, as a few do). Cleaning the inside of your printer can extend its useful life, because dust and dirt tend to contribute to a gradual buildup of component-destroying heat. Be sure, of course, to follow the cleaning and maintenance instructions specific to your printer.

Tip: For a Great Look, Try Specialty Papers

The one thing about printed photos that is so appealing is their physical reality—holding something that evokes memories, emotions, and ideas. You can enhance the impact of your prints by using specialty paper. This can include textures (glossy, pebbly, matte, even canvas-like), prescored templates (for greeting cards, business cards, and novelty items), or color (not just the background but also preprinted borders, frames, and decorations). Just be sure that the paper you choose is appropriate for your specific printer.

From Camera to Printer: A Language Issue

Time was when digital cameras and color printers seemed to speak a different language. You'd get a great photo with your camera, but the printer would interpret it all wrong. The only hope you had for getting a decent print without much fuss was to be sure your printer was made by the same company as your camera.

Nowadays, most digital cameras and printers (especially inkjet and snapshot devices) communicate with each other quite clearly, using industry standard *firmware* (internal programming) that allows them to share information about how your photos were created and or how you want them output. This streamlines the printing process.

You hear several different buzzwords and acronyms thrown around when shopping for your printer, including the following:

- **PictBridge**—PictBridge is an industry standard that enables direct printing from a camera connected to a printer (without going through a computer), regardless of what brand either is. If you want the ability to print directly from your camera, be sure that both your camera and your printer are PictBridge enabled (or use the same proprietary scheme).

- **DPOF (Digital Print Order Format)**—DPOF allows you to choose which photos you want printed and how many copies of each—while they are still in your camera (saved to the memory card or internal memory). When your camera is connected to a computer or directly to a printer, or when your memory card is inserted into a computer, printer (see "Direct Connect and Memory Card Printers" earlier in the chapter), or printing kiosk (see "Reality Check: Do You Really Want to Do Your Own Printing?" sidebar), then your photos can be automatically printed according to your DPOF instructions. Again, both the printer and camera need to recognize and use DPOF for it to work.

- **PostScript**—PostScript is a well-established print-description language that was originally created to ensure high-quality output of text and illustrations. Is the extra cost of a PostScript printer (versus non-PostScript) worth it? For business documents and desktop publishing (DTP), the output from a PostScript printer is superior, but only incrementally so, given how far printers have come in recent years. Add to that the fact that people no longer have such high expectations in terms of how well type is created. However, if how your documents are important to you, then make the investment to have the best—that is, Postscript. As M. David Stone, *PC Magazine's* lead analyst for printers and scanners, explains, "Vendors like Lexmark and HP still recommend using PostScript for best looking graphics and photos, and that's what I use for printer photo tests, if it is available."

- **PIM (Print Image Matching)**—PIM is Epson's color and image technology that allows Epson Photo Stylus inkjet printers to match the colors and image definitions embedded by PIM-enabled cameras into your photos' metadata. (It's actually written into the *EXIF* header.) Many manufacturers build PIM into their digital cameras. You should seek out a PIM-enabled camera only if you plan on using an Epson Photo printer. Also, be aware that when you edit your photo in your computer, the software might strip away the PIM information. One exception we know of is if you use the PIM import plug-in for Photoshop, which will apply PIM information to the photo before you edit it in Photoshop.

In addition to the preceding technologies, non-PIM EXIF and other metadata (see Chapter 5) embedded in digital photos can provide useful information to printers regarding how the picture was created. This, in turn, helps set the printer's parameters so it can output properly.

Not every digital camera and/or printer supports all these standards. Fortunately, manufacturers make no secret of which standards they support, displaying them proudly on their boxes and marketing material.

Printing Your Photos

The actual process of printing your photos can be quite simple, even if you aren't using the direct connect or memory card printers we mentioned earlier. Once your picture is in your computer

(see Chapter 17), open it up in your photo-editing or viewing software, select Print from the File pull-down menu at the top of your screen, and hit the Print or Okay button.

Easy, right? Well, as we say about so many things, the answer is yes and no.

If you want to be satisfied with the results, you'll want to be aware of certain factors, including:

- The correct size photo for the print you want
- How to get the colors on your print to match the ones on your computer monitor
- How to get multiple prints at different sizes

The Correct Size Photo for Your Print

As a rule of thumb, a printed photo should have a resolution of about 300 dpi (though many printers can do a good job with 200 dpi) at the physical width and height of the print you want (such as 4″×6″).

What is important to understand is that when a photo is brought into your computer, your software might see it not as 300 dpi, but as, say, 72 dpi. That doesn't mean it has a lower resolution, because it's still the same file that was represented by 1200 × 1800 pixels (to use the preceding example). It's simply that it's trying to spread the same pixels out in a different manner. In the case of the 4″×46″ 300 dpi photo, at 72 dpi, it would be 16.667″× 25″. It's still the same number of pixels. But if you just use the Print command without instructing the software how to spread the pixels out, your computer will either tell you that the photo is too large for your printer, or it will automatically cut the picture, printing only the inches that fit.

So, before you hit that print button, check the size of the photo in your program's Image Size command (which may also be called Resample, Resize, or some other name.)

See Chapter 15 for a full explanation on how to measure and resize your photos.

By the way, this doesn't usually apply to the direct connect or memory card printers, which typically have the intelligence to read an image file and optimize it for the best print.

Color Management: The Art of Controlling Print Colors

Often as not, when people are disappointed in their digital photo prints, the problem is that the colors they got weren't the colors they were expecting. Everything looked great on their computer monitor, but when the photo came out of the printer, they were dull or had a color shift or just didn't look right.

The two technologies (the monitor and the printer) simply don't understand color in the same way.

As we explained in Chapter 8, scientists, artists, and philosophers have struggled for many years to come up with a universal description of colors. There is, unfortunately, no such critter. One of the reasons is that different technologies create color in different ways. For example, the color on computer screens is *transmissive*. In other words, the light source is projected to create the colors on your monitor. Printers use *reflective* color, in which light from another source (the sky, overhead fixtures, desk lamp, and so on) falls onto the paper and reflects it back to your eyes.

To help understand and use these very different technologies, scientists have created *color models*, which use primary colors (and other aspects of light) as building blocks to define every color that can be reproduced or created by the specific technology.

ALL THE COLORS OF THE RAINBOW . . . OR ALMOST

Unfortunately, no one color model serves everybody's needs, which is why there are so many of them. For the purpose of understanding digital photography and photo printing, we'll cover only a handful of them:

- **RGB**—In this pervasive color model, which is based on the properties of light, all perceived colors can be said to be made up of varying amounts of red, green, and blue. Adding together equal parts of red, green, and blue will yield white, and the absence of color is black.

- **sRGB**—Hewlett-Packard and Microsoft developed this color system, which theoretically includes all the colors that can be displayed on a computer monitor. While it is fine for images that will live their entire existence only in computers or on the Web, it has a limited gamut. In other words, it doesn't include as wide a range of colors as other models. However, it is the one that is used in all current digital cameras.

- **Adobe RGB**—Developed to try to represent the colors possible in printing when dealing with pictures on the monitor, this color model has a wider gamut than sRGB. Better digital cameras offer the option of using Adobe RGB instead of sRGB for photo capture. If you're shooting for the Web, use sRGB; if it's going to end up a print (and your camera has the option), set it to Adobe RGB.

- **CMY**—This is the basic reflective color model used in most printers, in which the primaries are cyan, magenta, and yellow. In contrast to RGB, the absence of color is white, while combining all the colors is black—at least theoretically. Inexpensive printers will use cyan, magenta, and yellow inks to produce all their colors, but rarely are they capable of printing a true black. Not having black severely limits their ability to print neutral grays.

- **CMYK**—By adding black (K), better printers can reproduce deep shadows and true blacks, for a better color gamut.

Some of the many other color models include acronyms such as HSB or CIE LAB, but we needn't address them for our current discussion. If you wish a more in-depth explanation of color management, check out M. David Stone's excellent "Color Matching" article on http://www.extremetech.com/article2/0,1558,15467,00.asp.

Tip: Never Trust an Uncalibrated Monitor

Unless you use at least the most basic color management to create and save a profile for your computer screen, never believe the colors, brightness, or contrast you see on your monitor. Instead, do a print to see what you'll really get when you edit your photo. But if you don't want to buy and use a calibrator, go into your monitor settings and turn down the color temperature to 6,500 degrees Kelvin. It will help by displaying colors closer to what your printer will output, though not as close as calibration would probably give you.

COLOR MANAGEMENT: THE ROSETTA STONE OF COLOR MODELS

Unfortunately, there is no definitive formula for translating a color from one model (or color space) into a duplicate color existing in another model. That's one of the reasons color management (creating color that looks the same in the camera, on your screen, and in print) can be tricky.

As we mentioned earlier, current digital cameras and printers do a fairly good job of communicating color and other definitive aspects of a photo to each other. In addition, the operating systems in modern PCs and Macs have far superior color controls than earlier versions. Poor color tends to enter into the mix when a photo's colors, brightness, and contrast are edited on a monitor that isn't speaking the same color language as your printer. Using proper color management will help bridge that lack of communication.

Here are three methods you can use to help you fine-tune your system:

- **Create reference prints**—Pick typical photos (such as a portrait, a landscape, and a party scene), save them in a special location on your computer, and print them out. Then, when you edit a photo on your computer, compare its colors to the appropriate reference image (which you keep open on the screen while viewing the relevant print). This is a cumbersome process, but one that has the advantage of giving you real examples of how a color edit will affect prints that come off your particular printer.

- **Use color management software for your monitor**—The idea behind color management programs is that every monitor adds its own inaccurate shifts to the display of color, brightness, and contrast. You need to remove these "impurities" and bring the monitor display into a neutral condition that will allow more accurate colors to be shown. A typical monitor color management program will display colors and varying levels of gray and ask you to discern subtle differences between them. Using your answers, it will then generate a monitor *profile,* that is, a description of how the monitor displays color and brightness. When you save that profile into the correct location in your operating system (which some programs do automatically), the monitor display will then be adjusted to remove color shifts and other false or misleading color information that would otherwise be introduced into the display. The problem with this system is that you have to have a good eye for seeing subtle differences between colors and brightness levels. Many monitors come with their own color management software, as do some photo-editing programs (such as Photoshop), so you might not need to spend a single cent to correct your monitor display.

- **Use a calibration device with color management software**—(See Figure 20-5.) Rather than depending upon the unreliable human eye to discern subtle differences, this method attaches a device (a colorimeter or densitometer) directly to the monitor and plugs it into the USB port of your computer. As your monitor displays colors and grays, the device reads them and feeds back that information into the computer. Then, the software calculates an accurate monitor profile, which is used to adjust the monitor's colors and brightness so they more closely approximate the colors of your printer. In the past, the only such devices were complex professional units that would cost many hundreds, even thousands of dollars. But recently, a new class of easy to use consumer calibrators have become available at very reasonable prices. If color is critical to you, check out consumer model calibrators from companies such as Monaco Systems and Pantone.

When you calibrate your monitor (create and save its profile in your operating system), the colors, brightness, and contrast you see as you edit will be much more accurate. You still might see differences between what's displayed and what is printed, but they won't be as dramatic. A professional color management system also creates profiles for the input devices (scanners and digital cameras) as well

as the printer. However, for the typical user, calibrating your monitor will at least bring the colors in your photos closer to reality and reliability.

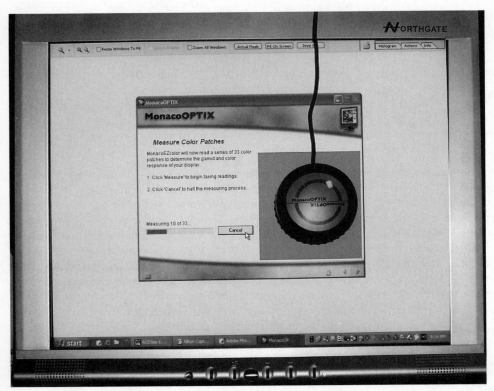

Figure 20-5: We use a Monaco Optix to calibrate all our monitors to be sure that the colors we see on our computer screens are accurate and much closer to those we'll get from our printers. (Photo taken with a Koday EasyShare CX7430 Zoom.)

Tip: Your Calibrated Monitor Won't Look as Bright

Most monitors have a factory default setting of about 9,300 degrees Kelvin. This means they're bright and colorful, great for displaying text and computer graphics. Unfortunately, bright and colorful isn't what you want or need if you want a display that will look much more like what your photos will look like when you print them out. Typically, the color temperature of a calibrated monitor is about 6,500 degrees Kelvin (also known as D65), which is significantly duller and more subdued than the factory setting you're probably used to. Get over it—a calibrated monitor and accurate color is much more important than a bright display if you want great photo prints.

Printing Software That Makes the Task Easier

The majority of photo printers use $8\frac{1}{2}'' \times 11''$ paper, but what if you want a smaller print, such as a $3\frac{1}{2}'' \times 5''$ or a $5'' \times 7''$? Perhaps, you have a frame of just that size, or the image file doesn't have enough data to produce a photo that would look great larger. Another consideration is cost. Every time you output a full-sized picture, you are spending that much more ink and paper. It can become expensive, especially if you want the best quality print, which means spending extra for premium photo paper. Add to that the time and energy of printing out an entire folder worth of prints for several people (such as all those birthday party photos you promised).

Some consumer photo-editing programs, such as Roxio PhotoSuite or Microsoft Digital Image Suite, come with easy-to-use templates for printing several photos of different sizes onto a single piece of paper. Usually, you just drag and drop the photo(s) into the space on the template, and the program should automatically resize and rotate it to fit. This saves money and time as well as gives you the ability to control just what size photo you'll get.

Our favorite program for laying out dozens, or even hundreds, of photos onto predefined or custom templates on any size paper is ACD Systems' FotoSlate. It's a practical, inexpensive piece of software that produces excellent quality prints and is easy enough for novices, but powerful enough for professionals.

Reality Check: Do You Really Want to Do Your Own Printing?

We owe prints of digital pictures we've taken to so many people we've lost count. The fact is it's very time-consuming and labor intensive to select, edit, and output photos. Don't you long for the days when all photography required of you was to take pictures? Then, you'd drop your film off at a minilab or drug store or send it through the mails to a photo finisher. Soon, you'd have prints in your hands.

It can be that way again. Most retail stores that process film can now give you film-quality prints from your digital photos. You can simply drop off your memory card at the counter and later pick up your prints, just like you did with film. You'll probably get a CD of your images, as well as prints, though you'll have to specify exactly what you want. Conversely, you can use the Internet to upload your digital photos, often to the same retail store or photo-finishing service you've always used. Then, you can have the option of either picking up your prints (and CD) if it is a nearby location or having them sent to you by mail. Of course, you can order prints (and other photo novelty items) from all the photo-sharing sites on the Internet (see Chapter 19).

And then there's kiosk printing. (See the accompanying sidebar figure.) A kiosk is like an ATM, but it dispenses photos instead of money. These self-operated vending machines and interactive monitors are cropping up everywhere—in office buildings, malls, drugstores, cruise ships, theme parks, and of course, retail photo shops. Swipe your credit card and put in your memory card, select the photos you want, specify what size and how many of each, and then hit print. Some kiosks even allow you to do some basic editing, though more and more shops are doing away with that because it means a customer will spend too much time at the station rather than relinquishing it to the next paying customer. Kiosks aren't limited just to memory cards. Some have scanners so you can copy prints you already have, while others even accept film. What you get depends on the services available: prints, CD, posters, and so on. So, be selective in deciding which kiosk you walk up to, choosing the ones that

Reality Check: Do You Really Want to Do Your Own Printing? *(Continued)*

will give you what you want. The prices and the quality are generally very competitive with traditional film printing.

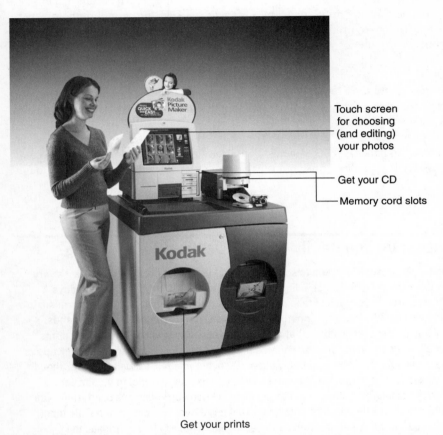

Touch screen for choosing (and editing) your photos

Get your CD

Memory cord slots

Get your prints

Kiosks come in all sizes, offering a wide range of services, but they're great for getting quick prints (and sometimes CDs) of your digital photos. Imagine being at a meeting, taking pictures of your associates in the morning and handing out prints after lunch. (Courtesy Eastman Kodak Company.)

Tip: For More Information . . .

If this chapter has piqued your interest about the process and prospects of printing your digital photos, then you might want to check out David Karlins' *PC Magazine Guide to Printing Great Digital Photos, (Wiley, 2004)* which contains a wealth of additional detail about many of the topics we have discussed.

Summary

Some of the key points covered in this chapter include:

- Printer technologies used for printing photos include silver halide, inkjet, laser, dye sublimation, and phase change. Each has its own pros and cons.

- When evaluating printers, consider their resolution, number of color inks used, speed, cost of consumables, and duty cycle.

- An increasing number of snapshot and inkjet printers can now print directly from your camera or your memory card without using a computer.

- To help your printer give you satisfactory service for as long as possible, you'll want to practice some basic good printer maintenance.

- Use color management on your monitor to help you get predictable color from your prints.

- If you don't want to do your own printing, you can use retail or Internet services.

- Printing at kiosks is convenient, cost-effective and usually offers high quality.

Chapter 21

Organizing, Managing, and Archiving Your Digital Photos

Digital photos proliferate at an incredible rate. Perhaps, it has something to do with the fact that 10 or 100 or 1,000 pictures cost no more to shoot than taking only one. It's amazing how quickly you can end up with thousands of files on your computer's hard drives, though where they may be is anyone's guess. And most of them have obscure names like `DSC_0083.jpg`, assigned automatically by the camera when you took them.

So, what do you do when you need to find that one particular picture you shot of your boss at the company picnic for a newsletter or the perfect snowy landscape for this year's holiday card? If your picture library is cataloged with an effective photo management program, it's no problem. You'll be able to zero in on a particular image in no time. Otherwise, plan on meandering about your computer's folders, opening and closing photo files, perhaps for hours, until the one picture you need shows up.

In this chapter, we discuss how photo management programs help you organize, manage, and back up your digital photos.

The One Program You Must Have

The programs that make it comparatively easy to achieve control over your hundreds or thousands of image files are the saving grace of digital photography. Image or visual database, media asset management, photo management—various names are used to describe similar applications. They're like library card catalogs (or computer-based databases) that help you find a particular book out of hundreds of thousands or millions, by title, subject, or author. If you buy no other software for your digital photography, you'll need one of these. Why? Because it can be the conduit for all your digital photo work, including:

- Organizing your vast number of digital photos. (And, yes, even the most casual photographers will end up with vast numbers.)

- Searching for particular photos and/or subjects

- Browsing through your image files and seeing exactly what they are

353

- Reading and editing metadata, captions, and other nonvisual information related to your photos

- Touching up your pictures

- Sharing your photos

- Printing your pictures individually or as collections and contact sheets

- Archiving (backing up) your library

Organizing Your Photos

The trick to organizing your photos intelligently is using a system that makes sense to you. We can tell you how we do it, and the methods others use, but in the end, what will work for you could be quite individual to your personality and the way you like to work.

Generally speaking, photos are organized using three different methods:

- Folders and subfolders

- Timeline and calendar

- Keywords and tags

These three methods are not mutually exclusive and can work together to provide even more control over your photo library.

Tip: Easily Select Groups of Photos

When working with these programs, you will encounter processes that you will want to do on a series of pictures, such as transferring files, renaming, rotating, correcting exposure, and so on. But first, you'll have to select all the photos in the series. Go into the thumbnail view (which all these programs have) and click on the thumbnail of the first photo in the series. Then, hold down the Shift key on your keyboard and click on the thumbnail of the last photo in the series. That selects the entire group. You can also select discontinuous files (photos that aren't right next to each other) by using Control+Click (Windows) or Command+Click (Mac) on each thumbnail you want to select.

FOLDERS AND SUBFOLDERS

If you know how to work with Windows Explorer, then this section will seem somewhat familiar, and organizing your photos under this structure will probably be second nature to you. If not, then, reading through this section will not only help you understand one important method for organizing your photos on both Macs and PCs, but also give you a better insight into your computer itself.

A disorganized computer filled with photo files is like a steam trunk in the attic where you have dumped all the unframed, unwalleted prints you have. Every time you make new prints, they get thrown in on top of the others. Want to find a particular photo or type of picture? Go digging.

But what if you took that trunk full of photos and organized them into file cabinets? Each cabinet would be for a particular area of your life, such as business, family, vacations, personal art, and so forth.

Then, each drawer would be a subsubject within each area. For example, in the vacations cabinet, you might have a drawer for New England, another for Canada, a third for Europe, and so on. And within each drawer would be folders for specific vacations, such as Thanksgiving in Boston 2005, Quebec May 2004, and so on.

Organizing your photos into folders and subfolders works pretty much in the same way. And it's the way we like to work (in combination with keywords, which we explain later in this chapter). All our folders have descriptive names, because we function best with words rather than obscure numbers (see Figure 21-1). When we transfer photos from a digital camera (or scanner or CD), we immediately put them into the folders where they belong (and where we will know to look for them). It takes almost no time at all. Here are the steps we use for the vast majority of our transfers:

1. Insert the memory card into a card reader attached to our computer, put a disc into the CD/DVD drive, or attach the camera directly to the computer.

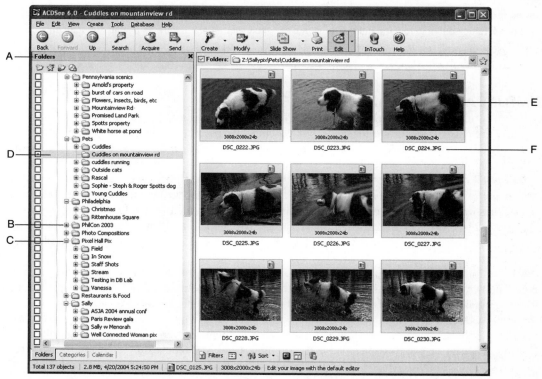

Figure 21-1: (A) On the left side of this ACDSee screen, you can see how we have organized some of our personal photos using folders and descriptive names. (B) The + sign to the left of various folder names indicate that other folders are nested under it. (C) Clicking on the + sign will turn it to a − sign and open up the folder to reveal the next layer of folders underneath. (D) The current folder (Cuddles on mountainview rd) is highlighted in the folder view, and (E) the thumbnails of its photos are displayed to the right in the thumbnail view. (To simplify this illustration, we have turned off the preview, calendar view, and other portions of the ACDSee interface.) (F) Notice that the names of the photos are quite obscure. We'll deal with naming photos later in this chapter. (Courtesy of ACD Systems.)

2. Open ACDSee (which our systems are set to automatically activate whenever a card or disc is inserted or an attached camera is detected).

3. View the thumbnails of the photos we have taken and decide in which folders they would fit (or create new folders for them).

4. Since we tend to take lots of photos in particular situations or specific subjects, we usually have groups of pictures that need to be transferred to the same folder. So, we select all the pictures that belong in the same folder.

5. Click and drag the group of photos into the folder where we want them to be.

If you decide to go this route, be sure you name and nest the folders in ways that fit the way your mind works. Remember, you can have numerous levels of subfolders, if you wish.

Tip: If You Are Already Using a Folders-Based Organization . . .

Not all of these programs have a folders view to display the hierarchy of folders and subfolders you have developed. Check out how folders and the thumbnails of their related photos are displayed and manipulated to make sure the program you are considering will fit into your workflow.

TIMELINE AND CALENDAR

Okay, we admit it; to some extent we're geeks. We have been using folders and subfolders for so long that they are entirely direct and logical to our way of thinking. But if you are comparatively new to photo organization and/or don't already have some method already in place, you may find timeline and calendar organization more intuitive.

Nearly all digital cameras automatically record the date that a photo is taken, saving it in the *metadata*. When you bring the photos into your computer, those management programs with calendars or timelines will automatically read the metadata and organize the pictures by the date each was taken (see Figure 21-2). You needn't do anything to make it happen and don't even have to think about it. So, in terms of ease of use, time-based organization has it hands down over any other kind of photo management.

We find time-based organization useful for our searches (see the discussion of searching later in the chapter), though we still use our folders and subfolders for our actual organization. Depending on the program you decide to use, you may (or may not) have both folder and calendar views. For example, ACDSee and Jasc Paint Shop Photo Album offer both, while Photoshop Album and Picasa focus only on time organization. However, photo management software will be evolving quite a bit over the next year or two, with new versions adding features and redesigning their interfaces. What each program offers may change by the time you read this book.

Tip: Don't Forget to Set Your Camera's Date and Time

When you first power up your digital camera, it will ask you to set the current time and date. Do it right away, and check to make sure that it stays in memory when you change the battery. Otherwise, your photo management software won't be able to be truly accurate in its handling of your pictures.

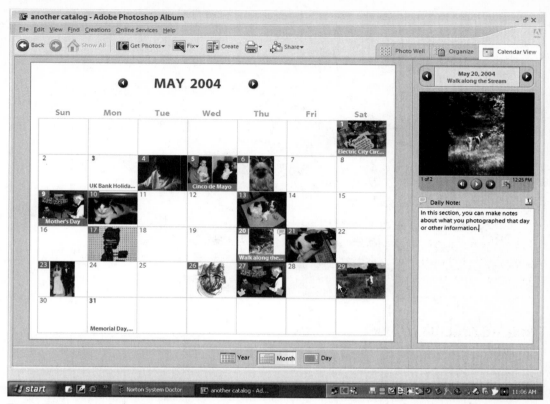

Figure 21-2: A popular method of organizing photos is by the date they were taken. In this Calendar view of Adobe Photoshop Album, you can see the days that we took photos (or on May 26th, created digital art). It is possible to assign an event name to a day, as well as to write notes about the day. Another view shows individual thumbnails sorted by date, with a useful timeline on top of the screen. (© 2004 Adobe Systems Incorporated. All rights reserved. Adobe and Photoshop are registered trademarks of Adobe Systems Incorporated in the United States and/or other countries.)

KEYWORDS AND TAGS

Whether you use a time-based or folder organization, a valuable tool for helping you sort through your photos are *keywords* or *tags*. Keywords and tags are essentially the same thing—words or phrases that identify properties or characteristics of a photo, which might be used in a search for that photo.

For example, typical keywords on our system include *flowers*, *mountain*, *daniel*, *sally*, *cuddles*, *philadelphia*, *budapest*, *beach*, *sunset*, *computer*, *digital camera*, *pet*, and so on. (We don't use capital letters in our keywords, as we explain later in this chapter.) Suppose that we knew we had a photo of Daniel sitting by a river with a mountain in the background, but weren't sure where we had taken it or when. We could do a search on *mountain*, *daniel*, and *river*, and the software would display thumbnails of all the pictures on our network that had those keywords.

The differences between tags and keywords are procedural and relate to the type of software you're using. Consumer-level software, seeking to make keywording less cumbersome and more automated, use predefined tags that you can add to and customize (see Figure 21-3). Usually, all it involves is

selecting a group of photos (see the tip "Easily Select Groups of Photos" earlier in this chapter) and then choosing the tags you wish to associate with them.

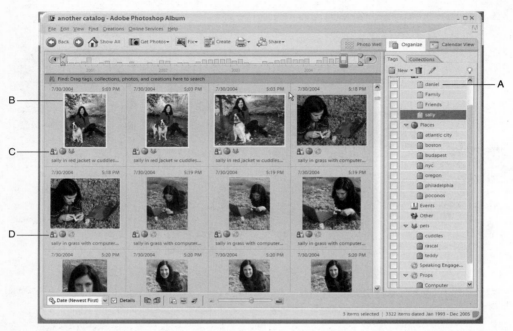

Figure 21-3: (A)In Adobe Photoshop Album we have customized the tags. All that's involved in adding a tag to a picture file is clicking and dragging it onto the thumbnail. (B) In the thumbnail view, we have several photos of Sally. In some, she is by our stream with our dog Cuddles. In others, she is working on a laptop and sometimes looking at a digital camera. We've tagged all of them *sally* and *poconos*. (C) However, only some are tagged *cuddles*. (D) Others have tags for computer and digital camera. (© 2004 Adobe Systems Incorporated. All rights reserved. Adobe and Photoshop are registered trademarks of Adobe Systems Incorporated in the United States and/or other countries.)

Professional and advanced amateur programs (such as Extensis Portfolio or ACDSee) provide feature-rich tools for defining and refining keywords. The most important of these is a Master List, a customized reference list from which you choose your keywords. Using a Master List ensures that you're consistent with spelling, punctuation, and other variables that could affect the reliability of your search (see Figure 21-4). For example, if some photos have a keyword *philadelphia* while others have it misspelled as *phildelphia*, when we search for photos of our hometown, the program will return only those pictures with the precise spelling we type.

Obviously, the better job you do at defining your keywords or tags, the more useful they'll be. Here are some suggestions:

- Use the mantra "who, what, when, where, and why" to help you come up with appropriate keywords or tags.

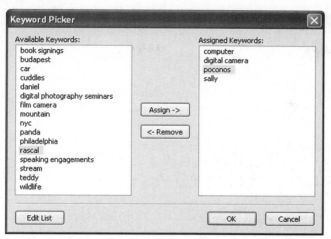

Figure 21-4: In ACDSee, we have created a Master List of keywords (left column) to which we can add. Double-clicking any of them (or clicking on a keyword and then on the Assign button) puts that keyword into the right column to assign it to the current photo or group of selected photos. Using a Master List in this manner assures consistent keywording. (Courtesy of ACD Systems.)

- If the photos are part of a professional or business project, create keywords or tags with the project name, client, and other identifiers.

- Attach a keyword or tag to a photo only if you would want to have that photo pulled up when you use that keyword. For example, if the picture has a mountain in the background, is that an important enough part of the composition and/or location identification to warrant attaching *mountain* to the file?

- Be consistent with your keywords. Use a Master List if at all possible (see Figure 21-4).

- Some programs are case sensitive. If you type the keyword or tag in lowercase letters, the software won't recognize the same word capitalized. To avoid the potential problem of typing in the wrong case, we never use capitals, even on proper names.

- Take advantage of the batch processing capabilities of these programs. At the very least, you should be able to select groups of photos that were taken at the same time of the same subject and assign the same keywords to all of them at once.

Tip: Try Before You Buy

Photo management is such an important aspect of your digital photography that you really should check out various programs before you choose the one you'll depend on. As we explain in Chapter 18, most software manufacturers' Web sites have trial versions you can download, tutorials, and/or at the very least tours of their programs. Try them and see what fits you best.

Search

The whole purpose of organizing your photo library is to be able to quickly and easily find specific pictures when you want and need them. Three methods are commonly used to search for photos:

- **By date**—Searching by date is incredibly easy in those programs that have a timeline and/or calendar view—that is, it's easy if you have a clear idea of when a photo was shot (see Figure 21-5).

- **Simple keyword or tag search**—Depending on the software, you type in a keyword(s) or tag(s) or select it from a list, using as many as you wish to refine your search. In some programs (such as Picasa and Photoshop Album), the thumbnail view will update as you type (or select), providing very fast search results.

- **Boolean search**—Available only in more advanced programs, a Boolean search is defined not only by what is being sought, but also by what you don't want. Important words in Boolean searches are *and*, *or* and *not*. For example, a search of *daniel* or *sally*, and *cuddles*,

Figure 21-5: In Jasc Paint Shop™ Photo Album™, the calendar and timeline view are displayed in the same screen. Click on a date in the calendar, or a month in the timeline above it, and thumbnails of the photos that were taken (or the images that were created) on that day or in that month are automatically displayed. (Courtesy of Jasc Software.)

not *poconos* would return all photos in which Daniel or Sally posed with our dog Cuddles that weren't taken in the Pocono Mountains. (See Figure 21-6.)

Figure 21-6: A Boolean-type search in Extensis Portfolio can search not only keywords, but all kinds of information, including the dates created and updated, file type, resolution, and so on. (Courtesy of Extensis.)

Browse

One of the more enjoyable aspects of these programs is the ability to visually browse through your photo library. It's like flipping through a family album, but with the option of stopping and editing the pictures or rearranging their locations and order. The thumbnails are often sizable, so you can make them small to fit more on a page or bigger to see more details. Double-clicking on any thumbnail will open the full-sized photo in either a viewing or editing window. In most programs, clicking and dragging the thumbnail into an open photo-editing program (such as Photoshop) will open the picture in the photo editor. But clicking and dragging it into other programs, such as Microsoft Word, will place it in a document in that program.

Tip: Not All Photo Management Software Can View RAW Files

If you shoot RAW file format (see Chapter 5), you'll want to be sure that your photo management program supports your particular camera's RAW. Extensis Portfolio appears to support the most RAW formats, while many programs don't support any. Also, be aware that some (like ACDSee) will acknowledge that a RAW file it can't read is in a folder or catalog by displaying an icon instead of a thumbnail. Other programs will ignore RAW completely and even say that a folder or catalog is empty when it is filled with RAW files.

Metadata, Captions, Properties, and Other Nonvisual Data

Computers excel at tracking information, and digital photography is no slouch in taking advantage of the medium. Some of the many kinds of data you can track, edit, and add to in photo-managing programs include:

- Metadata
- Filenames
- Captions, comments, and notes
- Ratings

METADATA

It all starts with the moment of capture, when your camera embeds information into the picture's *metadata* about the camera used, exposure, color balance, flash, and other settings, plus the time and date. In some of the more advanced photo managers, you can add to the metadata (or properties) with copyright and other information. (For more information on metadata, see Chapter 5).

RENAMING YOUR IMAGE FILES

Even in the most basic photo managers, you can at least rename the file, replacing the obscure numbers (such as DSC_0072.jpg) with something that makes sense to you. We favor highly descriptive names. If it's a professional job, then the filename should include the client's name and project ID. If it's a personal photo, then we tend to become very verbal, such as Sally_&_Cuddles_at_stream_0035.tif.

Don't go overboard with descriptors, however. Windows and OS X have limitations on the number of characters you can have in a filename, so try to be as brief as possible without creating cryptic abbreviations and shortcuts whose meaning you may forget.

Every program we've tested will do batch renaming. First, select a series of related photos (see the tip on easily selecting groups of photos at the beginning of this chapter) and choose a root name that would apply to all of them. For example, it might be Daniel 2004 LA seminar. Then, the program automatically appends consecutive numbers at the end of the filenames.

CAPTIONS, COMMENTS, AND NOTES

Similarly, your program may allow you to add captions, comments, and notes to your image files. How you use this capability is highly personal. But you should be aware that in those programs that can create Web pages or slideshows, the captions may be used within the layout.

RATINGS

Let's face it. Only some photos are great. Others are good. Some you hold onto just because of the memories they invoke, even though they really aren't well exposed or nicely composed. When you do a search for specific photos, usually it's because you want to use the pictures, and that means you really want to see only those that are at least good quality. That's where the rating systems come in. In many photo managers, you can rate your pictures, usually using a five-star scale. How you define what makes a five-star (top-quality) photo as opposed to a three or one is up to you.

Touch Up

No photo managing program can compete with a full-blown photo-editing program (see Chapter 18). However, all but the professional programs have some editing capabilities. They usually are restricted to common tasks, such as correcting red eye, cropping, rotating, resizing, and so on. If it has exposure or color correction tools, they will tend to be very simple, if not a one-button autofix.

A major advantage of the touch up tools in these programs is that you can apply a single edit on an entire series of photos. Consider a shoot in which all the photos are slightly underexposed; it's certainly easier to correct all of them at once than dealing with each picture, one at a time.

When you do any photo editing, don't forget to maintain an untouched original. (See the discussion of archiving later in the chapter.) In other words, don't save your edited version to the same name as the original, which would overwrite the original.

Share

As we discussed in Chapter 19, digital photos are made for sharing. These photo-managing programs, with their focus on organizing entire libraries of pictures, provide a natural conduit for sharing collections of photos as slideshows, Web sites, and albums. Sharing isn't limited only to consumer fun and family memories. After all, the purpose of professional programs is to maintain and leverage an accurate inventory of valuable photos, and sharing with clients, associates, and potential customers is certainly an important aspect of the business of photography and the photography of businesses. For example, Extensis Portfolio NetPublish or NetPublish Server (which are additional programs to Portfolio) can actually drive an interactive Internet catalog.

Here are some things to remember when you want to use these programs for sharing:

- Emailing photos from these programs is usually so easy that it can become a mindless process. Be aware of what your program is doing to prepare your photos for emailing. Most consumer programs will automatically resize photos so they're appropriate for email, but others will allow you to send full-sized pictures, which we don't recommend as a rule (see Chapter 15). Just because you *can* send entire collections of pictures via email doesn't mean that you *should*. Remember: large or multiple attachments can bog down your computer and your recipient's. Worse yet, many network servers won't even let them through.

- Some photo management programs will display a slideshow of your photos that can't be shared. If slideshow sharing is important to you, check the software before you buy to make sure that it will allow you to create and save slideshows that are viewable on systems that don't have the program installed.

- Don't buy a program just because it offers a link to purchase a specific type of photo novelty (such as mugs or printed books). Most such items are available to anyone over the Web. On the other hand, the links do make it much easier to order, and the programs may help with assembling the appropriate layout of your photos for those specific items.

- If you are creating catalog Web sites, the most popular ones are those that link thumbnail views to larger pictures. For those photographers who are concerned about having their photos pirated, most of these programs will resize even the larger views so they won't contain enough data to produce high-quality prints. But if unauthorized copying is an

important issue for you, check to make certain that is really what is happening. (Large printable photos aren't really appropriate for the Web, because they have too much data for quick and easy page access.)

Print

Yes, of course, these programs can output individual prints of each photo in your library. But where they excel is in creating easy reference prints, such as contact sheets. (See Figure 21-7.) Pros use contact sheets to provide a quick overview of everything in a collection. (Contact sheets originated as a way to determine what photos were on a roll of film.) Nowadays, because most photos are digital rather than film-based, pros often use contact sheets as visual file references to quickly see what is on their various hard drives, CDs, or DVDs. Some of these programs also do multiple layouts of different sizes and CD/DVD labels.

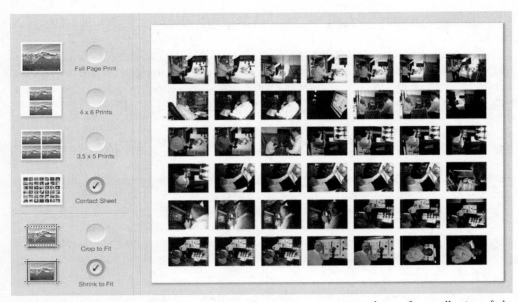

Figure 21-7: In this Picasa print dialog, we have chosen to output contact sheets of our collection of photos of Daniel testing cameras in our DigitalBenchmarks Lab. Notice that we could have elected to print all the photos in the collection at other sizes, as well as have the program either crop or shrink the photos to fit the template. In some programs, you can add captions, page headers and footers, and other information. (Picasa is a trademark of Picasa, Inc.)

Archive

Few things are more ephemeral, and yet more precious, than digital photographs. Whether they're pictures from the family's Bermuda vacation or product shots for a sales presentation, everything can disappear in the blink of an eye through human or computer error.

To protect their valuable originals (a.k.a. digital negatives), pros often back up a shoot as soon as they upload it to their computer, before they start editing. And after the job is delivered, they will create a backup (on CDs or DVDs) of the entire project. Actually, many pros burn two sets of backups as insurance, which they then store in two separate places.

Everyone who treasures their digital photos should develop their own backup strategies. Happily, most photo management programs make it relatively simple to burn and track your archives.

Here are some guidelines on archiving:

- Be sure to use a program that not only allows you to burn entire catalogs or collections to CDs or DVDs, but also keeps the thumbnails and information about the backed up photos on your computer. That way, when you search for a particular picture, even if it is on a CD or DVD, the software will find it for you and tell you the specific disc on which it can be found.

- In addition to backing up catalogs that are recognized by your software, be sure the photos on your archive discs will be readable if you no longer have that particular program.

- Use only high-quality brand-name discs that incorporate gold foil rather than cheap generics that use aluminum, don't write on them with a pen whose ink will eventually seep into the plastic, and store them in a lightproof, low-humidity environment.

- As technology changes, be sure to copy your discs to the new media. This will be especially important in years to come when your computer may no longer have the drives for reading today's CDs and DVDs.

- Print out contact sheets (see Figure 21-7) for each of your backup discs, so you can tell at a glance (without turning on a computer) exactly what photos each holds.

- Use a consistent, informative naming convention for your backup discs that reflects their contents. We prefer descriptive rather than numerical, cryptic names.

- Take the time to print out CD/DVD labels that say what each disc contains. Use acid-free labels with a nondestructive adhesive.

- Never trust a computer or any other digital technology. In other words, make backups of your backups the way pros do.

Summary

Some of the key points made in this chapter include the following:

- Variously called image or visual database, media asset management, photo management, and other names, these programs will help you get control over the vast number of photos that you'll inevitably save to your computer.

- Three methods commonly used to search for photos are by date, by simple keyword or tag search, or by Boolean search.

- Not all photo management software can view RAW files.

- Some of the many kinds of data you can track, edit, and add to in photo-managing programs include metadata, filenames, captions, comments and notes, and ratings.

- These programs, with their focus on organizing entire libraries of pictures, are useful for sharing collections of photos as slideshows, Web sites, and albums.

- If you treasure your digital photos you should develop a backup strategy.

Glossary

Action mode A *program* mode that many digital cameras have that will automatically choose the optimum settings for capturing action shots, such as a soccer player kicking a ball. Also called sports mode.

ADC Analog-to-digital converter. A chip inside your digital camera that takes the image capture from the *image sensor* and converts it into the digital data that your computer can read.

AE A common abbreviation that stands for auto-exposure. When you are looking for your camera's *metering options*, they may be controlled by an AE button or an AE icon on the control panel.

AE-L Auto-exposure lock, sometimes also designated as AEL. A button on some digital cameras that allows the user to lock focus without having to hold the shutter button down halfway. It's often the same as the *autofocus* lock or *AFL* button.

AF See *Autofocus*.

AF Assist A source of light (fluorescent, incandescent, infrared, laser) or sound (sonar) emitted by some digital cameras that helps the *autofocus* function when the *ambient light* is too dark for it to work on its own.

AF-L Autofocus lock, sometimes also designated as AFL. A button on some digital cameras that allows the user to lock focus without having to hold the shutter button down halfway. It's often the same as the *auto-exposure* lock or *AE-L* button.

Algorithm Any bit of code or programming that defines a process. But when it comes to digital cameras, algorithm refers the internal programming that processes the image data. This is where each camera manufacturer applies its own particular brand of imaging science (related to color, sharpness, contrast, noise, scene recognition, and so on), and it is one of the factors that differentiates one brand from another.

Ambient light The light that exists within a scene that the photographer encounters rather than creates. For example, it is the daylight streaming through the windows and the normal overhead lights in a room. A photographer may add her own lighting to augment the ambient light. **367**

Anti-aliasing A process that smoothes the staircase-like "jaggies" that form on curves when displayed on a computer monitor or print. Most often, it refers to a kind of font or type in which the curves in letters like *S* or *Q* are made to appear smooth rather than ragged.

Aperture The hole or diaphragm in a lens—usually adjustable—through which light passes into a camera. See also *f-stop* and *depth of field*.

Aperture priority An exposure mode that is often marked on the camera's mode dial with an *A.* or *Av.* When your camera is set at aperture priority, you choose the *f-stop* (*aperture*) you want, and the camera automatically sets the *shutter speed* that matches it, according to its analysis of the proper exposure for the scene. This is the opposite of *shutter priority*.

Artifacts Image data that doesn't really belong in the picture. This can be stray *pixels* that make the photo look dirty or noisy, a flare of light, or any other bit of extraneous visual data that doesn't have anything to do with representing what the photo captured. They are unwanted and often caused by image sensor *blooming*, inaccurate or overdone image processing, electronic noise, and so on.

Aspect ratio The relationship of the height of a picture to its width. For example, if your picture is 4″×6″, it has the same aspect ratio as an 8″×12″ picture. (The aspect ratio of both is 2:3.) When you resize a picture, you want to be sure to preserve the aspect ratio, unless you want to introduce a fun-house type of distortion, making the subject look shorter and fatter, or taller and thinner, than in the original picture.

Auto-bracketing A camera process that automatically takes a series of photos with each photo in the series incrementally adjusted in terms of exposure, white balance, or other settings. For example, in an exposure auto-bracket, the first shot in the series could be exactly what the camera's auto-exposure calculates as correct for the scene. Then, the second would be one increment darker, while the third would be one increment lighter, and so on. The amount of the increment may be user-definable, as well as the number of photos in the series.

Autofocus The electro-mechanical mechanism that automatically focuses a lens. A sensor reads the scene you are photographing and automatically chooses an optimum focus for it. This is activated by pointing your lens at the main subject and pressing the shutter button halfway.

Available light The light in a scene that already exists. When you shoot with available light, it means that you aren't adding a flash, strobes, or any other auxiliary lights.

AVI Audio Video Interleave. The most common file format that digital cameras and DV camcorders use to record animated movies with sound.

Bayer pattern The checkerboard-type pattern of red/green/blue/green filters used on most image sensors to enable them to capture colors.

Bit depth A measure of the number of colors that can be represented in a digital picture. 24-bit color (which can display 16.7 million different colors) is considered photo-realistic, because it is closest

among the various possible bit depths to the number of colors the human eye can discern. (A photo-realistic grayscale picture has 8 bits.)

Blooming An unwanted artifact in a digital photo that is caused by light spilling over into the wrong area in an image sensor. The result looks like a flare of light in your picture.

Bracketing The same as *auto-bracketing*, except that the photographer manually changes the settings incrementally, as she fires off each shot.

Broadband High-speed data communications over the Internet. Broadband is very useful in sending, posting, or emailing digital images because it moves the data in just seconds. Ordinary slower transmissions may take minutes to transmit the same picture.

Burst, or burst mode The ability of a camera to take several photos one right after the other when you hold your finger on the shutter button. It's great for action shots such as following an athlete running down a field with a ball. However, flash does not usually function in the burst mode.

Byte The smallest indivisible data component. (However, just as an atom is made up of electrons and protons, each byte consists of 8 bits of data.) Bytes are the building blocks of computer information. Every digital photograph is made up of thousands or millions of separate bytes. See also *Pixel*.

Cascade menu See *Pull-down menu*.

CCD Charge-coupled device. The most widely used *image sensor* in digital cameras, a CCD is a photo-sensitive semiconductor chip that captures visual data. A CCD is analogous to film in a conventional camera, though it cannot process or store visual data on its own. That's what various other electronic components in a digital camera are designed to do. See also *CMOS*.

Center weighted metering A mode of measuring the amount of light entering the lens of a camera and adjusting the exposure settings accordingly. Fifty percent of its value is apportioned to the subject in the center of the viewfinder, and the remaining 50 percent apportioned to the 4 corners (12.5 percent per corner). Center-weighted metering allows users to split the exposure between the main subject in the middle of the viewfinder, balanced against the light in the rest of the picture frame. See also *Meter, Metering options, Spot metering,* and *Matrix metering*.

Click-to-click The interval between when you take a shot with your digital camera and when it's ready to shoot again. It's also referred to as recycle time.

CMOS Complementary metal-oxide semiconductor. A versatile semiconductor chip that can be fabricated to collect visual data. Similar to a *CCD*, CMOSs are used in digital cameras as image sensors. But, unlike CCDs, they often perform processing functions (in addition to image capture), thereby simplifying and reducing the amount of support circuitry needed in a digital camera. Low-end CMOS chips under 3 megapixels are generally considered optically inferior to comparable CCDs. However, high-end 6 to 14–megapixel CMOS chips are often equal to high-end CCDs and are found in several expensive pro digital cameras.

CMYK Cyan, magenta, yellow, and black. A *color model* commonly used by printers to define and mix all the colors they are capable of outputting. Many desktop color printers have inks of these colors.

Color calibration The act of adjusting the color output of a specific device to an industry standard or to another device, such as calibrating a monitor to display accurate colors or matching the colors captured by a specific digital camera with the prints produced by a specific printer. See also *Color management.*

Color channel The visual component of a color digital image that represents all the pixels in that picture made up of a specific primary color. For example, in a typical digital photo, the primary colors of red, green, and blue (from the *RGB color model*) create all the colors in that photo, which may be represented by three color channels, each of red, green, or blue. (See Color Figure 5.)

Color management The process of calibrating your computer monitor to your input (such as a scanner or digital camera) and output devices (printer) so that the colors captured, displayed and printed are the same. Without color management, each device will influence colors in different ways, often skewing the final display or print so it is inaccurate and/or disappointing. See also *Color calibration.*

Color model Scientific formulae used to describe how colors are created. No color model is perfect, and each relates to specific ways that colors are defined, displayed, captured, or output. The two color models most relevant to digital photography are *RGB* (red, green, blue) and *CMYK* (cyan, magenta, yellow, and black). RGB is how color is typically created in the camera (and scanner) and displayed on your computer monitor. Many desktop printers use CMYK, or a derivative of it, for mixing the inks that they use to output your color pictures.

Color shift A change in the overall color values of a photo. In digital photography, it is usually caused by using the wrong setting for the ambient light or not using *white balance* when it is needed. For example, when taking a picture in a typical office environment, which uses fluorescent light bulbs, the photo can end up having a greenish yellow or blue cast if the white balance is incorrectly set to daylight or tungsten. (See Color Figures 7, 8, and 9.)

Color temperature The degrees on the *Kelvin* scale of the light in a scene (whether added by the photographer or *available* light). Professional photographers use color *meters* to measure the color temperature so they can adjust their camera's white balance internally or by using color gels on their lights.

Compression Using mathematical algorithms, compression is the process of squeezing and consolidating data to shrink an image file to a more manageable size. See also *JPEG.*

Consumables Those items that are used up during normal operations, and for which the consumer must pay to replenish. In printing, it's the inks, media, and paper used when you output your photos and documents. Consumables provide significant profits for manufacturers.

Continuous tone When the colors of a photo print blend smoothly into each other, with no banding, or breaks in transitions or gradations, it is said to be continuous tone, which is the gold standard of photo-realism.

Control panel A gray rectangular LCD panel on many advanced cameras, which is usually on the top near the shutter button or sometimes on the back above the LCD viewfinder. The control panel displays current settings, such as those for the flash and metering mode, file format, how much battery power remains, an estimate of the number of pictures (using current settings) you have space left for on your memory card, and so on. See Figure 3-6 in Chapter 3.

Conversion factor Since most image sensors used in *D-SLRs* are smaller than 35mm film (1″×1.5″ or 24mm×36mm), the lenses designed for 35mm cameras will cover less of an area, and thereby magnify the image. This is called the magnification or conversion factor. For example, if the *image sensor* is 15.5mm×23.7mm, or approximately 50 percent as large as a frame of 35mm film, a 200mm telephoto lens will have an effective focal length of 300mm.

Crop The act of using a software tool (usually called a crop tool) to trim away excess parts of your photo or image. A crop is always rectangular, and it removes the outer edges, as far into the center as you wish. You set the area of the crop by drawing a rectangle in your photo using the crop tool. Then, depending on the program, you either click once inside your drawn rectangle or click on a button to instruct the software to do the actual cropping.

Default mode The settings that are used by your camera when you first turn it on. Also called factory settings, it's generally the "point-and-shoot" mode that doesn't require any decisions by the user, nor does it offer much photographer control. When the batteries are removed, the camera usually returns to its original factory settings, which is useful when you've applied so many changes that you aren't sure how to get back to the starting point.

Depth of field The area of a picture, from foreground to background, which is sharply in focus. Depth of field is controlled by the *f-stop* or *aperture*. The smaller the aperture, the higher number *f*-stop (such as *f*11 or *f*16), the greater the depth of field. The larger the aperture, the lower number *f*-stop (such as *f*2), the more limited the depth of field. Lower *f*-stops are great for portraits and other photos in which you want to focus only on the subject and blur the foreground and background. Higher *f*-stops are more appropriate for group pictures, party scenes and photos in which you want to show the subject within the context of a scene, with everything in focus.

Diaphragm See *Aperture*.

Digital zoom The ability of a digital camera to magnify a scene when shooting it so that a smaller portion of the picture fills the entire frame. Unlike an optical zoom, which is a physical attribute of the lens, digital zoom is a bit of programming sleight of hand that typically diminishes image quality. We recommend that you turn off digital zoom if your camera has it, and never use it.

Download The process of transmitting or transferring data from one device to another. In digital photography, it usually refers to getting photos from the camera to a computer, printer, kiosk, or

other device. It doesn't matter what connection is used or how it is done, it is still called download, except when it's called upload. To all practical intents and purposes, download and upload are now synonymous, though they originally referred to sending data in two different directions.

dpi Dots per inch. This is the measure of how many points of ink a printer can place on a page. It is often confused with *ppi*, or pixels per inch, which is the measure of data points that can be displayed on a computer screen. The term ppi should be used in relationship to scanned pictures or photos that are viewed on the computer. The term dpi relates only to printers. However, in everyday parlance, dpi and ppi are often used interchangeably. Though it's inaccurate nomenclature, for the sake of making sure your photos are the right size for whatever purpose you have planned for them (though purists will cringe to hear us say this), it doesn't really matter whether you use one acronymic measure or the other.

DPOF Digital Print Order Format. In most consumer digital cameras, you can mark which photos you want to print, how many of each, and, in some cases, other variables related to their printing, such as size. Then, when the camera is attached directly to a printer or the memory card inserted into a printer, your camera or memory card is connected to your computer (which is attached to a printer), or the files are sent to a professional print service, those preselected photos are automatically printed in the manner and order you specified.

DSP Digital signal processor. A chip (or chips) inside your digital camera that contain(s) instructions on how to process the data captured by the image sensor as it is converted into an image file that can be read by your computer and printers.

D-SLR Digital Single Lens Reflex. A semi-pro or professional digital camera that incorporates eye-level, through the lens viewing via an optical pentaprism and movable mirror and interchangeable lenses.

Duty cycle A rating that defines how solidly built a device is by determining how much or how long it will work without unduly stressing or breaking down within a specific time period. For example, it's the number of copies a printer can output each and every month without putting too much of a strain on the device.

Dynamic range An analysis or measure of how much shadows, highlights, and midtones a digital photo captures. Represented graphically in some photo-editing software and on higher-end cameras by a *histogram*, the dynamic range is directly related to the exposure, contrast, and brightness of the picture. A photo that is said to have a wide dynamic range has captured details throughout the grayscale, from deep shadows, through the midtones to bright highlights. A narrow dynamic range "clips" (doesn't have) deep shadows and/or bright highlights, which means it will tend to be a low contrast picture. An underexposed picture (one that is too dark) will have a skewed dynamic range that clips the highlights, while an overexposed picture (one that is too bright) will be missing the details that it should have in shadows.

Electronic flash Also called a strobe or strobelight, it's a sealed tube, filled with xenon gas, through which a brief high-intensity electrical charge is pulsed that flashes very briefly but very brightly.

Because the gas is inert, it doesn't burn up with the discharge, so it can light up many thousands of times without needing replacement. Most digital cameras come equipped with a built-in electronic flash. Some may support an auxiliary (optional) flash.

Emulsion The word to describe the type of film a camera is using. It's the photosensitive silver halide coating that captures images when processed through a series of chemical baths. Emulsions are typically described as high speed, fine grain, color, black and white, and so on. Almost all emulsions can be emulated within a digital camera or with sophisticated image editing software.

EV The acronymic symbol for *exposure compensation,* it stands for exposure value.

Eye-level viewfinder The small piece of glass that you look through to frame your photo. It's like the traditional eyepiece that you're used to having in film cameras. In some cameras, it's an *optical viewfinder*, while others have a tiny electronic screen inside. If it's an electronic screen, the higher the pixel rating and refresh rate, the better its quality.

Exposure compensation A control on most cameras that will adjust the exposure of a photo about to be taken. Usually represented as a scale that goes from -2 to $+2$ in increments of 1/3 or 1/2 *f-stops*, it will increase or reduce the amount of light reaching the image sensor. Using exposure compensation is a great way to *bracket* exposures, when you want to be sure you get the photo. *EV* (for exposure value) is the acronym for exposure compensation.

f-**stop** The measure of how small or large the aperture is (the adjustable hole through which light passes through the lens). A large hole is designated by a small number such as $f2$, while a small hole may be $f11$ or higher. The *f*-stop is one of the important factors for controlling *depth of field*. Because varying the size of the aperture changes the amount of light that reaches the *image sensor*, the *f*-stop is always balanced against the shutter speed to control image exposure.

File extension On computers that use Windows as their operating system, all filenames have what are called file extensions. That is the three-letter designation that comes after the dot, which indicates what *file format* was used for saving the data. For example, with a file that is called "rascal.jpg" just by looking at the file extension of ".jpg" we know that it is an image file that was saved using the *JPEG* file format. In Windows XP, it is possible to hide all file extensions (so it looks like a Mac)—an option that we invariably disable, because we like being able to recognize the data type at a glance.

File format All information used by computers are simply series of zeroes and ones, bits and bytes of data. The data must be organized in such a manner that the computer, camera, printer, software, and other technologies know what to do with it. The structure of the organization is the file's format. Digital cameras use three file formats: *JPEG, TIFF,* and *RAW.* You've encountered other file formats in your typical computer work, such as DOC for Microsoft Word, HTML for the Web, PDF for Adobe Acrobat, and so on. The format of a file allows the data to be reconstructed in the same way every time it is opened. In other words, when you open your just shot photo onto your computer screen, it will look like it did on your camera's LCD viewfinder. If the file doesn't have the correct format for a program or device, the data won't be recognized.

Fill flash A mode setting in which the camera analyzes a scene and fires its flash so the intensity and length of light is just enough to fill in the shadows balanced against the *ambient light*. It is very useful for times when a face is in shadow, or other situations in which there's good ambient light, but the main subject needs just a bit more illumination to bring out details.

Firmware Programming that is part of the hardware of a digital device. For example, how a digital camera processes a photo is determined by the code that is written onto specific chips within the camera. On many cameras, the firmware can be upgraded by downloading the file from the manufacturer's Web site and installing it into the camera via its USB port or memory card. The term firmware is often used to distinguish the camera's internal programming from that in software, which the user can install into a computer and choose whether or not to use.

Gamut The range of colors that can be perceived, described, and/or reproduced by a technology or *color model*. A device or color model is said to have a limited gamut when it doesn't have as large a range of possible colors as other larger gamut technologies.

Gigabyte (GB) 1024 *megabytes* of data.

Grain Film photos are created when tiny photosensitive silver halide crystals are exposed to light and then treated chemically. Sometimes, the individual points of color created by these crystals are distinguishable, and the photo is said to have a grainy appearance. In fine-grained photos, on the other hand, they are imperceptible. Some *photo-editing programs* have a filter that adds grain to digital photos, to emulate the appearance of film. See also *Noise*.

Histogram A graph that portrays a statistical analysis of a photo's *dynamic range*. (See Figure 6-11 in Chapter 6.) It shows the number of *pixels* that capture highlights, shadows, and all the midtones in between. Therefore, an overexposed photo would have a histogram that had lots of spikes in the highlight end of the graph and none or few in the shadows. Advanced *photo-editing software* and many better digital cameras have histogram tools to help you determine and manipulate the dynamic range of a photo. In cameras, if you see that the histogram of a just shot (or about to be captured) photo is unbalanced (over or underexposed), you can adjust your exposure controls (*f-stop*, *shutter speed*, and/or *exposure compensation*) to get a better photo.

Hollywood Squares A tic-tac-toe type of arrangement of small versions of photos. In digital cameras, it is a playback mode (often called thumbnails view) that allows you to see 4, 9, or 16 of your captured photos on the same screen. In software, it is often an editing view (called "Variations" in Photoshop) that displays nine different versions of the same photo, using various editing settings.

Image sensor The photosensitive component of any digital camera (or scanner), which reacts to light, generating a signal that can be processed into a photo by the electronics within the camera or scanner (or in the case of *RAW file format* by special software in the computer). In digital cameras, the image sensor is usually a *CCD* or *CMOS*, though others, such as Foveon's *X3* and Fujifilm's *SuperCCD,* are variations on the basic image sensor.

Imaging or image-editing software See *Photo-editing or imaging software*.

Interpolation The process of creating data from analyzing existing data and filling in the blanks. In digital photography, interpolation boosts the number of pixels in an image file so it can be viewed or printed in a larger size than originally captured. Sometimes, interpolation works well, but in other instances, it increases data without a corresponding boost in sharpness or definition and can actually degrade perceivable image quality. It's always better to shoot at the correct resolution than having to later interpolate the image. See also *Sampling*.

ISO equivalency A measure of a digital camera's sensitivity to light. It is based on the ISO ratings used for film, in which an ISO of 100 or 200 is used in most situations. Higher ISOs increase sensitivity so the camera can capture photos in darker situations. However, increasing ISO equivalency also increases the likelihood that the picture will have greater *noise*.

Jog switch A set of up/down, left/right arrow buttons found somewhere on the back of most digital cameras. Use these buttons to navigate through the *menus* on the *LCD viewfinder.*

JPEG Joint Photographic Experts Group. The most commonly used *file format* in digital photography. It compresses the image data, so the file can be processed and saved faster. Also, JPEG creates a smaller size file and is therefore better suited for sending via email and posting on the Web. While JPEG compression will actually throw away image data, a small amount of such compression tends to be visually imperceptible except to the most expert eye. In Windows, the *file extension* for JPEG is .jpg.

JPEG 2000 A new compression file format that has not yet been accepted by the industry, but is being touted as the next standard for compressed image files. It reportedly supports higher bit depth (more colors) than traditional JPEG and is *scalable*.

K See *Kilobyte* or *Kelvin*.

Kelvin, or degrees Kelvin The unit of measure for *color temperature*, written as K. Generally speaking, 5000°K to 5500°K is a neutral daylight. The higher the number, the bluer the light, while lower numbers tend toward red. Photographers measure color temperature with a color *meter* and use the information to adjust *white balance*.

Keywords Words or phrases associated with a photo file that will help you find that particular picture among the hundreds and thousands in your collection using a *photo management program*. Keywords typically answer the questions, "Who? What? Where? and When?" Some programs use the word "tag" instead and provide predefined tags to which you can add your own.

Kilobytes A unit of measure of data in a file, which is used often for digital pictures. The abbreviation for kilobytes is *K*. 1,024K equals one *megabyte*. (When estimating values, many people round that figure to 1,000.) When you are emailing photos to someone who doesn't have a fast Internet connection, your pictures should be no more than a few hundred kilobytes.

Landscape mode A description of pictures that are wider than they are tall, which is why it can be appropriate for photographing landscapes. The opposite is *portrait mode*.

LCD See *LCD viewfinder.*

LCD viewfinder The small color monitor, viewer or screen on the back of the vast majority of digital cameras. The LCD viewfinder can be used to preview and review your photos, as well as to navigate through the *menus* and choose settings for taking or playing back your pictures. Turning and keeping the LCD viewfinder on tends to use up battery power, which is why we recommend using the *eye-level viewfinder* to frame your photos when you can.

LED Light-emitting diode. When electricity is sent through LEDs they generate colored light, which is why they can be in *LCD viewfinders*. See also *OLED*.

Lossless and lossy compression Two categories of *compression*, which are used to shrink the size of image files. Lossy compression (such as *JPEG*) will actually throw away image data in the process of making the picture fit into a smaller file. A small amount of compression tends to be imperceptible to most people and is generally considered acceptable. Lossless compression, as its name implies, uses other, less destructive methods for shrinking image files.

LPI Lines per inch. A measure of the *resolution* of printing presses (the technology used for producing newspapers, magazines and other large-scale print jobs). The higher the LPI, the closer your photos will be to *photo-realistic*. If you are sending your images to a service bureau or print shop, you'll need to know what LPI will be used. Then, multiply it by 1.5 or 2 to determine the *ppi* you'll need your photos to be.

Macro Macro has two unrelated definitions in digital photography. (1) A focus mode on a film or digital camera that allows you to photograph something up close, usually from about 20" down to as close as 1/2". If you use the macro mode, small, even tiny objects can be made to fill the entire frame and details can be shown and examined. Activating macro mode is usually done by pressing the button with the white flower on it. (2) A shortcut that invokes several consecutive, sequential processes when you click on your mouse button or press a key on your keyboard. You can create macros in software for a series of processes that you do often. For example, suppose the photo you use for the first page of a monthly newsletter must always be a certain size, *resolution*, and have a particular filename. That's a great candidate for a macro, to save you time, energy and having to remember the needed parameters.

Matrix metering A metering option that reads several areas throughout the scene and averages their values. Many (but not all) digital cameras use matrix metering as their default setting. When the lighting in a scene is somewhat even, and when no specific area needs a greater attention than others, this is generally the best all-around mode. See also *Meter, Metering options, Spot metering,* and *Center-weighted metering*.

Megabyte (MB) A unit of measure of data in a file. Most digital photo files are measured in megabytes. 1,024MB equals a gigabyte (GB), which is the unit of measure usually used for hard drive space. And 1MB consists of 1,024 *kilobytes* (K).

Megapixel A unit of measure used to indicate the amount of data an *image sensor* is capable of capturing. Often confused as a measure of quality, it is nothing more than a number related to the volume of data. The more megapixels, the larger your photo will be, which, among other things, means it can be printed larger.

Menu The series of options in your digital camera that are displayed and chosen using the *LCD viewfinder* and, usually, a *jog button*. These settings relate to how your camera captures, playbacks, saves, and otherwise handles your photos.

Metadata Nonvisual information about your photos stored with the image data. For example, all digital cameras insert the time and date of when a picture was taken. Most also save the camera model name, the exposure and color settings, and so on. The metadata is not visible in the photograph, but it can be read and displayed by many programs when you want that information. In some software, you may be able to add to the metadata with your own comments, copyright notice, *keywords*, and so on.

Meter Also referred to as a *sensor*. A device that reads the amount of light falling on or reflected from the subject or scene being photographed. Digital cameras have very sophisticated internal meters or external meters, which will recommend or automatically sets various combinations of *f-stops* and *shutter speeds* that would produce an appropriate exposure. Professional photographers also use standalone meters (unattached to any other device) for measuring the amount and color of light. See also *Metering options, Center weighted metering, Matrix metering,* and *Spot metering*.

Metering options More advanced digital cameras usually offer several metering options, so the photographer can choose which areas of a scene the meter should read to determine the correct exposure settings for the picture. See also *Meter, Center weighted metering, Matrix metering,* and *Spot metering*.

MPEG Short for Moving Picture Experts Group. A common video and audio file format used in many digital cameras and DV camcorders.

Multi-exposure A setting that some digital cameras have that allows users to capture a quick series of 9 or 16 small pictures and save them within one photograph. Typically, it is used for action photos, such as a golf swing. In most modern digital cameras, multi-exposure has been replaced by faster *burst modes*.

Noise Tiny perceptible dot patterns in a digital image that are often misplaced *pixels* or *artifacts*, sometimes created by electronic interference within the camera. The digital equivalent to film *grain*, noise can be an undesirable effect that detracts from overall image quality or something you choose to create artistically.

OLED Organic light-emitting diode. A recently developed display technology that is being used by some digital camera manufacturers to replace *LCDs*. OLEDs supposedly use less battery power and are brighter and more contrasty, which should mean that they'll be easier to use.

Optical viewfinder An *eye-level viewfinder* that is made of optical glass and views the actual scene rather than displaying a miniature electronic monitor.

Optical zoom The ability of a lens to reduce or magnify a scene so a larger or smaller area or detail fills the entire frame. The photo captured using an optical zoom is almost always superior to any that was shot using *digital zoom*. We recommend never using digital zoom.

Pan and zoom A useful function in the *playback* mode that allows users to magnify the captured image in the *LCD viewfinder* (which makes the image too large to fit in the viewfinder) and then, by using the *jog switch*'s four-way buttons, to move or pan around the image. Typically, pan and zoom allows users to magnify the image 2X or 4X, though better cameras can zoom up to 16X. By magnifying the images and zeroing in on a specific section, you can see details not visible when the entire image is sized to fit the viewfinder. This way, you can decide if you captured the detail you wanted or if you should reshoot.

Panorama A type of photo that displays a wide (or tall) vista. Panoramas are usually created by taking multiple overlapping shots and "stitching" them together. Some digital cameras have a panorama mode that displays guides in the *LCD viewfinder,* which helps you accurately line up the overlapping photos. However, you can create the component photos for panoramas in any camera with or without the panorama mode. In either case, the final stitching is usually done by special panorama software. When done properly, the finished image looks like a single seamless picture. Some panoramas can be as wide as 360-degree pictures. For best results, shoot panoramas from a tripod.

PDF Portable Document Format. Adobe's proprietary file format for creating and passing along any document so the recipient sees exactly the same thing on his monitor as the sender, including typeset formatting, embedded pictures, and graphics. Anyone can receive and display .pdf files using the free Acrobat Reader available at www.Adobe.com. But you'll need to purchase other Acrobat software to be able to generate or edit those files. Because of its versatility, transportability, security, and other benefits, the .pdf format has become the *lingua franca* for transmitting documents.

Photo-editing or -imaging software Programs in which you can alter your photos and/or create digital images. Depending on the software, you can improve exposure, color and other attributes of your picture, paint on it, add type, apply special effects, resize it, combine it with other pictures, prepare it for email or posting on the Web, output it to a printer, or do any number of other manipulations or edits. The software varies in cost from under $30 to hundreds of dollars. Popular programs include Adobe Photoshop, Corel Painter, Macromedia Fireworks, Roxio PhotoSuite, and so on.

Photo management software Programs that provide the tools for organizing, managing, searching, and archiving your library of digital photos. Even novice digital photographers end up with thousands of photos on their computer, which is why we highly recommend using some form of photo management to help gain control over the chaos of pictures. This is especially important for businesses in which photos are assets. If nothing else, it helps you find a particular picture out of the thousands quite easily using timelines and/or *keywords.* Also known as image or visual database or media asset management, they range in price from about $50 to hundreds of dollars. Popular programs include ACDSee, Adobe Photoshop Album, Extensis Porfolio, Picasa, and so on.

Photoreceptor site Also called a pixel well, it's an etched rectangle or octagon on an *image sensor* that collects photons and turns them into electrons. The electrical charge from the photoreceptor is passed on to a chip called an *analog-to-digital converter (ADC),* which calculates and converts those charges into digital information: zeroes and ones. In turn, that data are used to recreate color and form. Every image sensor has hundreds of thousands or millions of photoreceptor sites that, when

composited together, capture the information that eventually produces a coherent, recognizable digital image. The number of sites of a digital camera's image sensor is measured in *megapixels*.

Photoshop compatible plug-in See *Plug-in*.

Photosite See *Photoreceptor site*.

PictBridge A standard embedded in most digital cameras and many printers that allows any camera to be connected directly to any PictBridge-compatible printer, regardless of brand or model, without having to go through a computer. PictBridge enables users to generate prints directly from the attached camera or memory card. It's good for producing quick snapshots that require little or no corrections, since image-editing capabilities are typically limited. For more sophisticated editing or corrections, you'll have to give up the speed and convenience of a PictBridge connection and *download* your images into the computer so they can be worked on in a *photo-editing program*.

PIM Print Image Matching. Epson's proprietary system that automatically optimizes print quality when pictures shot with any PIM-enabled digital camera are output on certain models of Epson printers. A number of digital camera manufacturers have embedded PIM in their products, because it makes printing easier and the quality higher. But as you can expect, companies like Canon and Hewlett-Packard, which also make photo printers, do not support PIM in any way, shape, or form.

Pixel Pixel is short for picture element, the smallest indivisible piece of data in a digital image. Every digital image is made up of thousands or millions of pixels, each with its own color characteristic. When viewed together, they will look like a seamless, continuous tone photograph rather than millions of individual pixels. See also *Byte*.

Pixel transition The technical measure of how sharp an image a digital camera can produce. The fewer *pixels* used in transitioning from an absolute white to an absolute black line, the better the camera's pixel transition score and the sharper its images will be. See Figure 7-1 in Chapter 7.

Pixel well See *Photoreceptor site*.

Playback The name of the mode used for displaying and reviewing captured images in a digital camera.

Plug-in A subprogram, usually developed and sold by a third party, designed for a specific purpose that installs itself in the menu of a popular application like Photoshop. Plug-ins may be special effects filters, but may also be drivers for digital cameras or scanners. Many plug-ins are said to be Photoshop-compatible, which means they will work in just about every *photo-editing program* and not just Photoshop. Most plug-ins are easy to install and work transparently within the application program.

Portrait mode Portrait mode is the term used to describe pictures that are taller than they are wide, which is why it can be appropriate for photographing portraits. The opposite is *landscape mode*.

Posterization An effect that can occur when the number of colors available for display or printing is limited. It's often associated with 8-bit color, which can uses only 256 colors. With such a small palette, gradations or transitions between different shades and hues are much fewer than 16-bit (65,000 colors) or 24-bit color (16.7 million colors), so they are much more abrupt and noticeable, and much less natural. It's called posterization because silkscreen posters usually exhibit only a few different colors and not a full palette. Posterization is considered a default or defect when printing photographs, though it may be a desired artistic effect for some digital art, which is why some imaging programs have a posterizing special effect.

POTS An acronym that stands for plain old telephone service, POTS is a very slow Internet connection that comes over traditional telephone lines. Many people are still connected via POTS, which means that they don't have the kind of high-speed (*broadband*) connections that can easily handle large photo files.

ppi See *dpi*.

Profile A profile is information about a device—be it a digital camera, scanner, monitor, or printer—generated and used by *color management* software to define and refine how that device produces color, light, and contrast. Professional photographers and graphics pros use profiles in an overall color management system to coordinate their cameras, scanners, monitors, and printers so they all see, interpret, and display color the same way.

Program mode Predefined camera settings that are optimized for specific shooting situations and subjects, such as sports, a sunlit beach, and snow scenes; low-light and night candids; fireworks and the inside of museums; landscapes and portraits; and so on. Many models have program modes that are useful in squeezing out more quality and performance than simply leaving the camera in the point-and-shoot mode.

Prosumer A class of digital camera designed for serious photographers. Prosumer cameras are equipped with higher-quality lenses and offer faster performance than amateur models. They also have more pro-like features, such as eye-level through the lens viewing, and the ability to shoot RAW mode image files. What distinguishes them from semi-pro models is that they aren't true *D-SLRs* with interchangeable lenses. But they are significantly less expensive than D-SLRs.

PSD Photoshop Document. Photoshop's proprietary file format, which maintains information regarding all the editing you apply to a photo within that program. This means you can reverse or adjust it. It is not a universal file format; it can't be read by many other programs and is not appropriate for sharing photos. We always maintain an original .psd version of those pictures we edit in Photoshop, saving a copy to more universal formats (such as *JPEG*) for sharing.

Pull-down menu The lists of options, commands and additional menus found by clicking on the words at the top of a program's screen. These words can include File, Edit, Image, Help, and so on.

RAW A proprietary file format unique to each digital camera manufacturer that preserves all data captured by the *image sensor*. Instead of processing the image inside the camera (which permanently

changes or throws away data), the RAW file is created and processed later, in the computer. Pros prefer RAW because it is much more forgiving than any other file format, is relatively fast to save, and doesn't take up as much file space as TIFF files, and because all data are saved, the final picture can be of higher quality if tweaked correctly. However, RAW files do require that the photographer spend more time on the processing of the data into a usable photo file.

RAW JPEG Several prosumer, semi-pro, and professional digital camera models allow users to shoot and simultaneously save two files for each image: a RAW file and a JPEG file. The reason is to allow the photographer to see the picture in any image viewing program or device; many devices cannot display RAW files, but they all can recognize and display JPEGs. The JPEGs associated with this file format are for viewing only, and not intended to be edited or used.

Reflective color Color, such as that on a printed page, that is created when light from another source falls onto the object and is reflected back to your eyes.

Resample See *Resize*.

Resize Resize is the command or the process by which an image's dimensions or file size are changed. There are times when you may wish to resize a picture, such as to be able to output a print that fits a certain paper or picture frame size or to reduce it for faster transmission to the Internet or sending as email. Some digital cameras have a resize menu command accessible during playback.

Resolution Resolution refers to two different measures. (1) The amount of data, or *megapixels*, that a digital camera's *image sensor* is capable of capturing. Megapixel resolution refers, not to image quality, but to the amount of information the camera delivers, which in turn directly affects the maximum size an image can be printed or displayed at optimum quality. For example, a 3-mega-pixel digital camera's maximum print output size is approximately 8″ × 10″; beyond that, print quality deteriorates. (2) The other definition of resolution refers to a camera's resolving power, or the ability of a camera to capture detail (sharpness) in a photograph. Using industry standard measurements, a typical 3-megapixel digital camera has a resolving power of 1,050–1,100 lines, whereas an 8-megapixel digital camera has a resolving power of 1,750–1,850 lines. The more lines, the greater the detail. Whereas an image sensor's resolution is fixed by its number of pixels, the resolving power of the entire system is affected by a number of variables, such as the optical quality of the lens (and how clean it is), *ADC* and *DSP* chips, and the *algorithms* that create color and form. That's one reason two cameras with the same image sensor resolution can produce very different picture quality.

Resolving power See *Resolution*.

RGB Red, green, blue. The *color model* that is used in digital cameras and by computer monitors. Of the various flavors of RGB, two are particular important in digital photography: sRGB and Adobe RGB. HP and Microsoft developed sRGB, which includes all the colors that can be displayed on a typical computer monitor. While it is great for images that will spend their entire existence only in computers or on the Web, it has a limited *gamut*. Adobe RGB includes a larger gamut of colors than sRGB, especially in the blues and cyans, which makes it more appropriate for print output.

sRGB is the default color space in the vast majority of digital cameras. When a camera offers Adobe RGB as an option, we invariably switch to it.

Rocker switch A two- or three-way switch that toggles between or among functions by pushing it one way or another. For example, a zoom rocker switch may activate wide angle when the left toggle is pushed, and telephoto when the right side is pushed.

Sampling Also called resampling, it's when the camera, computer, or software changes the size (amount of data). It is most frequently used to refer to shrinking the image size. See also *Interpolation*.

Saturation The density of color in an image. Many digital cameras have a saturation mode, accessible through the menu, that allows users to select the degree of saturation desired: light, normal, or heavy. However, be aware that if you select light or heavy saturation, it will be more difficult to change the color in the image editing process. We suggest leaving saturation on normal, and if you wish lesser or greater saturation in your picture, you can always adjust the level in your computer.

Scalable In terms of image files, scalable refers to the ability of a single file to contain several different sized versions of a picture. This means that when a picture is output to a specific device, the file format will deliver only that amount of data that is necessary for display or printing on that device. Consider a photo that you want to have as a high quality print as well as to transmit to a friend's cell phone. The print would need a larger amount of data than the cell phone display. A scalable file format (such as *JPEG 2000*) automatically delivers only the amount of data required for the specific operation or device.

Self-timer An electronic delay mechanism that adds 2–10 seconds between the time when the user fully presses the shutter button and when the photograph is actually snapped. A self-timer allows the photographer enough time to put himself in the picture, but it's also useful in minimizing camera motion while shooting. Using the self-timer means firmly anchoring the camera during the countdown, either on a tripod or minipod, or other solid surface such as a table or desk.

Sepia A color mode in most digital cameras that turns images into a brown and white pictures. Sepia is meant to emulate old-fashioned, nostalgic, turn-of-the-century (1900, not 2000) photographs like those taken by our great-great-grandparents.

Shutter A mechanical or electronic device (actually a hybrid electronic *and* mechanical device on most digital cameras) designed to regulate the amount of time that the *image sensor* is exposed to light. Typically, the shutter's opening and closing speed is measured in fractions of seconds, such as 1/500th, 1/2000, 1/100th, 1/30th, and so on. Faster shutter speeds are used to capture action, and slower speeds are for low light, a controlled blur effect, or to boost the depth-of-field by allowing a smaller *aperture* to be selected.

Shutter lag Because every digital camera undergoes a number of nearly simultaneous processes the instant the shutter button is fully depressed—checking focus and exposure, preparing the *image sensor* to divert data to the *DSP*, getting ready to fire the flash—there is an inevitable, unavoidable delay before the camera actually takes the shot. In pro and semi-pro cameras, that

lag is negligible and does not affect the shooting experience, but in less expensive digital cameras, shutter lag can mean losing the shot you thought you were getting. Depending upon the model, shutter delay can last as long as 1.5 seconds. You can minimize shutter lag by holding the shutter button down halfway to freeze focus and exposure while you compose the picture.

Shutter priority A semi-automatic exposure mode in which the user manually selects the shutter speed, and the camera automatically sets the corresponding appropriate *f-stop*. Shutter priority is useful when shooting sports and other action subjects, when a high shutter speed is desired and the *f*-stop only a secondary consideration. See *Aperture priority*.

Shutter speed The interval during which a camera shutter opens and closes. Each doubling of the shutter speed changes the exposure equation by one *f-stop*.

Single Lens Reflex (SLR) See *D-SLR*.

Solarization A process that partially, but not fully reverses the colors and contrasts of an image, producing a strange and bizarre looking picture. Some digital cameras have a solarization mode in the color section of the menu. Use it for fun and special effects.

Sports mode See *Action mode*.

Spot metering Most digital cameras offer several *metering modes* for measuring the light of a scene and adjusting proper exposure. Spot meter mode is where the light is read only in a small portion of the center of the subject, usually about 5 percent of the total picture. It's useful for guaranteeing that the part of the subject you care the most about will be properly exposed, such as a piece of jewelry around the neck of a model, the radiator ornament on the hood of a car, or the clock in a church steeple. See also *Meter, Metering options, Matrix metering,* and *Center weighted metering*.

Strobe, or strobelight See *Electronic flash*.

Subsample See *Sampling*.

SuperCCD Fujifilm's proprietary *image sensor* that uses unique octagon shaped *photoreceptor sites*. This allows for hardware *interpolation*, effectively doubling the resolution without degrading image quality. The latest generation SuperCCD IV comes in two versions: one that doubles the resolution without resorting to hardware interpolation, and the other that extends *dynamic range* for greater detail in the highlights and shadows by placing 2 pixels at every photoreceptor site.

Tag See *Keyword*.

TIFF Tagged Image File Format. TIFF is a universal image *file format* which can be read by almost all imaging applications and which preserves all image data. Unlike *JPEG*, there's no compression, nor does the file change (degrade) every time you save it. It used to be the preferred format for serious digital photographers, but has been largely eclipsed by the RAW format, which offers more latitude, faster processing time, and potentially better image quality. Saving TIFF files in a digital camera can be very time-consuming, longer than any other format. What's more, because it's uncompressed,

it takes up the most storage space. The rule of thumb for highest quality imaging is to shoot RAW, but save a TIFF copy once you begin working on it.

Time exposure To capture details while shooting at night or in low light, a user must set the *shutter* to a slow speed. Time exposure refers to any exposure that is longer than 1 second. While film cameras can take time exposures that last hours, for technical reasons, the longest time exposures on most digital cameras is 30 or 60 seconds. To take a properly exposed time exposure, the camera should be on a tripod or anchored securely, and the low *noise* setting should be activated. Also, to prevent camera shake, the shutter should be fired remotely, or activated via the *self-timer*.

Time lapse or time interval Some digital cameras have the ability to automatically shoot a series of pictures according to a user-defined interval. For example, if the user specifies 1 minute, the camera will take a picture every 60 seconds, until a preset time is reached or the camera runs out of memory space or battery power. Time-lapse photography usually involves mounting the camera on a tripod or some other stationary anchor, and the time between frames usually can be varied between 1 minute and 1 hour. Time lapse is used for nature photography, surveillance, and documenting scientific, medical, or industrial processes or procedures. For ongoing time-lapse photography, a video camera may be preferable, especially if high resolution is not needed.

Transmissive color Color that is transmitted to your eyes directly from the light source. For example, light from your computer monitor is transmissive color, as are film transparencies and negatives. Its opposite is *reflective color*, in which light bounces off the subject or a print to your eyes. Because it comes from the light source, transmissive colors are always brighter and more saturated, which is why there are different *color models* for transmissive and reflective color.

TTL Through the lens. The ability of some cameras to have their flash or auxiliary strobelight be controlled by an intelligent sensor that reads the actual light reaching the *image sensor*. TTL flash is more precise and produces more natural light than non-TTL.

Upload See *Download*.

USB Universal Serial Bus. One of the primary means that a computer communicates with peripherals, including digital cameras, keyboards, scanners, printers, and so on. All computers newer than 3 years old have built-in USB, while even more recent computers feature high-speed USB 2.0 capable of transferring data many times faster than the older 1.1 standard. Almost all digital cameras now communicate with PCs via a USB port.

USB storage class Most digital cameras have a *USB* interface, and most USB interfaces can be set up two ways (which are not mutually exclusive): as a dedicated device that automatically loads in that manufacturer's image acquisition software or as a USB storage class device. If the user sets the camera to be a dedicated device, attaching the USB cable will automatically download the images to the computer. When it's set up as a storage class device, it's automatically recognized as an external disk drive, and the images files can be transferred by using Windows' or OS X's drag-and-drop capability.

White balance The ability of a digital camera to recognize and adjust to pure white under a variety of different lighting conditions. The theory is that adjusting the color balance so the white in a scene is truly white will automatically remove any *color shift* from the picture and all the other colors are captured accurately. Most digital cameras provide automatic white balance as well as presets—such as fluorescent, tungsten, daylight, and overcast—and some also feature manual white balance. In manual white balance, the user points the camera at a sheet of white paper, presses the white balance button, and the camera then sets all the colors relative to that white.

X3 A type of *image sensor* developed by a company called Foveon that combines all three primary colors in a single *photoreceptor site* rather than the traditional method that requires a separate photoreceptor site for each primary color. Supposedly, it improves color fidelity and sharpness while eliminating color aliasing. There may also be some resolution boost.

Index

continued

continued

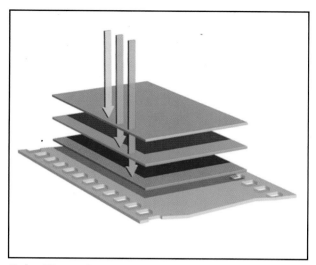

Color Figure 1

Basic color film actually consists of three layers of black and white film sandwiched in between red, green, and blue filters, all attached to a piece of plastic (usually Mylar). When developed, the black and white silver halide in each layer is replaced by corresponding red, green, and blue dyes. When composited (sandwiched) and viewed together, they appear as full color. (©1998–2004 Foveon Inc.)

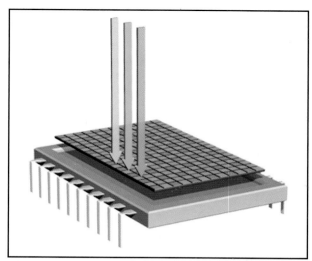

Color Figure 2

A Bayer pattern image sensor. Note the checkerboard pattern of alternating red/green/blue/green filters, which is the type of color filter array that is used in most digital cameras. The color of the filter covering each pixel allows only photons of that color to pass through. In other words, when light reaches the red square over a pixel well, only that light which is red will get through to the pixel. All other colors will be blocked. And so it goes with the green and the blue pixels. Later in the digital capture process, these primary colors are composited together to make the full color photo. By the way, the number of green pixels is doubled in the Bayer pattern, because, due to a combination of psychology and physiology, the color green makes the image appear sharper to the human eye. (©1998–2004 Foveon Inc.)

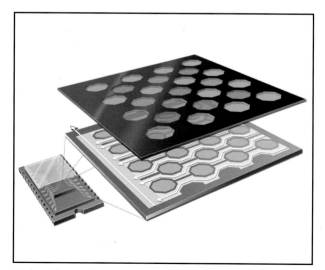

Color Figure 3

Fujifilm's SuperCCD image sensor uses an interlocking honeycombed design that forces each octagonal pixel to abut each other. The space between each pixel is used to carry information about the electrical charge of each pixel.

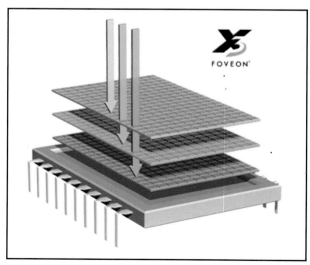

Color Figure 4

Foveon's X3 image sensor captures red, green, and blue light at each pixel by collecting the various wavelengths of light at different depths. (©1998–2004 Foveon Inc.)

Color Figure 5

In both film and digital photography, color photos are created by using the RGB color model. In this figure, the light of a scene is broken up into its red, green, and blue primary colors and then recombined to make all other colors that the camera is capable of capturing.

Color Figure 6

The photo on the left is 24-bit color, the minimum bit depth for photorealistic pictures. 24-bit color uses a palette of 16.7 million different colors to create smooth gradations and transitions. The photo on the right is 8-bit color, which has a palette of only 256 different colors. Notice the banding, or posterization, that is most prominent in the left cheek of the 8-bit picture.

Color Figure 7

If the ambient light is fluorescent, and you shoot with daylight white balance settings, you'll end up with a sickly yellow-green color shift. (Photographed with a Minolta DiMAGE A1.)

Color Figure 8

Here we changed the white balance to tungsten, which introduced a blue color shift. (Photographed with a Minolta DiMAGE A1.)

Color Figure 9

But when we switched to fluorescent white balance, the photo reproduced the true colors of the scene. Whenever you are disappointed in the colors of your photos, first check that you are using the appropriate white balance setting. (Photographed with a Minolta DiMAGE A1.)

Color Figure 10

When we used the Minolta DiMAGE A2's RGB natural color setting, the colors captured are quite accurate.

Color Figure 11

Using the DiMAGE A2's vivid color setting, the stein's colors are slightly heightened. Look at the red jacket and the rosy cheeks. In some situations, vivid color gives that little bit of extra punch that can be quite appealing.

Color Figure 12

Shooting with an Olympus C-8080, we took this photo of our assistant Jake Rae at the camera's lowest saturation setting (-5). The result is a bit washed out for this portrait. Low saturation is sometimes great for pictures in which you don't want the color to overpower the subject.

Color Figure 13

Here's another portrait of Jake with the Olympus C-8080's saturation at its default setting (0).

Color Figure 14

Pushing the Olympus C-8080's saturation to its highest setting (+5) works for this portrait, because Jake is so fair skinned that the extra rosiness is appealing.